California's Best

Old West Art & Antiques

Bradley L. Witherell
and Brian L. Witherell

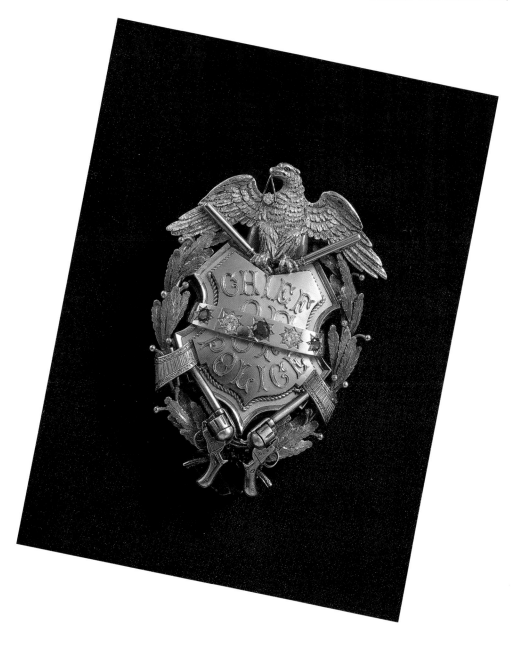

4880 Lower Valley Road, Atglen, PA 19310 USA

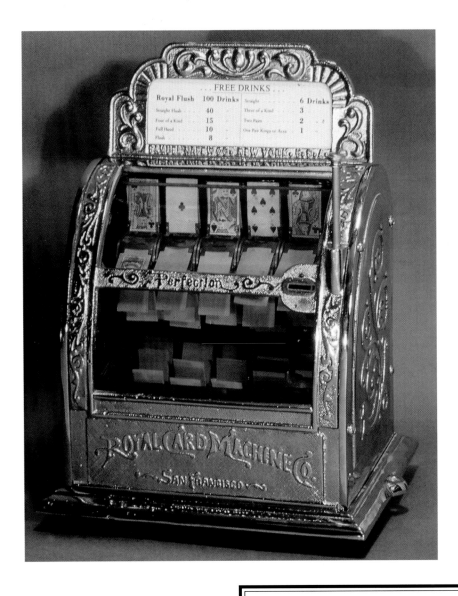

Library of Congress Cataloging-in-Publication Data

Witherell, Bradley L.
 California's best: Old West art & antiques/Bradley L.
Witherell and Brian L. Witherell.
 p. cm.
 ISBN 0-7643-0841-6 (hardcover)
 1. California--Collectibles--Catalogs. 2. Antiques--Cali-
fornia--Catalogs. I. Witherell, Brian L. II. Title. III. Title:
California's best Old West art & antiques.
NK835.C3W58 1999
745.1'09794'075--dc21 99-18461
 CIP

Designed by "Sue"
Type set in Americana X Bd BT/Dutch 801

ISBN: 0-7643-0841-6
Printed in China
1 2 3 4

Published by Schiffer Publishing Ltd.
4880 Lower Valley Road
Atglen, PA 19310
Phone: (610) 593-1777; Fax: (610) 593-2002
E-mail: Schifferbk@aol.com
Please visit our web site catalog at **www.schifferbooks.com**

This book may be purchased from the publisher.
Include $3.95 for shipping.
Please try your bookstore first.
We are interested in hearing from authors
with book ideas on related subjects.
You may write for a free catalog.

In Europe, Schiffer books are distributed by
Bushwood Books
6 Marksbury Rd.
Kew Gardens
Surrey TW9 4JF England
Phone: 44 (0)181 392-8585; Fax: 44 (0)181 392-9876
E-mail: Bushwd@aol.com

Dedication

To Josiah Witherell, 1812-1864,
who had the courage and determination to follow his dream by ship and land
through the Isthmus of Panama with a wife and six children to California

In memory of Hebert C. Witherell, 1905-1977,
who generously shared both time and disciplines with his son

And in memory of Velma O. Witherell, 1907-1996,
who inspired us both with her artistic insight, refinement, and generosity

ACKNOWLEDGMENTS

Special thanks is offered to pioneering collector Hugh Hayes whose inspiration and knowledge of California is unsurpassed. In addition to the best lunch date a fellow could have, his wife, Maryanne, and dog, Bobo, are always fun to visit. Collectors Francis and Duke Cahill always trusted us and helped us get established in Sacramento. Crocket Blacklock unsuccessfully negotiated the purchase of a Henry rifle from Brad in 1959 (when he was 16 years old; the price was $250, that's all it was worth back then). We have done business together ever since and he has always been fair and honorable.

Jim Mackie provided us with a great amount of information on advertising. James Nottage of Autry Museum of Western Hertiage, Jon King, Michael Weller of Argentum The Leopard's Head, Bob Nylon of Nevada State Museum, Marshal Fey of Liberty Belle Saloon, Richard C. Cote of the United States Department of The Treasury, Lisa Kathleen Graddy of National Museum of American History, Herb Ratner Jr., Peter McMickle, James Klein, Roger Graham, Margaret B. Caldwell, Ron and Sandra Van Anda and J. Hill Antiques all gracelessly provided photos.

Thanks is offered to all the private collectors who allowed us to come into their homes and photograph their vast and important collections; they were memorable experiences. Brad and Mary and Rob Watts, Al and Carol Cali, Paul and Margeret Friedrich, Robert and Dorothy Soares, Charlie Zawila, Don and Charlotte Smith, Bill and Marline Rebello, Mike and Sally Butler, Roger Baker, Gary and Susan Dubnoff, Paul Schweizer, Bob Butterfield, Richard Siri, Tom Jacobs, Donald and Gloria Littman, Jim Lund, John and Donna Herman: we thank you.

Also to all the others who allowed us to photograph their items: Michael W. Bennett of The San Joaquin County Historical Society, Oakland Museum of California History, Fat Lady Restaurant, Russell and Dolly Evitt the Columbian Lady, Joe Welch, John Boessenbecker, John Rauzy, Tod Ruse, Adams Collection, Wygant Collection, and Don Reed.

The California State Library and its staff provided important information which is only as good as its source— and in California, this is the Motherload.

And a very special thanks to Angie Witherell who has always allowed us to follow our pursuits without compromise, second guessing, or nagging. We feel fortunate to have you in our lives.

CONTENTS

PREFACE

On the eve of the Gold Rush Sesquicentennial and the dawn of the California Statehood Sesquicentennial, this work represents the most comprehensive study of Old West antiques from the Golden State to date. Its content represents historical California furniture, gold and silver objects, gambling tools, firearms, edged weapons, and advertising items from the years 1850 to 1920, the preferred material of gold rush romantics. Ordinary as well as extraordinary items are presented to give readers an opportunity to learn about this unique period of American history through the culture surrounding their use.

Connoisseurship of California art and antiques is founded on few simple guidelines, principle among them the desirability of the subject matter, its condition, and its provenance. Here the introductory text, descriptions of the pictured items, and biographical information of the makers and manufacturers provide the necessary information to understand these historical and often very beautiful California art and antiques.

The following lessons and thoughts of legendary figures in the antiques trade are presented as guidance when pursuing antiques on your own:

On **condition**: "THAT WAS NO $46,000 STRIP JOB, THAT WAS A $152,000 STRIP JOB! We have a corrected figure to report from our annual winners, losers list of last month. Because of a transposed figure in December coverage of Christie's October 1996 American auction, the wrong figure crept into print for the amount the Manneys paid for the Boston Chippendale table they resold at the fall Americana sale. The table, with old surface, cost them $198,000 in 1987; stripped and refinished, it brought $46,000. That makes for a record loss by stripping, a whopping $152,000 lost." (*Maine Antique Digest*)

On **growth**: "You know, we all have to adjust our eye and sort of get use to what is a better object. And I certainly know in my thirty years of being an antique dealer, I never made the same mistake twice. I remember buying a highboy when I was young and finding out it had four new legs and getting two thirds or a third of what I paid. I really think that losing money is like a child's learning about a hot burner by putting his hand on it." (Ronald P. Bourgeault, *Maine Antique Digest,* March, 1994)

On **less is more**: "...you have to decide whether you are going for one important object or a number of objects. And again, I can only relate to you my own experience that my wife and I had when we were starting out. We made the decision that we would save our funds and go after one object a year. At that time, this meant setting aside about fifteen hundred dollars a year for a single piece. I found this approach to be a good way to go. I would rather put the bulk of the money I had available in one or two objects. I would never regret those purchases. I hate to have to tell you, I'd rather live in a house with one great chair and the rest of it be empty than live in a house with second-rate stuff." (Brock Jobe, *Maine Antique Digest,* March, 1994)

On **raising the bar**, in a 1954 letter from Isreal Sack to Henry Francis du Pont: "Not long ago I visited a collector who was an accumulator of fourth-rate American antiques. He asked my opinion of this collection. I told him that when collecting American antiques, it is economical to be extravagant, and much too extravagant to be economical." (*Antiques and Arts Weekly,* April 19, 1996)

On **discipline**: "Fred Giampietro discovered the antique business was a lot like the music business. Both required self discipline. He had learned such discipline playing for a symphony orchestra. He had learned to hold back when it was someone else's turn to be heard. Antiques were the same way. When a man bought and sold things worth tens of thousands of dollars, he had to discipline himself not to buy a candlestick for $350, even when he knew he could sell it for $1,500. If he wanted to be a great dealer, he had to have great things. When a $1,500 candlestick entered his shop, everybody knew it. It was a lesser thing and lesser things make lesser dealers." (Thatcher Freund, *Objects of Desire,* Pantheon Books, 1993)

The relative values of the items in this book are indicated by a letter following the caption as follows:

 A less than $1,000
 B $1,000 to 5,000
 C $5,000 to 10,000
 D over $10,000

INTRODUCTION

Populated by people with a pioneer spirit, some precipitated by the discovery of gold in 1848, Californians have realized unprecedented growth in population, cultural change, and artistic achievement. Through enterprise, sacrifice, and outright conquest its people are responsible for developing the California frontier, nearly eradicating a race (Native Americans of several tribes), and completing a railroad system considered the crowning achievement of the Industrial Revolution. Ingenuity extended into the 20th century with the expansion of the motion picture industry, the creation of the Hollywood cowboy, the introduction of the California bungalow, the invention of the custom car, and by pioneering the computer. Progress and prosperity are responsible for making California today home to more people and more millionaires than any other state. Its farmers grow much of the nation's produce, and California's trillion-dollar economy is ranked seventh in the world.

These ingredients historically have made California a microcosm of the American dream. California promised a better life to those who came and fostered a climate that is as socially diverse as its geography is distinct. Mark Twain described the pioneers who comprised the gold rush as, "thieves, murderers, desperadoes, lawyers, Christians, Chinamen, Indians, Spaniards, gamblers, poets, preachers, and jack ass rabbits." A conglomeration, isolated by deserts, mountains, and sea, which evoked an ideology that through time has proven wildly productive and creative.

In its artistic endeavors, California's regionalism and bravado manifested a unique and independent style characterized by fashioning localized material and symbols into standardized forms. The people created a distinct vernacular that evolved with the current styles. It is the intent of this book to bring to focus the material that describes California's legacy through imagery.

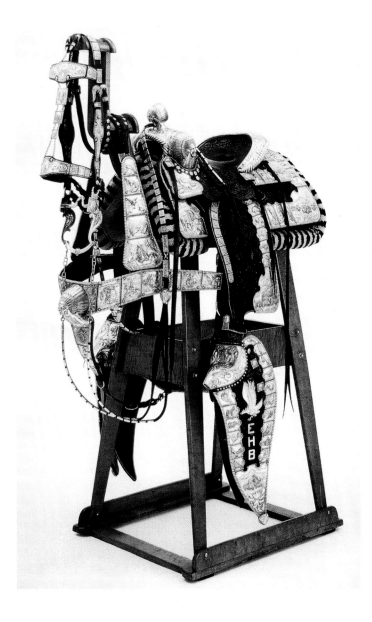

Chapter 1

FURNITURE

The furniture market in California has had a resounding affect on the furniture industry in America as a whole for the past one hundred and fifty years. In California, the furniture market was infused with an unprecedented demand for goods as consequence of the wealth from gold and silver fortunes, building the transcontinental railroad, and embracing the industrial revolution. This combination energized the growing Grand Rapids, Michigan, furniture industry and transportation of furniture to the Golden State expanded the fortunes of California's railroad barrons. A handful of wealthy Californians, at great expense, commissioned prestigious New York decorators to outfit their mansions. An opulence was created here that would continue through the nineteenth century. Then a new California style emerged fostering a decorative climate that stimulated new artisans who kept California on the cutting edge of the decorative arts movement.

The first furniture manufacturers and dealers to arrive in California were byproducts of the 1849 California gold rush. Although very few documented furniture pieces survive from these early years, there are a number of records relating to the sale of such furniture. Among the pioneer dealers were Christian Screiber and James Goodwin of San Francisco along with John Breuner of Sacramento. By the late 1850s, Charles Plum and the Emanuel Brothers of San Francisco had gained notoriety. In the 1870s, the greatest influx of manufacturers and dealers took place. After the transcontinental railroad was completed in 1869, California supported a multitude of furniture makers and dealers. The following statistics were reported in *The Alta California Commercial Edition* for the year 1888. "This branch of manufacture...represents 18 establishments employing 800 hands, consuming 9,000,000 feet of lumber and producing goods to the value of $1,300,000. San Francisco furniture is sold all over the pacific slope and for novelty of design, perfect finish, durability and cheapness, cannot be excelled."

For super rich Californians, however, who had amassed great fortunes, the Midwestern furniture which W.J. Henney & Company carried and the manufactured furniture which J.B. Luchsinger produced was not at all suitable. These individuals, such as Milton S. Latham, required the assistance of firms like Herter Brothers, New York's most fashionable decorators.

By the time Milton Latham began to build and furnish his Herter Brothers-decorated, $250,000, mansion on the San Francisco peninsula in 1872, he had already held the offices of United States congressman, senator, and California governor. His wealth is believed to have been generated by building railroads but, like most robber barons of the time, it was perhaps augmented through some form of corruption. If his fortune was acquired through any shady means, this fact was not understated by the flamboyance with which he lived. The 1901 *San Franciso Call* described his life-style as a "...reign of gaiety and lavish entertainment such has never been dreamed of or equaled since." His household extremities were purported to included solid silver light fixtures and hitching posts in the stable. Properly titled "Thurlow Lodge," the Herter-furnished residence was completed in 1874. It was one of many California commissions for Herter Brothers, which included the homes of Darious Mills, Mark Hopkins, and James Flood. The Latham commission was certainly their greatest accomplishment in the "Renaissance style."

In the last quarter of the nineteenth century, house decorating taste in California and the rest of the world had changed course. The Japanese and Asian exhibits at the1876 Centennial Exhibition in Philadelphia inspired a shift in design taste which propelled a less-is-more philosophy that has become known as the "Aesthetic movement." No longer were "Renaissance style" heavily sculpted designs preferred but rather clean, gentle lines with naturalistic adornment were sought. The firm of J. B. Luschinger & Son in San Francisco used the Centennial Exhibition booth of furniture dealers Kimble and Cabus to advertise their line of "artistic" furniture. The firm of Charles Plum & Co. offered a "Japan style" desk in their trade catalog about the same time. The new style would continue to manifest itself and by the turn of the twentieth century California would blossom into a leader of the Aesthetic movement offshoot known as the Arts and Crafts movement.

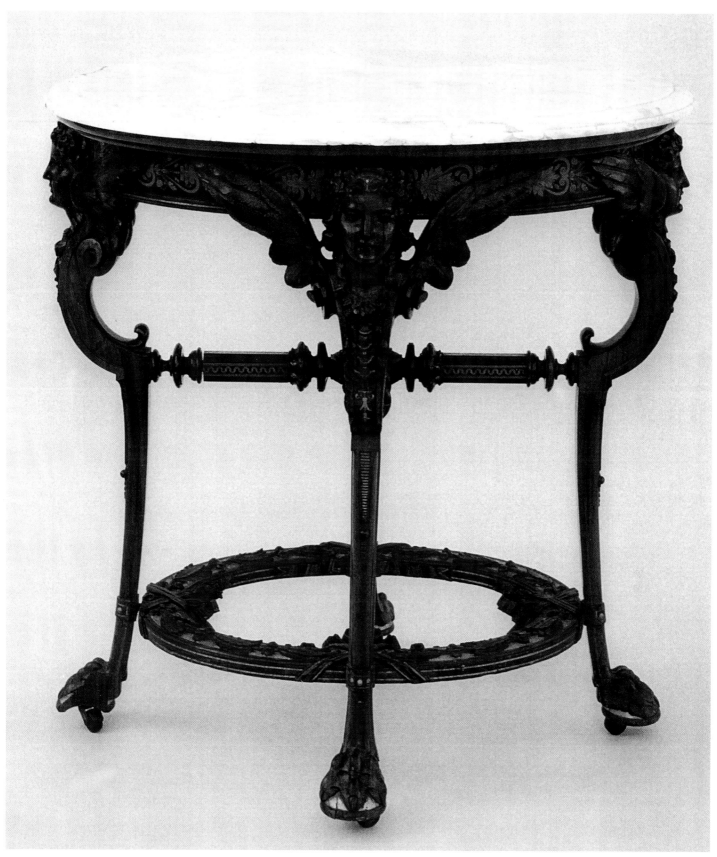

Rosewood, marquetry, and parcel gilt tea table in the Art Furniture style with onyx top, inscribed in pencil *Gustavson*, presumably the carver working for Herter Brothers, and twice *Latham*, the recipient. Milton S. Latham maintained residences in both San Francisco and Menlo Park, and although this example matches an auction catalog entry from the 1942 sale of the Menlo Park residence it also resembles a description from the library of his San Francisco mansion. This library was described in the *San Francisco Call* as, "The finest room in the house..." The room is further said to be "... furnished with classic severity, but with perfect taste...Two faust arm chairs, heavily carved lounges, easy Turkish chairs, ... and a gilt rosewood

table." (See Loughead, Flora, *The Libraries of California*, A. L. Bancroft & Co.; San Francisco, 1878)

In keeping with the best of Herter Brothers furniture (see Howe, Katherine S., *Herter Brothers Furniture and Interiors for a Gilded Age*, New York, 1994, p.106), this model is of the highest aesthetic quality. Having presence beyond its size, the compact form is applied with a virtual myriad of decorative schemes, creating both a luminous and visually stimulating aspect. Its original surface is enriched by an explosive stance which propels the expanding three-dimensional winged ladies to seemingly take flight. Circa 1867-1874, 29 by 23 by 30 in. *Private collection, photo courtesy of Witherell's.*

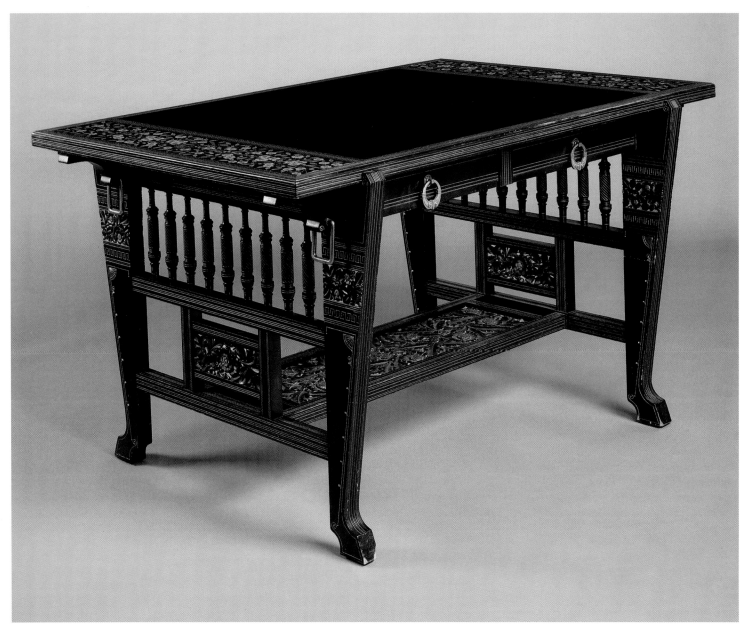

Parcel-gilt, carved and inlaid ebonized cherrywood center table in the Art Furniture style branded on underside of stretcher, *HERTER BRO'S.* Beleived to be executed for the San Francisco mansion of Mark Hopkins, 56 by 35 by 35 3/4 in. high. Circa 1878-1880. *Butterfield & Butterfield, Auctioneers Corp., 1998.*

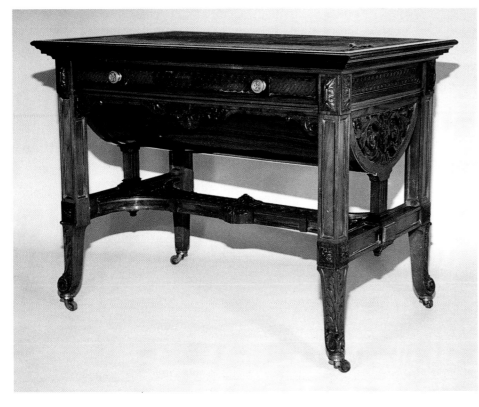

Rosewood and parcel gilt sewing table in the Art Furniture style. The stance, style, and five degit, stenciled number, *61156* are all consistant with the furniture executed for Linden Towers, the six-hundred acre, forty-five room, Menlo Park mansion of James C. Flood. As reported in the August 20, 1881 edition of the *Redwood City Times Gazette*, "...the furniture was executed by Pottier & Stymus of New York," 40 by 26 by 30 in. Circa 1878. *Robert and Dorothy Soares, photo courtesy of Witherell's.*

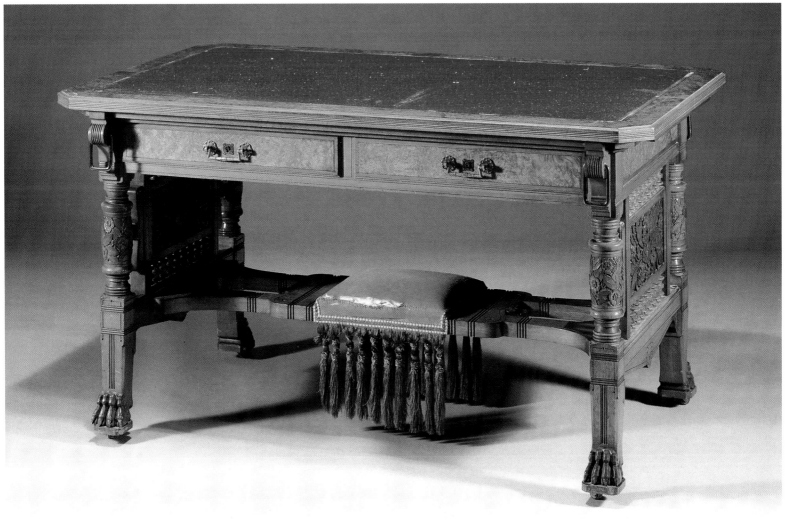

Parcel-gilt walnut library table in the Rennaisance style executed by Herter brothers, for the Darious Ogden Mills,' Milbrea, California mansion, 66 by 30 1/4 in. high. Circa 1869-1871. *Butterfield & Butterfield, Auctioneers Corp., 1998.*

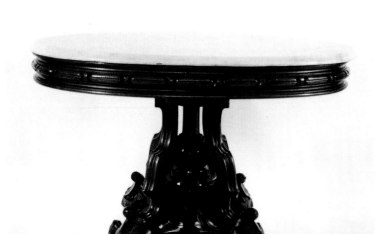

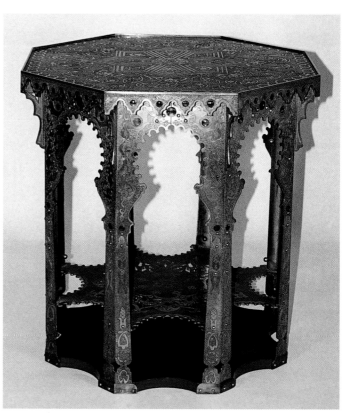

Walnut, burl and marquetry library table in the Aesthetic style stenciled, *Plum & Co., / Post St., / S.F.,* circa 1875-1877. *Private collection, photo courtesy of J. Hill Antiques.* **B**

Walnut parlor table in the Renaissance style with marble top. Attributed to the shop of Goodwin & Co., on the basis of its San Francisco provenance, the existence of an example in the Crocker Art Museum, original to the E. B. Crocker House, Sacramento, and another which bears the stenciled, *Goodwin & Co., No. 528 Washington St., San Francisco,* with a delivery address of *Wickersham ... Petaluma,* in the California State Capital collection. Likeley, I. G. Wickersham head of the First National Gold Bank and president of the Sonoma Marin Railway Company. Circa 1864-1868. *Wygant collection, photo courtesy of Witherell's.* **B**

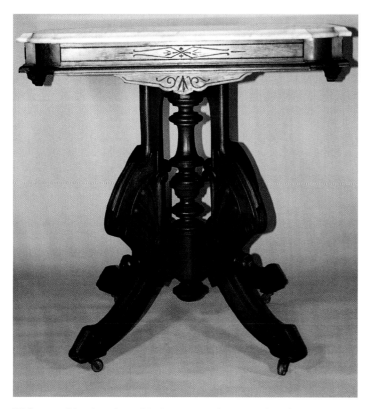

Copper, brass, and jeweled tabourette in the Syrian style impressed, *Otarcraft.* 21 by 21 in., high. Circa 1919-1941. *Robert and Dorothy Soares, photo courtesy of Witherell's.* **B**

Walnut and burl parlor table in the Neo-Grec style bearing a California Furniture Manufactory Company stencil, circa 1872-1888. *Private collection, photo courtesy of Witherell's.* **B**

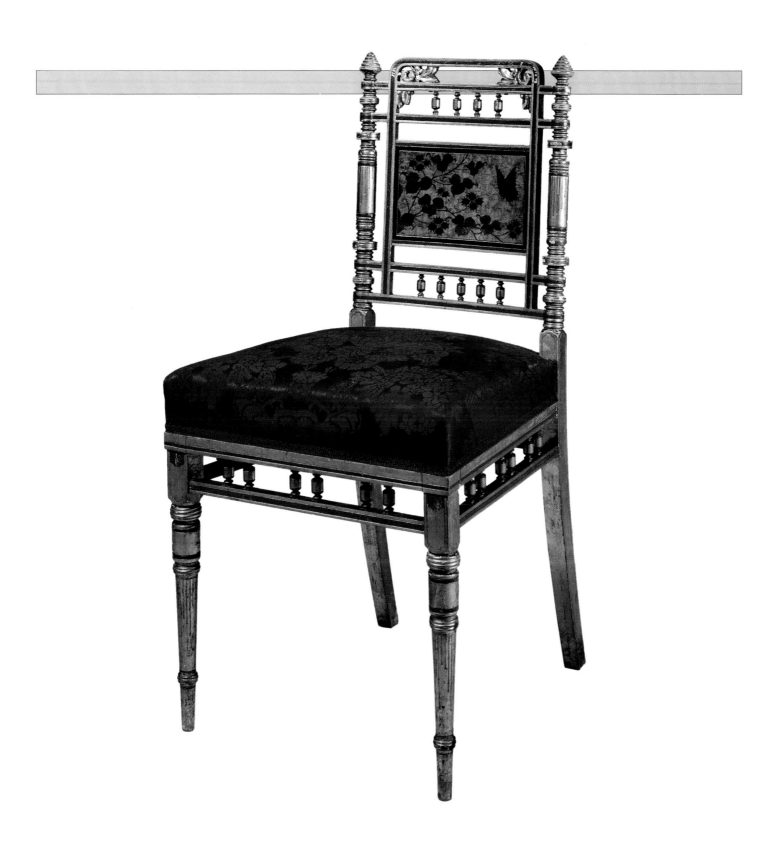

Gilt, polychrome, and marquetry side chair in the Art Furniture style inscribed on inner seat rail, *Mr. Hopkins* and numbered *4660.* In both style and design this chair is consistent with the furniture executed by Herter Brothers for the Mark Hopkins San Francisco residence. The chair's inlayed motif resembles the frescoed ceiling of the Hopkins bedroom which is described in the July 22, 1878 eddition of the *New York Times.* "...wherein are worked birds of gay plumage, butterflies, and quiant devices in blue and gold." Circa 1878. *Courtesy of Margaret B. Caldwell.* **D**

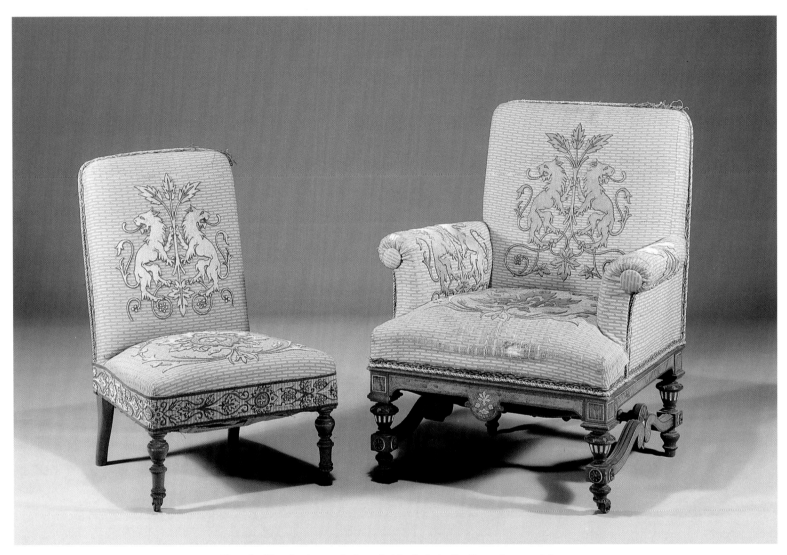

Parcel-gilt walnut arm chair and side chair in the Renneisance style
executed by Herter Brothers for the library of Darious Ogden Mills',
Millbrea, California mansion. Circa 1869-1871. *Butterfield &
Butterfield, Auctioneers Corp., 1998.* **D**

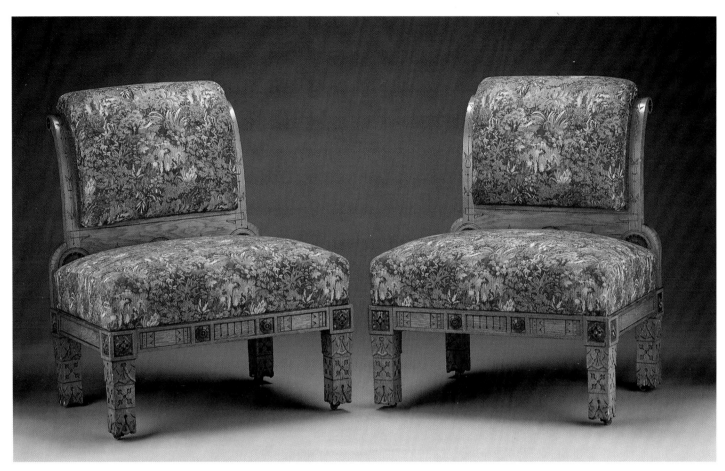

Pair of Western oak and walnut chairs in the Modern Gothic style probably manufactured in San Francisco for the armor room of the Mark Hopkins San Francisco residence, circa 1878-1880. A portion of this suite appears in 1942 photographs of Thurlow Lodge which Mrs. Hopkins purchased in 1883. The design of the furniture does not match that of the 1872-73 decoration of Thurlow Lodge and it is presumed the suite was part of Mrs. Hopkins' San Francisco residence and later moved to Thurlow Lodge. Later wood analisis concluded the oak was of western origon, probably California. *Courtesy Margaret B. Caldwell and Butterfield and Butterfield, Auctioneers Corp., 1998.* each **C**

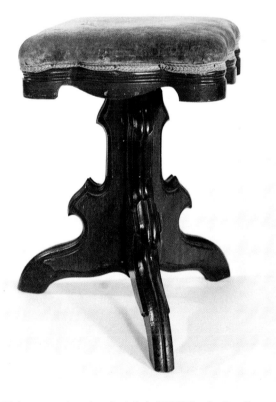

Left:
Santo Domingo mahogany arm chair with "US" intertwined in relief. Designed by Alfred B. Mullet, manufactured by J. B. Lucshinger & Son for the San Francisco Mint, circa 1874. *Photograph courtesy of the Department of the Treasury, Katherine Wetzel, photographer.* **B**

Walnut stool bearing the label, *THE/ Eureka Stool/ Patented June 17, 1873/ MANUFACTURED FOR/ SHERMAN & HYDE/ SAN FRANCISCO.* The firm later became Sherman and Clay. *Private collection, photo courtesy of J. Hill Antiques.* **A**

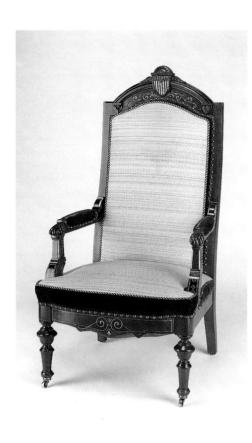

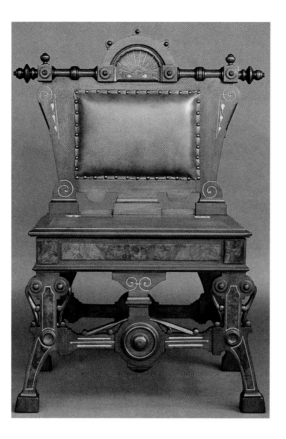

Far left:
Santo Domingo mahogany, polychrome and parcel gilt arm chair crested with U.S. shield. Designed by Alfred B. Mullet, manufactured by J. B. Luschinger & Son for the San Francisco Mint, circa 1874. *Photograph courtesy of the Department of the Treasury.*

Left:
Walnut, burl, and parcel gilt hall chair in the Neo-Grec style identical to illustration 97 in *California Furniture Manufactoring Co.,* trade catalog, circa 1872-1888. *Columbian Lady, photo courtesy of Witherell's.* **B**

Below and below right:
Walnut, burl walnut, and old growth redwood (secondary) chamber suite in the Neo-Grec style of West Coast manufacture, probably California, circa 1869-1885. Bed, 62 by 74 by 84 in. high; dresser 48 by 20 by 89 in. high. The use of old growth redwood on this suite and its history of ownership both substantiate a West Coast manufacture. Many San Francisco firms advertised during the 19th century the use of western woods including Puget Sound white cedar, Mexican prima vera, California oak, and redwood. The most distinguishable and certainly the most alluring of these woods is old growth redwood. Due to the exceptionally durable qualities of redwood, it was harvested to near extinction throughout the late 19th and into the 20th century and today nearly all existing groves of old growth redwood are held in regional, state, and national parks. The Giant Sequoia, which is the North American version of the redwood and source of this suite, is native to a narrow stretch of Pacific coast line 120 miles long and 60 miles wide, running roughly from Santa Cruz, California, north to the Oregon border. Private collection, photo courtesy of Witherell's. **C**

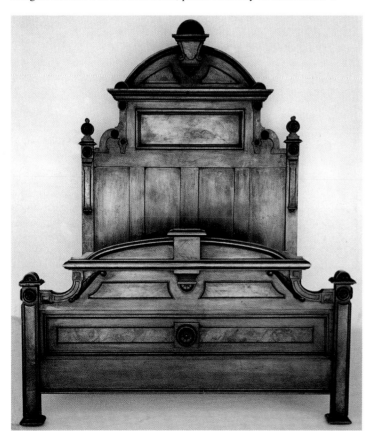

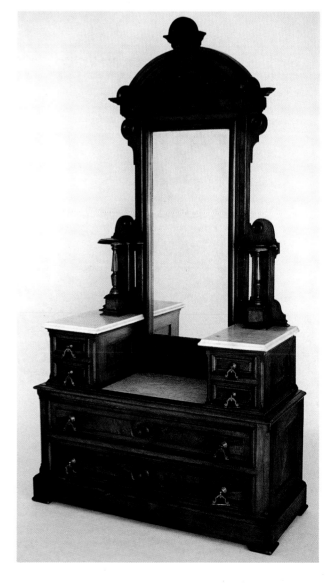

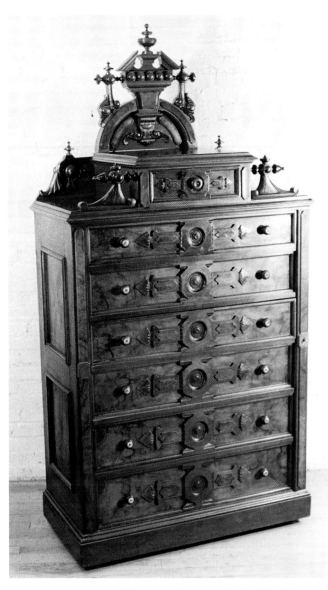

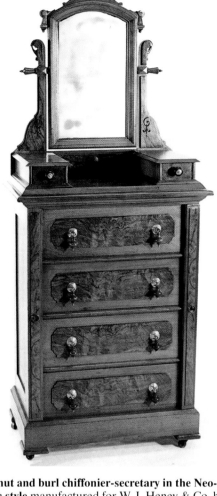

Walnut and burl chiffonier-secretary in the Neo-Grec style manufactured for W. J. Heney & Co. by Berkey & Gay. Stenciled, *W. J. HENEY & CO./ Importers Manf's of/ Furniture, Bedding & carpets,/ 725 MARKET STREET/ (Bancroft's Building.) ...San Francisco,* circa 1873-1881. *Private collection, photo courtesy of J. Hill Antiques.* **B**

Walnut and burl lock-side chest of drawers in the Neo-Grec style manufactured for W. J. Heney & Co., by Berkey and Gay. (see Witherell, *Late 19th Century Furniture by Berkey and Gay,* (Schiffer, 1988, p. 17.) Stenciled, *W. J. HENEY & CO./ Importers Manf's of/ Furniture, Bedding & Carpets,/ 725 MARKET STREET/ (Bancroft's Building.) ... San Francisco,* circa 1873-1881. *Private collection, photo courtesy of J. Hill Antiques.* **B**

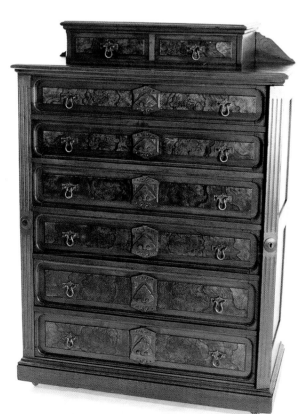

Right:
Walnut, burl, and parcel gilt lock-side chest of drawers in the Neo-Grec style manufactured for W. J. Heney & Co., by Berkey and Gay. (see Witherell, *Late 19th Century Furniture by Berkey & Gay*, Schiffer Publishing, 1998, p.15.) Stenciled, *W.J. HENEY & CO./ Importer Manf's of/ Furniture, Bedding & Carpets,/ 725 MARKET STREET/ (Bancroft's Building.) ...San Francisco,* circa 1873-1881. *Private collection, photo courtesy of J. Hill Antiques.* **B**

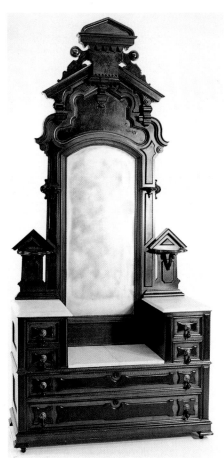

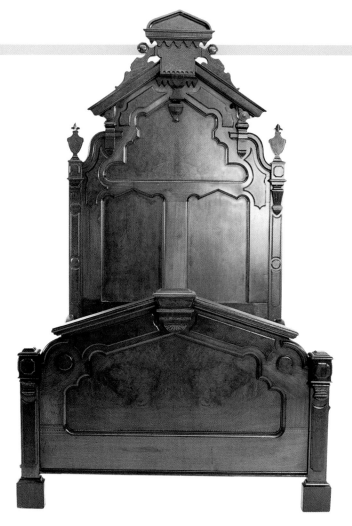

Walnut and burl dresser in the Neo-Grec style stenciled *GOODWIN & CO./ IMPOTERS AND MANF'RS/ furniture & Bedding/ 312 PINE Street, S.F.* Circa 1873-1879, 48 by 101 in. *Private collection, photo courtesy of J. Hill Antiques.* **B**

Walnut and burl bedstead in the Neo-Grec style in suite with Goodwin dresser. Circa 1873-1879, 105 in. *Private collection, photo courtesy of J. Hill Antiques.* **B**

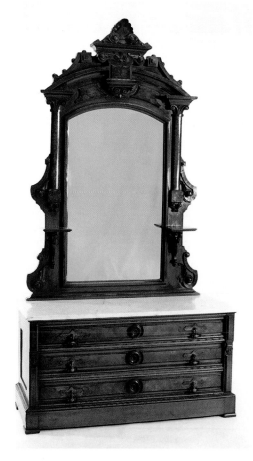

Walnut and burl Commode in the Eastlake style stenciled, *STANDARD FURNITURE CO./ FURNITURE, UPHOLSTERY,/ CARPETS/ HOUSEHOLD GOODS OF EVERY DESCRIPTION/ 1045 Market St., San Francisco./ CALIFORNIA AND EASTERN FURNITURE.*, Circa 1869-1885. *Private collection, photo courtesy J. Hill Antiques.* **A**

Walnut and burl flat top marble dresser in the Rennaisance style inscribed on verso *Chas. Plum & Co.,* circa 1875-1885. *Private collection, photo courtesy of J. Hill Antiques.* **B**

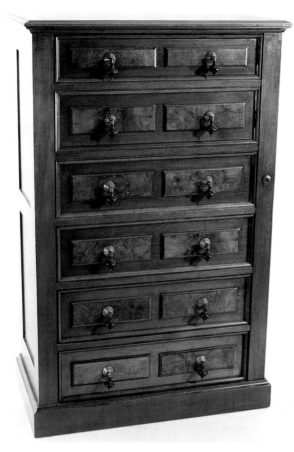

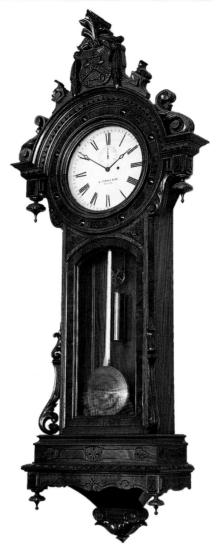

American banjo wall clock with crest of the of the Treasury. For the San Francisco Mint. Works by E. Howard & Co., Boston, case attributed to J. B. Lucshinger & Son, 6ft., 8 in. high. *Photograph courtesy of the Department of the Treasury.* **D**

Walnut and burl lock-side chest of drawers in the Neo-Gec style stenciled *OAKLAND/ Furniture Ware Rooms/ CHR. SCHREIBER,/ 1107 BROADWAY/ Bet. 12th and 13th Sts.,/ OAKLAND, - - - - CAL.* Circa 1875-1885. *Private collection, photo courtesy of J. Hill Antiques.* **B**

Walnut, burl, and redwood (secondary) bookcase stenciled *JOHNSON & BEST/ MAKERS/ 717 MARKET/ OFFICE/ 13 PINE St./ S.F.,* circa 1868-1876. *Private collection, photo courtesy of J. Hill Antiques.* **B**

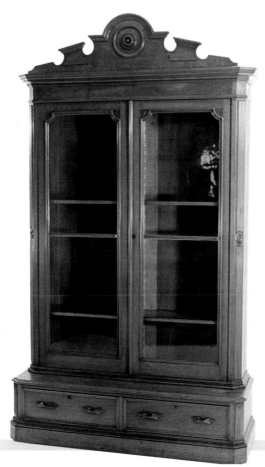

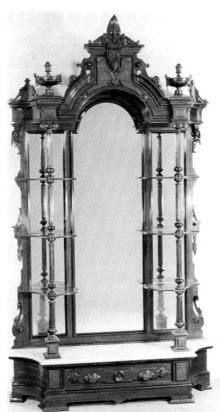

Rosewood and burl etagere in the Neo-Grec style identical to illustration 7, in the *California Furniture Manufactoring Co.,* trade catalog, circa 1872-1888. *Private collection, photo courtesy of J. Hill Antiques.* **C**

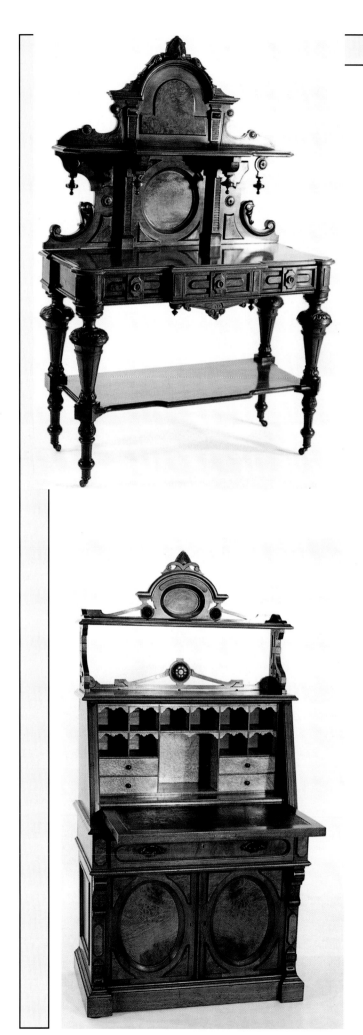

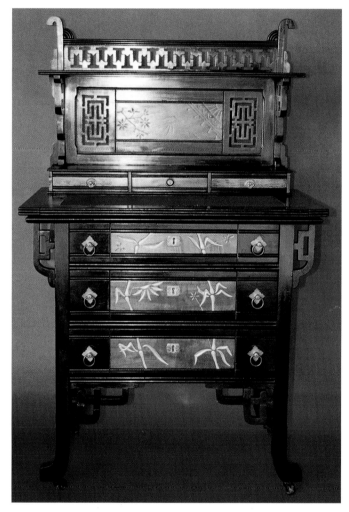

Walnut and burl server bearing a California Furniture Manufactory Company stencil, circa 1872-1888, 71 by 48 by 22 in. *Private collection, photo courtesy of J. Hill Antiques.* **B**

Mahogany, ebonized cherry, and parcel gilt writing desk in the Japan style. Likely manufactured in Grand Rapids, Michigan, by either the Phoenix Furniture Co., Nelson, Matter and Co., or Berkey & Gay for C. M. Plum & Co., San Francisco, an attribution based on the same model illustrated in the C. M. Plum & Co. trade catalog which was bound and printed in Grand Rapids, Michigan. This particular example was found in Santa Rosa, California. Circa 1880s. *Private collection, photo courtesy of Witherell's.* **B**

Walnut, burl, and birds-eye maple interior fall-front desk in the Neo-Grec style stenciled *CALIFORNIA/ FURNITURE MANF'G CO./ 220 to 226 Bush St./ San Francisco,* identical to illustration 43, in the *California Furniture Co.,* trade catalog, circa 1872-1888. *Private collection, photo courtesy of J. Hill Antiques.* **B**

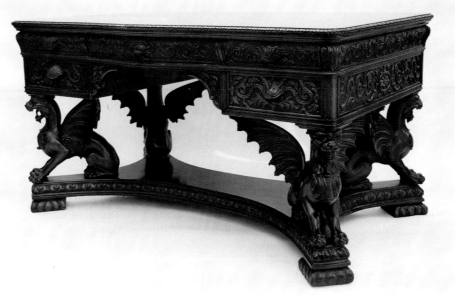

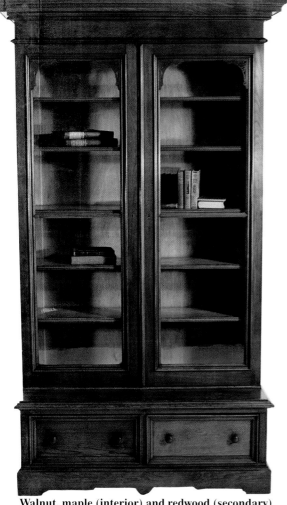

Carved mahogany partners desk in the Venetian style. According to family legend, this desk, along with a Tiffany chandelier, were purchased by Sumner and Amelia Carson, the son and daghter-in-law of lumber baron William Carson, builder of the famed Carson mansion in Eureka, California. Circa 1900. *Megan Mitchel collection, photo courtesy of Witherell's.* **C**

Walnut legislative desk, original to the Nevada State Capital, purchased from J. P. Goodwin & Co. Circa 1871. *Courtesy of Nevada State Museum, photo Scott Klette.*

Walnut, maple (interior) and redwood (secondary) bookcase stenciled *W. J. T. Palmer & Co., San Francisco,* circa 1869-1892, 48 by 22 by 96 in. *Private collection, photo courtesy of J. Hill Antiques.* **B**

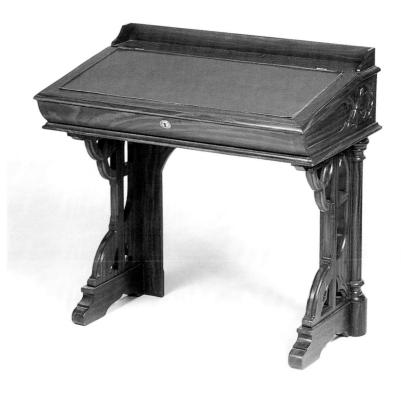

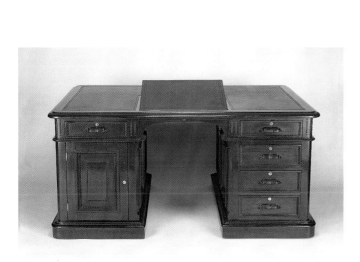

Santo Domingo mahogany partners desk designed by Alfred B. Mullet, manufactured by J. B. Luschinger & Son for the San Francisco Mint, circa 1874. *Photograph courtesy of the Department of the Treasury, Katherine Wetzel, photographer.* **C**

Chapter 2
GOLD

The quest for gold was responsible for some of California's growing wealth, and it was not long before businesses which manufactured gold jewelry in California began to prosper. The jewelry workmen, classified as lapidaries, jewelers, engravers, diamond-setters, machinists, and tool-makers, soon produced some of the finest jewelry items offered in the world. One unique style was gold quartz jewelry which incorporated unrefined quartz with gold veins into its designs. This jewelry became a symbol of California's wealth. Gold quartz rock could be found literally veined with gold either barley visible or sometimes so abundant and beautiful that jewelers would pay twice the price of pure gold for it. The San Francisco firm of Barrett and Sherwood claimed to be the inventors of gold quartz jewelry and exhibited it at the New York Crystal Palace Exhibition in 1853. Other manufacturing jewelers also prospered, most in San Francisco, including D.W. Laird who produced the finest presentation law badges.

Law Badges

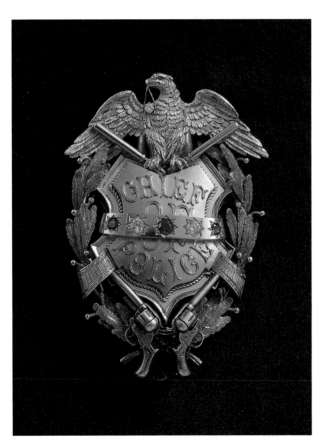

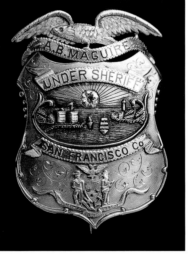

Gold shield-form law badge enameled *A. B. MAQUIRE / UNDER SHERIFF / SAN FRANCISCO,* and inscribed on recto *PRESENTED / BY THE ATTACHES / OF THE / SHERIFFS OFFICE / JUNE 24, 1893.* Paul Schweizer, photo courtesy of Witherell's. **D**

Multi-colored gold and jeweled presentation law badge inscribed on verso *Presented to / Oliver C. Jackson / by his friends as a / token of / their esteem / and / in recognition of his efficient services / Sacramento, Cal. / March 13, 1885.* As reported in the *Sacramento Union*, March 14, 1885 "... Mr. Jackson was presented a beautiful gold badge valued at $500.00..." 3 3/4 in. *Witherell's, photo courtesy of Witherell's.* **D**

Right:
Gold law badge, enameled *Wm. H. RIECKS / SHERIFF / SAN JOAQUIN / CO.* and inscribed on recto *TO / Wm. H. RIECKS / FROM HIS / MANY FRIENDS.* Circa 1910s, 2 1/4 in. *R. Tod Ruse, photo courtesy of Witherell's.* **D**

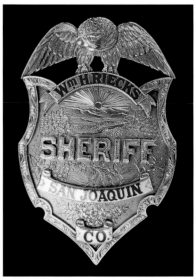

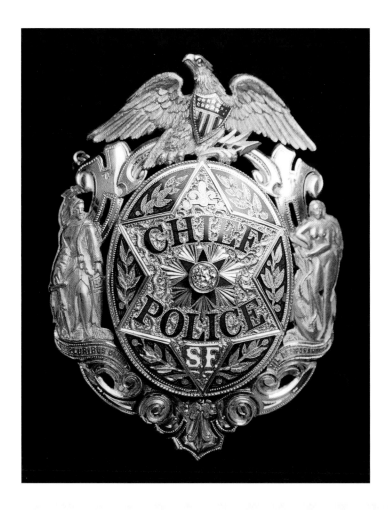

Gold law badge enameled *CHIEF / POLICE / SF,* and inscribed on recto, *PRESENTED / TO THE / CHIEF OF POLICE / HENRY H. ELLIS / BY HIS MANY FRIENDS / SAN FRANCISCO / DEC. 6TH / 1875.* As reported in the local paper, "PRESENTATION TO CHIEF ELLIS. Last evening, about fifty of the personal friends of Chief Ellis, met... to congratulate Capt. Ellis on his accession to the head of the Police Department... The badge, of elegant design and exquisite workmanship, was manufactured by Major D. W. Laird, of this city..." *Paul Schweizer, photo courtesy of Witherell's.* **D**

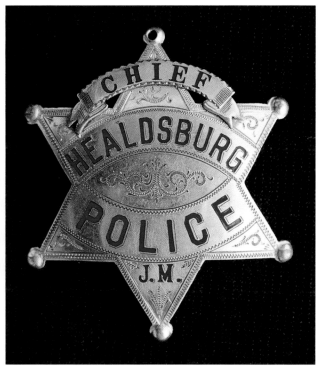

Gold star law badge enameled *CHIEF / HEALDSBURG / POLICE / J.M.*...was the former city marshal and became the first chief of Healdsburg, California circa 1920. 2 3/4 in. *P. I. F. collection, photo courtesy of Witherell's.* **B**

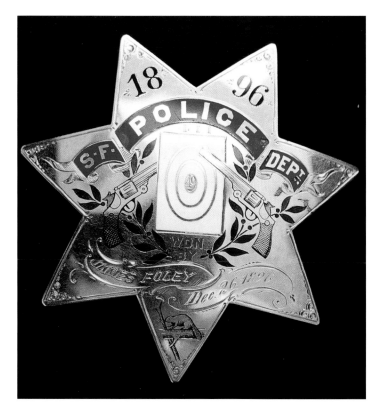

Gold star-form law badge manufactured by Shreeve & Co., enameled, *1896 / S.F. POLICE DEPT / WON BY / JAMES FOLEY / DEC. 26 1896.* As reported in the December 27, 1896 edition of *The San Francisco Call,* "Policeman James Foley of Captain Wittman's division is the champion pistol shot of the Police Department. Four prizes were recently offered..., the first being a gold star..." *Paul Schweizer, photo courtesy of Witherell's.* **D**

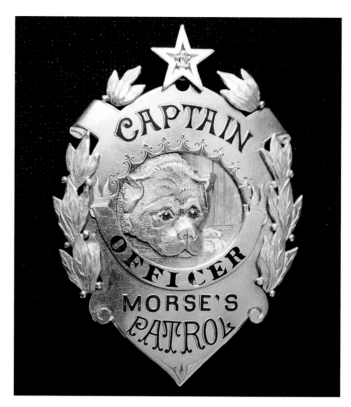

Gold law badge enameled *CAPTAIN /
OFFICER / MORSE'S PATROL*, circa 1889.
John Boessenecker, photo courtesy of Witherell's.
D

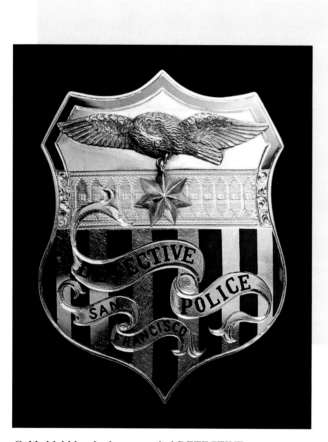

Gold shield law badge enameled *DETECTIVE
/ POLICE / SAN FRANCISCO* and inscribed
on recto, *PRESENTED TO / HENRY H.
ELLIS / BY THE BANKERS OF / SAN
FRANCISCO / JAN 1ST 1866. Paul Schweizer,
photo courtesy of Witherell's.* D

Gold shield retirement badge by Shreve & Co.
inscribed, *TO / GEORGE H. BURNHAM /
Chief Deputy Untited States Marshal / on his
retirement after / more than a quarter century / of
faithful service / FROM / U.S. MARSHAL Fred
L Esola / and his associates / as a token of their
high esteem / December 31st 1925 / San
Francisco, Calif. 3 in. Bob Butterfield, photo
courtesy of Witherell's.* B

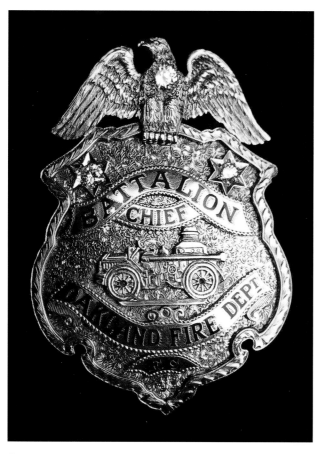

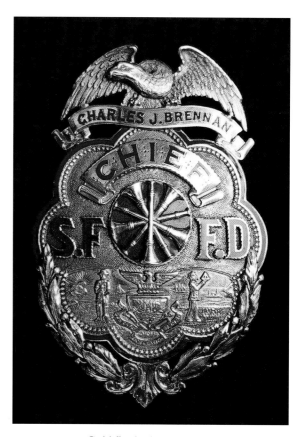

Gold fire badge enameled CHARLES J. BRENNAN / CHIEF / S. F. F. D. *Paul Schweizer, photo courtesy of Witherell's.* B

Gold and diamond fire badge enameled *BATTALION / CHIEF / OAKLAND FIRE DEPT.,* circa 1930s. *Paul Schweizer, photo courtesy of Witherell's.* **B**

Gold and jeweled Native Sons of the Golden West badge, circa 1896. *Paul Schweizer, photo courtesy of Witherell's.* **B**

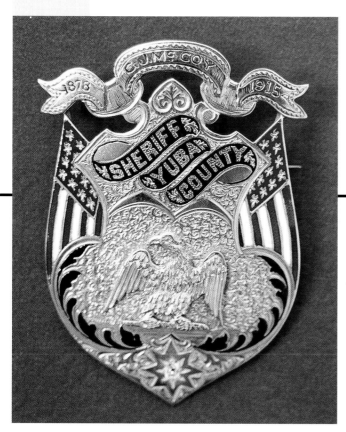

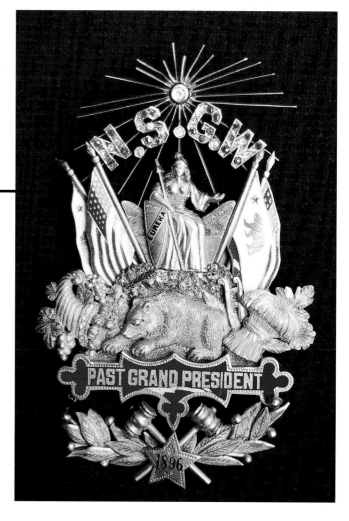

Multi-colored gold and enameled law badge inscribed *1878 / C. J. Mc COY / 1915 / SHERIFF / YUBA COUNTY*, 2 3/8 in. *Al and Carol Cali, photo courtesy of Witherell's.* **D**

Gold shield badge enameled *DEPUTY / SHERRIFF* and inscribed, *presented to / Benj. F. True / by his / Chinese friends / Jan'y 1st. 1879.* Benjamin True was the first police officer in Chico, California, 1 3/4 in. *Bob Butterfield, photo courtesy of Witherell's.* **B**

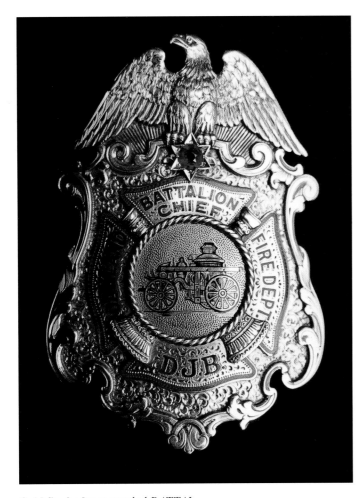

Gold fire badge enameled *BATTAL-ION CHIEF / OAKLAND / FIRE DEPT / D. J. B.,* circa 1930s. *Photo courtesy Witherell's.* **B**

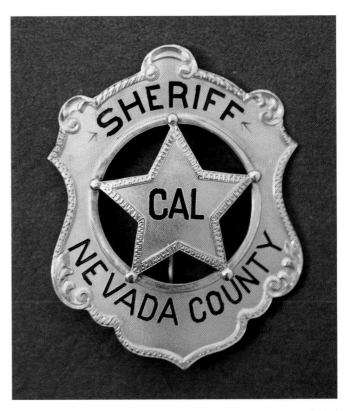

Gold law badge enameled *SHERIFF / CAL / NEVADA COUNTY,* back inscribed, *GEO. R. CARTER / FROM / HIS FREINDS / IN / GRASS VALLEY ,* 2 1/8 in. *Al and Carol Cali, photo courtesy of Witherell's.* **D**

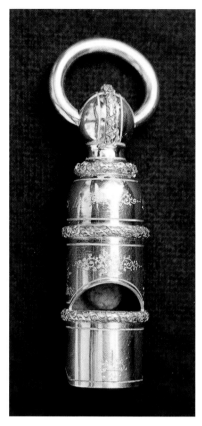

Gold whistle inscribed *PRE-SENTED BY HIS FRIENDS TO / HENRY H. ELLIS / CHIEF OF POLICE / SAN FRANCISCO CHRISTMAS 1875. Paul Schweizer, photo courtesy of Witherell's.* **D**

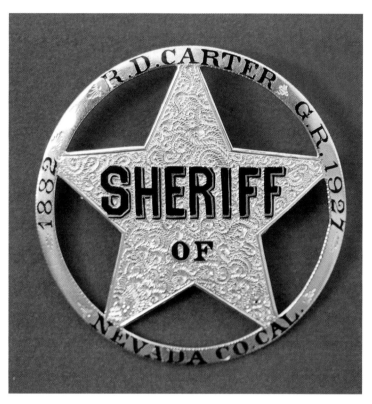

Gold circle star law badge enameled *R. D. CARTER / SHERRIF / OF / NEVADA CO. CAL.*, 2 in. Circa 1927. *Al and Carole Cali, photo courtesy of Witherell's.* **B**

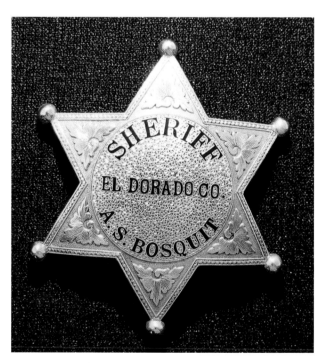

Gold star law badge enameled *SHERIFF / EL DORADO CO. / A. S. BOSQUIT.* 2 3/4 in. Circa 1900. *P. I. F. collection, photo courtesy of Witherell's.* **B**

Gold perpetual shooting badge enameled *Mc MAHON / RANGE / 1879. Mike and Sally Butler, photo courtesy of Witherell's.* **B**

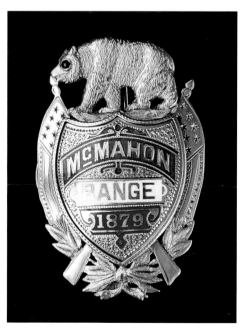

═══ Walking Sticks ═══

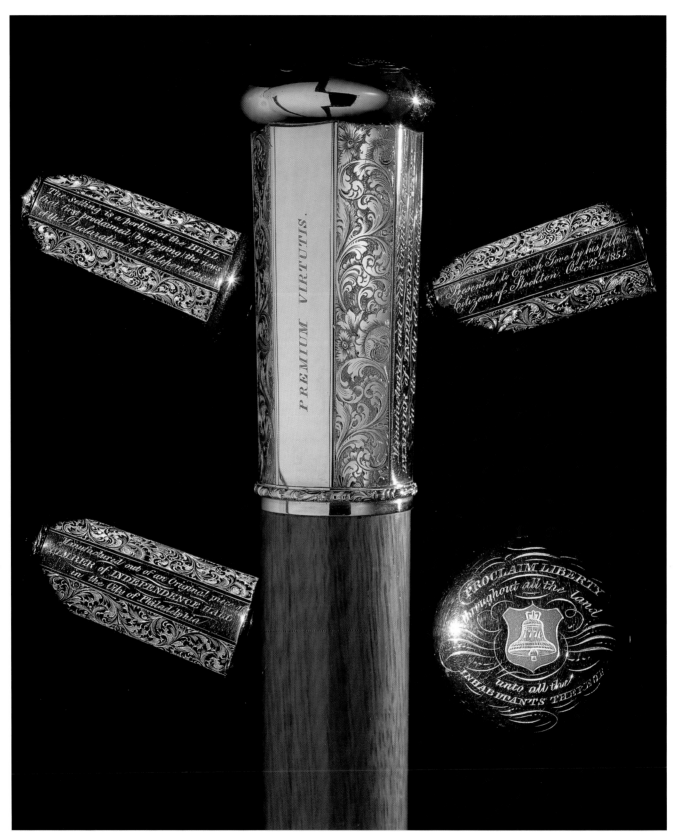

High relief engraved gold headed walking stick, the head and flutes inscribed *PROCLAIM LIBERTY throughout all the land unto all the INHABITANTS THEREOF / The setting is a portion of the BELL that first proclaimed by ringing the news of the Declaration of Independence / Manufactured out of an original piece of TIMBER of INDEPENDENCE HALL in the City of Philadelphia / Presented to Enoch Gove by his fellow Citizens of Stockton. Oct. 25th 1855.* As reported in the October 26, 1855 edition of the *Daily San Joaquin Republican,* "Col. Huggins, yesterday afternoon on behalf of the friends of Mr. Enoch Gove, presented that gentleman with a beautiful and heavily gold mounted cane, made in Philadelphia from a piece of oak used in the creation of the cupola of the old State House, of Revolutionary memory:..." *Private collection, photo courtesy of Witherell's.* **D**

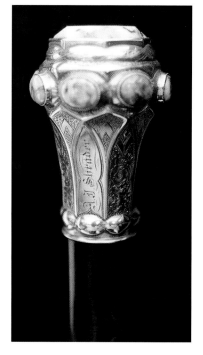

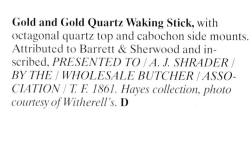

Gold and Gold Quartz Waking Stick, with octagonal quartz top and cabochon side mounts. Attributed to Barrett & Sherwood and inscribed, *PRESENTED TO | A. J. SHRADER | BY THE | WHOLESALE BUTCHER | ASSOCIATION | T. F. 1861.* Hayes collection, photo courtesy of Witherell's. **D**

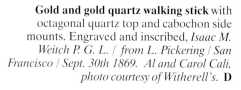

Gold and gold quartz walking stick with octagonal quartz top and cabochon side mounts. Engraved and inscribed, *Isaac M. Weitch P. G. L. | from L. Pickering | San Francisco | Sept. 30th 1869.* Al and Carol Cali, photo courtesy of Witherell's. **D**

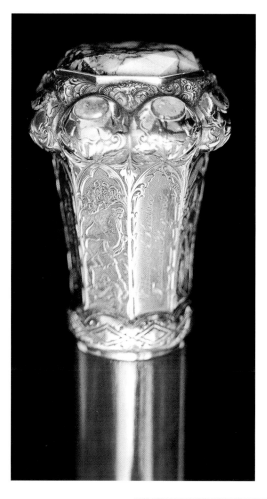

Left:
Gold and gold quartz walking stick with octagonal quartz top and upturned cabochon side mounts. Inscribed, *PRESENTED TO HENRY N. MORSE | SHERIFF ALAMEDA COUNTY | MARCH 2, 1878 | BY HIS DEPUTIES, JERMIAH TYLER, WILLIAM S. HAROLD | FREDERICK BRYANT JESSE VIERS | FRANK A. MILLER.* John Boessenbecker, photo courtesy of Witherell's. **D**

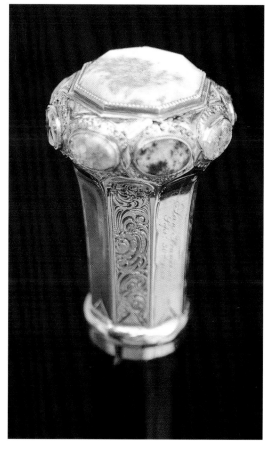

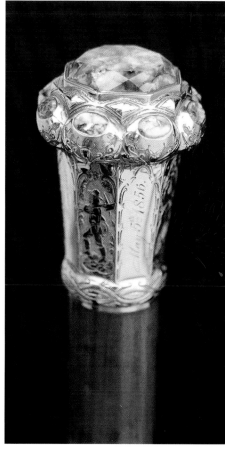

Gold and gold quartz walking stick by Barrett & Sherwood, San Francisco, with octagonal quartz top, upturned cabochon side mounts, and engraved flutes, comprising: Indian, bear, miner, and pack mule. Inscribed, *To Geo. W. Gibbs | late foreman | San Francisco | May 5th 1856 | St. Francis | Hook & Ladder | Co. No 1.* As described in the May 6, 1856 **Daily California Chronicle,** "PRESENTATION - G. W. Gibbs, Esq., who left us yesterday for a short visit East, was the recipient of a splendid quartz-headed cane, presented to him by the St. Francis Hook and Ladder Company of this city, over which he has presided for the last two years. Such civilities tend to preserve the harmony at the present existing amongst the members of the Fire Department of this city, and also tends to cement the bonds of friendship of the individual members of each company. The cane was from the establishment of Barrett & Sherwood, and was greatly admired by all who saw it." *Al and Carol Cali, photo courtesy of Witherell's.* **D**

Gold and gold quartz walking stick with alternating cabochon side mounts. Inscribed, *PRES. TO / E. J. CHAMBERLAIN / BY HIS JOURNEYMAN / EUREKA MILL / STATE NEV. / Feb. 10th 72. Courtesy Sandra J. Whitson and Ron Van Anda.* **D**

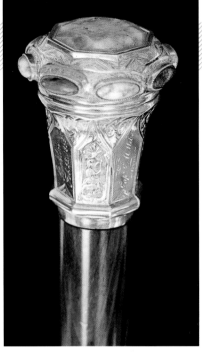

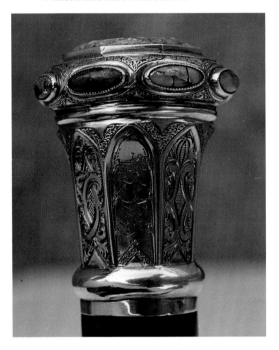

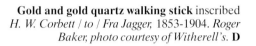

Gold and gold quartz walking stick inscribed *H. W. Corbett / to / Fra Jagger, 1853-1904. Roger Baker, photo courtesy of Witherell's.* **D**

Gold and gold quartz walking stick with octagonal quartz top, with alternating cabochon side mounts, engraved flutes comprising, California State Seal, Gold Miner, and Indian. Inscribed *TO / Capt. C. M. Webber from / Citizens of / Stockton / as a token of esteem / Stockton / Feb. 22, 1868. Courtesy of the San Joaquin County Historical Museum, photo courtesy of Witherell's.* **D**

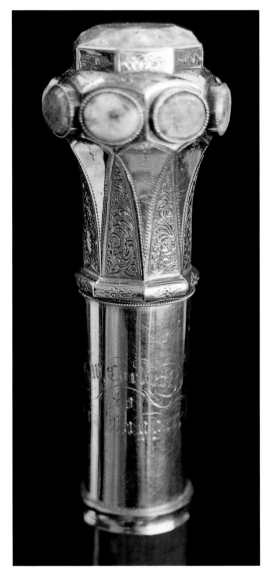

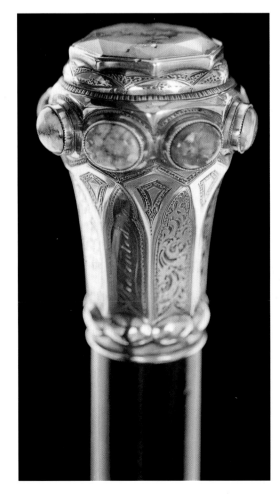

Gold and gold quartz walking stick with octagonal quartz top and cabochon side mounts. Manufactured by Barrett & Sherwood and inscribed, *PRESENTED TO / HENRY D HUDSON / by the members of / VIGILANT ENGINE Co. No. 9 / Nov 30 1866.* As reported in the 1888 edition of *Early Days In California,* "Mr. Hudson was a member of the Vigilant Engine Co., No. 9, of the Volunteer Fire Department, serving ten years and holding every position...During their late reunion he took an honored and forward part. The former company presented him with a gold headed cane, as a mark of esteem and confidence." Two days after the presentation the, *Alta California* reported, "...Messrs. Barrett & Sherwood had on exhibition some specimens of California manufacture consisting of...gold quartz articles, which would have done credit to any city in the world for excellence of design and finish. On Thanksgiving Eve the officers of the Volunteer Fire Department...were presented with the above mentioned ware." *Herbert Ratner Jr., photo courtesy of Witherell's.* **D**

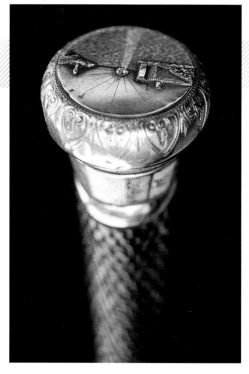

Multi-colored gold and gold quartz walking stick, Golden Gate scene over gold quartz band on shark skin wrapped shaft. Inscribed *John E. Powers / from August Schilling.* Circa 1853-1904. *Hayes collection, photo courtesy of Witherell's.* **D**

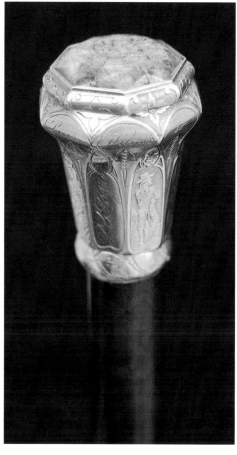

Gold and gold quartz walking stick engraved with Vaquero on horseback, Indian, and miner. Inscribed *To / A. C. Wilgus / California / L. C. Fogus / to / John / Tudor / Miller 1889. Al and Carol Cali, photo courtesy of Witherell's.* **D**

Gold and gold quartz walking stick inscribed to *Hon. M. S. Latham / from his friends and fellow citizens / of / Sacramento City / as a token of their / friendship & esteem / September 1853.*
As reported in the September 25, 1853 edition of the *Sacramento Bee*, "The friends of Hon. M. S. Latham in Sacramento presented to him, as a testimonial of their esteem, a magnificent cane, the cost of which was $250.00." *Oakland Museum, photo courtesy of Witherell's.* **D**

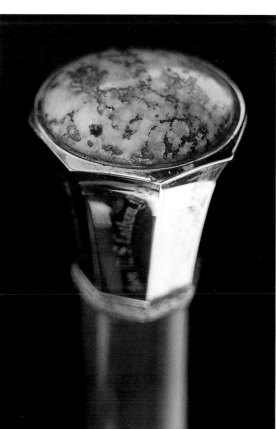

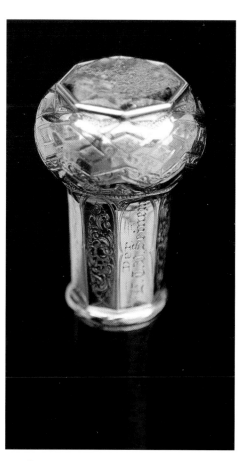

Gold and gold quartz walking stick inscribed *Ex-sprecher/ W. V. Ronn / S. Mriden 1 Feb. 1874. Al and Carol Cali, photo courtesy of Witherell's.* **C**

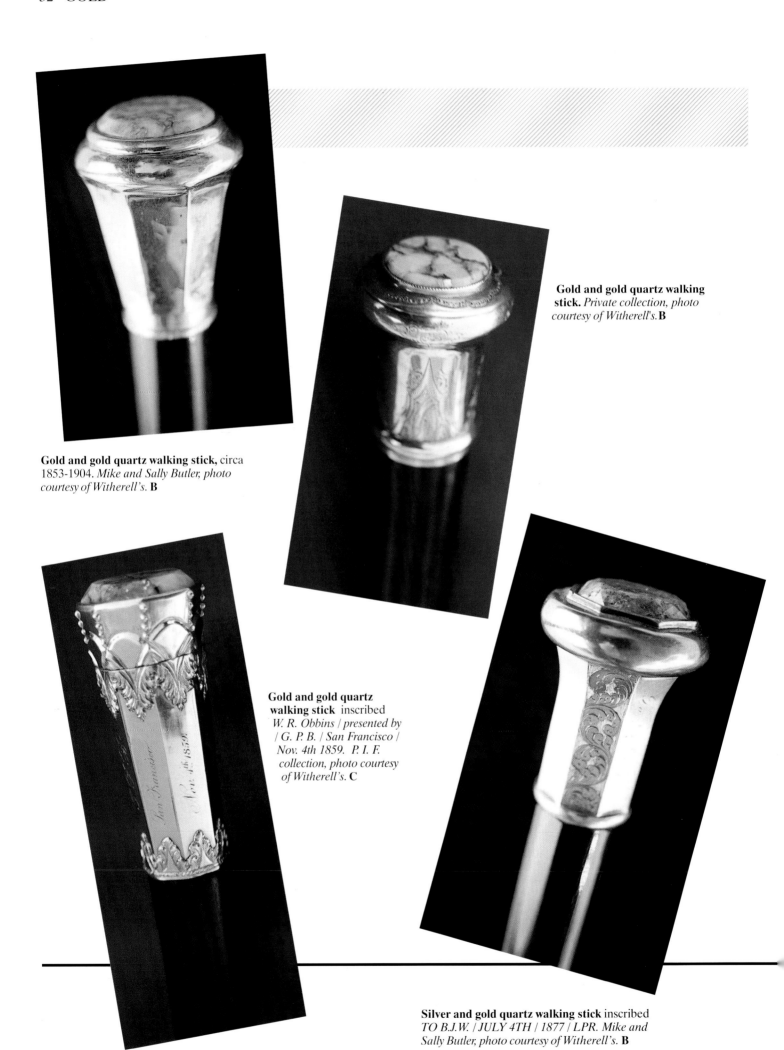

Gold and gold quartz walking stick, circa 1853-1904. *Mike and Sally Butler, photo courtesy of Witherell's.* **B**

Gold and gold quartz walking stick. *Private collection, photo courtesy of Witherell's.* **B**

Gold and gold quartz walking stick inscribed *W. R. Obbins / presented by / G. P. B. / San Francisco / Nov. 4th 1859. P. I. F. collection, photo courtesy of Witherell's.* **C**

Silver and gold quartz walking stick inscribed *TO B.J.W. / JULY 4TH / 1877 / LPR. Mike and Sally Butler, photo courtesy of Witherell's.* **B**

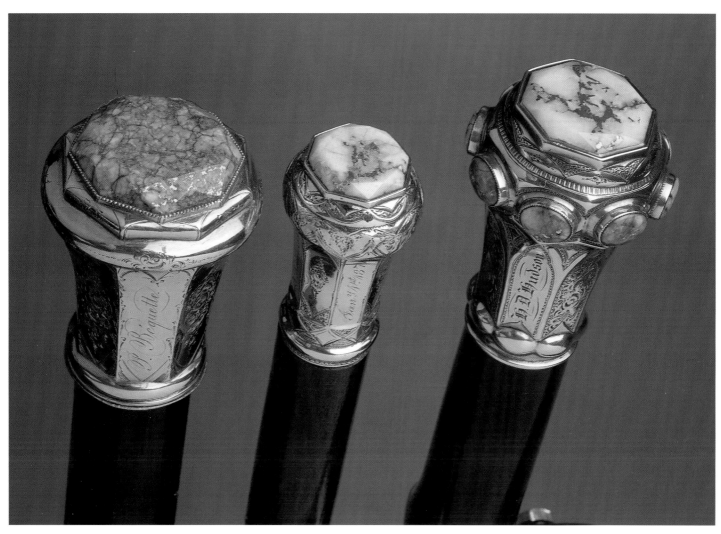

Three gold and gold quartz walking sticks. Right inscribed *PRE-SENTED TO / HENRY D HUDSON / by the members of / VIGILANT ENGINE Co. No. 9 / Nov. 30 1866;* Center inscribed *From M. T. Porter / San Francisco, Cal. / Jan. 1, 1871. / D. Landy;* Left inscribed *Presented to Henry Dodge by / P. Bequette. collection of Herbert G. Ratner, Jr., Richard A. Stoner photographer.* **D**

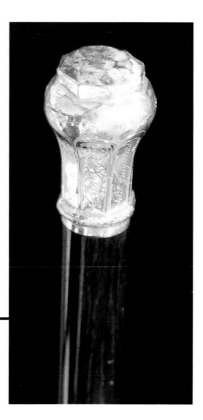

Gold and gold quartz walking stick, circa 1853-1904. *Al and Carol Cali, photo courtesy of Witherell's.* **C**

Gold and gold quartz walking stick inscribed *M. Burckes / Cha Mass / from L. L. B. / S. F. July 2d 1864. P. I. F. collection, photo courtesy of Witherell's.* **C**

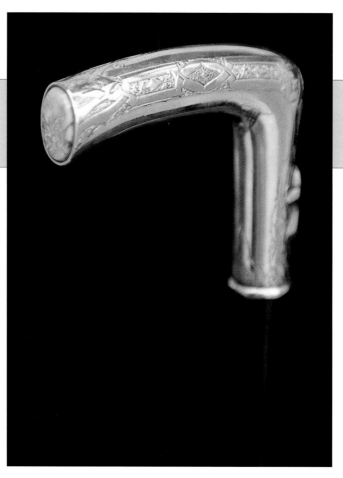

Gold and gold quartz cane inscribed *M.G./ from/ his friends.* Circa 1853-10904. *Al and Carol Cali, photo courtesy of Witherell's.* **C**

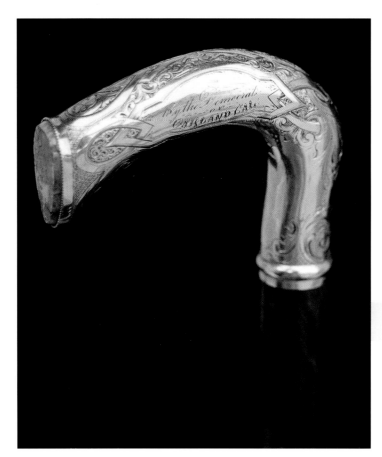

Gold and gold quartz cane inscribed *Presented/ to/ Hon. S. F. Gilden/ by the democrts/ of/ OAKLAND CAL./ October 1876.* Al and Carol Cali, *photo courtesy of Witherell's.* **C**

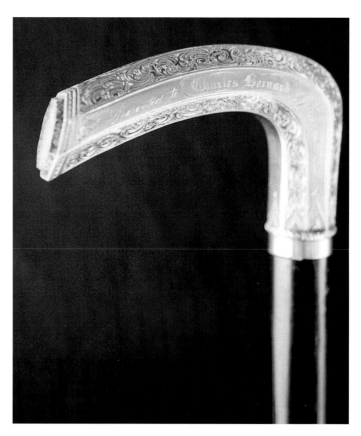

Gold and Gold Quartz Cane, partially inscribed, *presented to Charles Bernard June 20, 1860. Mike and Sally Butler, photo courtesy of Witherell's.* **C**

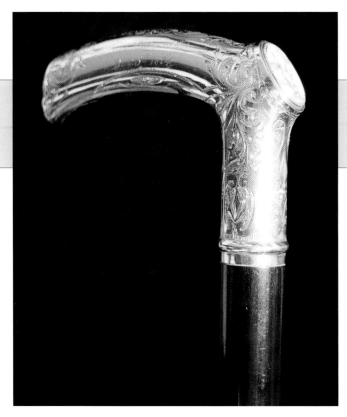

Gold and gold quartz cane, double inscribed, *presented to / J. M. Miner / by Jas. Hallican.* Verso, *presented by Miner / to Zieff,* circa 1853-1894. *P. I. F. collection, photo courtesy of Witherell's.* **C**

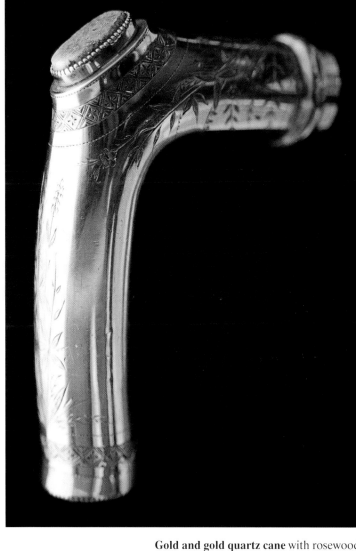

Gold and gold quartz cane with rosewood shaft, circa 1853-1904. *P.I.F. collection, photo courtesy of Witherell's.* **C**

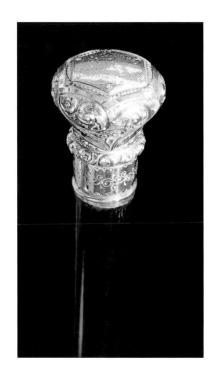

Gold walking stick inscribed *Merry Xmas / to T. C. from / Stockton Police / 1898. P. I. F. collection, photo courtesy of Witherell's.* **B**

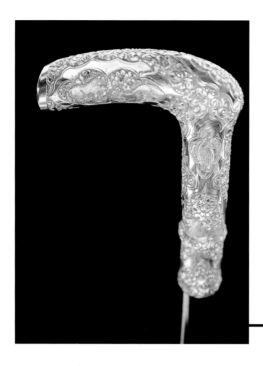

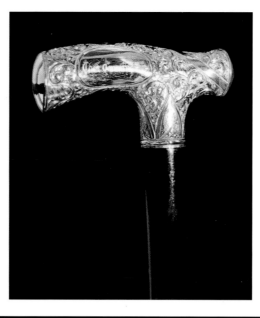

Far left:
Gold cane inscribed *Hon. Robert Howe / Speaker 28th session Cal. Legis. / Compl. of the attaches / 1889. Robert and Dorothy Soares, photo courtesy of Witherell's.* **B**

Left:
Gold cane inscribed *Thos. Cunningham.* Stockton, California sheriff, circa 1890. *P.I.F. collection, photo courtesy of Witherell's.* **B**

Snuff Boxes

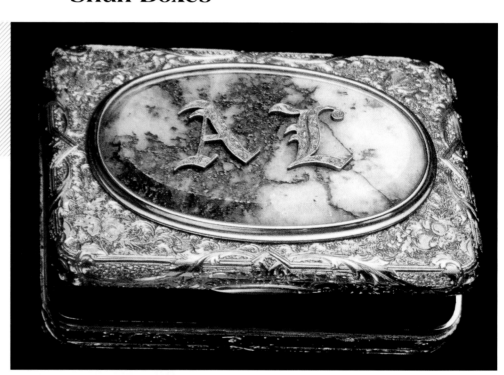

Gold and gold quartz snuff box presented to President Abraham Lincoln by the city of San Francisco, September 22, 1864. *National Museum of American History, Political History Department.* **D**

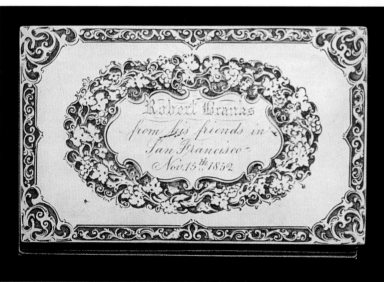

Gold snuff box, stamped twice, *Barrett & Sherwood / San Francisco* and inscribed, *Robert Branks / from his friends in / San Francisco / Nov. 15th 1852.* In original fitted leather case, 2 7/8 in. *Jim Mackie, photo courtesy of Witherell's.* **D**

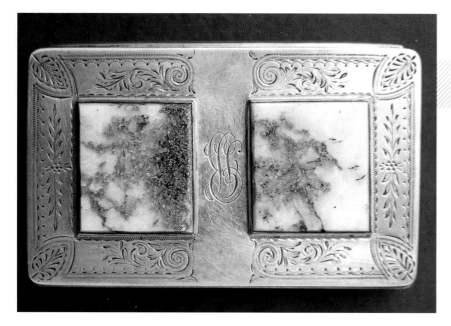

Silver and gold quartz snuff box by Gorham & Co.,
Providence, 3 1/8 in. Circa 1852-1865. *Al and Carol
Cali, photo courtesy of Witherell's.* **D**

Gold and gold quartz snuff box retailed by
Tiffany & Co. *Roger Baker, photograph
courtesy Witherell's.* **D**

Match Safes

**Gold and gold quartz
match safe,** circa 1853-
1904. *Courtesy Sandra J.
Whitson and Ron Van
Anda.* **D**

Gold and gold quartz match safe,
circa 1853-1904. *Roger Baker, photo
courtesy of Witherell's.* **D**

Gold and gold quartz match safe, circa 1853-1904. *Roger Baker, photo courtesy of Witherell's.* **D**

Gold and gold quartz match safe, circa 1853-1904. *Roger Baker, photo courtesy of Witherell's.* **C**

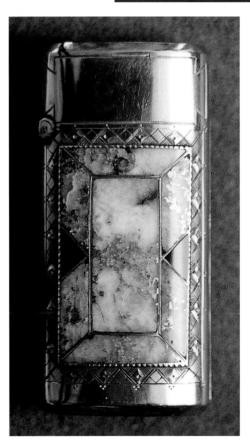

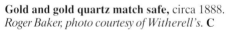

Gold and gold quartz match safe, circa 1888. *Roger Baker, photo courtesy of Witherell's.* **C**

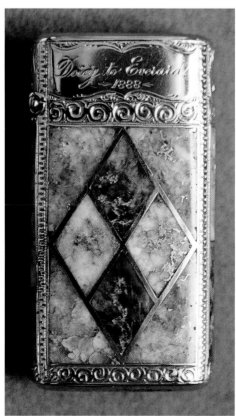

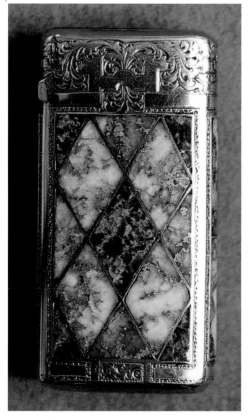

Gold and gold quartz match safe, circa 1852-1904. *Roger Baker, photo courtesy of Witherell's.* **C**

Gold and gold quartz match safe, circa 1853-1904. *Roger Baker, photo courtesy of Witherell's.* **C**

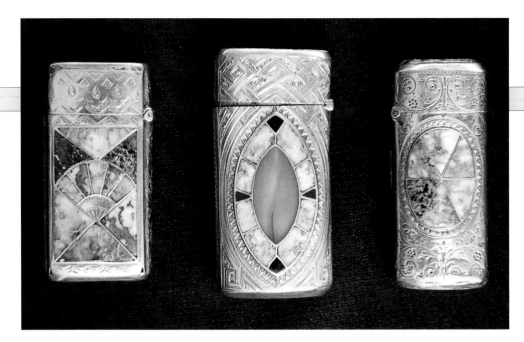

Gold and gold quartz match safes, 2 1/4 to 2 3/8 in. Circa 1853-1904. *Mike and Sally Butler, photo courtesy of Witherell's.* each **C**

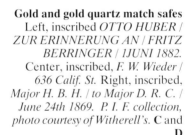

Gold and gold quartz match safes Left, inscribed *OTTO HUBER / ZUR ERINNERUNG AN / FRITZ BERRINGER / 1JUNI 1882.* Center, inscribed, *F. W. Wieder / 636 Calif. St.* Right, inscribed, *Major H. B. H. / to Major D. R. C. / June 24th 1869. P. I. F. collection, photo courtesy of Witherell's.* **C** and **D**

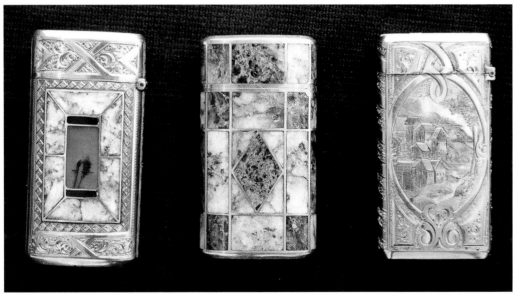

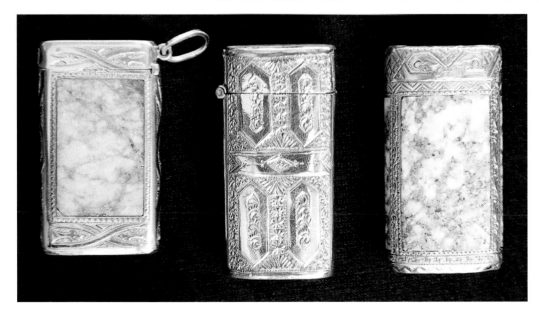

Gold and gold quartz match safes, 2 1/4 in. Circa 1853-1904. *Mike and Sally Butler, photo courtesy of Witherell's.* each **B**

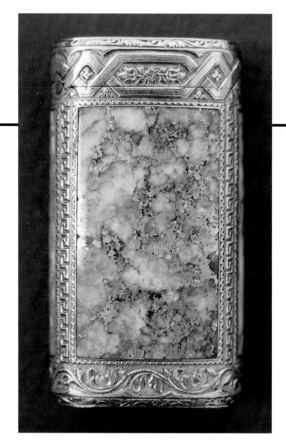

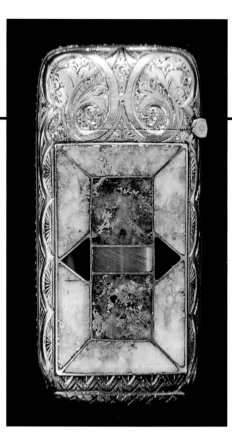

Right:
Gold and gold quartz match safe,
2 1/4 in. Circa 1853-1904. *Al and Carol Cali, photo courtesy of Witherell's.* **C**

Far right:
Gold and gold quartz match safe,
circa 1853-1904. *Private collection, photo courtesy of Witherell's.* **B**

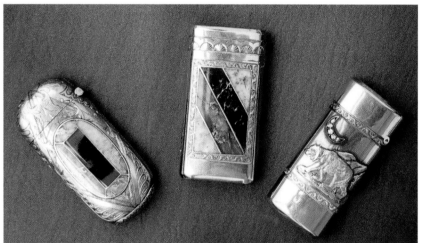

Gold and gold quartz match safes. Left, inset with moss agate, the verso engraved with a standing California Bear holding an open scroll of the Golden Gate. Center, inscribed on verso, *R. Mc. M / from / J. K. B. / Feb. 14, 1882.*, right, verso inscribed, *Jas. Fare / from / Jas A Fonttil / in memory of good deeds / esq. Jas. Grazier / May 30 1888.* Hayes collection, photo courtesy of Witherell's. **B**

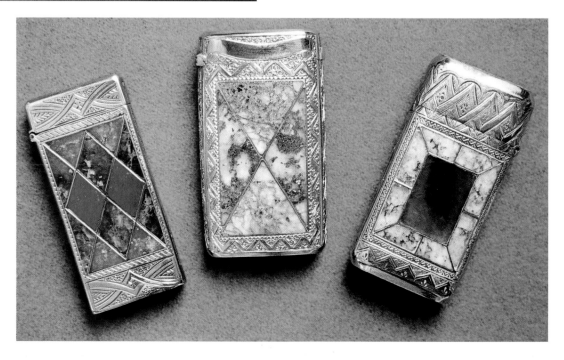

Gold and gold quartz match safes, circa 1852-1904. *Roger Baker, photo courtesy of Witherell's.* each **C**

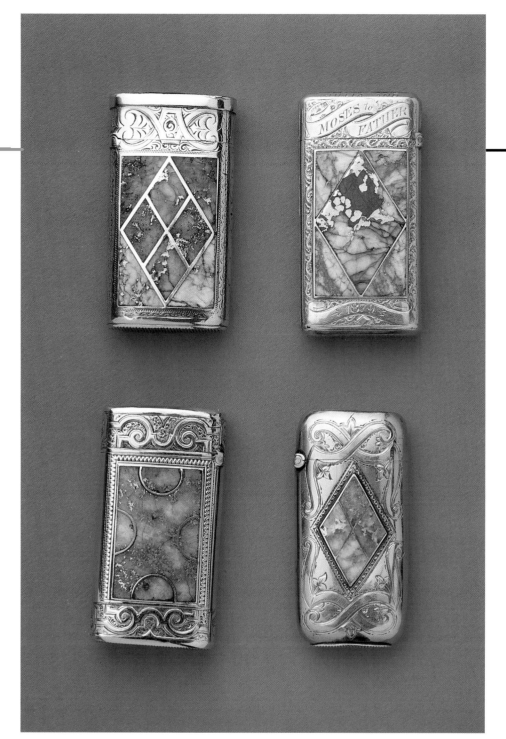

Four engraved gold and gold quartz match safes, circa 1853-1904. *collection of Herbert G. Ratner Jr., Richard A. Stoner photograph.* **C** and **B**

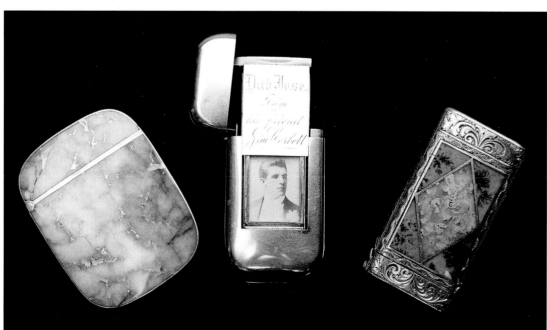

Three gold and gold quartz match safes, circa 1853-1904. *Paul Schweizer, photo courtesy of Witherell's.* each **B**

Gold Quartz Jewelry

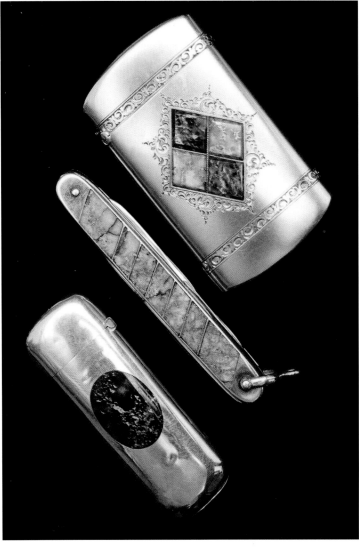

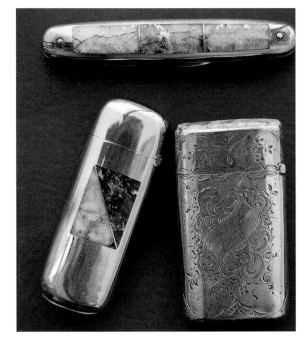

match safes, 2 1/4 and 2 7/8 in. Circa 1853-1904. *Al and Carol Cali, photo courtesy of Witherell's.* **B**

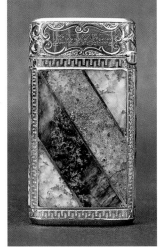

Gold and gold quartz match safe, inscribed, *Moses From Henry / Birthday Oct. 3rd 1875.* Courtesy Sandra J. Whitsen and Ron Van Anda. **C**

Gold quartz jewelry, comprising two match safes and pocket knife, circa 1853-1904. *John and Donna Herman collection, photo courtesy of Witherell's.* each **B**

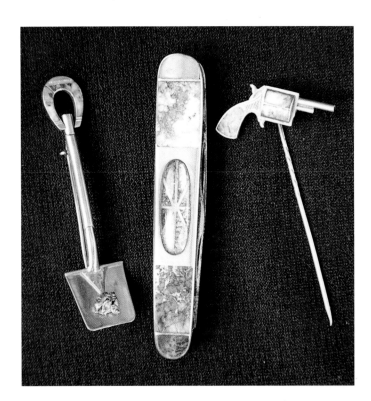

Left:
Gold quartz jewelry, comprising bar pin, pocket knife with ore samples, and stick pin. Circa 1853-1904. *Mike and Sally Butler, photo courtesy of Witherell's.* each **B**

Right:
Gold and gold quartz pocket knives, with specimen and ore samples, 2 3/4 -31/2 in. Circa 1853-1900. *Al and Carol Cali, photo courtesy of Witherell's.* **D**

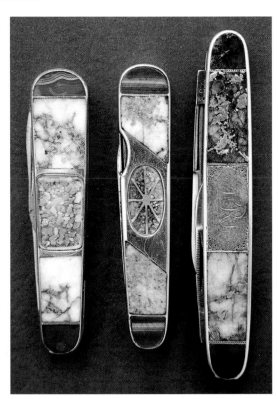

Watches and Chains

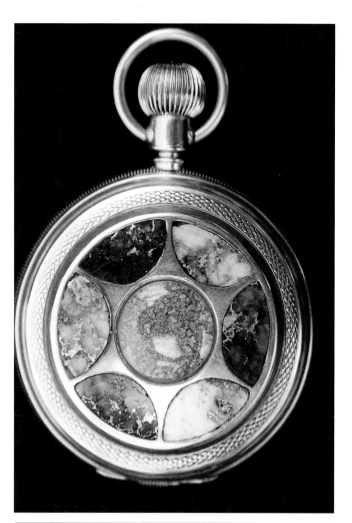

Gold and gold quartz watch, with placer gold fragments under crystal. E. Howard and Co., Boston, no.225006, size (N), circa 1880-1899. Note; the (N) size is slightly larger than 19 size. *Private collection, photo courtesy of Witherell's.* D

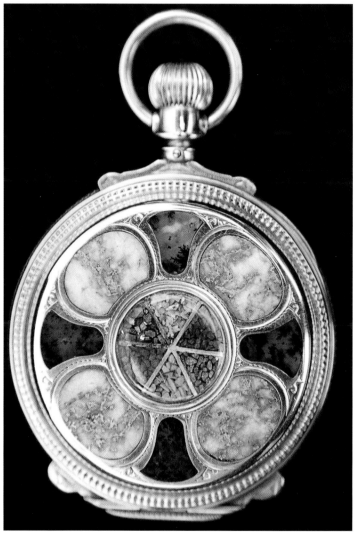

Gold and gold quartz watch, with ore samples under crystal. Waltham, no. 1075186, 18 size, circa 1877. *Private collection, photo courtesy of Witherell's.* D

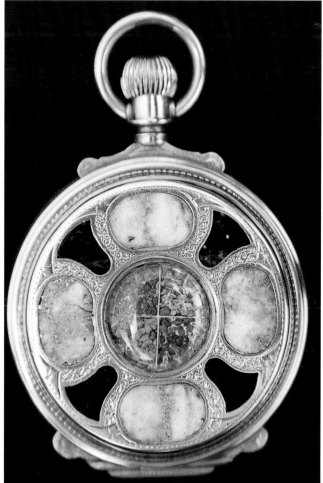

Gold and gold quartz watch, with ore samples under crystal. Waltham, no. 2099002, 18 size, circa 1883. *Private collection, photo courtesy of Witherell's.* D

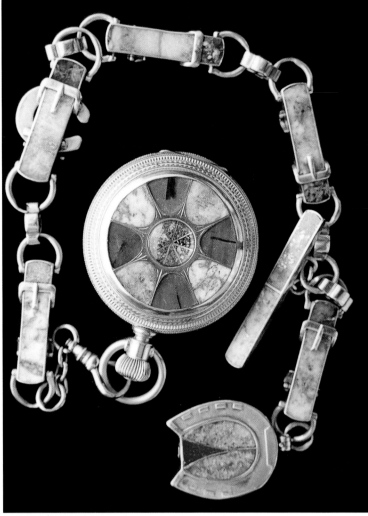

Gold and gold quartz watch, with ore samples under crystal, together with gold and gold quartz chain and fob, Waltham, no. 9062208, size 18, circa 1899. *P. I. F. collection, photo courtesy of Witherell's.* **D**

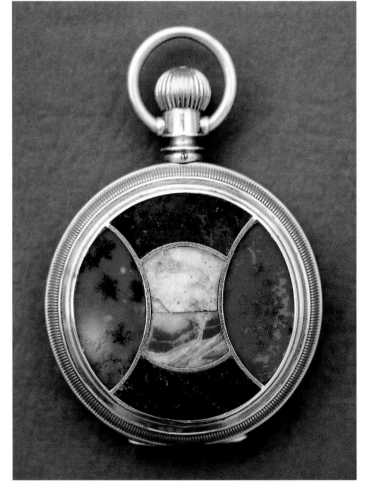

Gold, gold quartz, and mixed agate hunting case watch, Elgin Watch Co., Illinois, no. 602020, size 16, circa 1879. *Al and Carol Cali, photo courtesy of Witherell's.* **D**

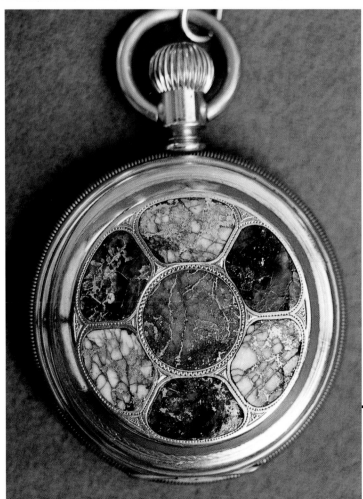

Gold and gold quartz watch, Howard no. 40167, size N, circa 1868-1883. *Roger Baker, photo courtesy of Witherell's.* **D**

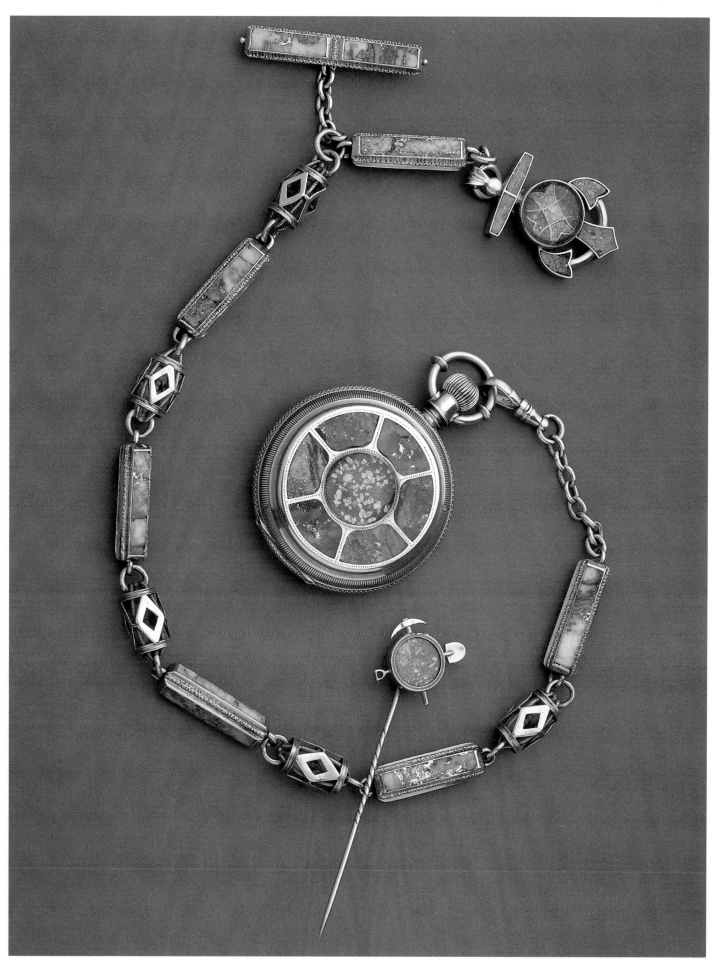

Gold and gold quartz watch, chain, fob, and stick pin, circa 1853-1904. *Collection of Herbert G. Ratner Jr.; Richard A. Stoner photograph.* **D**

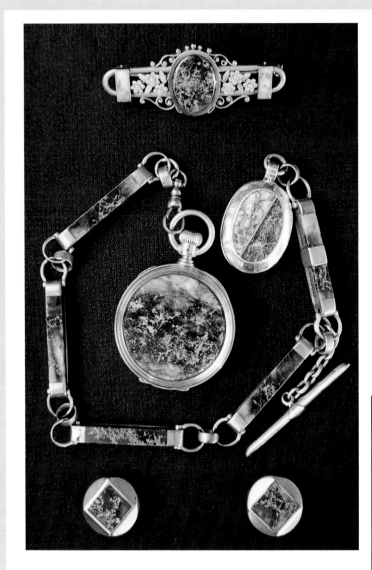

Gold and gold quartz jewelry, comprising, broach, cuff links, watch, chain and fob, circa 1853-1904. Mike and Sally Butler, photo courtesy Witherell's. each **B**

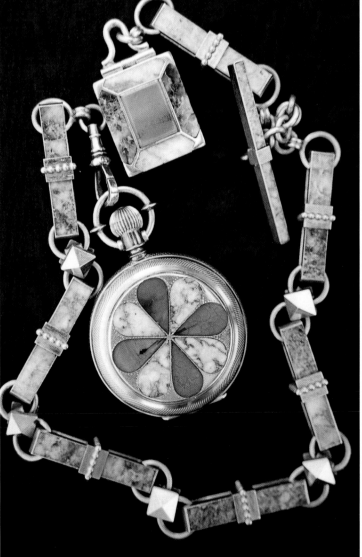

Gold and Gold Quartz Watch, together with gold and gold quartz chain. Waltham, no. 1485897, 6 size, circa 1879. *Private collection, photo courtesy of Witherell's.* **C**

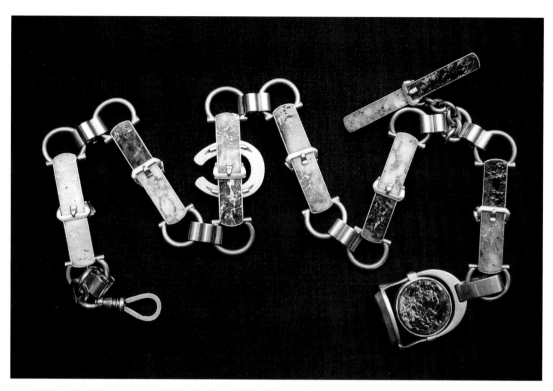

Gold and gold quartz watch chain, circa 1853-1904. *Paul Schweizer, photo courtesy of Witherell's.* **C**

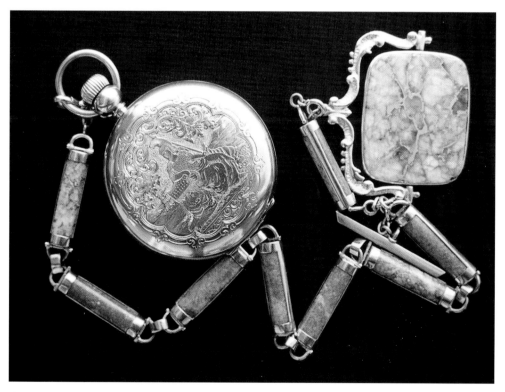

Gold hunting case watch, together with gold and gold quartz chain and spinner fob, recto; engraved with California State Seal, verso; engraved with Vaquero roping Long Horn Steer. Interior inscribed, *PRESENTED / TO / J. CLARK ESQ / ATTORNEY AT LAW / S.F. / BY THE SETTLERS OF / TAMALES / Jan. 1st 1862.* , case marked *Sherwood / Cal.,* works *Alexander / London,* no. 12276, size 18. *P. I. F. collection, photo courtesy of Witherell's.* **D**

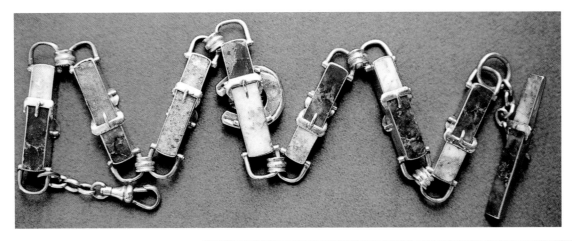

Gold and gold quartz watch chain, circa 1853-1904. *Roger Baker, photo courtesy of Witherell's.* **D**

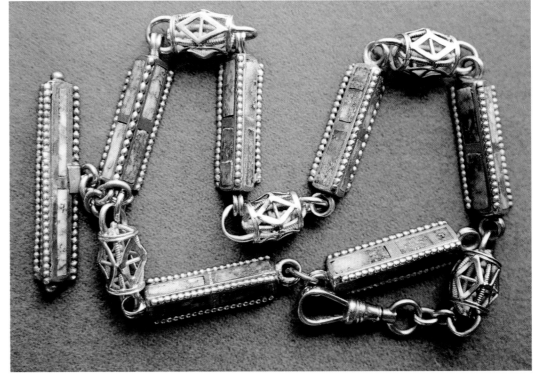

Gold and gold quartz watch chain, marked, *Markley Mathew / Pat. September 1878. Roger Baker, photo courtesy of Witherell's.* **D**

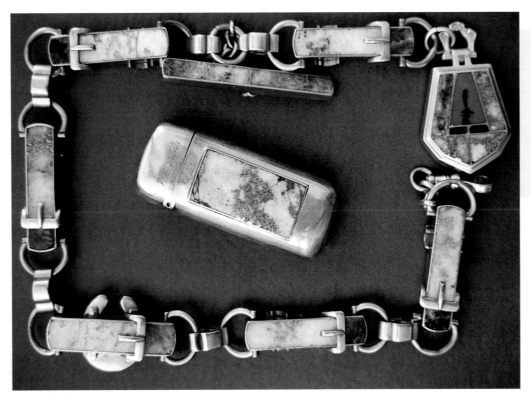

Gold and gold quartz match safe and large buckle chain, circa 1853-1900. *Al and Carol Cali, photo courtesy of Witherell's.* **C**

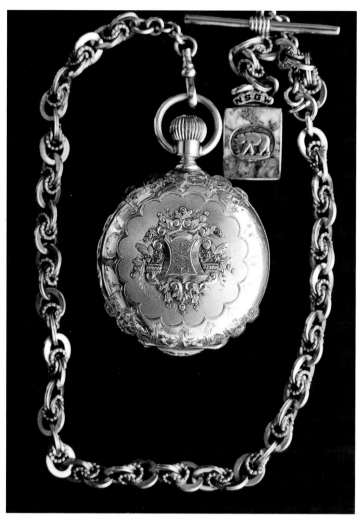

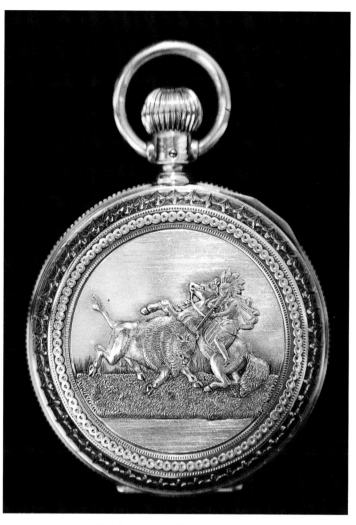

California link watch chain, together with gold quartz Native Sons of the Golden West watch fob and muti-colored gold watch. *P.I.F. collection, photo courtesy of Witherell's.* **C**

Multi-colored gold pocket watch, inscribed, *To Sir KT James McGee / from the Sir Knites and Ladies of New York State Battalion / San Francisco Aug. 1883.* Waltham, Serial no. 1,917,739, 18 size, circa 1882. *Private collection, photo courtesy of Witherell's.* **C**

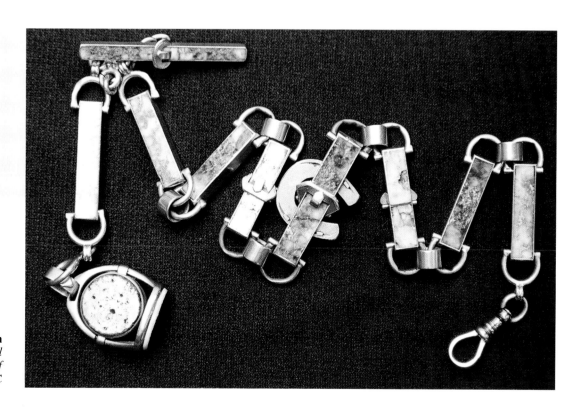

Gold and gold quartz watch chain, circa 1853-1904. *Paul Schweizer, photo courtesy of Witherell's.* **C**

Gold and gold quartz hunting case watch,
case marked, *Barrett and Sherwood, San
Francisco,* movement, Rockford Watch Co.,
Illinois, no. 148938, size 18, circa 1880. *Al and
Carol Cali, photo courtesy of Witherell's.* **D**

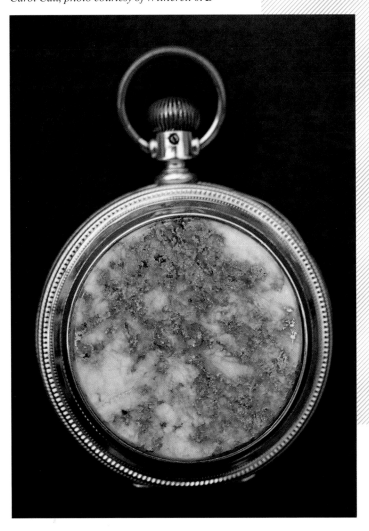

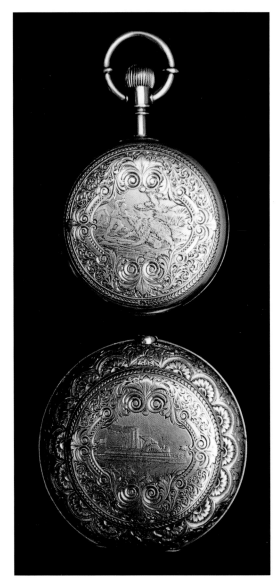

Gold watch, with convertible case retailed by A.
Andrewes, San Francisco. Inscribed, *PRESENTED
TO | E. J. BALDWIN | ON COMPLETION OF |
THE BALDWIN THEATER | BY | J. M. HOGEN |
APPRICIATIVE CITIZEN | OF S. F.* Howard, no.
42568, 18 size, circa 1868-1883. *Paul Schweizer,
photo courtesy of Witherell's.* **D**

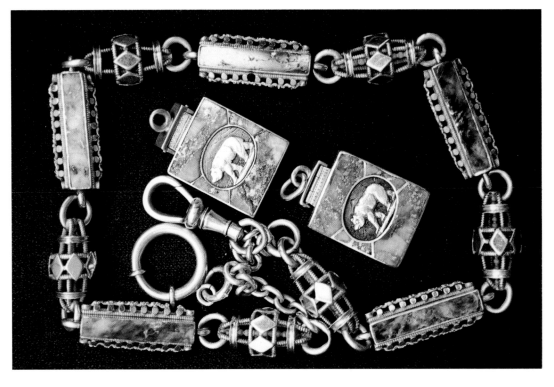

**Gold and gold quartz chain
with two California bear fobs,**
circa 1853-1904. *John and
Donna Herman, photo courtesy
of Witherell's.* **B**

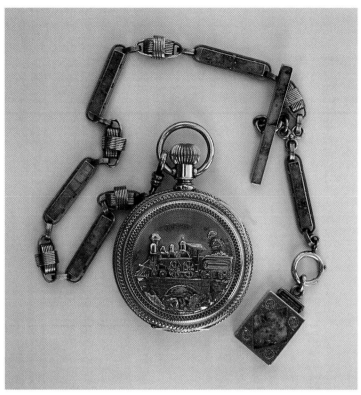

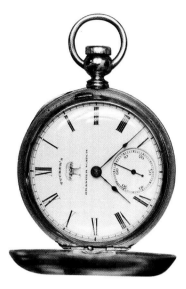

Gold hunter case watch, dial marked, *Tucker's Granger Watch,* no.326624 size 18, circa 1873, 18k. *Hayes collection, photo courtesy of Witherell's.* **A**

Multi-colored gold hunting case watch, together with gold quartz chain, Elgin Watch Co., Illinois, no. , size 16, circa 1890. *Private collection, photo courtesy of Witherell's.* **D**

Gold and gold quartz chain, fob, and match safe, circa 1853-1904. Together with Frank Wesson Vest Pocket Derringer. *Collection of Herbert G. Ratner Jr., Richard A. Stoner photograph.* **D**

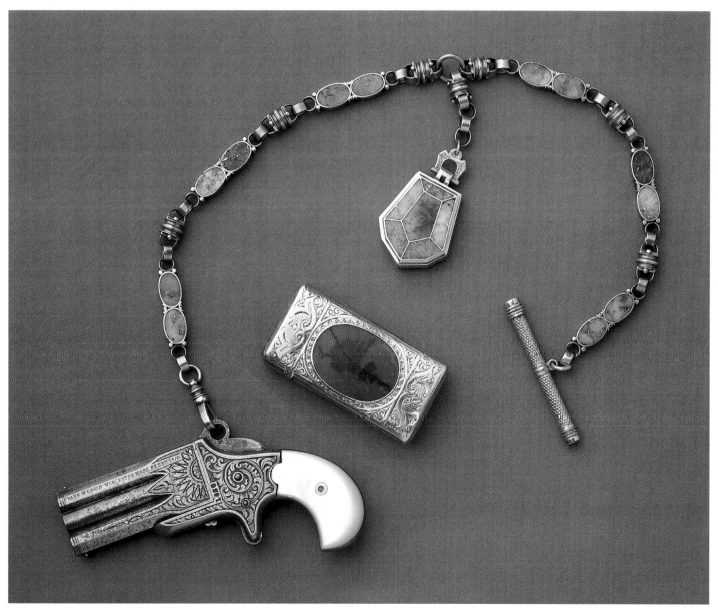

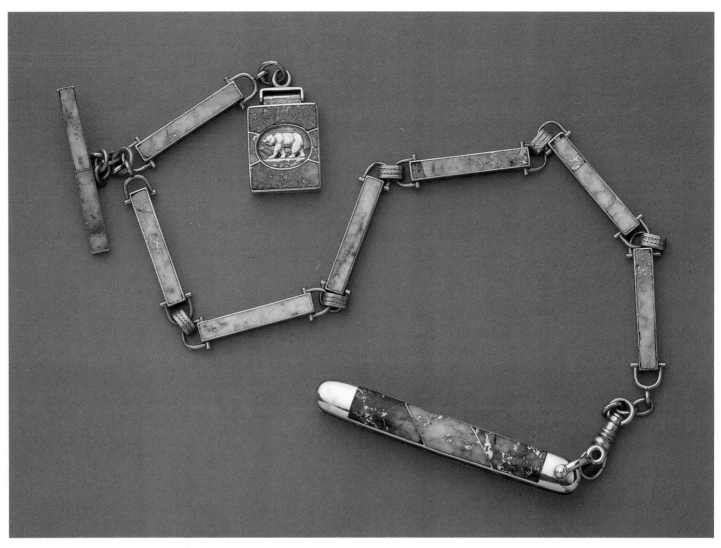

Gold and gold quartz chain, fob, and knife, circa 1853-1904. *Collection of Herbert G. Ratner Jr., Richard A. Stoner photograph.* **D**

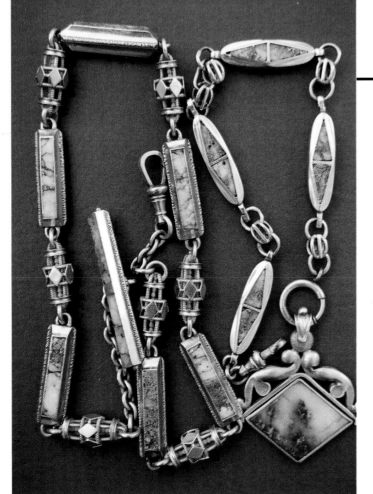

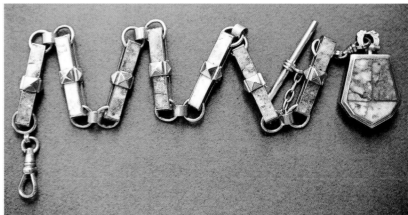

Gold and gold quartz watch chain, circa 1853-1904. *Roger Baker, photo courtesy of Witherell's.* **C**

Gold and gold quartz watch chain, circa 1853-1904. *Al and Carol Cali, photo courtesy of Witherell's.* **C**

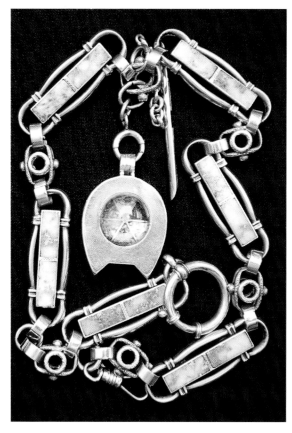

Gold and gold quartz chain with specimen fob, circa 1853-1904. *John and Donna Herman collection, photo courtesy of Witherell's.* **B**

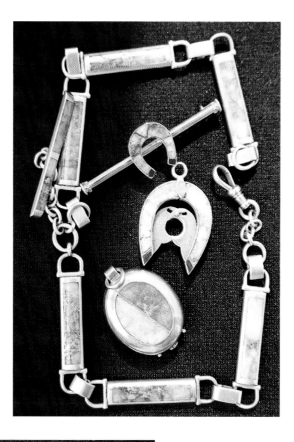

Gold and gold quartz jewelry, comprising watch chain, fobs, and bar pin, circa 1853-1904. *Private collection, photo courtesy of Witherell's.* **A** and **B**

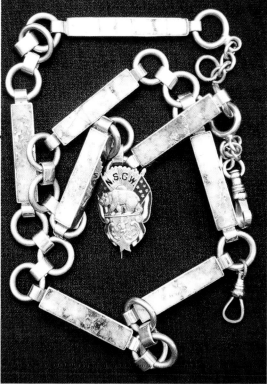

Gold and gold quartz chain, together with Native Sons of The Golden West pin, circa 1853-1904. *John and Donna Herman collection, photo courtesy of Witherell's.* **B**

Gold and gold quartz watch fobs, circa 1853-1904. *Al and Carol Cali, photo courtesy of Witherell's.* **B**

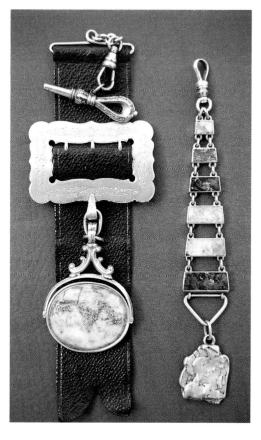

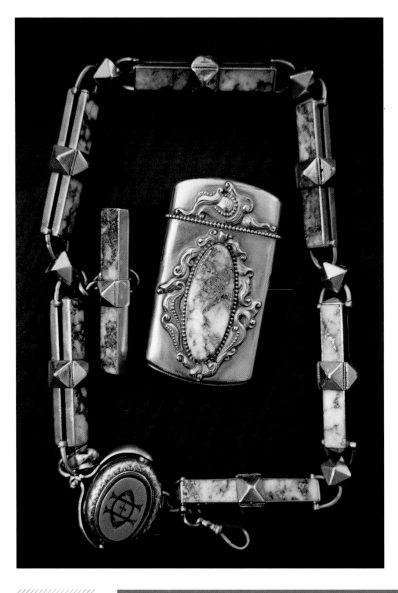

Gold and gold quartz match safe and large chain, chain 15 in., each link 1 3/4 in. Circa 1853-1900. *Al and Carol Cali, photo courtesy of Witherell's.* each **C**

Gold and gold quartz chain and fobs, circa 1853-1904. *Collection of Herbert G. Ratner Jr., Richard A. Stoner photograph.* **C**

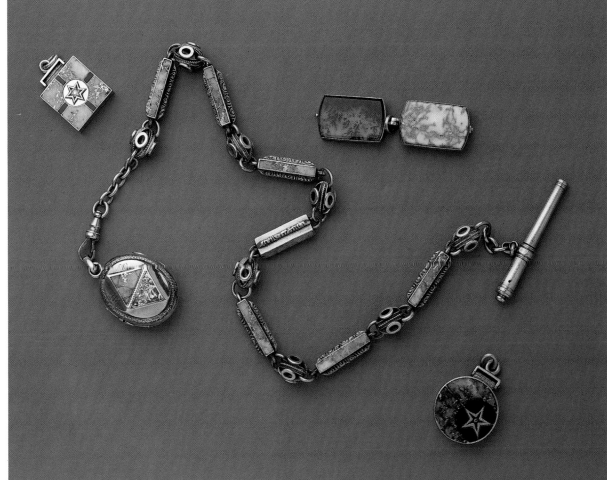

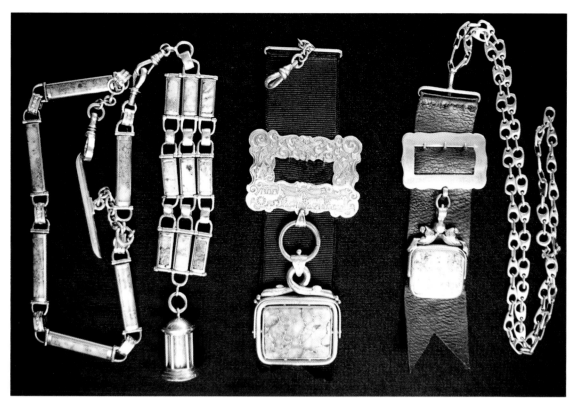

Gold and gold quartz jewelry, comprising chain and two fobs. Central fob, high relief engraved with Butterfield Stage Line, and mountain men. Circa 1853-1904. *Mike and Sally Butler, photo courtesy of Witherell's.* each **B**

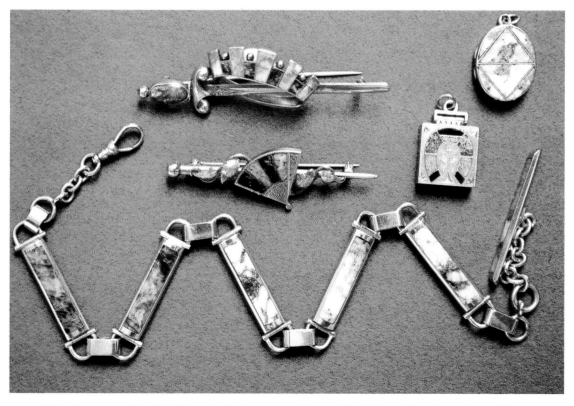

Miscellaneous gold and gold quartz jewelry, comprising; watch chain, two bar pins, and two fobs, circa 1853-1904. *Roger Baker, photo courtesy of Witherell's.* **B**

Gold Quartz Jewelry

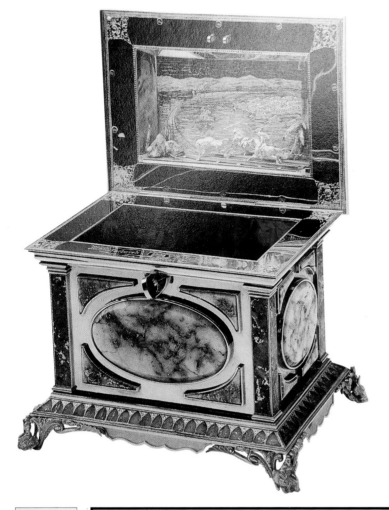

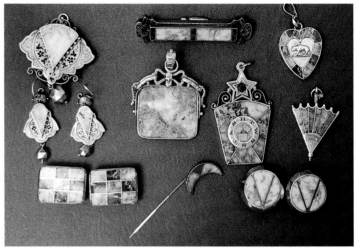

Gold and gold quartz jewelry, comprising, broach and earrings, bar pin, miscellaneous watch fobs, cuff links, and stick pin. Circa 1860-1904. *Hayes collection, photo courtesy of Witherell's.* **A**

Gold and gold quartz lidded box inscribed *MANUFACTURED BY A. ANDREWS 221 Montgomery, S. F. Cal. Oakland Museum of California History.* **D**

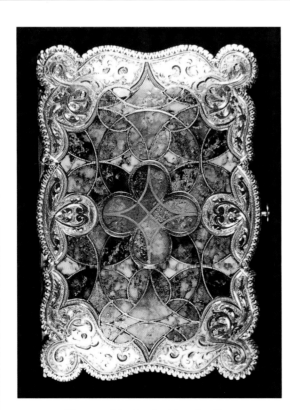

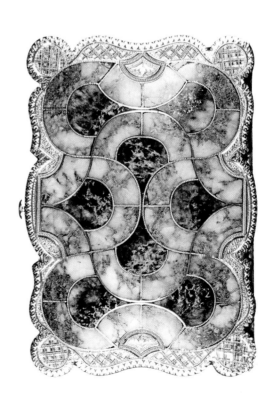

Front and back of gold and gold quartz purse with ore samples under crystal. Circa 1852-1904, approximately 3 by 5 in. *Courtesy Sandra J. Whitson and Ron Van Anda.* **D**

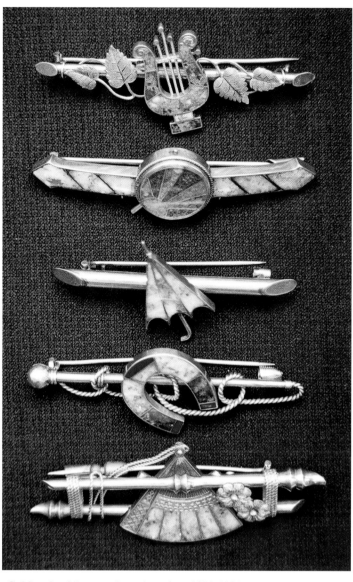

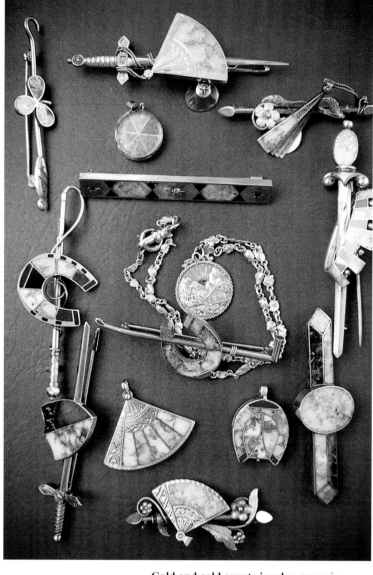

Gold and gold quartz bar pins, circa 1853-1904. *John and Donna Herman collection, photo courtesy of Witherell's.* each **A**

Gold and gold quartz jewelry, comprising bar pins, fobs, and broach. Circa 1853-1904. *Al and Carol Cali, photo courtesy of Witherell's.* each **A**

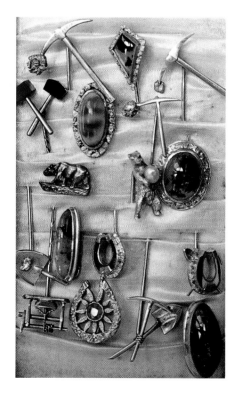

Assorted gold and gold quartz stick pins, circa 1853-1904. *Robert and Dorothy Soares collection, photo courtesy of Witherell's.* each **A**

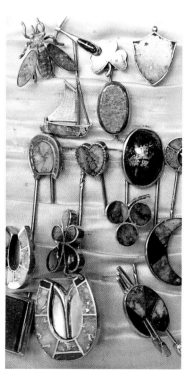

Assorted gold and gold quartz stick pins, circa 1853-1904. *Robert and Dorothy Soares collection, photo courtesy of Witherell's.* each **A**

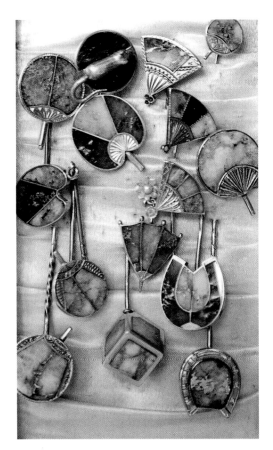

Assorted gold and gold quartz stick pins,
circa 1853-1904. *Robert and Dorothy Soares
collection, photo courtesy of Witherell's.* each
A

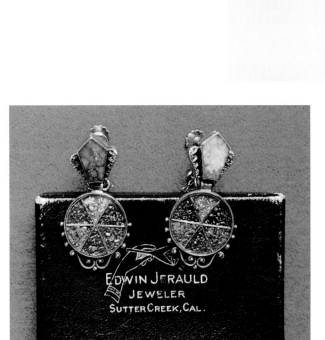

Gold and gold quartz earrings, with ore
samples, circa 1853-1904. *Roger Baker, photo
courtesy of Witherell's.* **B**

Gold and gold quartz bar pin, circa 1853-1904.
Roger Baker, photo courtesy of Witherell's. **B**

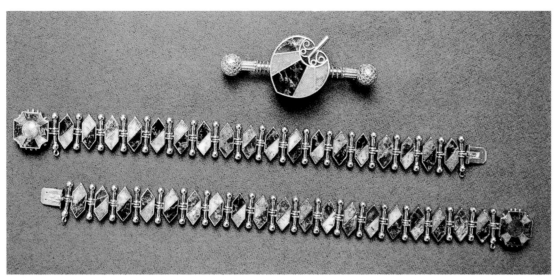

Gold and gold quartz combination bracelet/ necklace and bar pin, circa 1854-1904. *Roger Baker, photo courtesy of Witherell's.* **C**

Gold and gold quartz jewelry comprising brooches, fobs, and earrings. *P.I.F. collection, photo courtesy of Witherell's.* each **A**

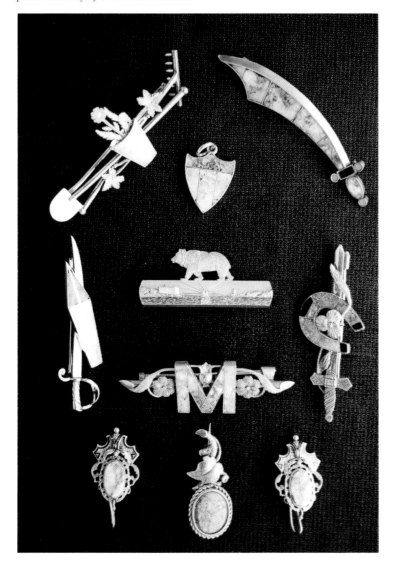

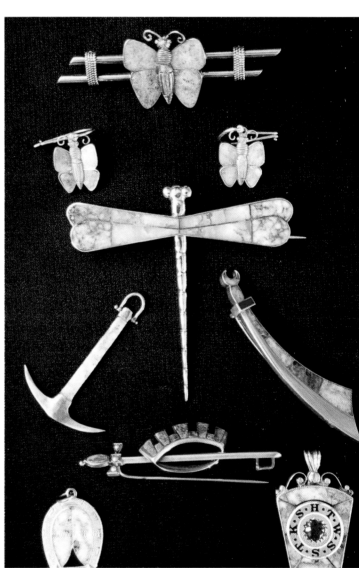

Gold and gold quartz jewelry comprising, earrings, brooches, and fobs, circa 1853-1904. *Mike and Sally Butler, photo courtesy of Witherell's.* each **A**

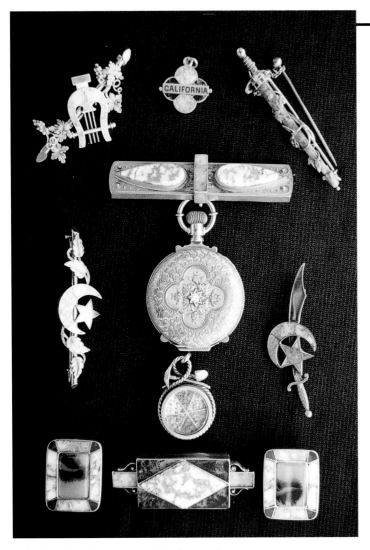

Gold and gold quartz match safe, together
with multi-colored gold watch, circa 1853-
1904. *Roger Baker, photo courtesy of Witherell's.*
C

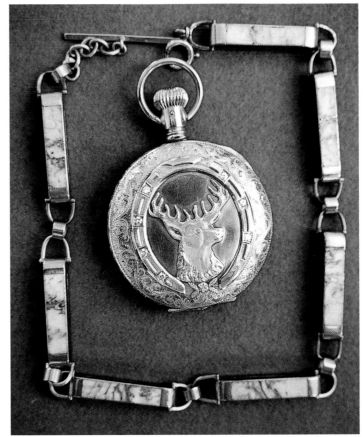

Gold and gold quartz jewelry comprising
brooches, fobs, cuff links, and bar pins. Circa
1853-1904. *P.I.F. collection, photo courtesy of
Witherell's.* each **A**

Gold and gold quartz specimen brooch from
various California and Nevada mines. Circa
1859-1904. *Mike and Sally Butler, photo
courtesy of Witherell's.* **B**

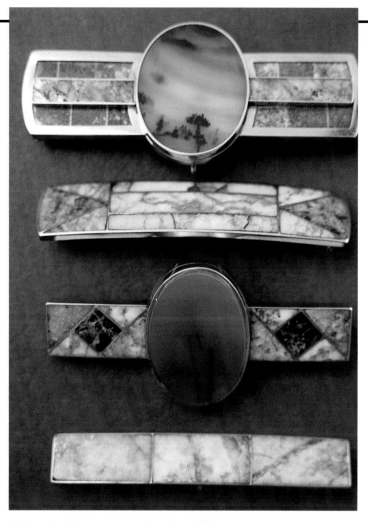

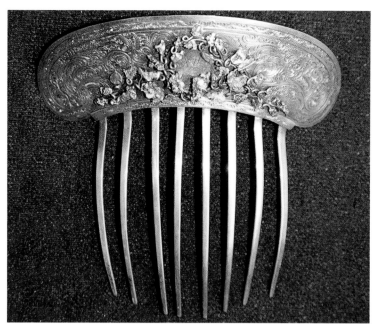

Gold and gold quartz hair comb, circa 1850-1890. *Paul Schweizer, photo courtesy of Witherell's.* **B**

Gold and gold quartz bar pins, circa 1853-1904. *Al and Carol Cali, photo courtesy of Witherell's.* **A**

Gold and gold quartz bar pin in the form of a butterfly, circa 1852-1904, 3 by 1 1/2 in. *Courtesy Sandra J. Whitson and Ron Van Anda.* **B**

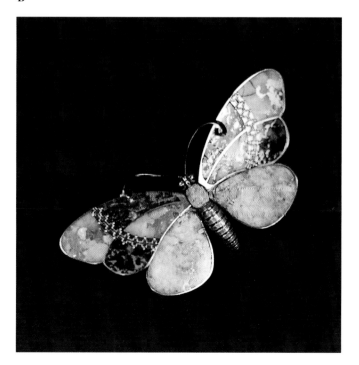

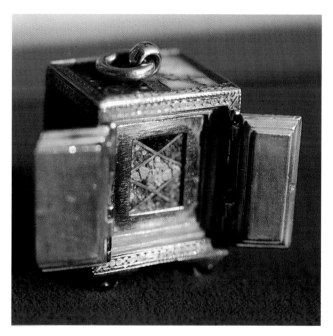

Gold and gold quartz watch fob, with ore samples under crystal, circa 1852-1904, 1 1/4 in. high. *Courtesy Sandra J. Whitson and Ron Van Anda.* **B**

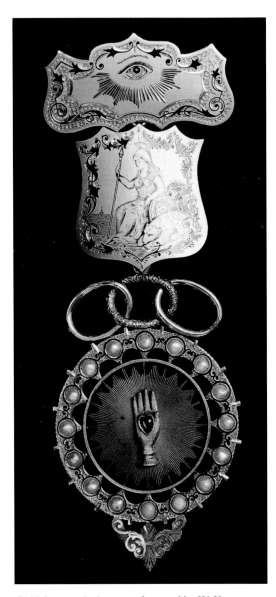

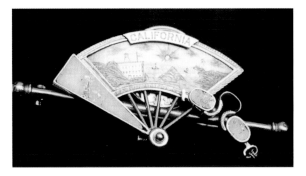

Gold and gold quartz pin, circa 1853-1904. *Paul Schweizer, photo courtesy of Witherell's.* **A**

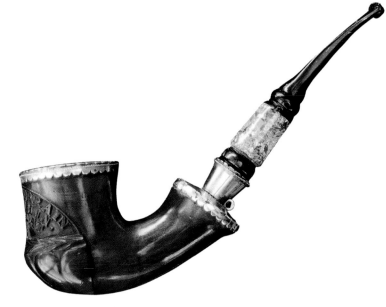

Gold adorned smoking pipe, carved, *TO JOHN LORRAIN / BY W. RABLIN / DUTCH FLAT / CAL / 1869. P. I. F. collection, photo courtesy of Witherell's.* **B**

Gold fraternal pin, manufactured by W. K. Vanderslice & Co. Inscribed, *CLARK N. JENKINS / PAST GAURD MASTER / FROM THE / GRAND LODGE / O0F THE STATE OF CALIFORNIA / I. O. O. F. / MAY 1896. Paul Schweizer, photo courtesy of Witherell's.* **B**

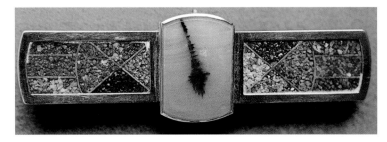

Gold bar pin, with ore samples, circa 1853-1904. *Roger Baker, photo courtesy of Witherell's.* **B**

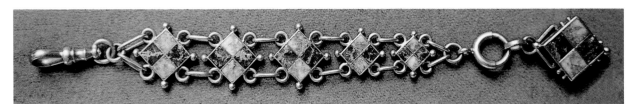

Gold and gold quartz fob, circa 1853-1904. *Roger Baker, photo courtesy of Witherell's.* **B**

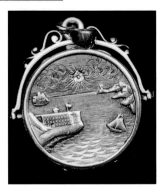

Gold watch fob, circa 1853-1904. *Paul Schweizer, photo courtesy of Witherell's.* **A**

Chapter 3
SILVER

Silver items were popular decorative accents in California before the gold rush of 1849. While California was still under Spanish control, wealthy landowners had silver fashioned into lavish costume decorations and riding equipment. Mexican cowboys were fond of incorporating silver in their outfits, and this tradition, known as the "Vaquero Style," continues to the present. Artisans of the nineteenth and twentieth centuries such as Edward H. Bohlin have developed the cowboy silver tradition into the "California Style," as it is known today.

The first silversmith to arrive in California after the discovery of gold was George Budd, who advertised in the September, 1850, San Francisco city directory as a silversmith. His tenancy was short-lived, however, for after two years he had vacated the city. A letter dated January 6, 1850, from 27-year-old William Swain to his brother George, expresses the hardships of the time. "There was some talk between us of your coming to this country. For God sake think not of it. Tell all whom you know that thousands have laid and will lay their bones along the routes to and in this country."

It was not until around 1860 that a significant amount of silverware was produced on the Pacific Coast. Frederick R. Reichel, who listed himself as a manufacture of silverware in 1861, and William Keyser Vanderslice, who listed himself as a silversmith in 1859, were among the earliest producers of silver items of special order scale in California. However, neither of them nor their respective firms produced much volume. The majority of the silverware in use on the Pacific slopes was shipped from manufacturing companies in Rhode Island and Connecticut. Today, early California-made silver items are quite desirable, especially those with California symbolism.

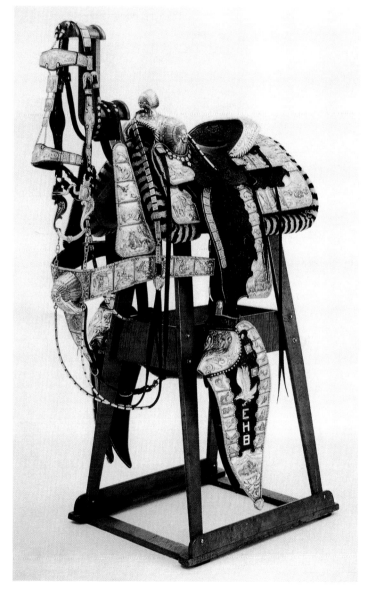

Silver, multi-colored gold, and carved leather saddle by Edward H. Bohlin, Hollywood, circa 1947. "The Big Saddle," Bohlin's personal masterpiece. Fourteen years of painstaking work was required to hammer and solder the layers of sterling silver and red, yellow, green and white gold which make up the components of this saddle. The result captured the West in true Hollywood style, with a vast array of western life. *Courtesy Autry Museum of Western Heritage.* **D**

Spurs

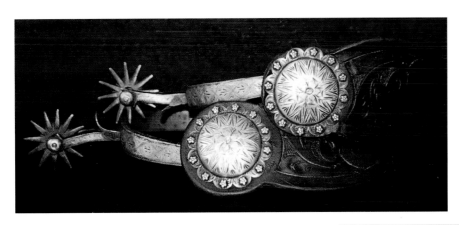

California silver mounted spurs, stamped, *L. D. STONE / SAN FRANCISCO,* circa 1852-1905. *Private collection, photo courtesy of Witherell's.* **B**

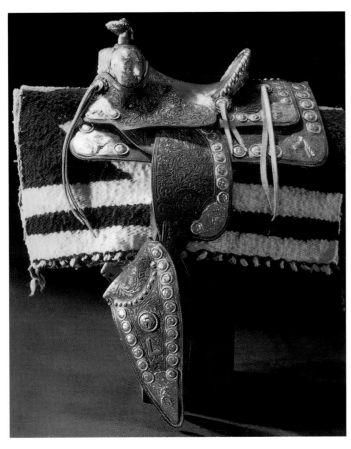

Miniature silver mounted and tooled leather saddle by Edward H Bohlin, Hollywood, circa 1926-1941, 21 by 13 in. *Adams collection, photo courtesy of Frank H. Boos Gallery.* **D**

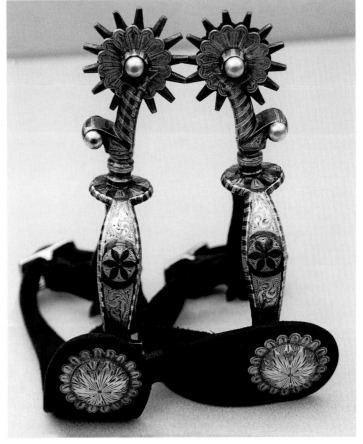

California silver mounted spurs, stamped, *GARCIA / SADDLE CO. / SALINAS, CALIF.,* circa 1935-1966. *Private collection, photo courtesy of Witherell's.* **B**

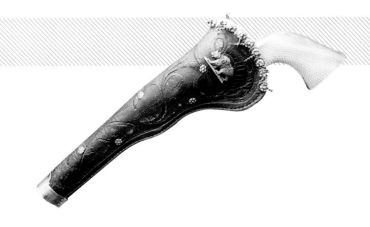

"California" pattern holster with silver attachments, for a Colt Model 1851 Navy Revolver, leather stamped *Fox / Los Angeles,* 11 1/4 in. *P. I. F. collection, photo courtesy of Witherell's.* **B**

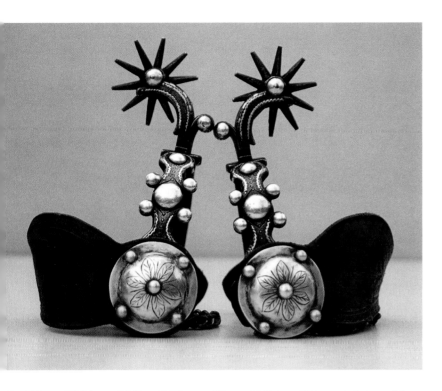

California silver mounted spurs attributed to
Alberto Esptnosa, circa 1858-1973. *Private
collection, photo courtesy of Witherell's.* **B**

California silver mounted spurs attributed to
Wesley Wimmer, circa 1920-1973. *Private
collection, photo courtesy of Witherell's.* **B**

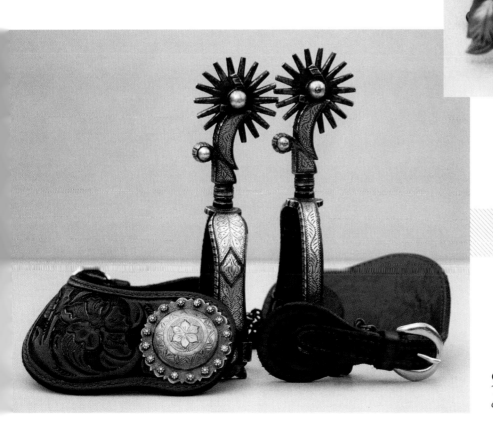

California silver mounted spurs attributed to
Tapia, circa 1870-1920. *Private collection, photo
courtesy of Witherell's.* **B**

Fire Parade Horns

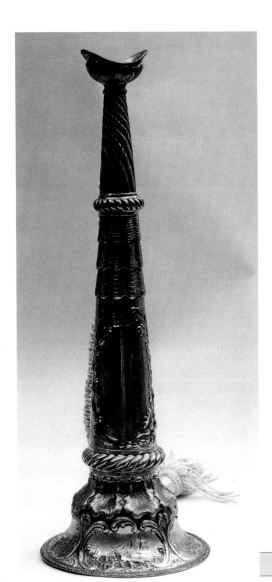

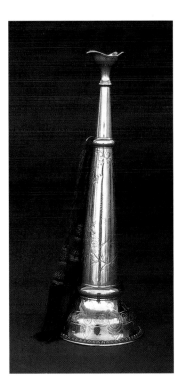

Silver plated fire parade horn inscribed, *SACRAMENTO / ENGINE CO. / No. 3.*, circa 1900, 17 in. *Private collection, photo courtesy of Witherell's.* **B**

Silver Loud Hail (fire parade horn) inscribed *DANIEL FOURTH / TO / CHARLES SCHARDIN ESQ. / FOREMAN / HYDROLIC HOSE CO. No. 1 / NORTH SAN JUAN / NOV 1862.* 22 in. *Paul Schweizer, photo courtesy of Witherell's.* **C**

Silver Loud Hail (fire parade horn) inscribed *PRESNTED BY / CAPT. ROBERITI McCORMICK / OF THE LATE BARK GREEN POINT / TO / CAPT. WILLIAM O. PUTMAN / THE REPRESINTITIVE & ONE OF A NUMBER OF AMERICAN CAPTAINS AT THE CHINCHA ISLANDS & AS A TOKEN OF GRATITUDE FOR / THEIR SPONTANEOUS AND UNEXPECTED ASSISTANCE IN AN HOUR / OF NEED AT CALLAO / AUG. 8TH 1853.* 22 in. *Paul Schweizer, photo courtesy of Witherell's.* **C**

Silver fire parade horn inscribed ... / *CALIFORNIA ENGINE CO. / No. 4... / SAN FRANCISCO 1856. Private collection. Photo courtesy Argentum The Leopard's Head.* **D**

Law Badges

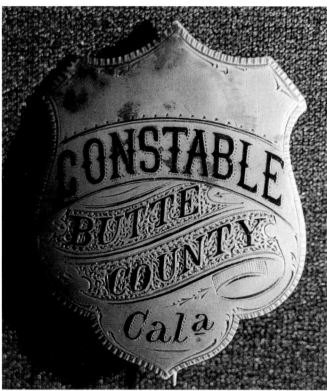

Silver shield law badge enameled, *CON-STABLE / BUTTE / COUNTY / Cala*, 2 1/8 in. Circa 1880s. *P. I. F. collection, photo courtesy of Witherell's.* **C**

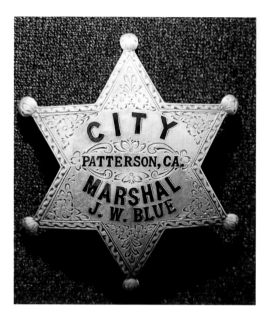

Silver star law badge enameled, *CITY / PATTERSON, CA. / MARSHAL / J. W. BLUE*, 3 in. Circa 1920s. *P.I.F. collection, photo courtesy of Witherell's.* **B**

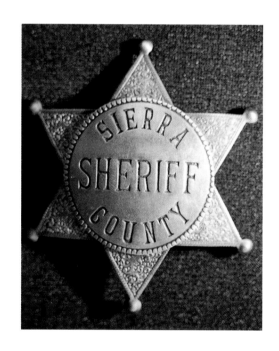

Right:
Silver star law badge inscribed, *SIERRA / SHERIFF / COUNTY*, 3 3/4 in. Circa 1880s. *P.I.F. collection, photo courtesy of Witherell's.* **B**

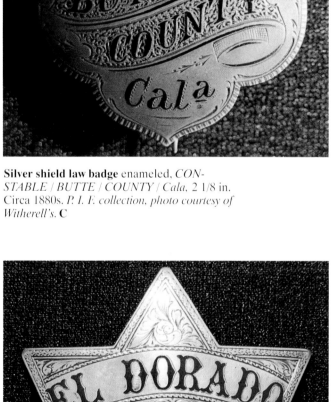

Silver star law badge enameled, *EL DORADO / SHERRIF / COUNTY*, 3 1/4 in. Circa 1900s. *P.I.F. collection, photo courtesy of Witherell's.* **C**

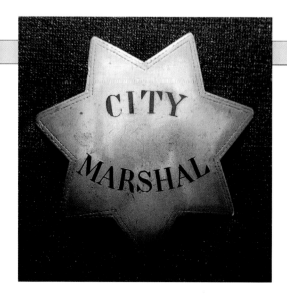

Silver star law badge enameled, *CITY / MARSHAL*, from Healdsburg, California. 3 in. Circa 1890s. *P.I.F. collection, photo courtesy of Witherell's.* **B**

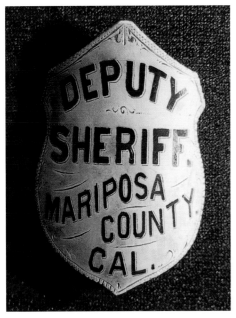

Silver shield law badge enameled *DEPUTY / SHERIFF / MARIPOSA / CO. CAL.* 2 3/8 in. Circa 1880s. *P.I.F. collection, photo courtesy of Witherell's.* **C**

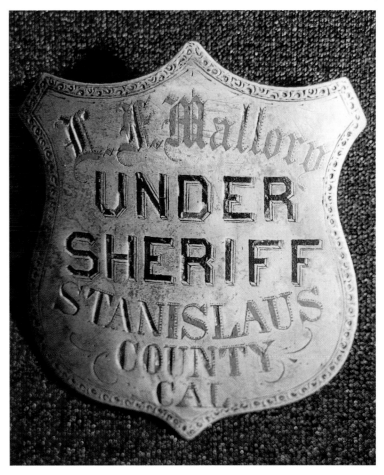

Silver shield law badge enameled *D. F. MALLORO / UNDER / SHERIFF / STANISLAUS / COUNTY / CAL,* 2 1/2 in. Circa 1880s. *P. I. F. collection, photo courtesy of Witherell's.* **C**

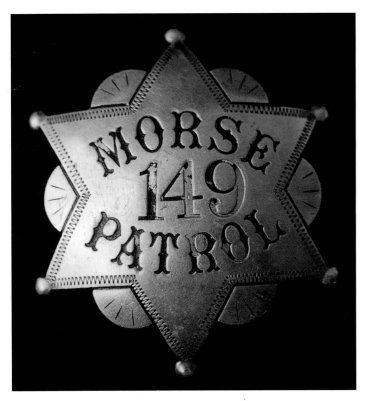

Silver plated star law badge enameled *MORSE / 149 / PATROL. John Boessenecker, photo courtesy of Witherell's.* **C**

Edward Jones' personal silver badge enameled *EDWARD JONES / ATHENS PARLOR No. 195 / OAKLAND CALIF,* manufactured by Edward Jones, Oakland, 4 in. Circa 1940. *Paul Schweizer, photo courtesy of Witherell's.* **D**

Watches

Silver hunter case watch, dial marked *Anna L. Silveria / Jewelry Palace / San Francisco Cal.* Hamilton, no. 25/185, size 18, circa 1902. *Hayes collection, photo courtesy of Witherell's.* **B**

Silver hunter case watch, dial marked, *Chas. Haas / Stockton Cal.* size 18. *Hayes collection, photo courtesy of Witherell's.* **B**

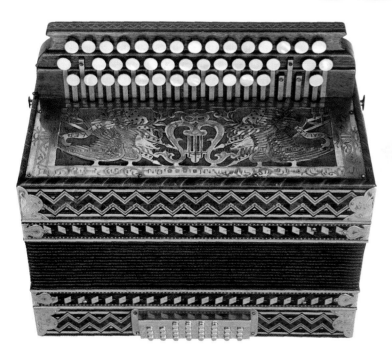

Silver and parquetry accordion, top marked, *SAN FRANCISCO / GALLEAZZI / MAKER,* plaque, *G. GALLEAZZI / ACCORDEON MAKER 478 JACKSON ST. / SAN FRANCISCO CAL. PAT. AUG. 18, 1896 / GOLD MEDAL AWARDED CAL. MID. EXP. Private collection, photo courtesy of Witherell's.* **B**

Cutlery

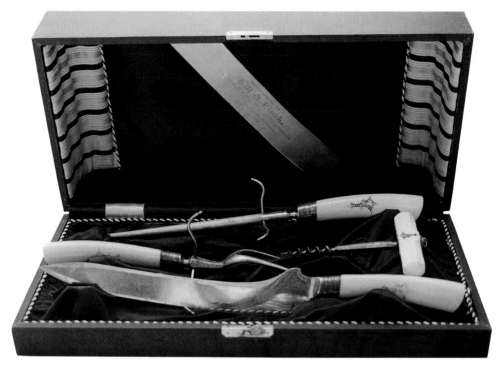

Factory cased ivory handle cutlery set,
accessories stamped *WILL & FINCK / S.F.
CAL.,* 17 in. Circa 1863-1900. *Al and Carol
Cali, photo courtesy of Witherell's.* **B**

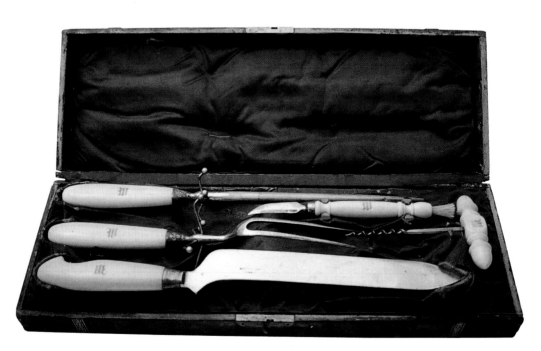

Factory cased ivory handle cutlery set,
accessories stamped, *M. PRICE / SAN
FRANCISCO,* 19 in. Circa 1857-1889. *Al and
Carol Cali, photo courtesy of Witherell's.* **B**

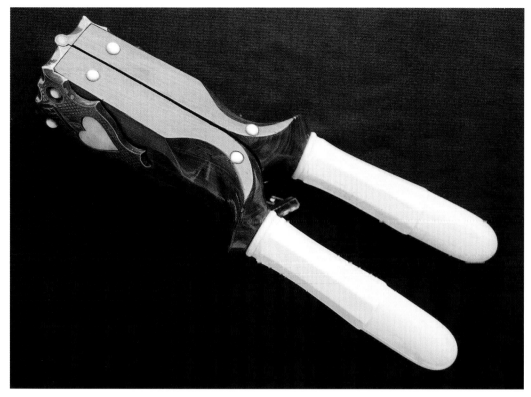

Silver, ivory, and rosewood lime squeezer
stamped, *J. H. SCHINTZ / SAN FRANCISCO,*
circa 1872-1884, 10 in. *P.I.F. collection, photo*
courtesy of Witherell's. **B**

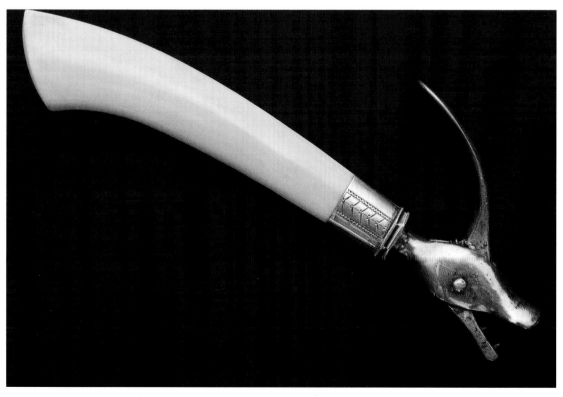

Ivory and silver skewer puller stamped, *Will & Finck / San Francisco*
/ 1877. This was patented by Will & Finck on October 30, 1877. It is
said to resemble the head of a California Grizzly Bear. *Lund*
collection, photo courtesy of Witherell's. **A**

Trophies

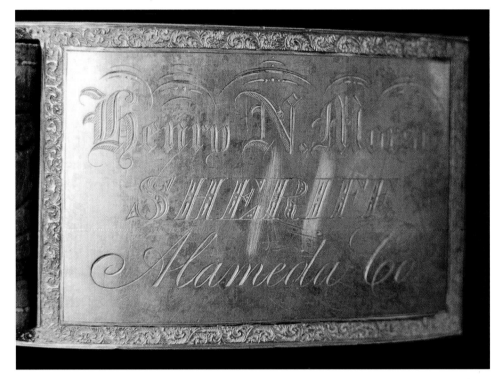

Silver belt buckle inscribed *Henry N. Morse /
SHERRIF / Alameda Co. John Boessenecker,
photo courtesy of Witherell's.* **D**

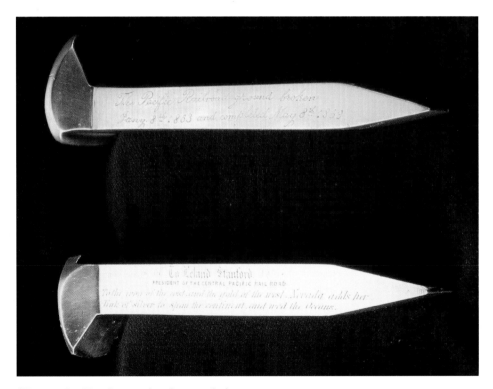

Silver and gold spikes used at the completion
of the Transcontinental railroad at Promentary
Point, Utah, on May 10, 1869. *Photo courtesy
Argentum The Leopard's Head.* **D**

Silver and gold presentation loving cup, Shreve & Co., San Francisco. The gold shield-form panels are engraved with placer mining and gold panning scenes, one is inscribed *To / Hon. Jacob Hart Neft / FROM / THE MINERS OF CALIFORNIA / Who love him for his / Noble and unselfish labors / in their behalf / 1897. Private collection, photo courtesy of Argentum The Leopard's Head.* **D**

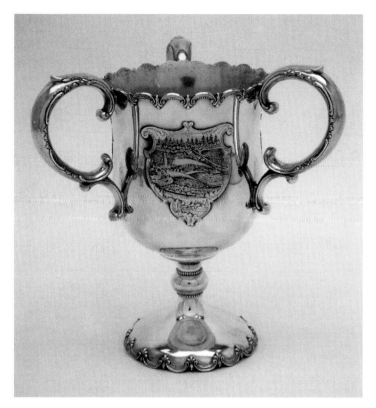

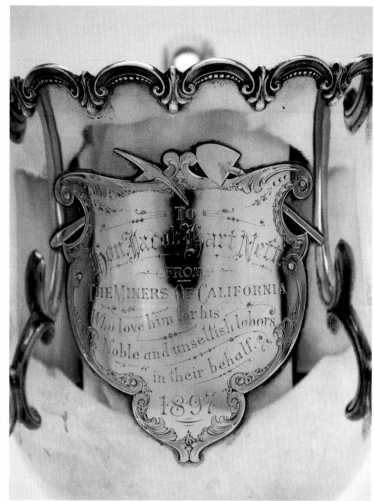

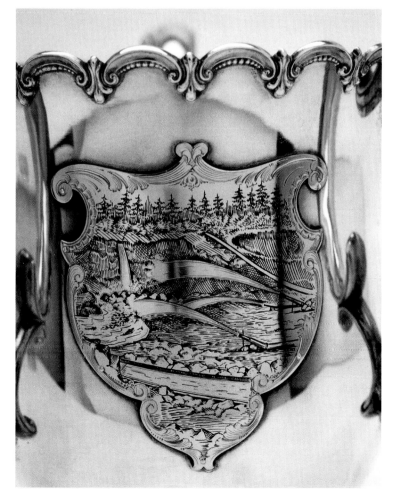

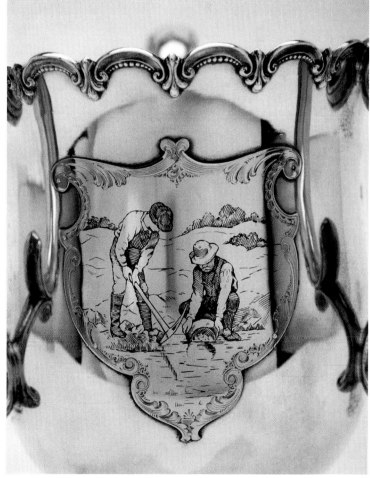

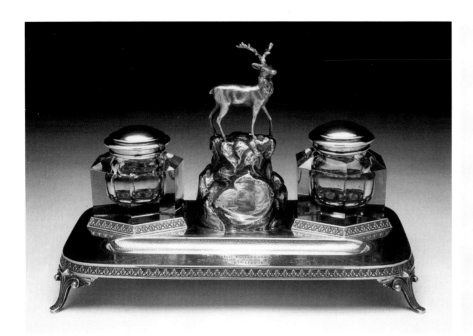

Silver ink stand by W. K. Vanderslice, San Francisco, circa 1874. *Private collection, photo courtesy of Argentum The Leopard's Head.* **B**

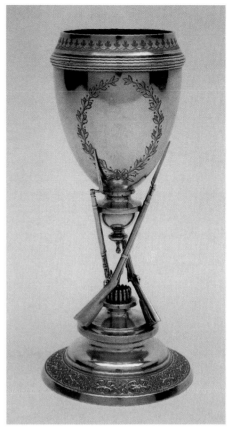

Silver shooting trophy by W. K. Vanderslice & Co., San Francisco, circa 1858-1876. *Private collection, photo courtesy of Argentum The Leopard's Head.* **A**

Silver trophy attributed to W. K. Vanderslice & Co., San Francisco, on the basis of an 1858 advertisement which states they were "prepared to furnish all premiums for State Fairs and County Fairs." Inscribed, *TO J. B. HOYT / THE / BEST SPANISH / MERING BUCK / 2 YEARS OLD / 1861 / AWARDED BY THE CALIFORNIA STATE AGRICULTURURAL SOCIETY,* 7 in. *Robert and Dorothy Soares, photo courtesy of Witherell's.* **A**

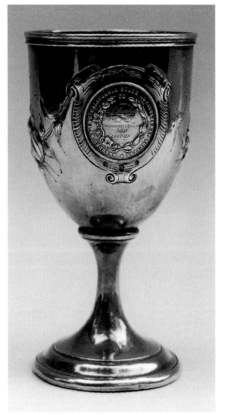

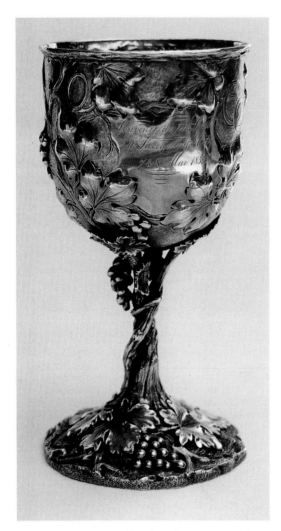

Silver trophy attributed to W. K. Vanderslice & Co., San Francisco and retailed by Samuel Jelly, Sacramento. Inscribed, *To / L. P. MARSHAL / FOR BEST / THOROUGHBREED STALLION / II YEARS / LEOPOLD / 1862 / AWARDED BY THE CALIFORNIA AGRICULTURAL SOCIETY.* 7 in. *Paul Schweizer, photo courtesy of Witherell's.* **B**

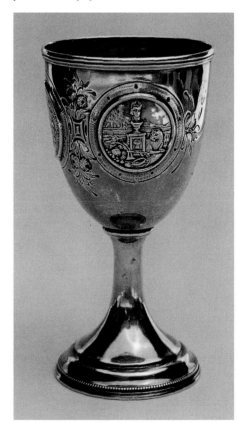

Silver goblet by Bailey, inscribed *Souvenir du tir Luisse / a Sacramento City / 7 & 8 Mai 1853,* 8 in. *Robert and Dorothy Soares, photo courtesy of Witherell's.* **B**

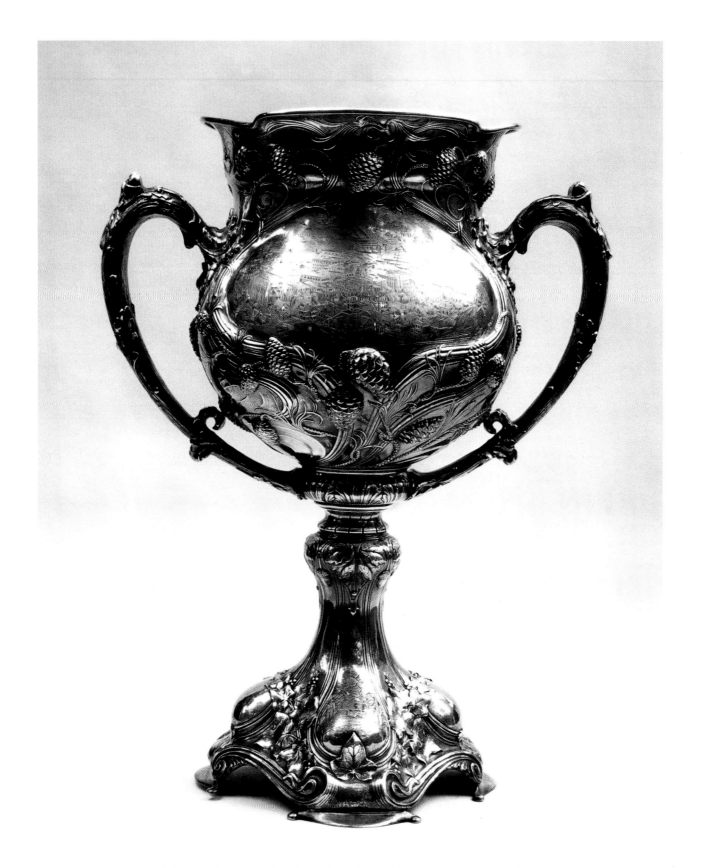

Silver presentation cup inscribed *Mrs. Phebe Hearst / FROM / The men, women, and children of Lead, South Dakota in grateful / acknowledgement of how many acts of kindness to them / 1903.* 21 1/2 in., 160oz. *Paul Schweizer, photo courtesy Argentum The Leopard's Head.* **D**

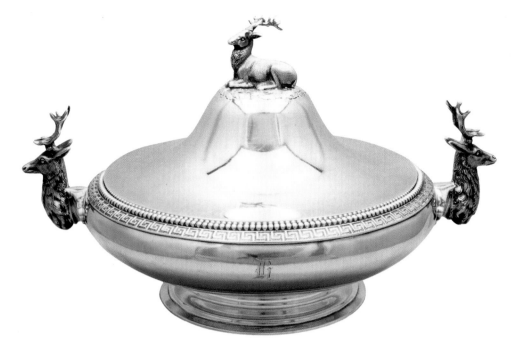

Silver soup tureen and cover by W. K. Vanderslice & Co., San Francisco, circa 1858-1876. *Private collection, photo courtesy of Argentum The Leopard's Head.* **B**

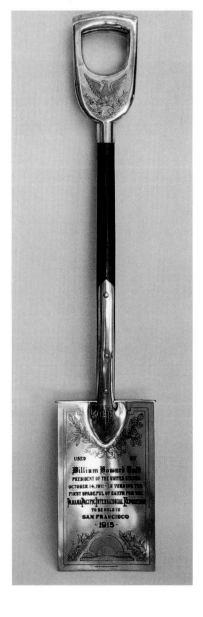

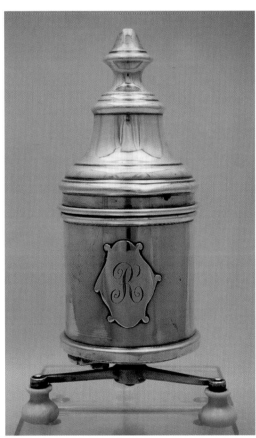

Silver shooting trophy stamped *A.L.O... S.F.* Embossed, *THIRD / NATIONAL BUNDES / SHOOTING FESTIVAL / ONE BY / SAN FRANCISCO / JULY 14 / 23RD. / 1901*, 8 1/2 in. *P. I. F. collection, photo courtesy of Witherell's.* **A**

Silver pepper mill by W. K. Vanderslice & Co., San Francisco, steel and ivory works by Will & Finck, San Francisco, circa 1863-1871. *Private collection, photo courtesy of Argentum The Leopard's Head.* **B**

Silver shovel by Shreve & Co., inscribed, *USED BY / William Howard Taft / PRESI-DENT OF THE UNITED STATES / OCTO-BER 14, 1911 - IN TURNING THE / FIRST SPADEFUL OF EARTH FOR THE / PANAMA PACIFIC INTERNATIONAL EXPOSITION / TO BE HELD IN / SAN FRANCISCO / 1915.* As reported in the October 15, 1911 edition of the **Daily Morning Call,** *The spade with which Taft dug out the first bit of earth excavating for the fair and the earth itself, carefully preserved in a glass case, were on exhibit in the tapestry room of the St. Francis under guard of a big policeman.* 36 in. *Robert and Dorothy Soares, photo courtesy of Witherell's.* **D**

Tableware

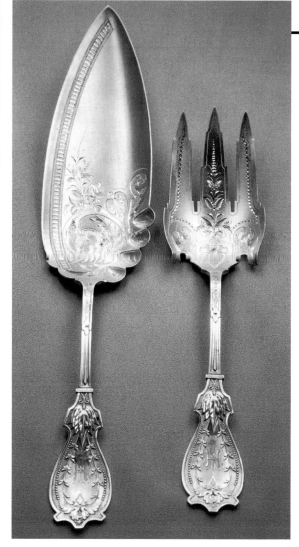

Silver serving spoon and fork by Schulz & Fischer, San Francisco, in the "Faralone" pattern, circa 1875. *Private collection, photo courtesy of Argentum The Leopard's Head.* **A**

Silver flatware by Schulz & Fischer, in the "Medallion" pattern, circa 1867-1890. *Lund collection, photo courtesy of Witherell's.* **B**

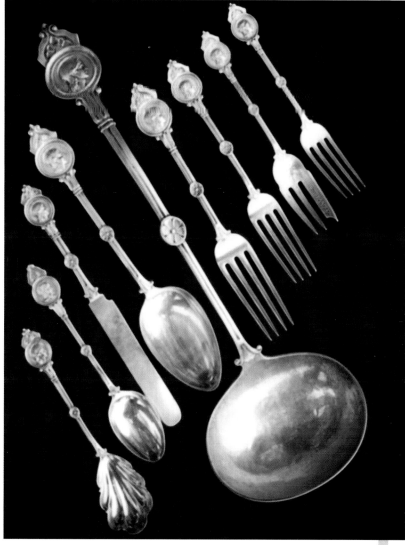

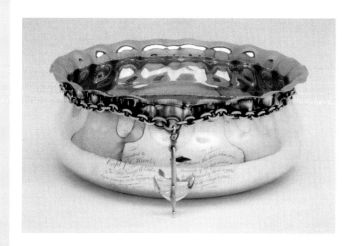

Silver presentation bowl by George C. Shreve & Co., San Francisco, inscribed, *Presented to / Capt. J. C. Hunter / of the ship George W. Elder / by his passengers on the voyage to ____ / between the dates below, as a / momento of the trip and as a / testimonial of their regard / July 17 - Aug. 3, 1888. Private collection, photo courtesy of Argentum The Leopard's Head.* **D**

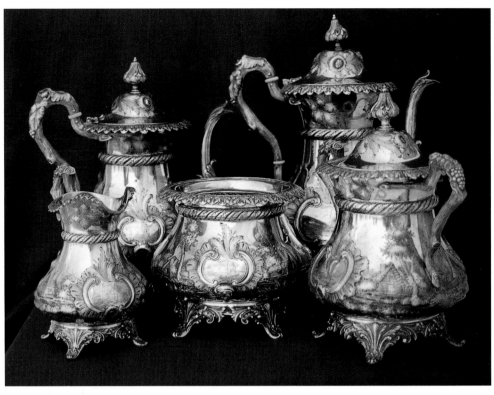

Five-piece coin silver, Rococo Revival, tea service by Bailey & Co., Philadelphia, circa 1850-1865, engraved with the state seal of California. *Private collection, photo courtesy of Witherell's.* **D**

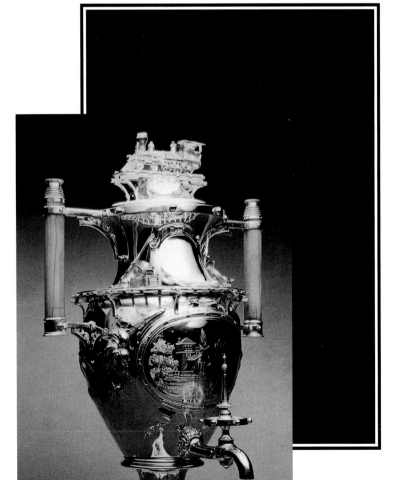

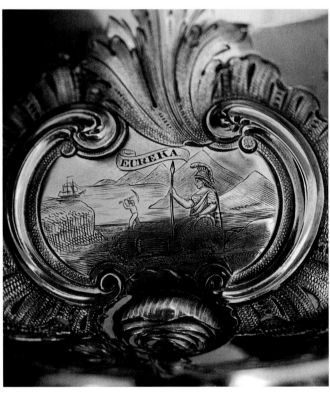

Detail of tea service showing California State Seal.

Silver and ivory handled urn, by Gorham & Co., Providence, retailed by J. W. Tucker & Co., San Francisco, pitcher from set inscribed, *Presented to E. D. Baker / by the merchants of San Francisco / CALIFORNIA / as a token of their esteem and confidence / 1860. Oakland Museum History Department, photo courtesy of Argentum The Leopard's Head.* **D**

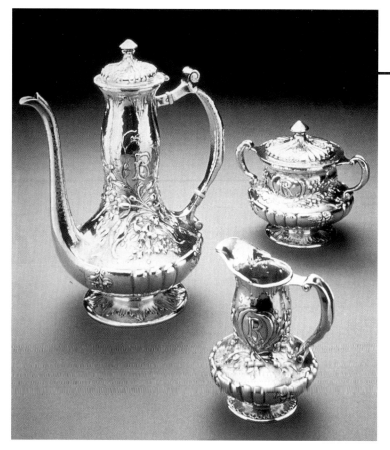

Three-piece silver tea set by Clemens Friedell, Pasadena, circa 1920-1930. *Private collection, photo courtesy of Argentum The Leopard's Head.* **C**

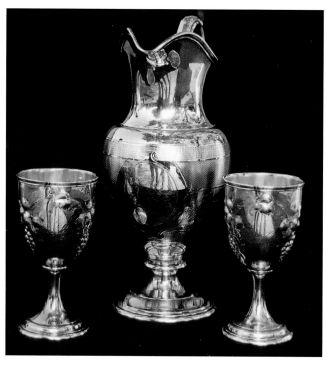

Silver presentation pitcher and goblets by Gorham Manufacturing Co., retailed by Samuel Jelly, Sacramento, goblets inscribed *Presented by / Mr. Callahan to / the Golden Eagle / Hotel Stake for / three year olds / May 1864. Private collection, photo courtesy of Witherell's.* **B**

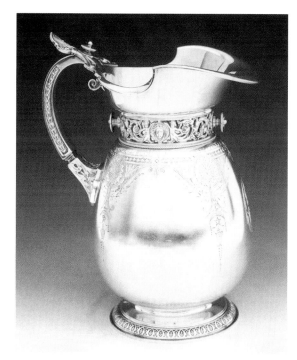

Silver pitcher by Koehler & Ritter, San Francisco, circa 1868-1884. *Private collection, photo courtesy of Argentum The Leopard's Head.* **B**

Silver pitcher by William Gale & Son, inscribed, *Milton S. Latham / Nov. 4, 1854,* then serving as California Congressman. *Private collection, photo courtesy of Witherell's.* **B**

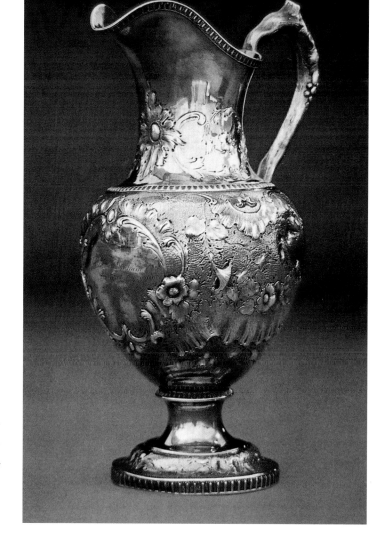

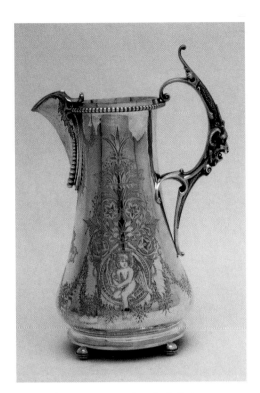

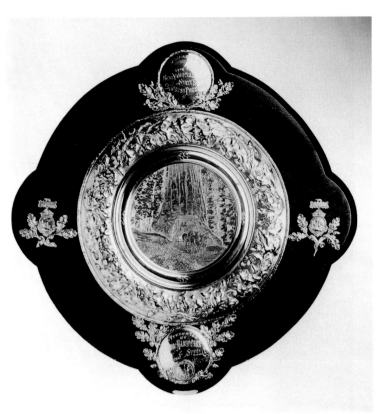

Silver pitcher presented to A. J. Ralston, made by W. K. Vanderslice & Co, San Francisco, circa 1870. *Private collection, photo courtesy of Argentum The Leopard's Head.* **B**

Silver and burl redwood California Industrial Exhibition plaque by Shreve & Co., San Francisco, inscribed, *AWARDED TO / FOR THE / BEST VARIETAL / STATE EXHIBIT / OF FOREST PRODUCTS / PRESENTED / BY / PACIFIC HARDWARE / & STEEL CO. / SAN FRANCISCO CALIFORNIA,* circa 1907. *Private collection, photo courtesy of Argentum The Leopard's Head.* **B**

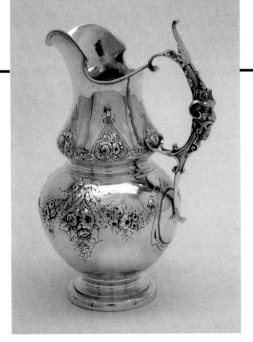

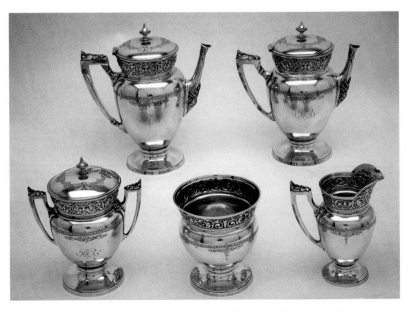

Silver pitcher by Frederich R. Reichel, San Francisco, circa 1861-1867. *Private collection, photo courtesy of Argentum The Leopard's Head.* **B**

Engraved five-piece silver tea and coffeesService by Schulz & Fischer, San Francisco, circa 1867-1890. *Private collection, photo courtesy of Argentum The Leopard's Head.* **C**

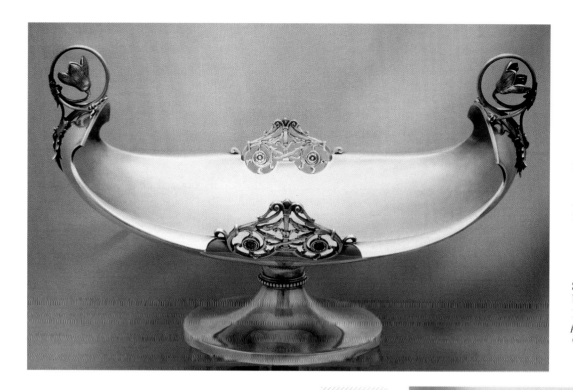

Silver compote by Koehler & Ritter, San Francisco, circa 1868-1884. *Private collection, photo courtesy of Argentum The Leopard's Head.* **B**

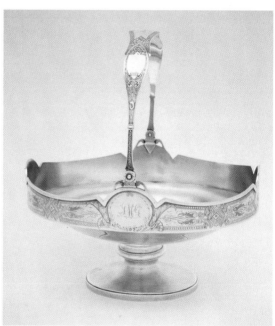

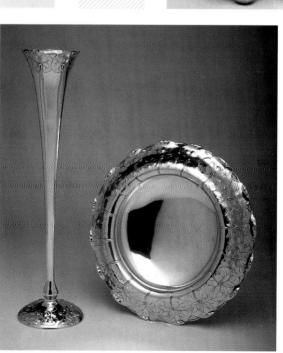

Silver basket by Schulz and Fischer, San Francisco, circa 1867-1890. *Private collection, photo courtesy of Argentum The Leopard's Head.* **B**

Silver and cut crystal decanter set by George C. Shreve & Co., San Francisco, circa 1883-1893. *Private collection, photo courtesy of Argentum The Leopard's Head.* **B**

Silver vase and bowl by George C. Shreve & Co., San Francisco, in the "Pondlilly Pattern" circa 1883-1893. *Private collection, photo courtesy of Argentum The Leopard's Head.* **B**

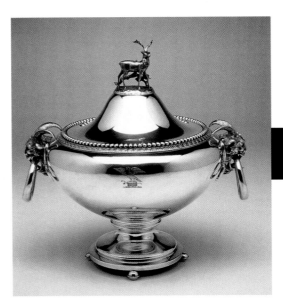

Silver soup tureen and cover by W.K. Vanderslice & Co., San Francisco, circa, 1858-1876. *Private collection, photo courtesy of Argentum The Leopard's Head.* **B**

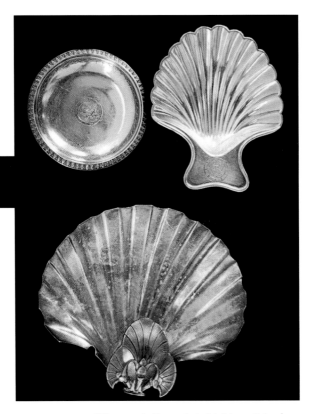

Silver and silver plated table articles by Tiffany and Co. and Gorham Manufacturing Co., circa 1869-1874, inscribed with monogram, *MSL*, for Milton Slocom Latham, former California Congressman, Senator, and Governor. *Private collection, photo courtesy of Witherell's.* each **A**

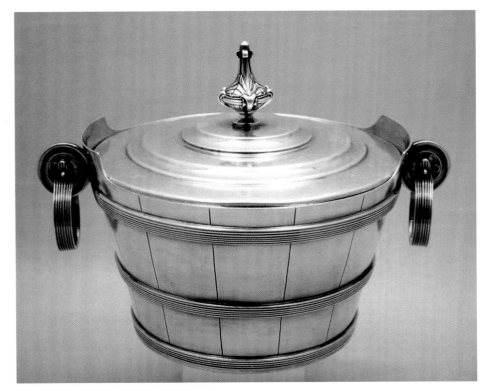

Silver bucket by Koehler & Ritter, San Francisco, circa 1867-1884. *Private collection, photo courtesy of Argentum The Leopard's Head.* **B**

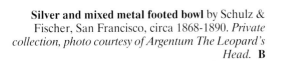

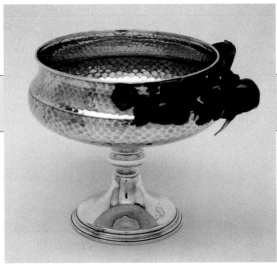

Silver and mixed metal footed bowl by Schulz & Fischer, San Francisco, circa 1868-1890. *Private collection, photo courtesy of Argentum The Leopard's Head.* **B**

Engraved tea caddy by W. K. Vanderslice &
Co., San Francisco, inscribed, *MAMIE*, circa
1858-1876 . *Private collection, photo courtesy of
Argentum The Leopard's Head.* **C**

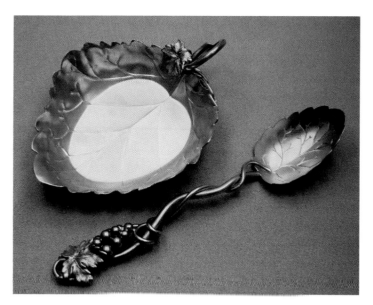

Silver and gold-washed tray and spoon by
Schulz & Fischer, San Francisco, circa 1867-
1890. *Private collection, photo courtesy of
Argentum The Leopard's Head.* **B**

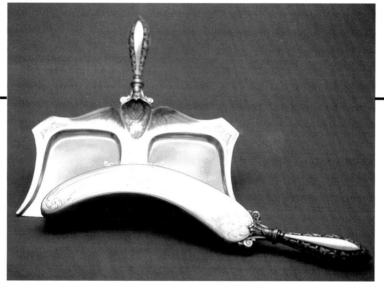

Silver crummer set by Schulz and
Fischer, San Francisco, circa 1867-
1890. *Private collection, photo
courtesy of Argentum The Leopard's
Head.* **B**

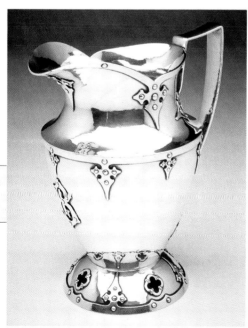

Silver pitcher by Shreve & Co., San Francisco,
circa 1900-1920. *Private collection, photo
courtesy of Argentum The Leopard's head.* **B**

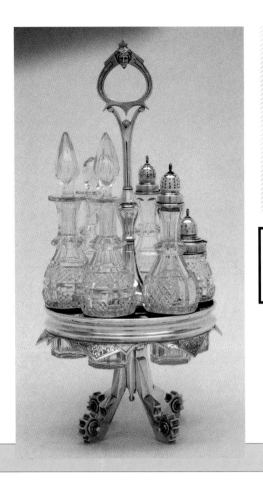

Silver and crystal cruet set by W. K. Vanderslice & Co., San Francisco, circa 1858-1876. *Private collection, photo courtesy of Argentum The Leopard's Head.* **B**

Silver centerpiece by W. K. Vanderslice & Co., San Francisco, circa 1860-1870. *California Historical Society, photo courtesy of Argentum The Leopard's Head.* **D**

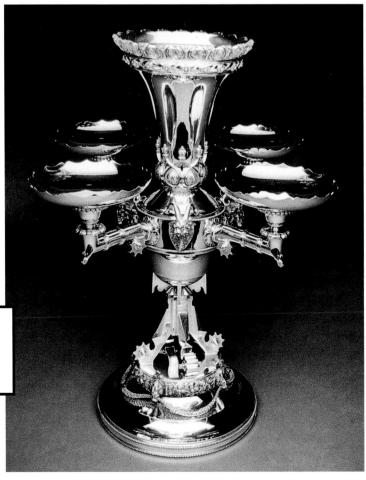

Chapter 4
GAMBLING

═══ Machines ═══

Native Americans were adept at different forms of gambling long before the discovery of gold in 1848. Surely the biggest gamble in their lives was waged by "forty-niners" who rushed to California to find gold, risking everything in the hope of great wealth. Gambling was so popular among the miners that a deck of cards was included as part of the miners' coat of arms. An account of one miner's escapades is noted in the letter of William B. Peters from San Francisco on January 1, 1850. "A sailor came back from the mines just a while ago with $6,000 prasters in gold. He ran to the gambling hall, threw his bag of gold on a Monte table, shouted 'Here's for Panama or back to the mines!' —thus gambling on one card the fruit of his labor. Fortunately, luck smiled on him. He returned to [N. York] with $12,000."

The demand for gambling equipment grew such that between 1863 and 1930 the firm of Will & Finck was manufacturing large selections of Faro equipment that included case keepers, dealing boxes, and layouts as well as Keno equipment, card trimmers, cheating devices, and corner rounders.

Because of an increasing demand for different types of gambling equipment, a coin-operated gambling machine was introduced at the end of the 19th century, being one of the few gambling devices inspired, invented and created in America. The earliest gambling machine originated on the east coast and later was manufactured in California. The "trade stimulator," or hard-luck-box, was common in cigar stores and saloons in California by the turn of the twentieth century. Winners were paid by proprietors in trade or money, hence the name "trade stimulator" developed. Charles Fey invented the three-reel, automatic pay-out machine (also known as a slot machine or one-armed bandit) and an entire gambling industry evolved soon thereafter.

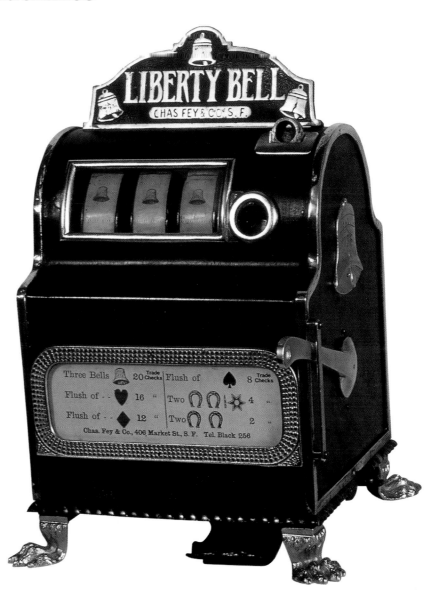

Sheet metal and brass slot machine LIB-ERTY BELL manufactured by Charles Fey & Co., San Francisco. The predecessor to more than a million slot machines to be manufactured over the next fifty years. Circa 1900s. *Courtesy Liberty Belle Saloon.* **D**

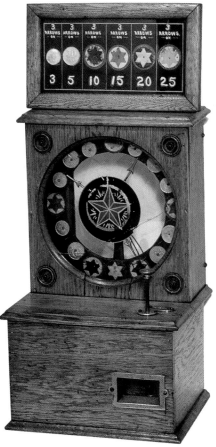

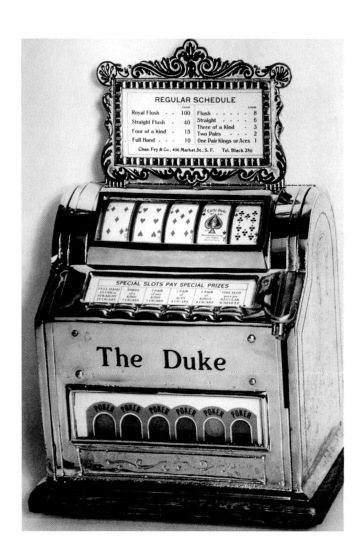

Left:
Wooden coin operated machine THREE SPINDLE manufactured by Charles Fey & Co., San Francisco, circa 1899-1910. *Courtesy Liberty Belle Saloon.* **D**

Right:
Cast iron trade stimulator THE DUKE manufactured by Charles Fey & Co., San Francisco, circa 1899-1910. *Courtesy Liberty Belle Saloon.* **D**

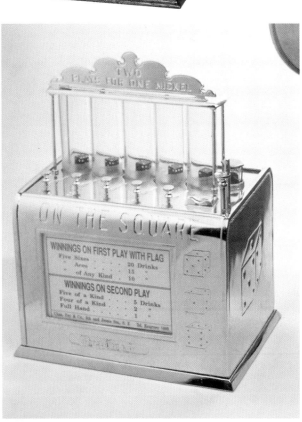

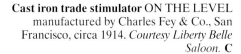

Cast iron trade stimulator ON THE SQUARE manufactured by Charles Fey & Co., San Francisco, circa 1906. *Courtesy Liberty Belle Saloon.* **C**

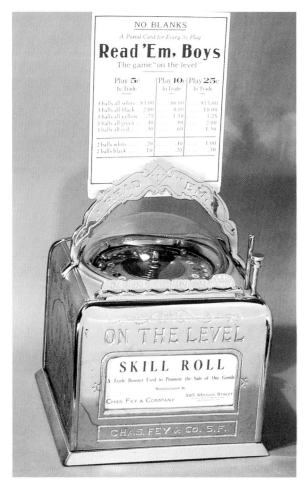

Cast iron trade stimulator ON THE LEVEL manufactured by Charles Fey & Co., San Francisco, circa 1914. *Courtesy Liberty Belle Saloon.* **C**

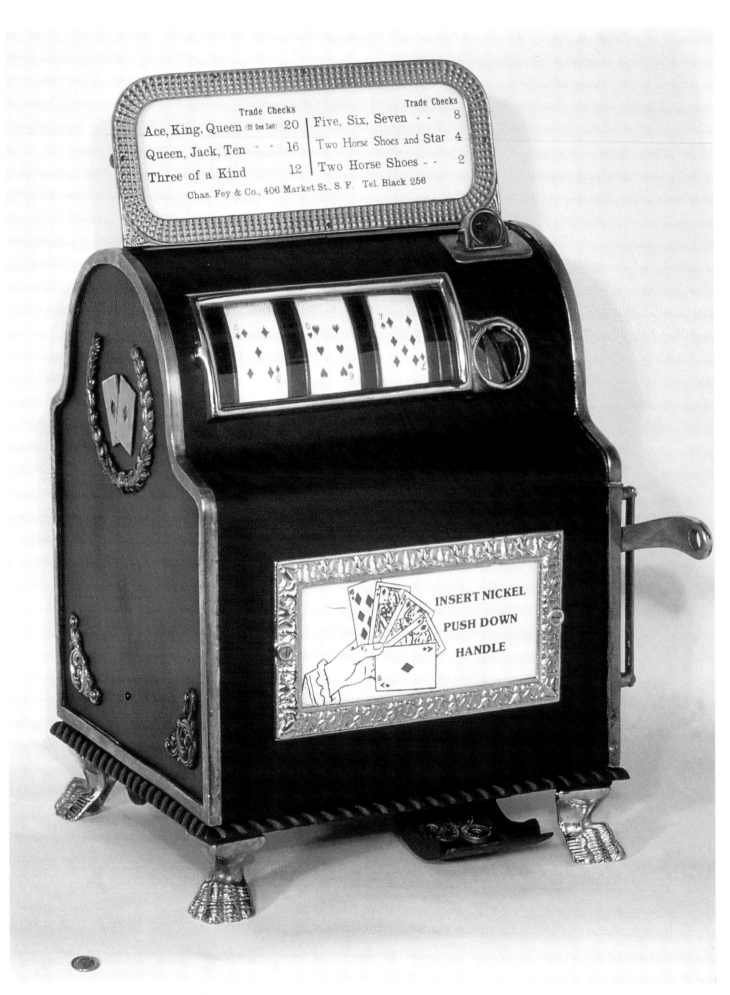

Sheet metal and brass slot machine CARD BELL manufactured by Charles Fey & Co., San Francisco, circa 1900s. *Courtesy Liberty Belle Saloon.* **D**

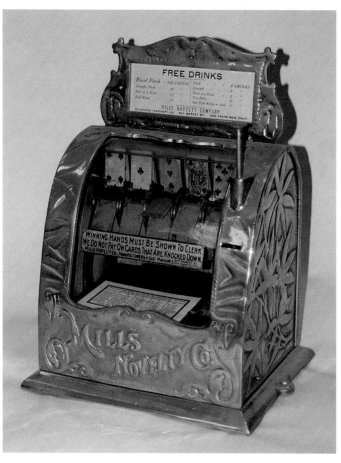

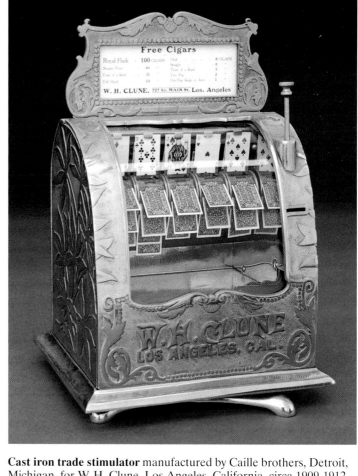

Cast iron trade stimulator manufactured by Caille brothers, Detroit, Michigan, for W. H. Clune, Los Angeles, California, circa 1909-1912. 16 by 11 in. *Private collection, photo courtesy of Witherell's.* **C**

Cast iron trade stimulator manufactured by Mills Novelty Co., San Francisco, circa 1907-1909. *Joe Welch, photo courtesy of Witherell's.* **B**

Cast iron trade stimulator ROYAL TRADER manufactured by Royal Novelty Co., San Francisco, circa 1897-1900. *Joe Welch, photo courtesy of Witherell's.* **C**

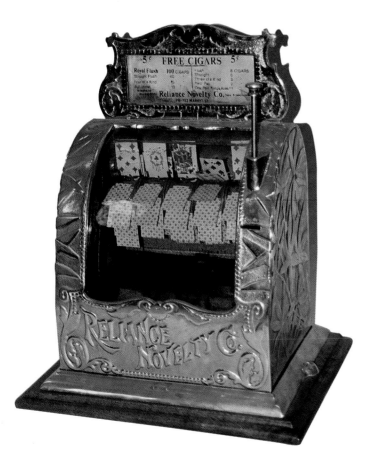

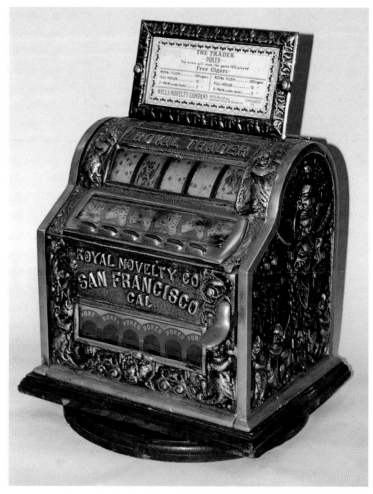

Cast iron trade stimulator manufactured by Reliance Novelty Co., San Francisco, circa 1897-1898. *Joe Welch, photo courtesy of Witherell's.* **C**

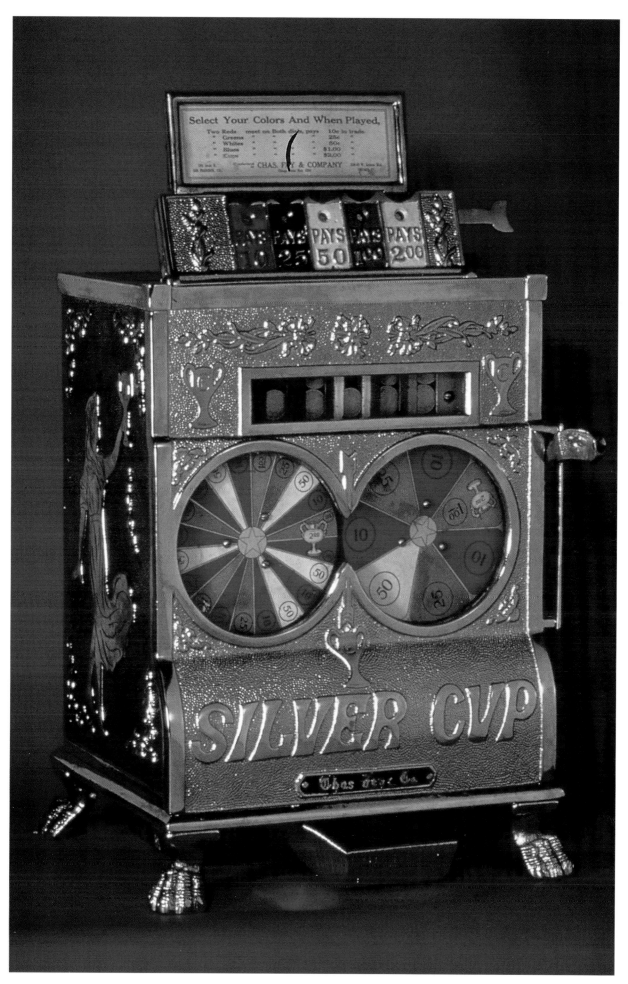

Cast iron slot machine SILVER CUP manufactured by Charles Fey
& Co., San Francisco, circa 1907. *Courtesy Liberty Belle Saloon.* **D**

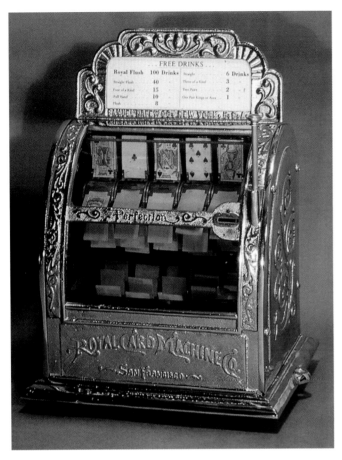

Cast iron trade stimulator PERFECTION manufactured by
Royal Card Machine Co., San Francisco, circa 1897-1898.
Courtesy Liberty Belle Saloon. C

Cast iron trade stimulator DRAW POCKER manufactured by
Charles Fey & Co., San Francisco, circa 1901. *Courtesy Liberty
Belle Saloon.* D

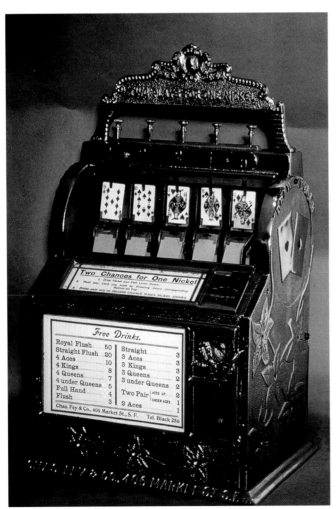

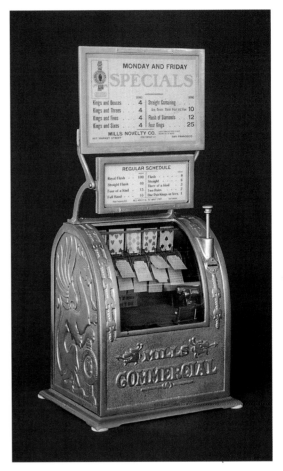

Nickel plated, cast iron trade stimulator THE
COMMERCIAL manufactured by Mills Novelty
Co., San Francisco. Circa 1907-1909. *Private
collection, photo courtesy of Witherell's.* B

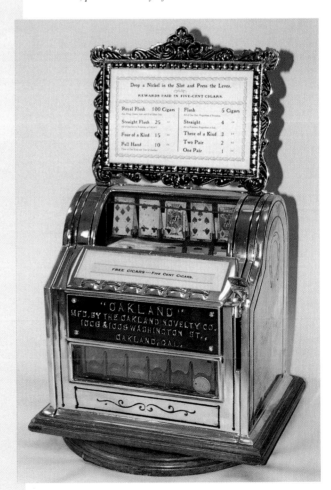

Cast iron trade stimulator OAKLAND manufactured by
Oakland Novelty Co., Oakland, Cal., circa 1902. *Joe
Welch, photo courtesy of Witherell's.* C

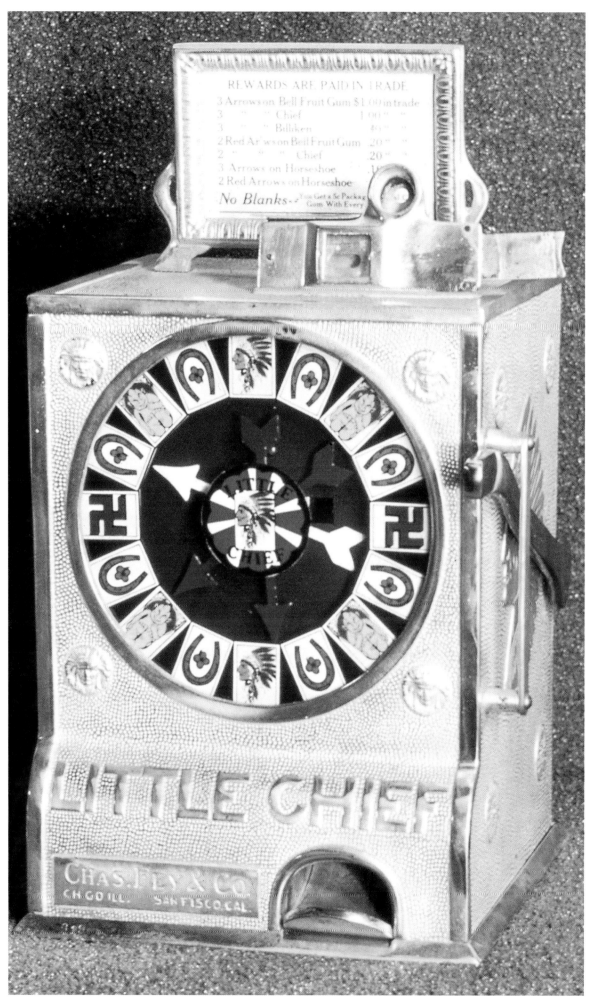

Cast iron slot machine LITTLE CHIEF manufactured by Charles Fey & Co., San Francisco, circa 1908. *Courtesy Liberty Belle Saloon.* **D**

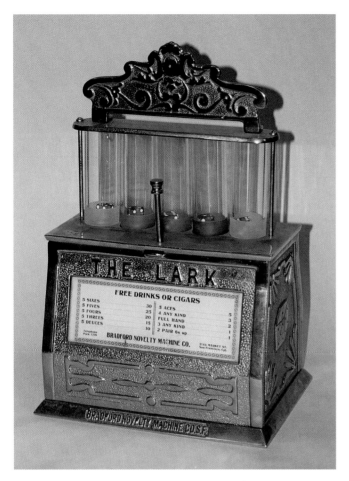

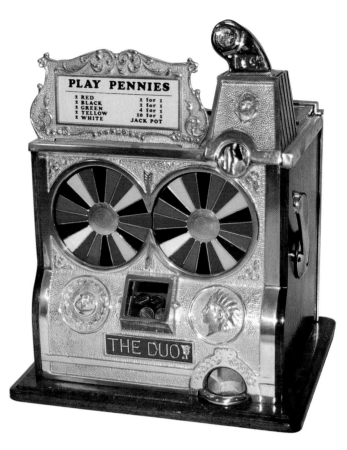

Cast iron trade stimulator THE LARK manufactured by
Bradford Novelty Machine Co., San Francisco, circa 1907-1916.
Joe Welch, photo courtesy of Witherell's. **C**

Aluminum and wood slot machine THE DUO manufactured by
Charles Fey & Co., San Francisco, circa 1927. *Joe Welch, photo
courtesy of Witherell's.* **C**

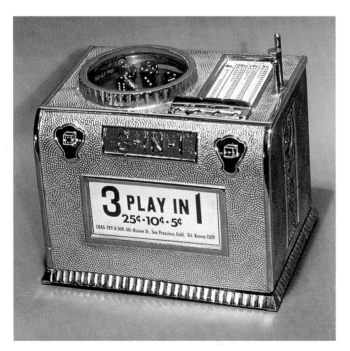

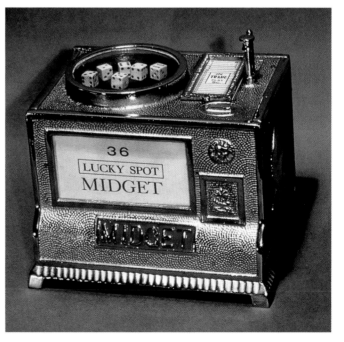

Aluminum trade stimulator 3-IN-1 manufactured by Charles Fey
& Co., San Francisco, circa 1924. *Courtesy Liberty Belle Saloon.* **B**

Aluminum trade stimulator MIDGET manufactured by Charles Fey
& Co., San Francisco, circa 1924. *Courtesy Liberty Belle Saloon.* **B**

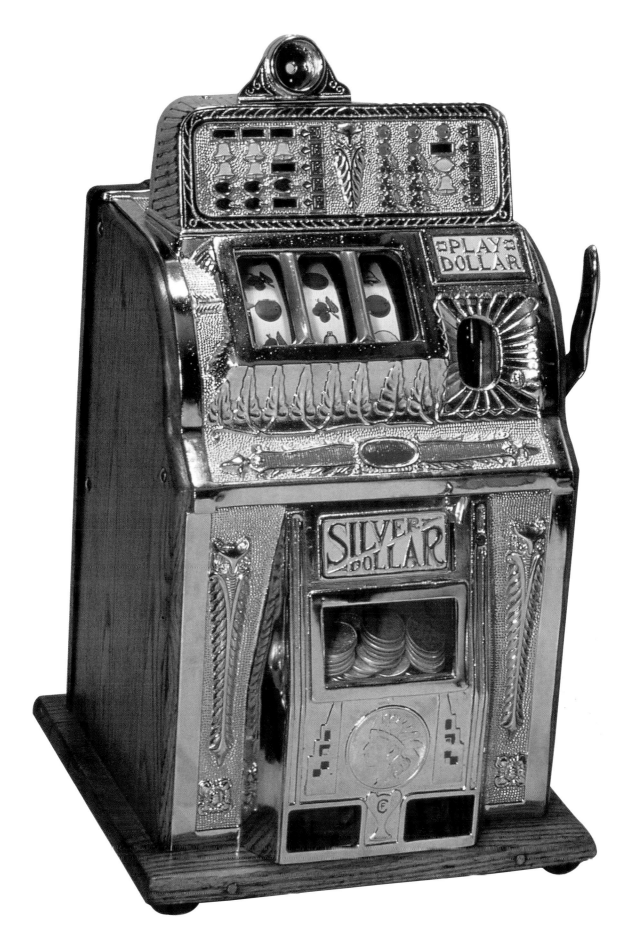

Aluminum and wood slot machine SILVER DOLLAR manufac-
tured by Charles Fey, & Co., San Francisco, circa 1929. The first
dollar-play machine. *Courtesy Liberty Belle Saloon.* **C**

Gaming Pieces

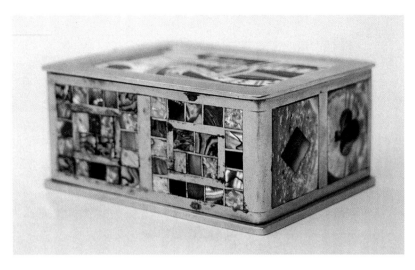

Silver plated, abalone inlay, Faro dealing box
with leather case. 4 in. Circa 1863-1930. *Al and
Carol Cali, photo courtesy of Witherell's.*

Brass and metal card holdout stamped *WILL
& FINCK / S. F. CAL.*, 6 in. Circa 1863-1930.
Al and Carol Cali, photo courtesy of Witherell's.
B

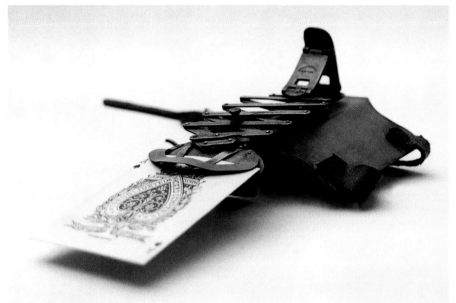

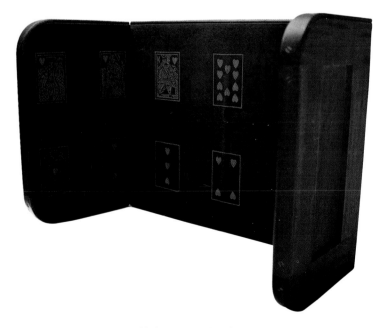

Folding Faro layout stenciled *WILL & FINCK
/ SAN FRANCISCO.*, Circa 1863-1930. *Al and
Carol Cali, photo courtesy of Witherell's.* **C**

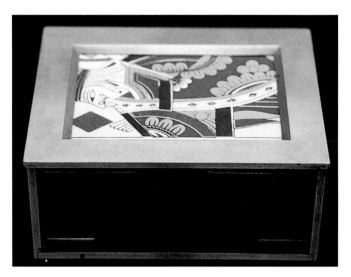

Nickel plated Faro dealing box stamped *WILL
& FINCK / S. F. CAL.*, 4 in. Circa 1863-1930. *P.
I. F. collection, photo courtesy of Witherell's.* **B**

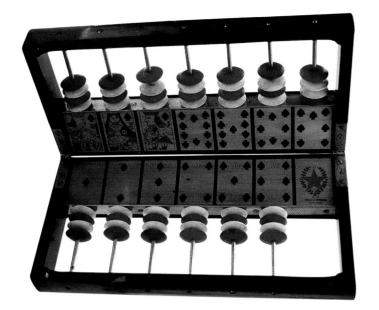

Left:
Rosewood Faro case keeper with boxwood carved faces and ivory counters, stamped *WILL & FINCK / S. F. CAL.*, 13 in. Circa 1863-1930. *Al and Carol Cali, photo courtesy of Witherell's.* **B**

Brass, metal, and wood card corner rounder stamped *WILL & FINCK / MAKERS / S. F. CAL.*, 5 in. Circa 1863-1930. *Al and Carol Cali, photo courtesy of Witherell's.* **B**

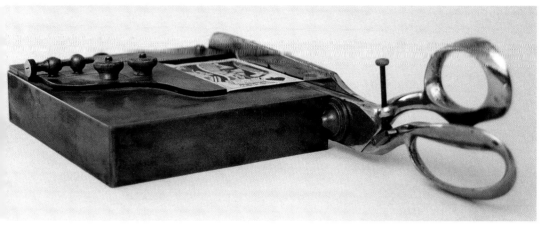

Brass and nickel "scissors style" card trimmer stamped *WILL & FINCK / S.F. CAL.* 10 1/2 in. Circa 1863-1930. *P. I. F. collection, photo courtesy of Witherell's.* **B**

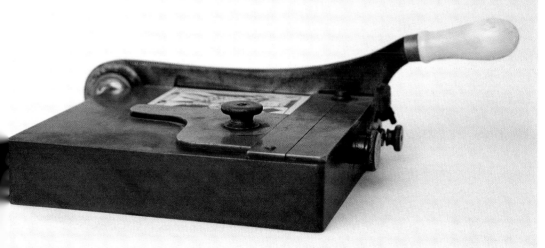

Brass, ivory, and steel card corner rounder stamped *WILL & FINCK / S. F. CAL.*, 7 in. Circa 1863-1930. *Al and Carol Cali, photo courtesy of Witherell's.* **B**

Brass, ivory, and steel card trimmer stamped *WILL & FINCK / S. F. CAL.*, 10 1/2 in. Circa 1863-1930. *P. I. F. collection, photo courtesy of Witherell's.* **B**

Right:
Wood, brass, ivory, and steel card trimmer stamped *WILL & FINCK / S. F. CAL.*, 10 1/2 in. Circa 1863-1930. *Al and Carol Cali, photo courtesy of Witherell's.* **B**

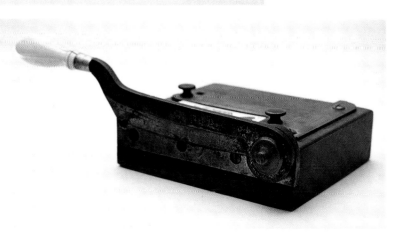

Chapter 5
WEAPONS

══ Sabers ══

The heroic and romantic life-style associated with the California frontier is reflected in the specialized firearms and edged weapons used during that time. Many such items came from the eastern states and Europe, but also small California businesses adapted to special local demand and produced items of excellent finish and elegant form. The high cost of labor and raw materials in California made the market competitive. From a truly unique California Bowie knife to glittering etched motifs on the imported models, to fine artistic design and craftsmanship of derringer guns, an awesome variety of weaponry was available. The selection was acknowledged and describe by forty-niner Hinton Rowan Helper. "I Have seen purer liquors, better segars, finer tobacco, truer guns and pistols, larger dirks and bowie knives and prettier courtesans than in any other place I have ever visited. California can and does furnish the best bad things that are available in America"

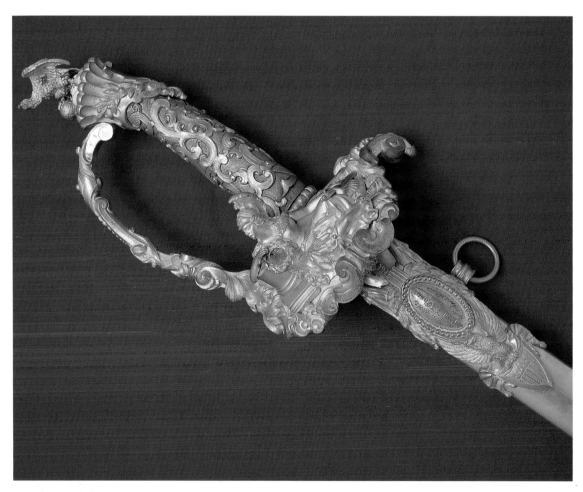

Presentation cavalry officer's saber by Schuyler, Hartley & Graham, New York, inscribed, *To Captain F. X. Ebner / by the Sacramento Hussars / April 26th 1872.* As reported in the April 27, 1872 edition of the *Sacramento Union,* "Last night Captain Frank Ebner was presented a splendid saber recently purchased in New York at a cost of about $150.00 and as handsome as any in the state..." *Private collection, photo courtesy of Witherell's.*

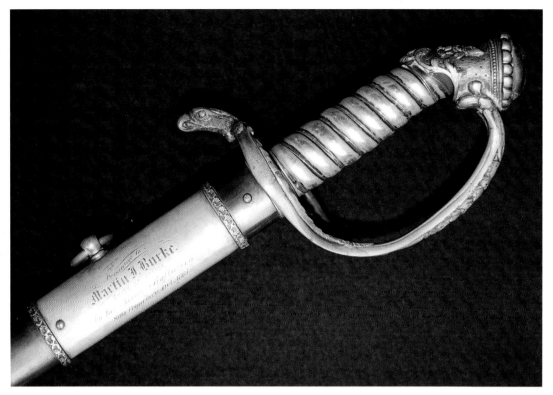

Presentation saber inscribed *Presented to / Martin J. Burke / CHIEF OF POLICE / by the police battalion / San Francisco Oct 1864.* As reported in the October 27, 1864 edition of *The San Francisco Bulletin,* " ... prior to leaving the Pavilion a splendid sword and sash were presented to Chief Burke by mayor Coen, on behalf of the policemen..." *Paul Schweizer, photo courtesy of Witherell's.* **D**

Firearms

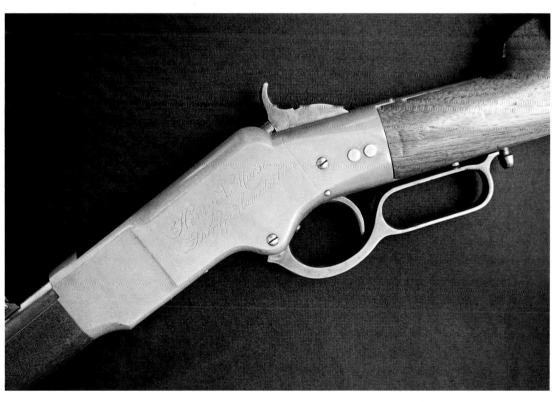

Winchester model 1866 saddle ring carbine with side plate inscribed *Henry N. Morse / Sheriff Alameda Co. John Boessenecker, photo courtesy of Witherell's.* **D**

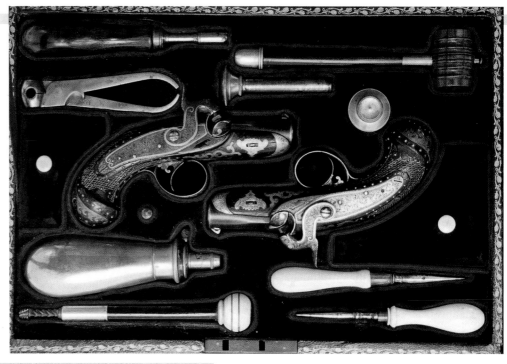

Factory cased pair of engraved and gold inlayed derringers, barrel stamped *SCHLOTTERBECK SAN FRANCISCO.* Walnut stocks with pierced silver inlays, studs, abalone ornamentation, and gold escutcheon inscribed. One, *Charles Mayne / A M me. / H. De Laurencel / Octobre 1860.* The other, *John B. Felton / A M me / H. De Laurencel / Octrbre 1860.* Gold inlayed and engraved with silver trigger guards in French style case with accessories including walrus handled cleaning rod with abalone inlay. *Hayes collection, photo courtesy of Witherell's.* **D**

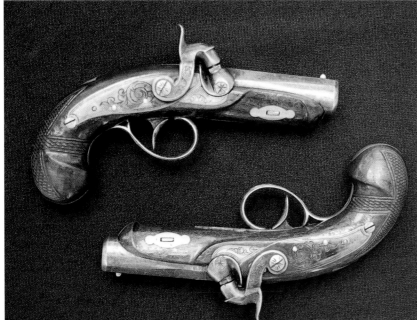

Pair of Philadelphia style derringers, escutcheons inscribed with the intertwined initials of Milton S. Latham, California congressman, senator, and governor. Circa 1860. *Private collection, photo courtesy of Witherell's.* **D**

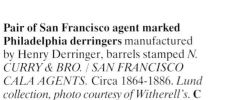

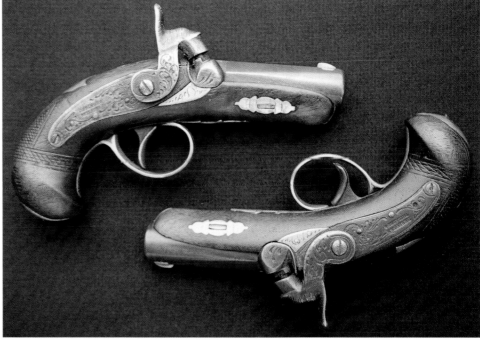

Pair of San Francisco agent marked Philadelphia derringers manufactured by Henry Derringer, barrels stamped *N. CURRY & BRO. / SAN FRANCISCO CALA AGENTS.* Circa 1864-1886. *Lund collection, photo courtesy of Witherell's.* **C**

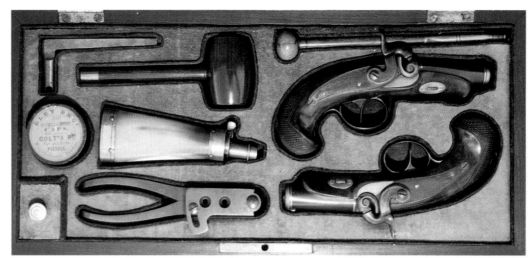

Factory cased pair of gold inlayed derringers, barrels stamped *A. G Genez, NY*, silver escutcheon's inscribed, *F. B. Berringer*. Fritz Berringer was a pioneer wine maker in the Napa Valley. 6 in. each. Circa 1860s. *P.I.F. collection. Photo courtesy Witherell's.* **D**

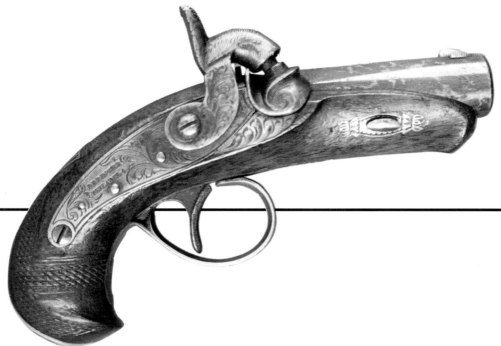

Agent market Philadelphia percussion derringer, barrel stamped *N. CURRY & BRO. / SAN FRANCISCO CALA / AGENTS*, 5 1/4 in. Circa 1863-1886. *Courtesy Al and Carol Cali, photo courtesy of Witherell's.*

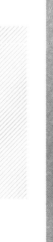

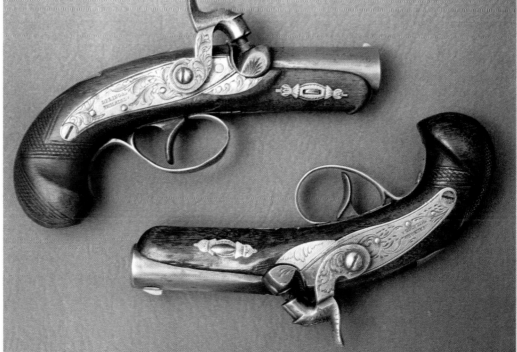

Two San Francisco agent marked, Philadelphia derringers. Top, barrel stamped *N. Curry & Bro.*, circa 1863-1868. Bottom, barrel stamped *C. Curry*, circa 1852-1863. *Hayes collection, photo courtesy of Witherell's.* each **B**

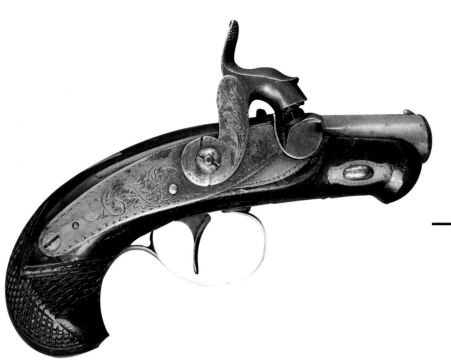

Percussion derringer stamped *E. KLEPZIG & CO.*, 5 in., San Francisco gunsmith working 1852-1878. *Courtesy Al and Carol Cali, photo courtesy of Witherell's.*

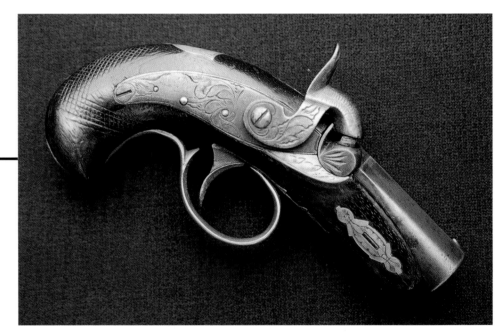

San Francisco agent marked Philadelphia derringer manufactured by Slotter & Co., barrel stamped *WILSON & EVANS / SAN FRANCISCO,* circa 1860-1863. *Lund collection, photo courtesy of Witherell's.* **B**

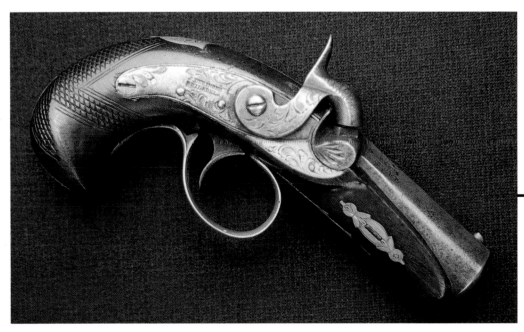

San Francisco agent marked Philadelphia derringer, barrel stamped *MADE FOR / A. J. PLATE / SAN FRANCISCO,* locked stamped *J. DERRINGER,* a mark used by Slotter & Co., circa 1863-1870. *Lund collection, photo courtesy of Witherell's.* **B**

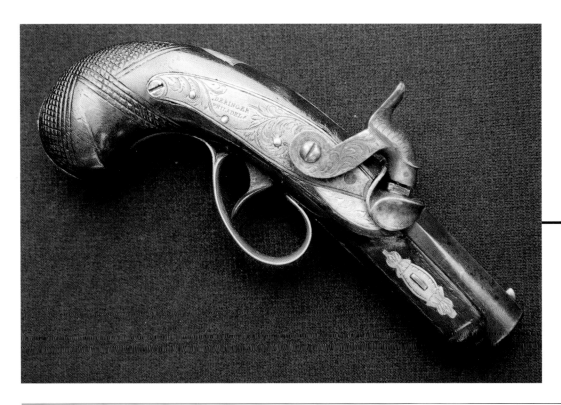

Agent marked Philadelphia percussion derringer, barrel stamped *C. CURRY / SAN FRANCO CALA / AGENT*, 5 1/4 in. Circa 1852-1863. *Lund collection, photo courtesy of Witherell's.* **B**

Factory cased and engraved Colt model 1851 navy percussion revolver with ivory grips, backstrap inscribed *Major JAs / F. Curtis / 2nd Infantry C. V. from his San Francisco friends October 11, 1861* (C.V. refers to California Volunteers) serial no. 96478. *Hayes collection, photo courtesy of Witherell's.* **D**

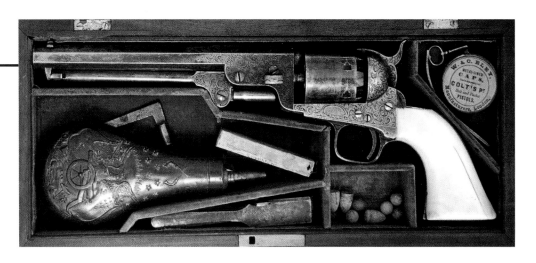

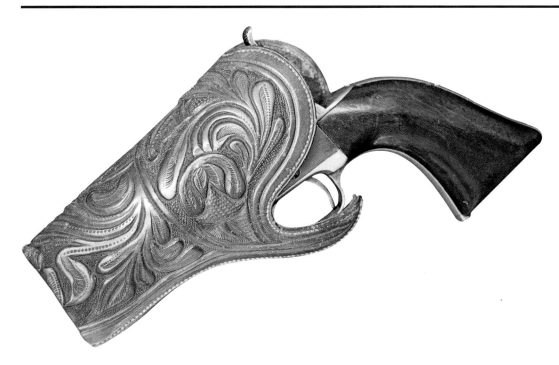

Sawed-Off 1851 Colt navy with "California style" holster stamped *MAIN & WINCHESTER / MAKER / SAN FRANCISCO,* serial no. 4992, circa 1851. *Bob Butterfield, photo courtesy of Witherell's.* **B**

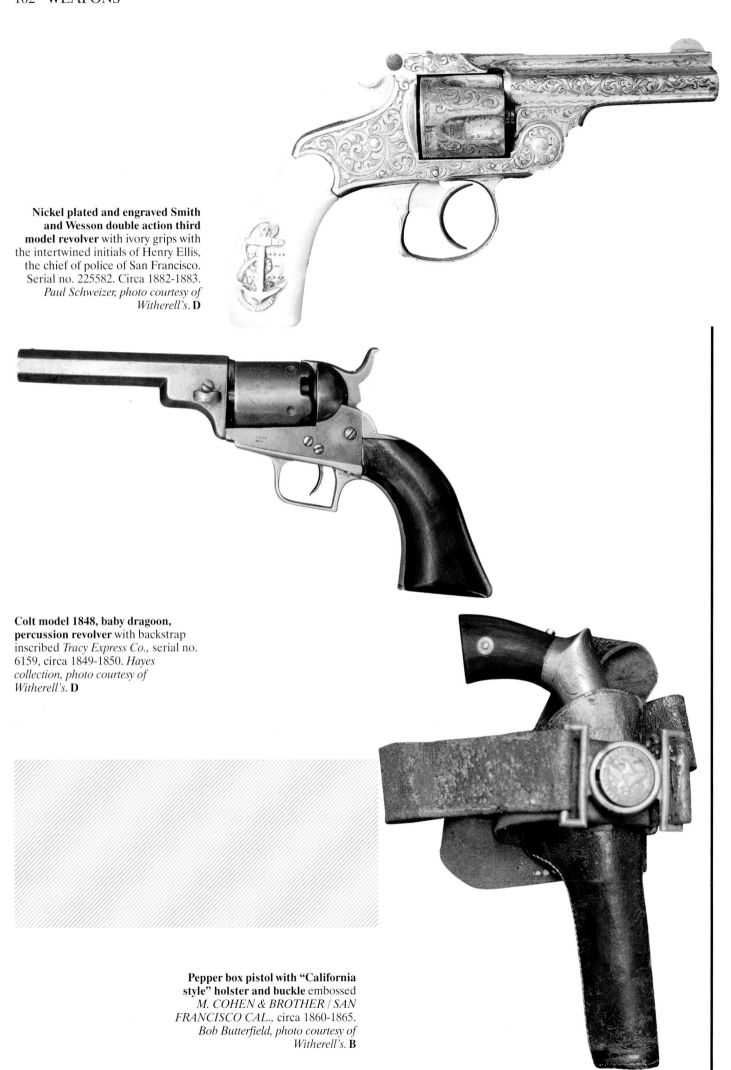

Nickel plated and engraved Smith and Wesson double action third model revolver with ivory grips with the intertwined initials of Henry Ellis, the chief of police of San Francisco. Serial no. 225582. Circa 1882-1883. *Paul Schweizer, photo courtesy of Witherell's.* **D**

Colt model 1848, baby dragoon, percussion revolver with backstrap inscribed *Tracy Express Co.,* serial no. 6159, circa 1849-1850. *Hayes collection, photo courtesy of Witherell's.* **D**

Pepper box pistol with "California style" holster and buckle embossed *M. COHEN & BROTHER / SAN FRANCISCO CAL.,* circa 1860-1865. *Bob Butterfield, photo courtesy of Witherell's.* **B**

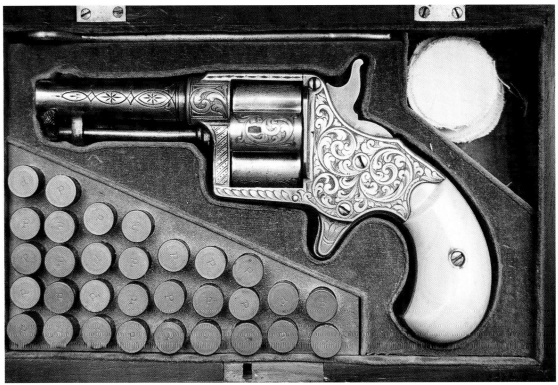

Cased and engraved Colt house model revolver with ivory grips, reportedly owned by Pike Bell of Auburn, California, serial no. 725. Circa 1871-1876. *Paul Schweizer, photo courtesy of Witherell's.* **D**

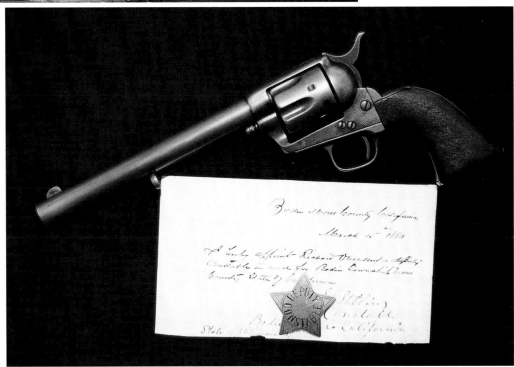

Colt single action revolver with law badge. Backstrap inscribed *R. O' Malle*, an 1880s lawman from Bodie, California. Serial no. 61963. *P.I.F. collection, photo courtesy of Witherell's.* **D**

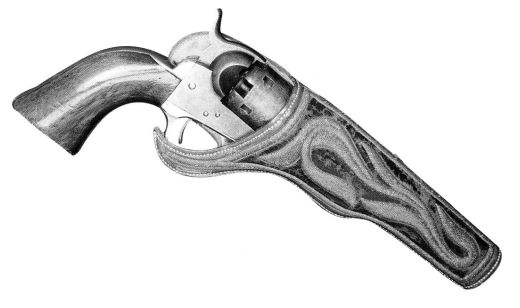

Colt model 1849 pocket percussion revolver with backstrap inscribed *Geo. G. Evans / California 1853*, "California style" holster stamped *Main & Winchester*, serial no. 50968. *Bob Butterfield, photo courtesy of Witherell's.* **B**

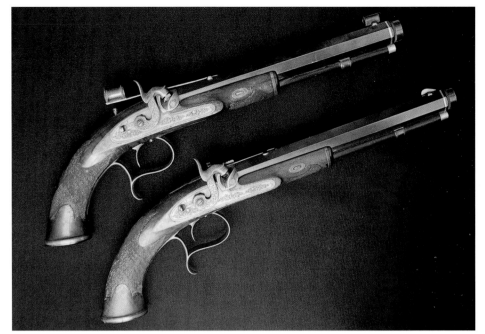

Cased pair of target pistols stamped *C. SLOTTERBEK LAKEORT CAL.* Checkered walnut stocks, engraved hardware, and gold-banded barrels, circa 1860s. *Hayes collection, photo courtesy of Witherell's.* **D**

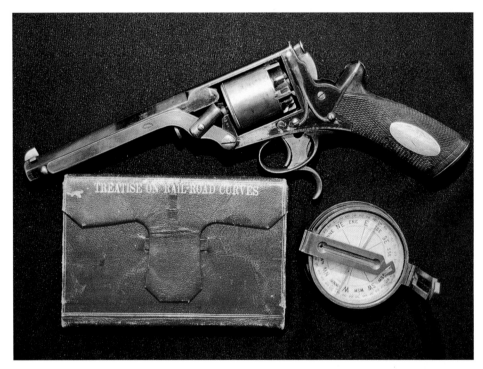

Tranter percussion revolver with silver escutcheon inscribed *John F. Rider / 1863 / E. Boundary Survey / of / California.* Right, *Hark from the tombs*, serial no. 13604, 12 in. *P. I. F. collection, photo courtesy of Witherell's.* **D**

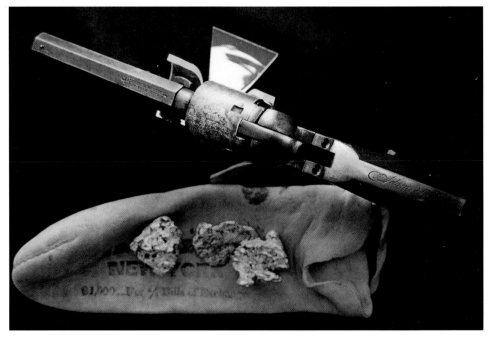

Colt model 1849 pocket percussion revolver with backstrap inscribed *Adam's & Co., No. 47,* serial no. 29707, 9 in. Circa 1852. *P. I. F. collection, photo courtesy of Witherell's.* **D**

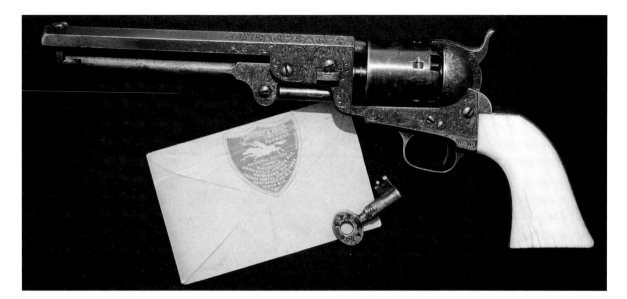

Factory engraved and ivory gripped, Colt model 1851 navy with backstrap inscribe *J. E. Ager / Langtons Express.* Serial no. 48106, 13 in. Circa 1856. *P. I. F. collection, photo courtesy of Witherell's.* **D**

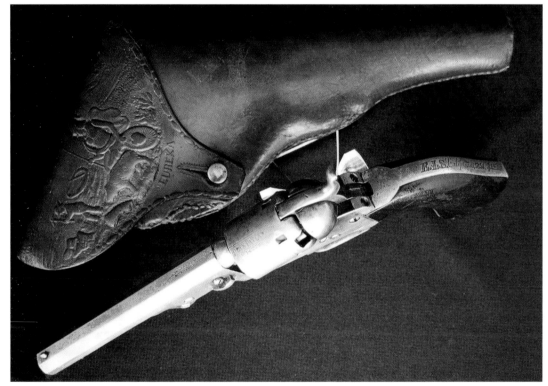

Colt model 1849 pocket percussion revolver with backstrap inscribed *E. L. S. / California, 1851 $12.00,* serial no. 14228, 10 in. Circa 1850. *P.I.F. collection, photo courtesy of Witherell's.* **D**

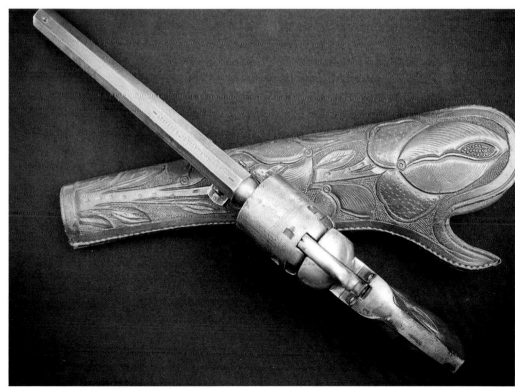

Colt model 1851 navy percussion revolver with backstrap inscribed *Adams Co., Sacramento,* serial no. 18823, circa 1852. *Hayes collection, photo courtesy of Witherell's.* **D**

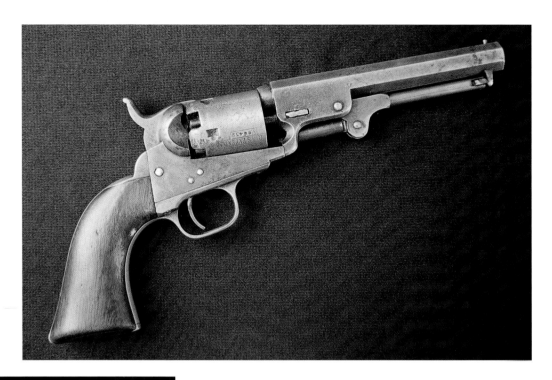

Colt model 1849 pocket percussion revolver with backstrap inscribed *H. N. MORSE / New York-Cala to see the elephant.* Serial no. 96432. Circa 1854. *John Boessenecker, photo courtesy of Witherell's.* **D**

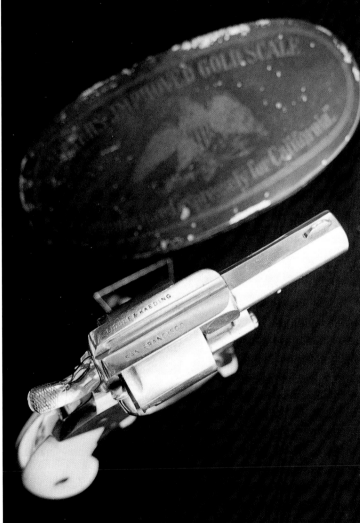

San Francisco Agent Marked Webley Revolver, barrel stamped, *Liddle & Keading / San Francisco.* Circa 1866-1891. *P. I. F. collection, photo courtesy of Witherell's.* **A**

San Francisco agent marked Webly revolvers with barrels stamped *LIDDLE & KEADING / SAN FRANCISCO. Hayes collection, photo courtesy of Witherell's.* each **A**

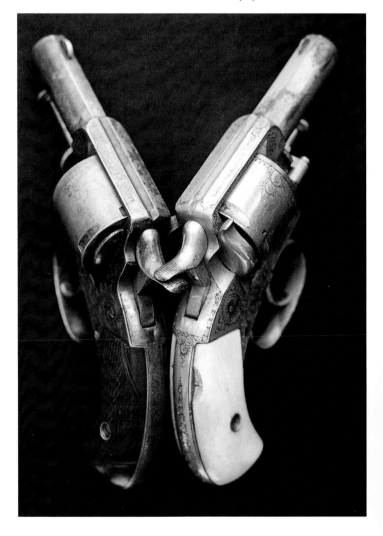

Bowie Knives

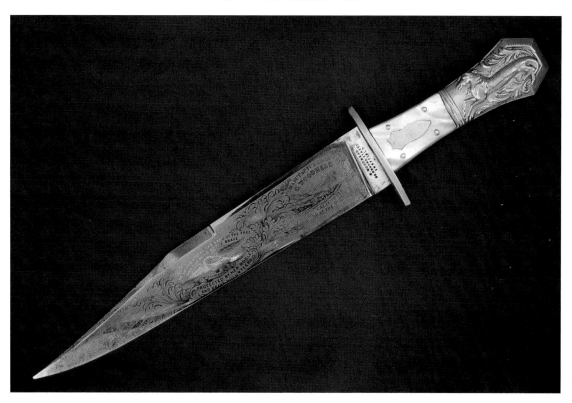

Mother-of-pearl and silver mounted Bowie knife with ricasso stamped *G. WOODHEAD / 36 HOWARD / SHEFFIELD.* Blade etched with three panel scenes comprising 1) American Eagle with *E PLURIBUS UNUM* ribbon and motto *THE UNITED STATES, THE LAND OF THE FREE / AND THE HOME OF THE BRAVE / PROTECTED BY OUR NOBLE / AND BRAVE VOLUNTEERS;* 2) mounted Indian warriors pursuing buffalo with the motto *CELEBRATED / AMERICAN BOWIE KNIFE;* and 3) San Francisco harbor inscribed *MANUFACTURED BY / G. WOODHEAD / CALIFORNIA / GOLD AT THE DIGGINGS.* 13 1/8 in. Circa 1850. *Private collection, photo courtesy of Witherell's.* **D**

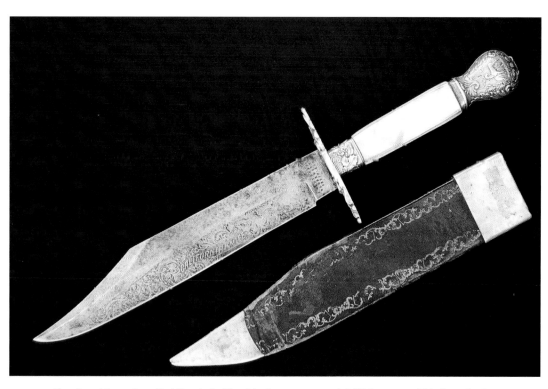

Pearl and ivory handled Bowie knife with ricasso stamped *J. Walterson* and blade etched *California.* 16 1/4 in. Circa 1850s. *P.I.F. collection, photo courtesy of Witherell's.* **D**

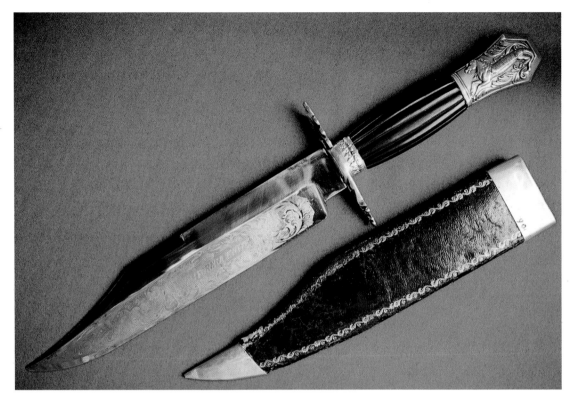

Ebony handled Bowie knife with blade etched *CALI-FORNIA KNIF.,* 16 in. *Roger Baker, photo courtesy of Witherell's.* **D**

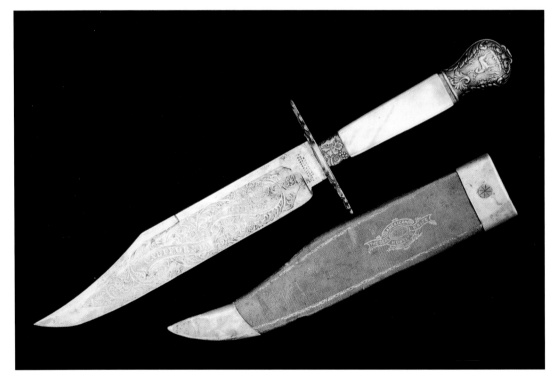

Four-piece, pearl handled Bowie knife with ricasso stamped *J. WALTERS & CO.* and blade etched *CALIFOR-NIA KNIFE.* 16 in. Circa 1850s. *Private collection, photo courtesy of Witherell's.* **C**

Two-piece, checkered ebony handled, Bowie knife with ricasso stamped *WRAGG* and blade etched *CALIFORNIAN KNIFE.* 13 1/2 in. Circa 1850s. *P.I.F. collection, photo courtesy of Witherell's.* **D**

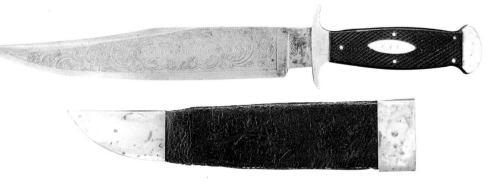

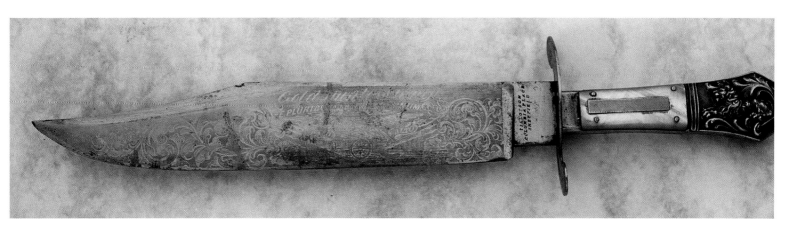

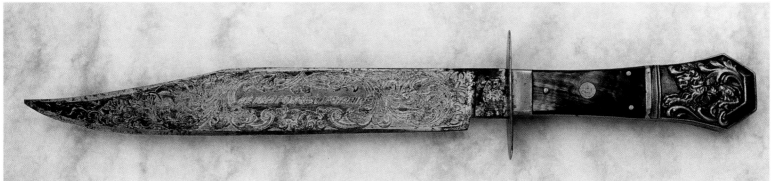

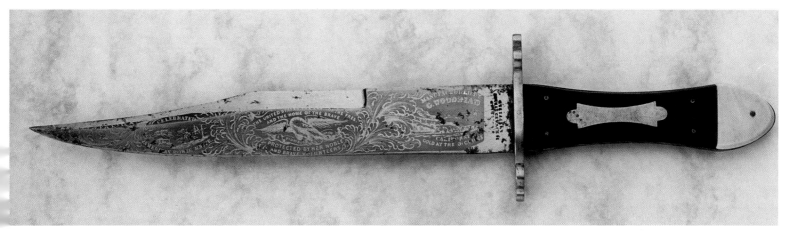

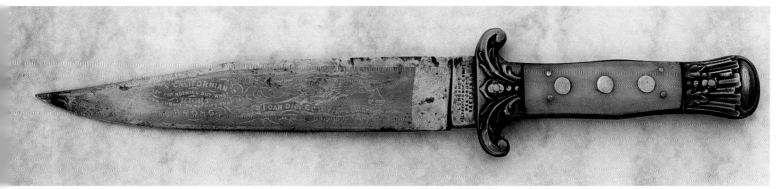

Top:
Two-Piece Pearl Handle Bowie Knife, ricasso stamped, *TILLOTSON,* blade etched, *Gold Hunters Knife / E. PLURIBUS UNUM / PALO ALTO,* 14 1/4 in. Circa 1850s. *Courtesy Al and Carol Cali.* **D**

Center:
Two-piece, horn handled Bowie knife with ricasso stamped *RAGG & SONS* and blade etched *HEIGH FOR CALIFORNIA.* 13 1/4 in. Circa 1850s. *Courtesy Al and Carol Cali.* **D**

Center:
Two-piece, ebony and ivory handled Bowie knife with ricasso stamped *C. WOODHEAD.* Blade etched with three panel scenes, comprising 1)

American Eagle with *E PLURIBUS UNUM* ribbon and motto *THE UNITED STATES, THE LAND OF THE FREE / AND THE HOME OF THE BRAVE / PROTECTED BY OUR NOBLE / AND BRAVE VOLUNTEERS;* 2) mounted Indian warriors pursuing buffalo with the motto *CELEBRATED / AMERICAN BOWIE KNIFE* and 3) San Francisco harbor inscribed *MANUFACTURED BY / G. WOODHEAD / CALIFORNIA / GOLD AT THE DIGGINGS.* 14 in. Circa 1850. *Courtesy Al and Carol Cali.* **D**

Bottom:
Two-piece, ivory handled Bowie knife with ricasso stamped *LINGARD'S* and blade etched *CALIFORNIA / ... / I CAN DIG GOLD FROM QUARTZ.* 11 1/2 in. Circa 1850s. *Courtesy Al and Carol Cali.* **D**

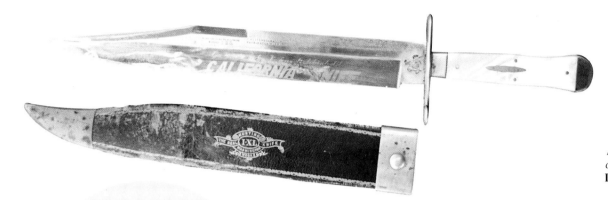

Two-piece, pearl handled Bowie knife, blade stamped *I X L* and etched *California*. 16 1/4 in. Circa 1850s. *P.I.F. collection, photo courtesy of Witherell's.* **D**

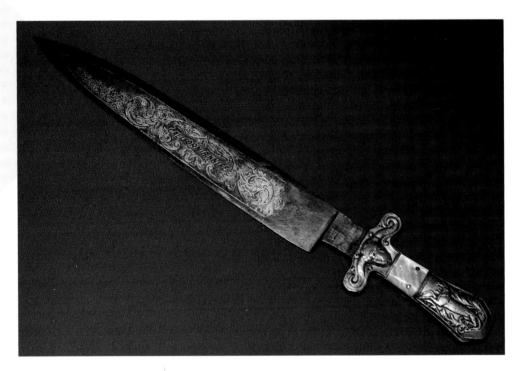

Two-piece, pearl handled Bowie knife with ricasso stamped *G. CROOKES / SHEFFIELD* and blade etched *CALIFORNIA KNIFE*. 15 in. Circa 1850s. *Courtesy James A. Klein* **D**

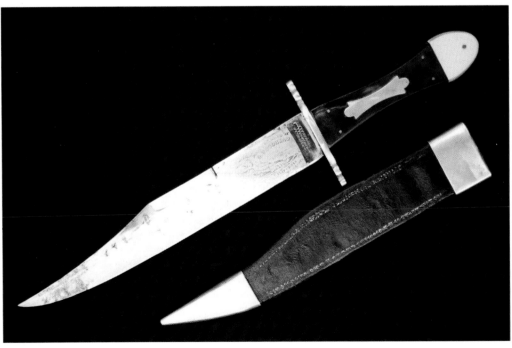

Four-piece, ebony and ivory handled Bowie knife with ricasso stamped *C. WOODHEAD.* Blade etched with three panel scenes comprising 1) American Eagle with *E PLURIBUS UNUM* ribbon and motto *THE UNITED STATES, THE LAND OF THE FREE / AND THE HOME OF THE BRAVE / PROTECTED BY OUR NOBLE / AND BRAVE VOLUNTEERS*; 2) mounted Indian Warriors pursuing buffalo with motto *CELEBRATED / AMERICAN BOWIE KNIFE* and 3) San Francisco harbor inscribed *MANUFACTURED BY / G. WOODHEAD / CALIFORNIA / GOLD AT THE DIGGINGS.* 13 1/2 in. Circa 1850. *Private collection, photo courtesy of Witherell's.* **D**

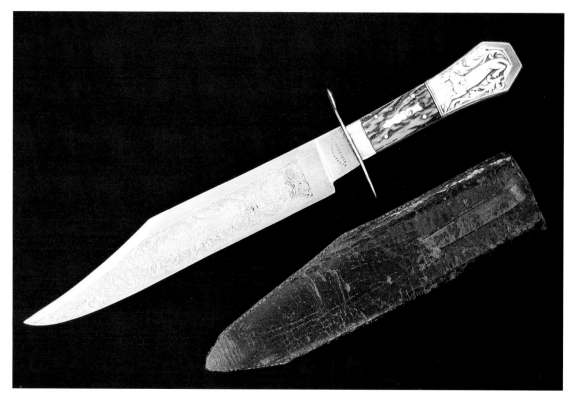

Half alligator-half horse, stag handled Bowie knife with ricasso stamped *CORIAN DENTON* and blade etched *GOLD SEEKERS PROTECTOR.* 14 1/4 in. Circa 1850s. *P.I.F. collection, photo courtesy of Witherell's.* **D**

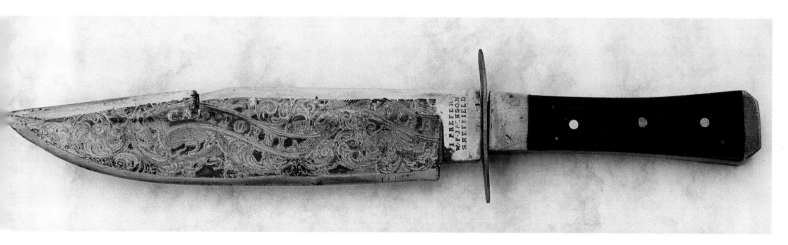

Two-piece, ebony handled Bowie knife with ricasso stamped *I. PREFER* and blade etched *CALIFORNIA.* 11 in. Circa 1850s. *Courtesy Al and Carol Cali.* **D**

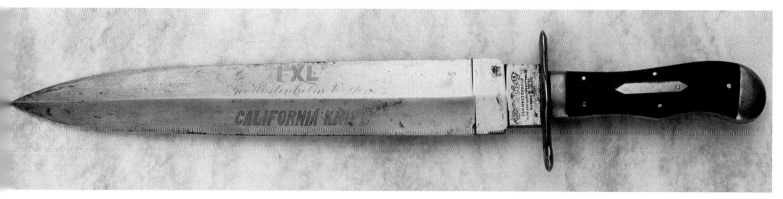

Two-piece, ebony handled Bowie knife with blade etched *I X L / CALIFORNIA KNIFE.* 17 1/4 in. Circa 1850s. *Courtesy Al and Carol Cali.* **B**

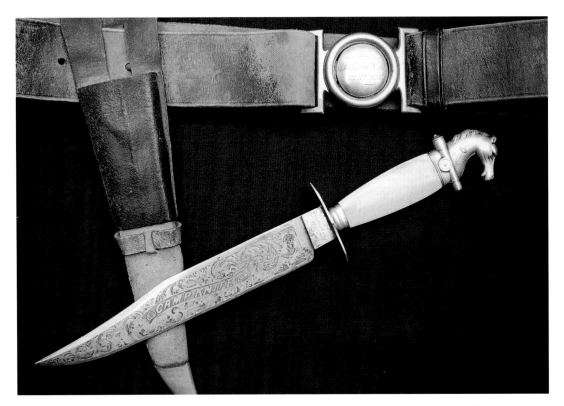

Ivory handled Bowie knife and belt, buckle inscribed *John M. O'Neill / MONTEREY.* Circa 1850-1890. *Paul Schweizer, photo courtesy of Witherell's.* **D**

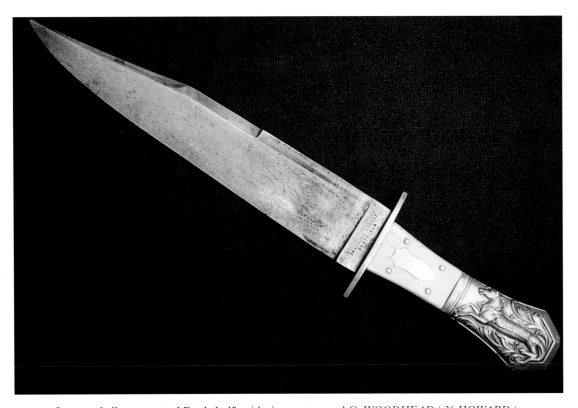

Ivory and silver mounted Bowie knife with ricasso stamped *G. WOODHEAD / 36 HOWARD / SHEFIELD* and blade etched with three panel scenes, comprising 1) American Eagle with *E. PLURIBUS UNUM* ribbon and motto *THE UNITED STATES, THE LAND OF THE FREE / AND HOME OF THE BRAVE / PROTECTED BY OUR NOBLE / AND BRAVE VOLUN-TEERS;* 2) mounted Indian warriors pursuing buffalo with motto *CELEBRATED / AMERI-CAN BOWIE KNIFE* and 3) San Francisco harbor inscribed *MANUFACTURED BY / G. WOODHEAD / CALIFORNIA / GOLD AT THE DIGGINGS.* 13 1/8 in. Circa 1850. *Hayes collection, photo courtesy of Witherell's.* **D**

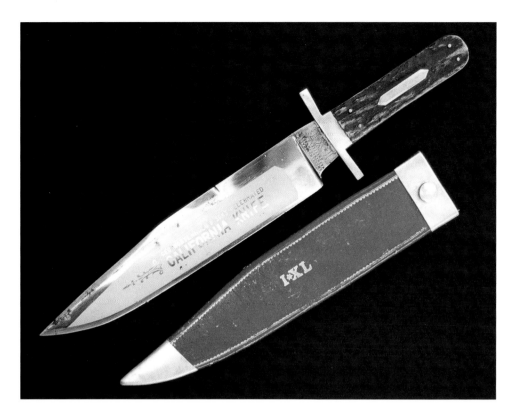

Two-piece, ivory handled Bowie knife with ricasso stamped *I X L*, and blade etched *GEO WOSTENHOLM & SON'S CELEBRATED / CALIFORNIA KNIFE.* 13 1/2 in. Circa 1850s. *P.I.F. collection, photo courtesy of Witherell's.* **D**

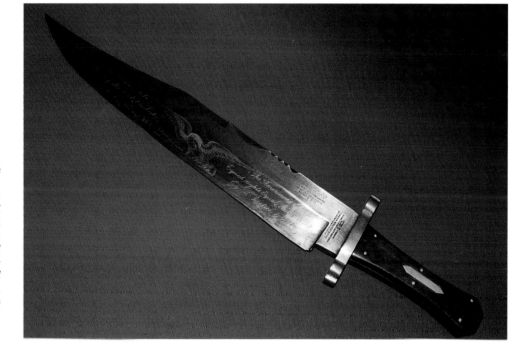

Two-piece, horn handled Bowie knife with ricasso stamped *G. WOSTENHOLM & SON / WASHINGTON WORKS / NONE ARE GENUINE BUT THOSE / MARKED IXL* and blade etched *Geo Wostenholm & Son Sole / Manufacturers of the Celebrated / IXL Cutlery / California Knife / The Americans Pride / Equal rights Equal Laws and / Equal Justice to all.* 16 in. Circa 1850s. *Courtesy James A Klein.* **D**

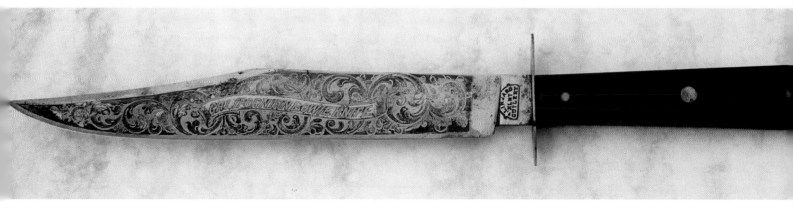

Two-piece, ebony handled Bowie knife with ricasso stamped *I. LINGARD* and blade etched *CALIFORNIA BOWIE KNIFE.* 18 1/4 in. Circa 1850s. *Courtesy Al and Carol Cali.* **D**

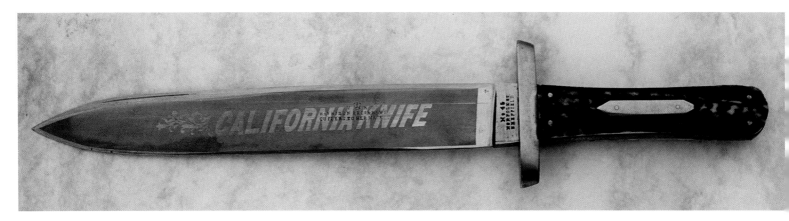

Two-piece, stag horn handled Bowie knife with blade stamped *HARRISON BROs & HOW'S* and blade etched *CALIFORNIA KNIF*. 12 1/4 in. Circa 1850s. *Courtesy Al and Carol Cali.* **D**

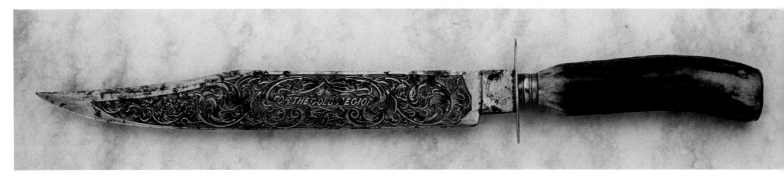

Stag horn handled Bowie knife with ricasso stamped *NICHOLSON* and blade etched *FOR THE GOLD PEGION*. 15 1/4 in. Circa 1850s. *Courtesy Al and Carol Cali.* **D**

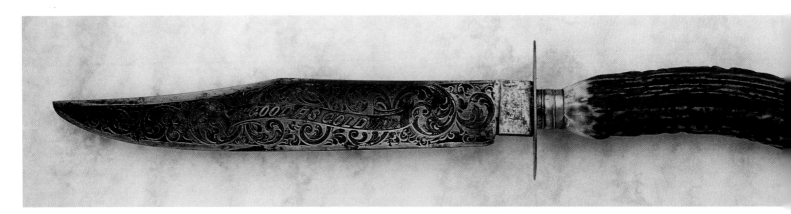

Stag horn handled Bowie knife with ricasso stamped *NICHOLS* and blade etched *GOOD AS GOLD*. 12 1/2 in. Circa 1850s. *Courtesy Al and Carol Cali.* **D**

Two-piece stag horn handled Bowie knife with ricasso stamped *CORSAN / BENTON / BORDENKIN & CO* and blade etched *CALIFORNIA BOWIE KNIFE*. 13 in. Circa 1850s. *P.IF. collection, photo courtesy of Witherell's.* **D**

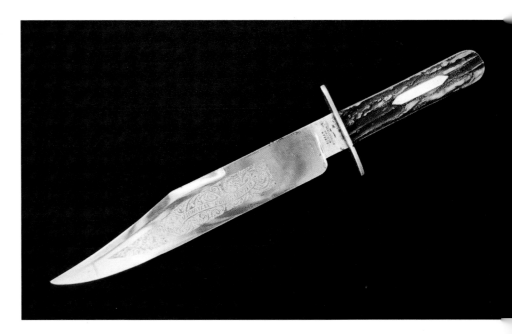

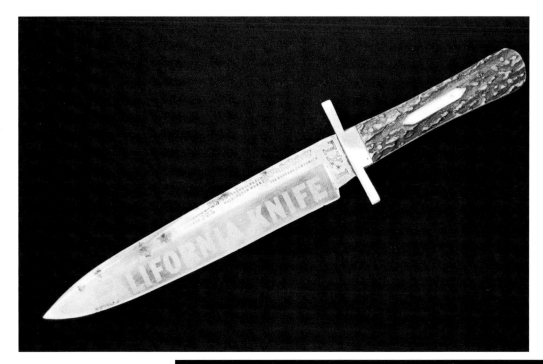

Two-piece, stag horn handled Bowie knife with ricasso stamped *I X L* and blade etched *CALIFORNIA KNIFE*. 12 1/2 in. Circa1850s. *P. I. F. collection, photo courtesy of Witherell's.* **D**

Cutlery handled Bowie knife with California etched blade. Gold poke (cloth bag) inscribed *Sullivan Cashman / San Francisco* that bears remnants of Wells Fargo wax seals from Yreka and Mariposa, California. *Bob Butterfield, photo courtesy of Witherell's.* **B**

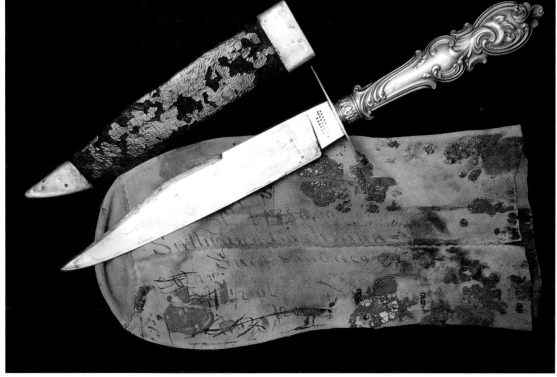

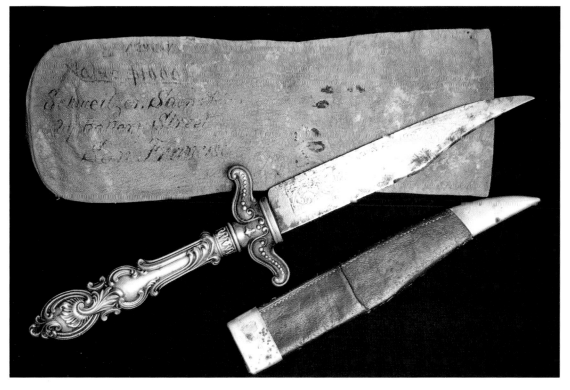

Cutlery handled Bowie knife with California etched blade. Gold poke (canvas bag) inscribed *paid / value $1,000.00 / Schueilizer, Sachs / 24 Battery Street / San Francisco. Bob Butterfield, photo courtesy of Witherell's.* **B**

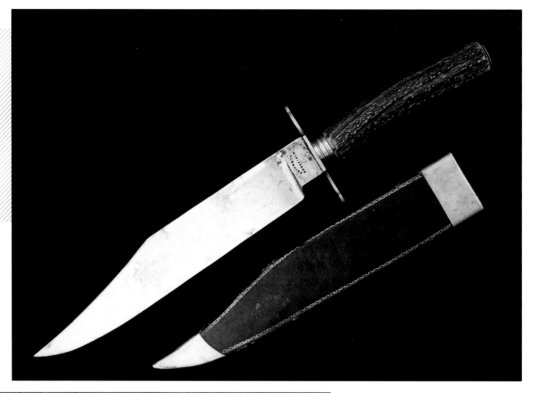

Stag horn handled Bowie knife with ricasso stamped *SMITH & CO.* and blade etched *CALIFOR-NIA.* 15 1/2 in. Circa 1850s. *Private collection, photo courtesy of Witherell's.* **D**

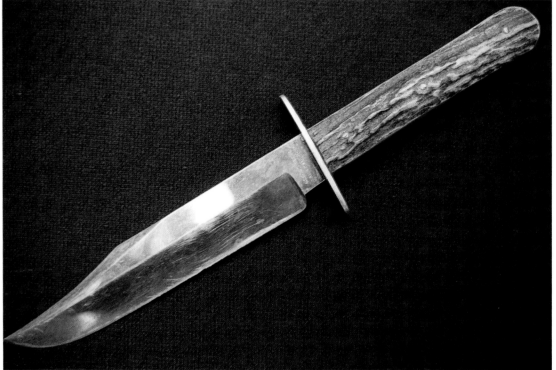

Left:
Stag horn handled Bowie knife with ricasso stamped *GEO C SHREEVE / SAN FRANCISC.,* 12 in. Circa 1858-1893. *Paul Schweizer, photo courtesy of Witherell's.* **B**

Below:
Two-piece, stag horn handled Bowie knife with ricasso stamped *M. PRICE / SAN FRAN.* 12 in. Circa 1857-1889. *Courtesy Al and Carol Cali.* **D**

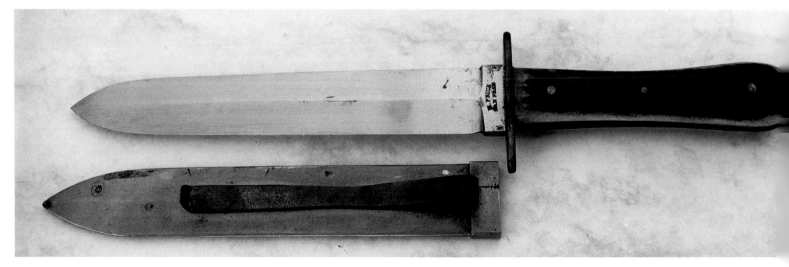

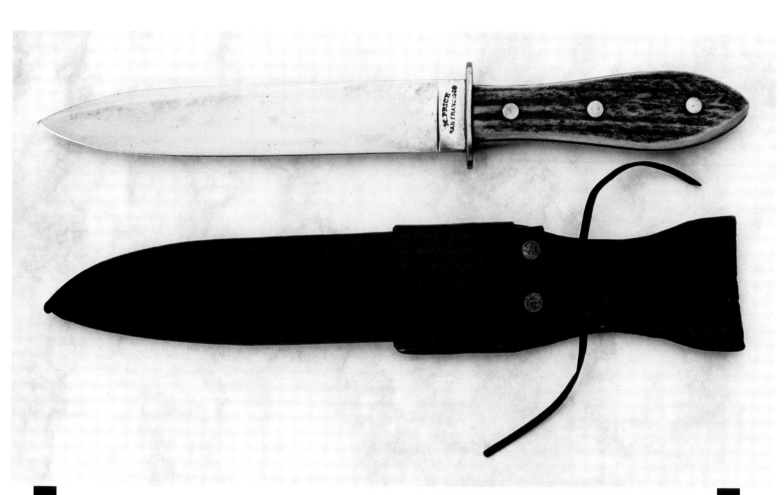

Two-piece, stag horn handled Bowie knife with ricasso stamped *M. PRICE / SAN FRAN-CISCO*. 11 1/2 in. Circa 1857-1889. *Courtesy Al and Carol Cali.* **D**

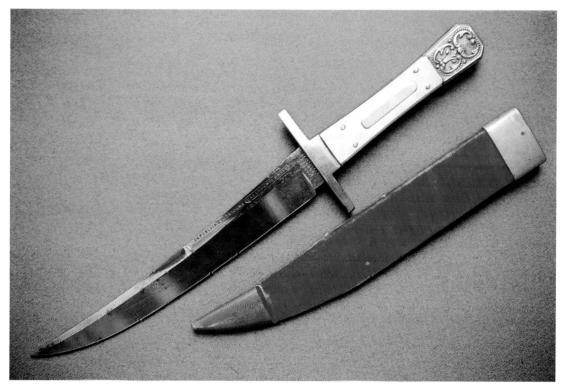

Two-piece, ivory handled Bowie knife with ricasso stamped *CORSAN / DENTON / BURDLKIN & CO,* and blade stamped *REPUBLIC MEXICANA CALAFORNIA KNIFE.* 11 in. Mid-19th century. *Roger Baker, photo courtesy of Witherell's.* **C**

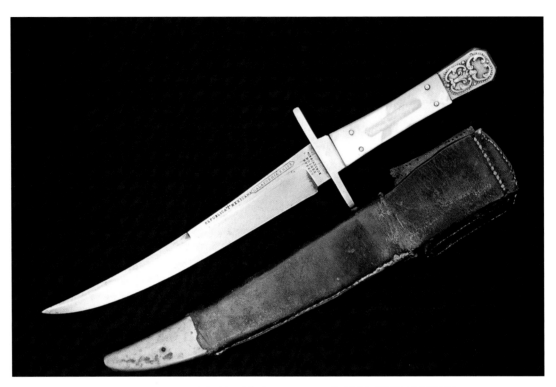

Two-piece, pearl handled Bowie knife with ricasso stamped *CORSAN / DENTON / BURDLKIN & CO.*, and blade stamped *REPUBLIC MEXICANA CALAFORNIA KNIFE.* 11 in. Mid-19th century. *Private collection, photo courtesy of Witherell's.* **D**

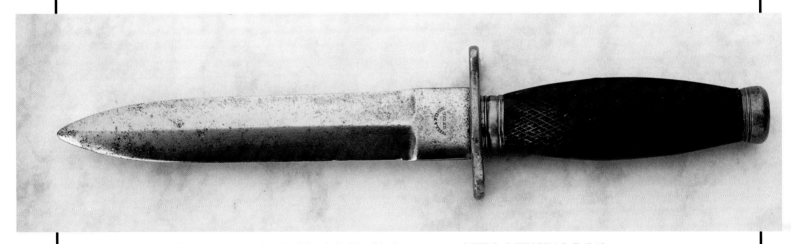

Checkered ebony handled Bowie knife with ricasso stamped *WILL & FINCK / S. F. CAL.* Circa 1863-1900. *Courtesy Al and Carol Cali.* **D**

Checkered ebony handled Bowie knife with ricasso stamped *WILL & FINCK / S. F. CAL.* Circa 1863-1900. *Courtesy Al and Carol Cali.* **D**

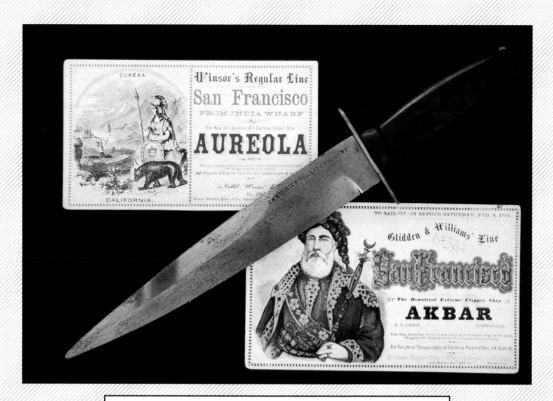

Walnut handled Bowie knife, blade stamped *CHEVALIER'S CALIFORNIA KNIFE.* 12 in. Circa 1850s. *P.I F. collection, photo courtesy of Witherell's.* **D**

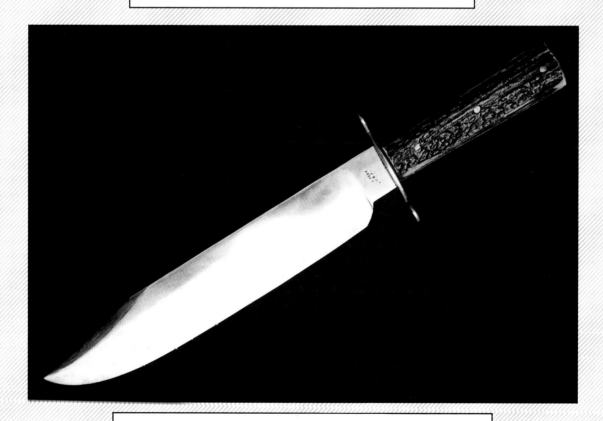

Stag horn handled Bowie knife with ricasso stamped *J. TODT / S. F.* 15 in. Circa 1880-1906. *Paul Schweizer, photo courtesy of Witherell's.* **B**

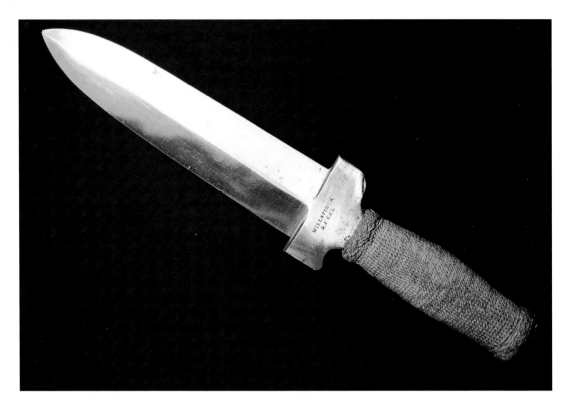

Twine wrapped handled Bowie knife with ricasso stamped *Will & Finck / S. F. Cal.* 13 in. Circa 1863-1900. *Donald & Gloria Littman collection, photo courtesy of Witherell's.* **C**

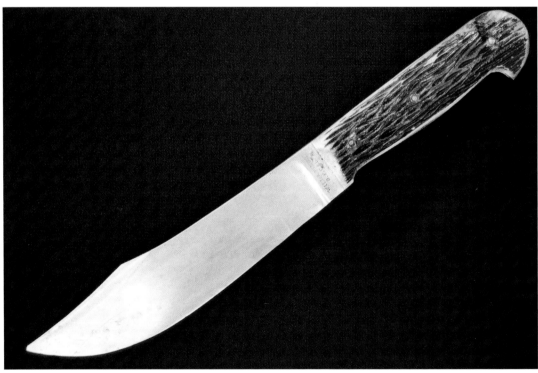

Two-piece, stag horn handled hunting knife with ricasso stamped *WILL & FINCK / S.F. CAL.* 12 in. Late 19th century. *P.I.F. collection, photo courtesy of Witherell's.* **C**

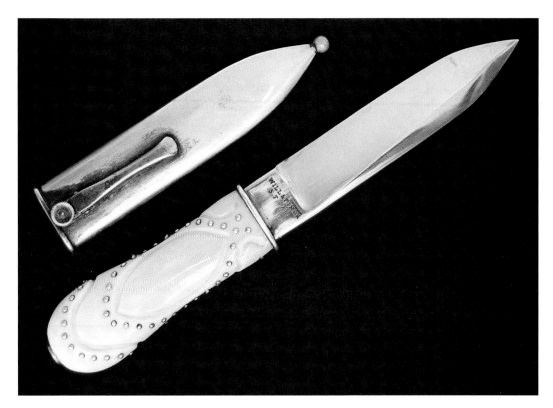

Carved ivory and gold stud handled Bowie knife with
ricasso stamped *WILL & FINCK / S. F. Cal.* 9 1/2 in.
Circa 1863-1900. *Hayes collection, photograph courtesy
Witherell's.* **D**

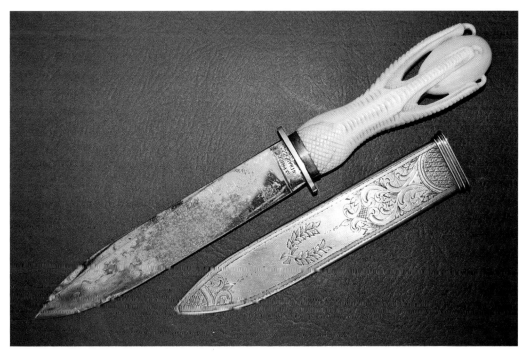

Pierced and carved ivory handled Bowie knife with
ricasso stamped *M. PRICE / _AN FRANCISCO.* 10 1/2
in. Circa 1857-1889. *Courtesy Al and Carol Cali.* **D**

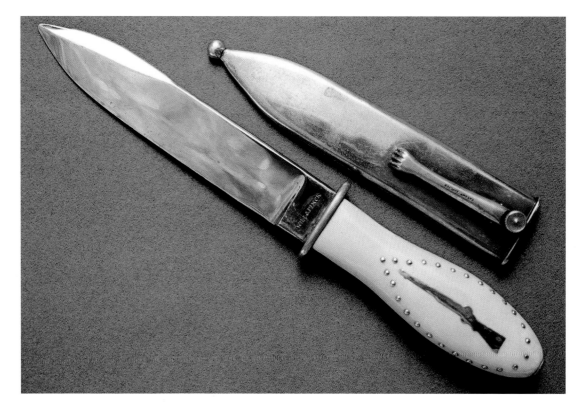

Ivory, silver inlay, and stud handled Bowie knife with ricasso stamped *WILL & FINCK*. 10 1/2 in. Circa 1863-1900. *Roger Baker, photo courtesy of Witherell's.* **D**

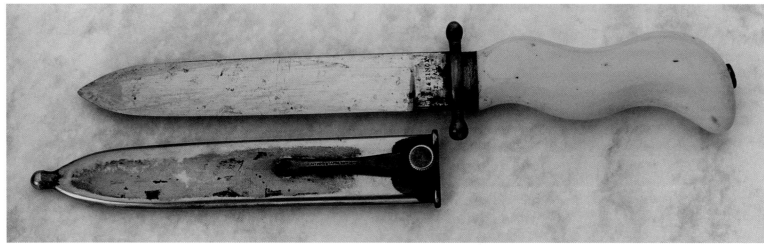

Ivory crooked handled Bowie knife with ricasso stamped *WILL & FINCK / S. F. CAL.* 11 in. Circa 1863-1900. *Courtesy Al and Carol Cali.* **D**

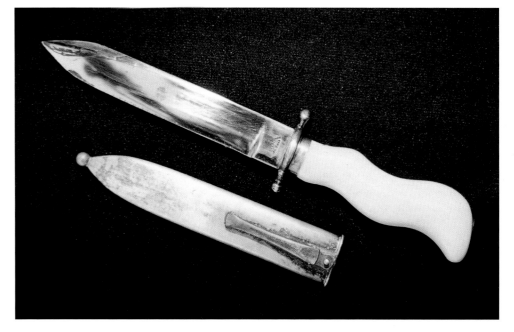

Ivory crooked handled Bowie knife with ricasso stamped *Will & Finck / S. F. Cal.* 11 in. Circa 1863-1900. *P.I.F. collection, photo courtesy of Witherell's.* **D**

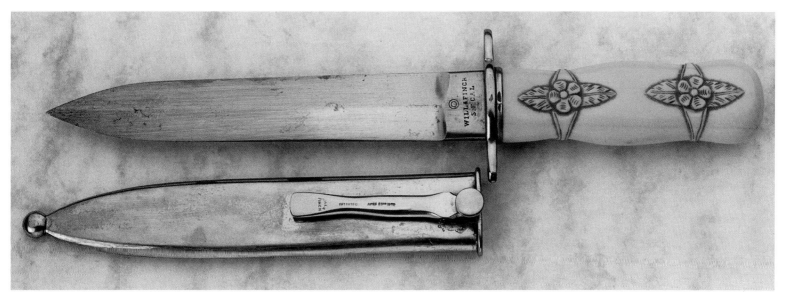

Carved ivory handled Bowie knife with ricasso stamped *WILL & FINCK / S. F. CAL.* 11 1/2 in. Circa 1872-1900. *Courtesy Al and Carol Cali.* **D**

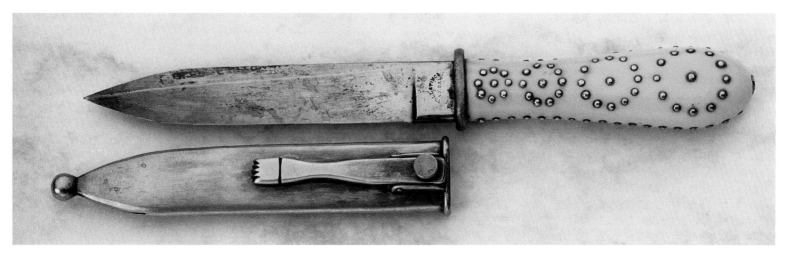

Ivory and silver stud handled Bowie knife with ricasso stamped *WILL & FINCK / S.F. CAL,* 8 3/4 in. Circa 1863-1900. *Courtesy Al and Carol Cali.* **D**

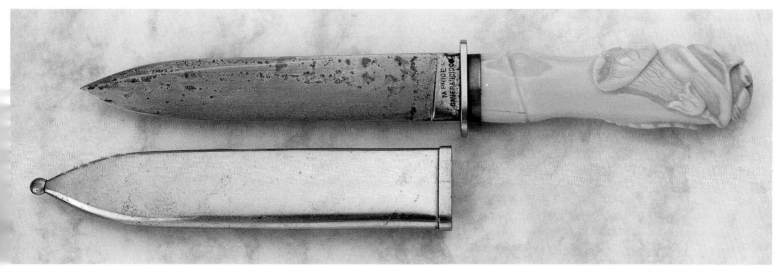

Carved ivory handled Bowie knife with ricasso stamped *M. PRICE / SAN FRANCISCO.* 9 3/4 in. Circa 1857-1889. *Courtesy Al and Carol Cali.* **D**

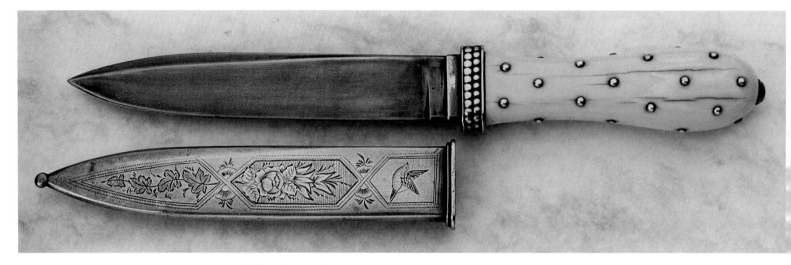

"California style" ivory and silver stud handled Bowie knife, 10 1/2
in. Circa 1860-1900. *Courtesy Al and Carol Cali.* **D**

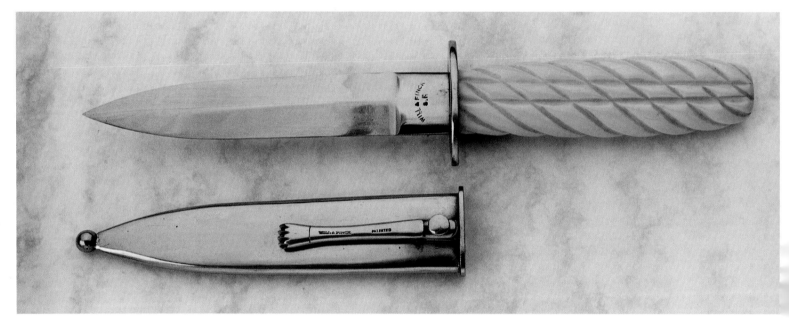

Ivory handled Bowie knife with ricasso stamped *WILL & FINCK / S.
F.* 10 1/4 in. Circa 1872-1900. *Courtesy Al and Carol Cali.* **D**

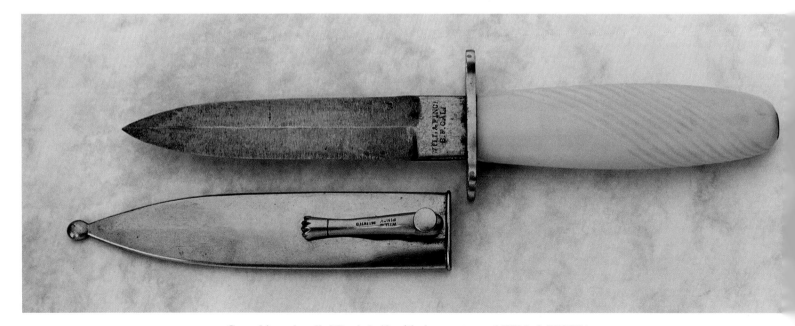

Carved ivory handled Bowie knife with ricasso stamped *WILL & FINCK /
S. F. CAL.* 9 1/2 in. Circa 1863-1900. *Courtesy Al and Carol Cali.* **D**

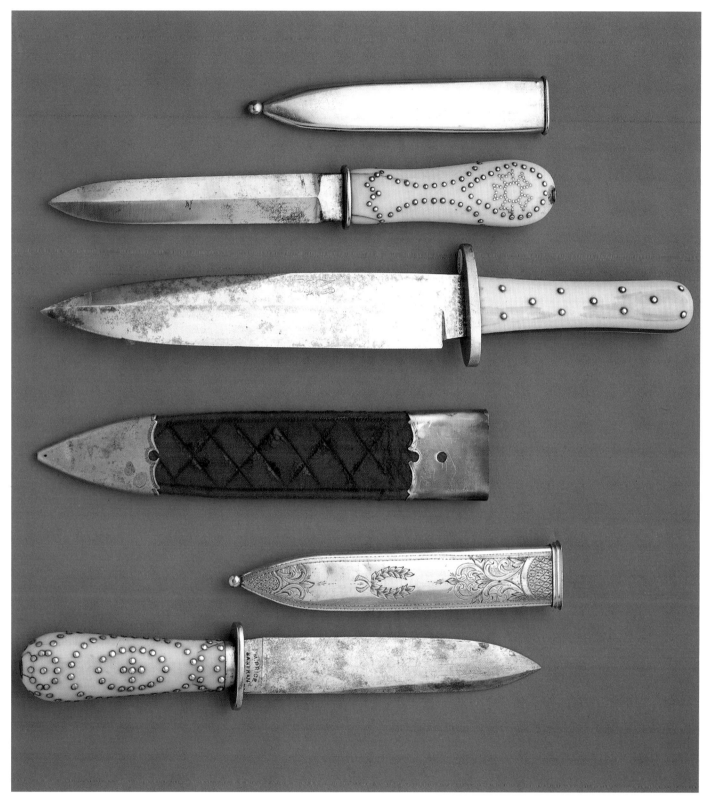

Three ivory handled Bowie knives. Top, ricasso stamped *WILL &FINCK / S. F. CA.* 10 7/8 in. Circa 1863-1900. Middle, ricasso stamped *Tillotson & Co. / Columbia Place / Sheffield.* 13 1/2 in. Circa 1850-1900. Bottom, ricasso stamped *M. PRICE / SAN FRAN.* 11 in. Circa 1857-1889. *Collection of Herbert G. Ratner Jr., Richard A. Stoner photograph.* each **D**

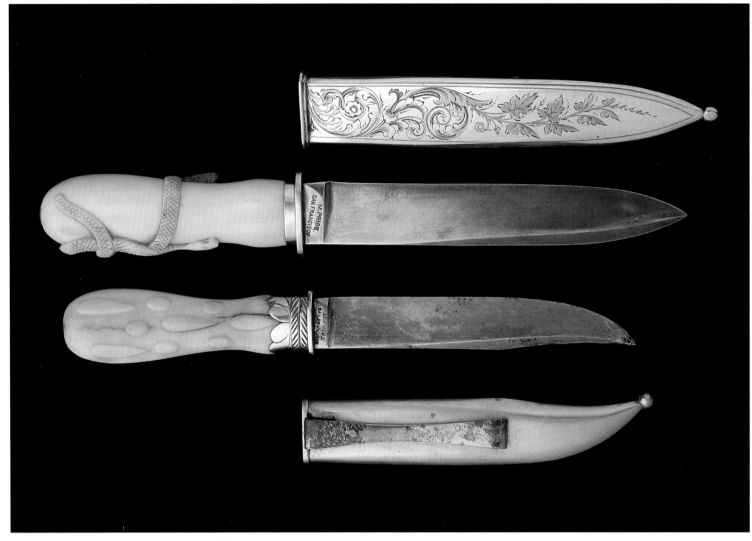

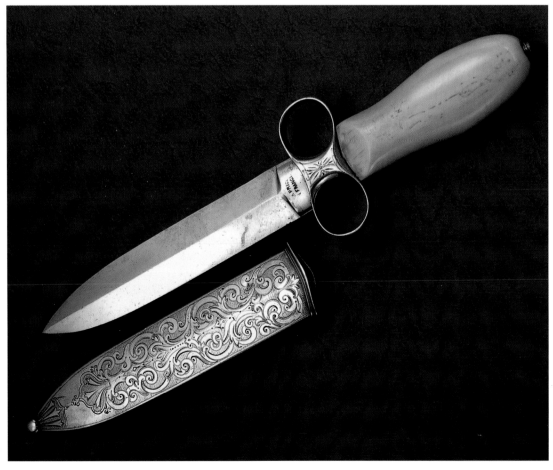

Two carved ivory handled Bowie knives, both ricassos stamped *M. PRICE / SAN FRANCISCO.* 10 in. and 11 1/4 in. Circa 1857-1889. *Collection of Herbert G. Ratner Jr., Richard A. Stoner photograph.* each **D**

Ivory and ring handled Bowie knife with ricasso stamped *M PRICE / __N FRANCI___.* 11 3/8 in. Circa 1857-1889. *Phil Lobred, photo by PointSeven Studios.* **D**

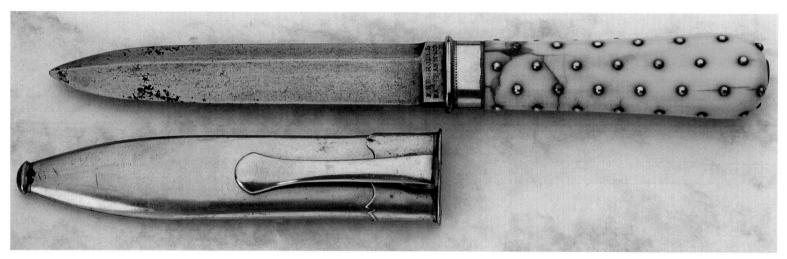

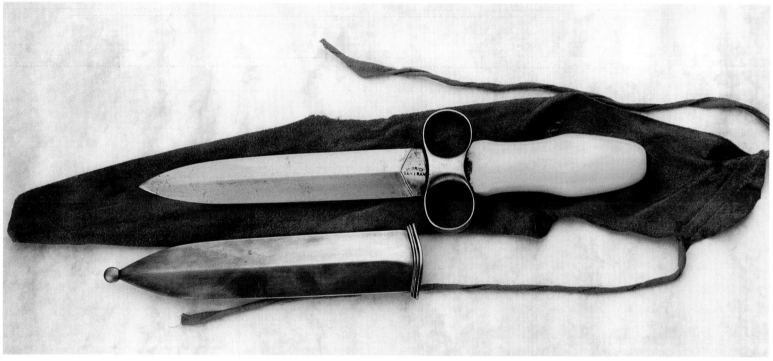

Top:
Ivory and silver stud handled Bowie knife with ricasso stamped *F. KESMODEL / SAN FRANCISCO.* Circa 1856-1867. *Courtesy Al and Carol Cali.* **D**

Above:
Ivory and ring handled Bowie knife with ricasso stamped *M. PRICE / SAN FRAN.*, 11 1/2 in. Circa 1857-1889. *Courtesy Al and Carol Cali.* **D**

Right:
California, ivory and ring handled Bowie knife. 10 in. Circa 1860-1900. *Roger Baker, photo courtesy of Witherell's.* **D**

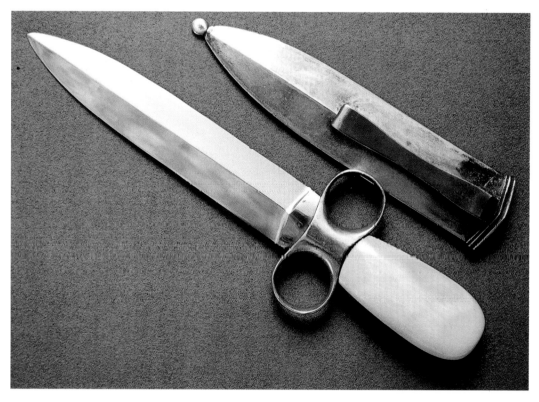

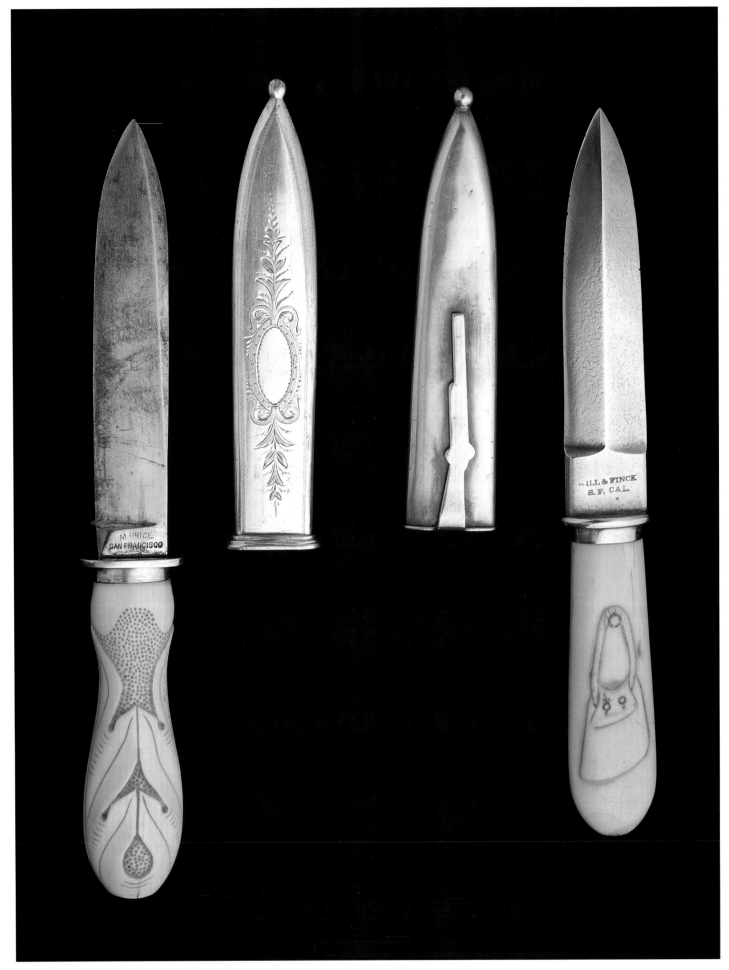

Two carved ivory handled Bowie knives. Top, ricasso stamped *WILL & FINCK / S.F. CAL.*
9 1/2 in. Circa 1863-1900. Bottom, ricasso stamped *M. PRICE / SAN FRANCISCO.* 10 1/8 in.
Circa 1857-1889. *Collection of Herbert G. Ratner Jr., Richard A. Stoner photograph.* each **D**

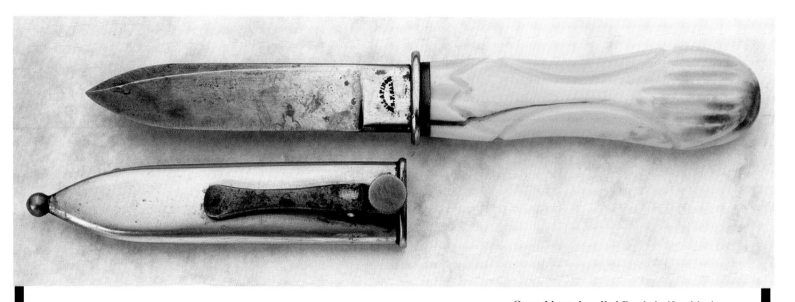

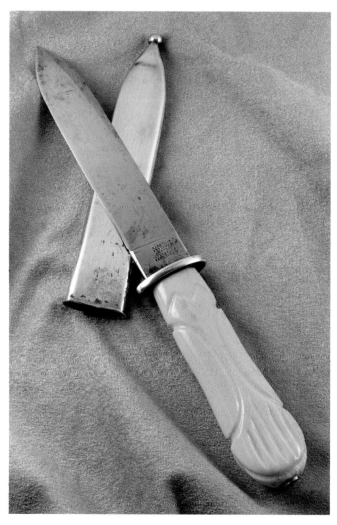

Carved ivory handled Bowie knife with ricasso stamped *WILL & FINCK / S. F. CAL.* 7 1/2 in. Circa 1863-1900. *Courtesy Al and Carol Cali.* **D**

"California style," carved ivory handled Bowie knife with ricasso stamped *Harrison Brothers & Howson, Sheffield.* Circa 1852-1900. *Courtesy Peter McMickle.* **D**

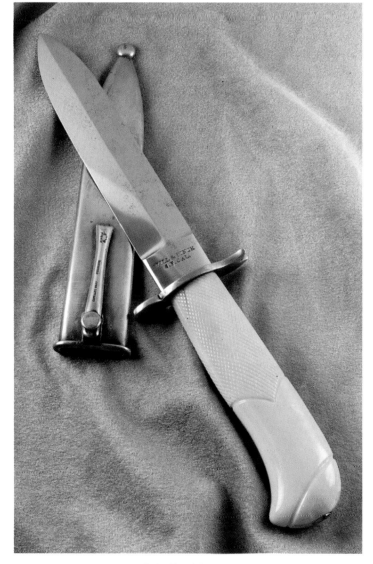

Carved ivory handled Bowie knife with ricasso stamped *WILL & FINCK / S. F. CAL.* Circa 1872-1900. *Courtesy Peter McMickle.* **D**

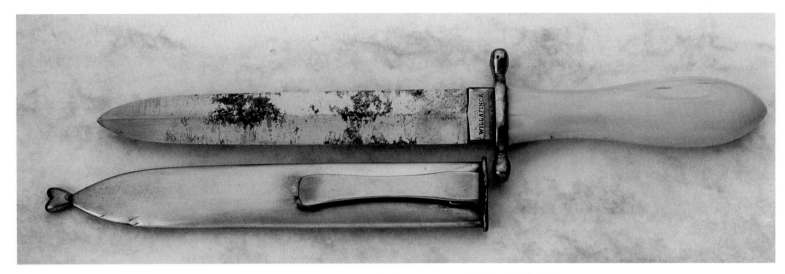

Ivory handled Bowie knife with ricasso stamped *WILL & FINCK.*
11 1/4 in. Circa 1863-1900. *Courtesy Al and Carol Cali.* **D**

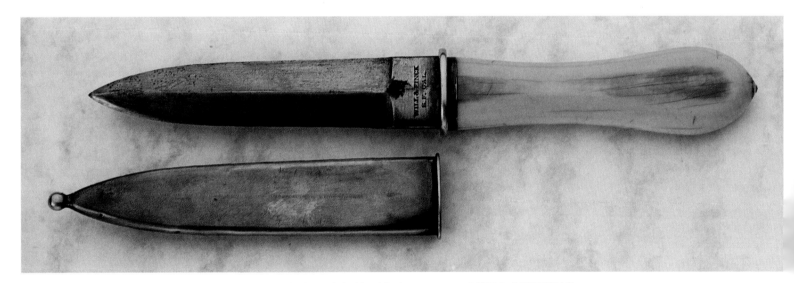

Ivory handled Bowie knife with ricasso stamped *WILL & FINCK / S.
F. CAL.* 9 7/8 in. Circa 1863-1900. *Courtesy Al and Carol Cali.* **D**

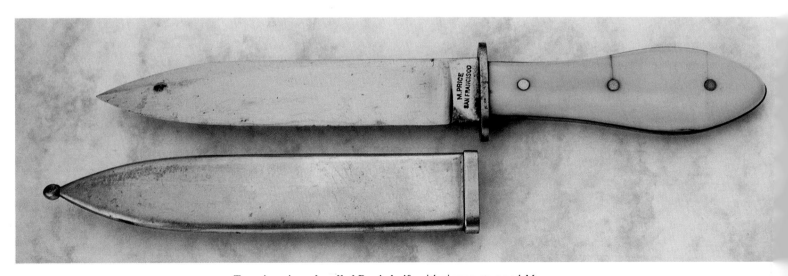

Two-piece, ivory handled Bowie knife with ricasso stamped *M.
PRICE / SAN FRANCISCO.* 10 1/4 in. Circa 1857-1889. *Courtesy Al
and Carol Cali.* **D**

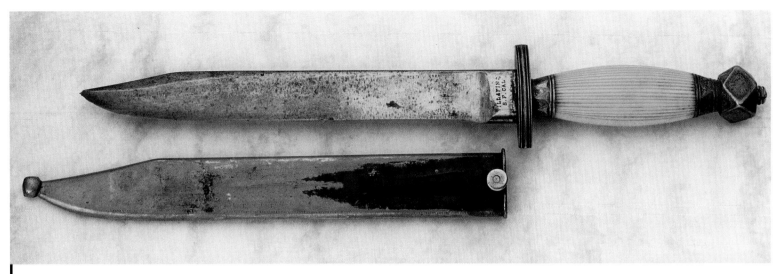

Ivory handled Bowie knife with ricasso stamped *WILL &FINC_ / S. F. CAL.* Circa 1863-1900. *Courtesy Al and Carol Cali.* **D**

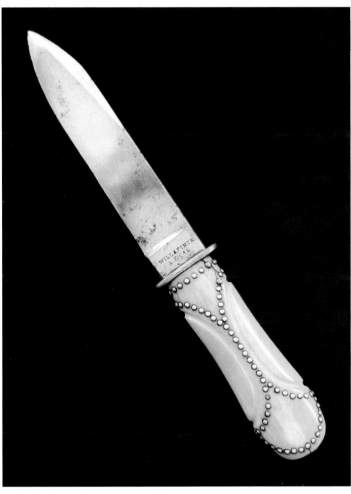

Carved ivory and gold stud handled Bowie knife with ricasso stamped *Will & Finck / S.F. Cal.* 10 3/4 in. Circa 1863-1900. *Donald & Gloria Littman, photo courtesy of Witherell's.* **C**

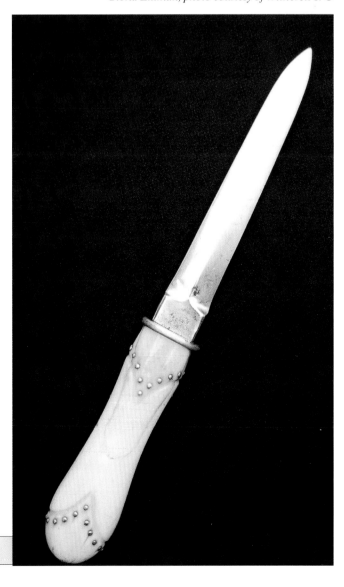

Ivory and silver stud handled Bowie knife with ricasso stamped *Will & Finck S. F. Cal.* 10 in. Circa 1863-1900. *P.I.F. collection, photo courtesy of Witherell's.* **D**

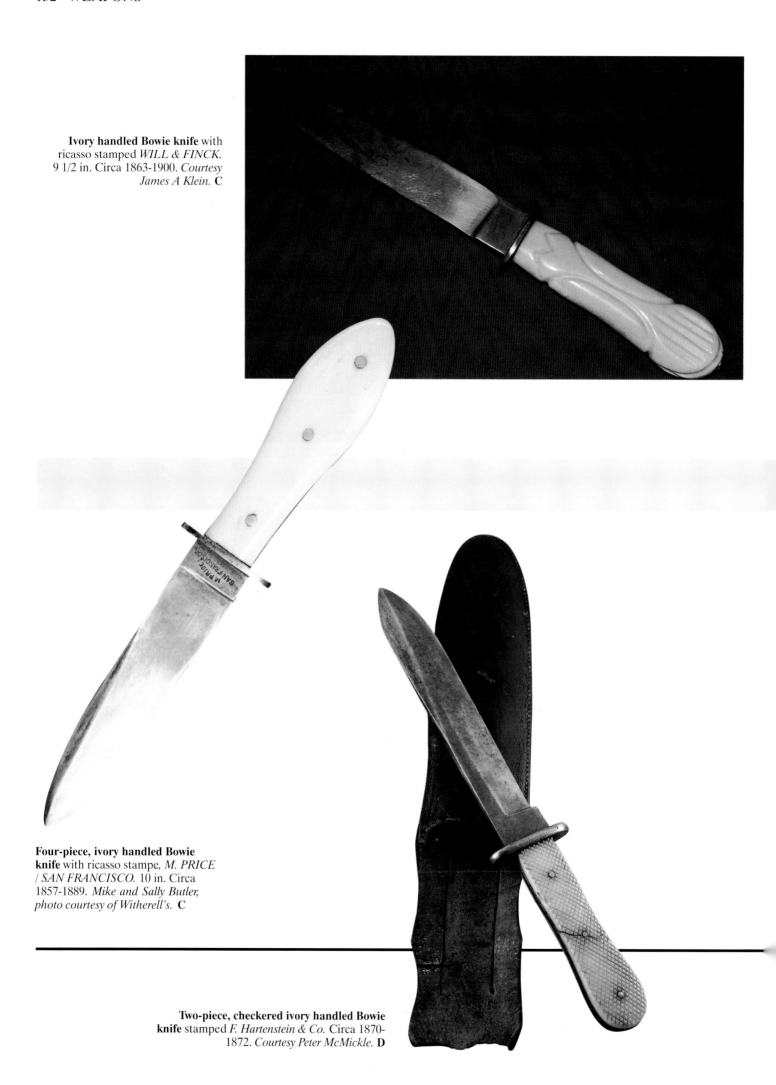

Ivory handled Bowie knife with ricasso stamped *WILL & FINCK.* 9 1/2 in. Circa 1863-1900. *Courtesy James A Klein.* **C**

Four-piece, ivory handled Bowie knife with ricasso stampe, *M. PRICE / SAN FRANCISCO.* 10 in. Circa 1857-1889. *Mike and Sally Butler, photo courtesy of Witherell's.* **C**

Two-piece, checkered ivory handled Bowie knife stamped *F. Hartenstein & Co.* Circa 1870-1872. *Courtesy Peter McMickle.* **D**

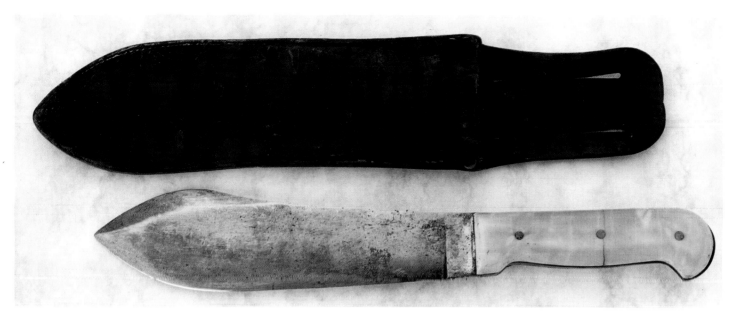

Pierced carved ivory handle bowie knife, ricasso stamped, *M. PRICE/ _AN FRANCISCO,* 10 1/2in. Circa 1857-1889. *Courtesy Al and Carol Cali.*

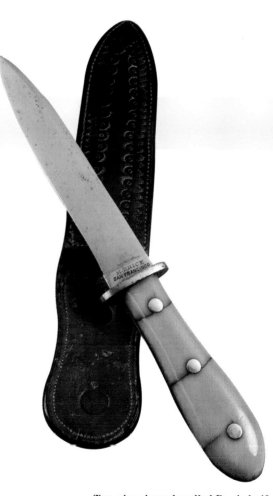

Two-piece ivory handled Bowie knife with ricasso stamped *M. PRICE / SAN FRANCISCO.* Circa 1857-1889. *Courtesy Peter McMickle.* **C**

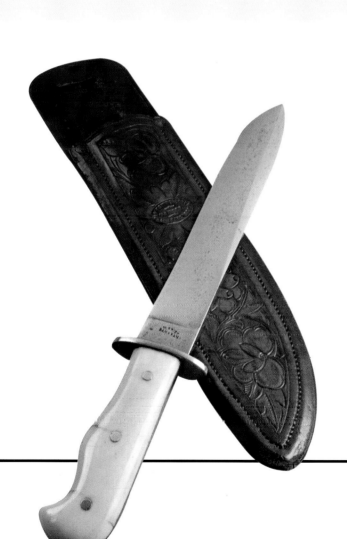

Two-piece ivory handle Bowie knife with ricasso stamped *M PRICE / SAN FRANCISCO.* Blade 8 3/8 in. Circa 1857-1889. *Courtesy Peter McMickle.* **C**

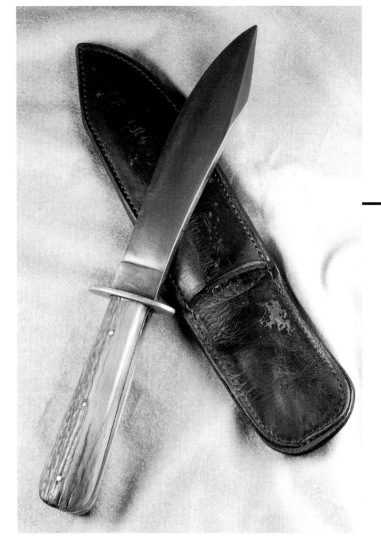

Two-piece stag horn handled Bowie knife with ricasso stamped *WILL & FINCK / S. F. CAL.* Circa 1863-1900. *Courtesy Peter McMickle.* **C**

Two-piece elk horn handled camp knife with ricasso stamped *WILL & FINCK / S.F. CA.*, Blade 10 in. Circa 1863-1900. *Courtesy Peter McMickle.* **C**

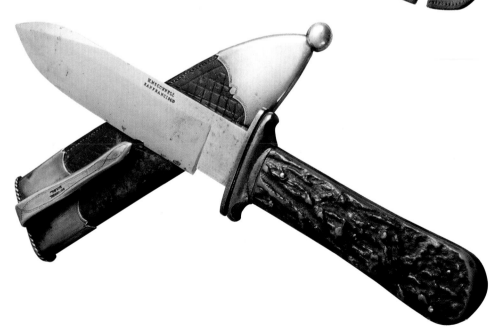

Stag horn handled Bowie knife, blade stamped *H. McCONNELL / SAN FRANCISCO.* Circa 1852-1863. *Courtesy Peter McMickle.* **D**

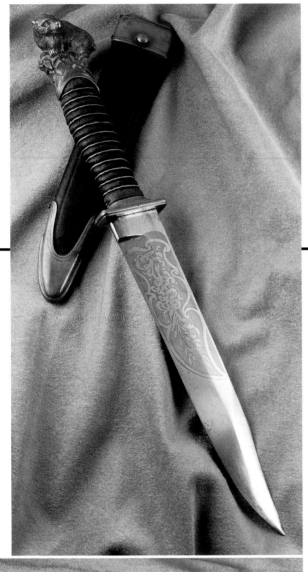

Bowie knife with "California bear" pommel. Ames manufacturing Co., Chicohee, Mass. Circa 1850-1900. *Courtesy Peter McMickle.* **D**

Two-piece elk horn handled Bowie knife with ricasso stamped *WILL & FINCK / S. F. CAL.* Circa 1863-1900. *Courtesy Peter McMickle.* **C**

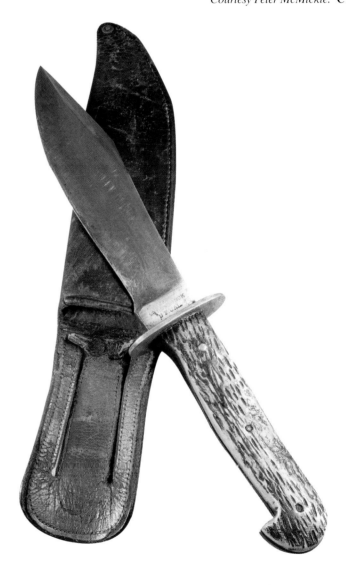

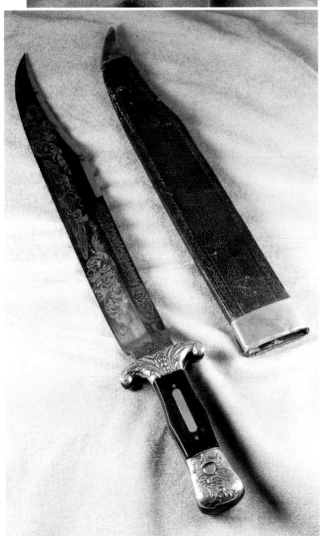

Two-piece horn handled Bowie knife with ricasso stamped *Crookes & Slater / Shefield.* Blade etched with roping scene and the name *William Johnson.* Blade 13 1/2 in. Circa 1850-1852. *Courtesy Peter McMickle.* **D**

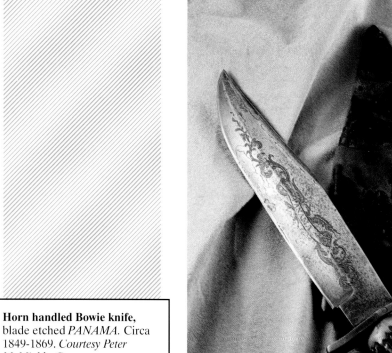

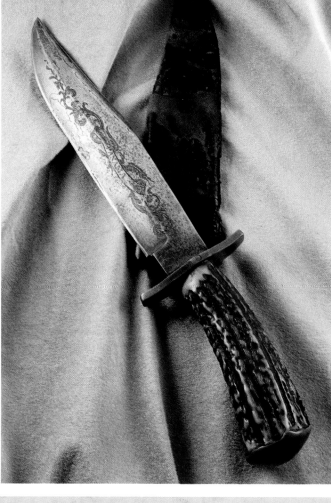

Horn handled Bowie knife, blade etched *PANAMA*. Circa 1849-1869. *Courtesy Peter McMickle.* **C**

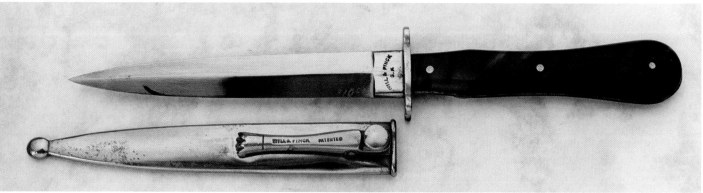

Two-piece tortoise-shell dirk with ricasso stamped *WILL & FINCK / S. F. CAL.* 7 1/2 in. Circa 1863-1900. *Courtesy Al and Carol Cali.* **D**

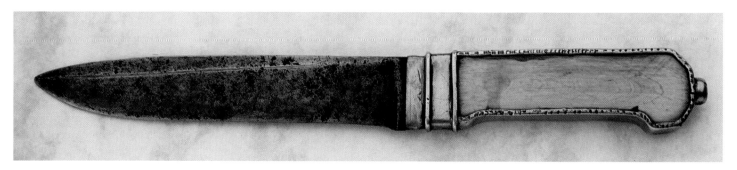

California, silver wrapped, ivory handled Bowie knife inscribed on handle *B. W. Studley, San Rafael.* Circa 1857-1890. *Courtesy Al and Carol Cali.* **D**

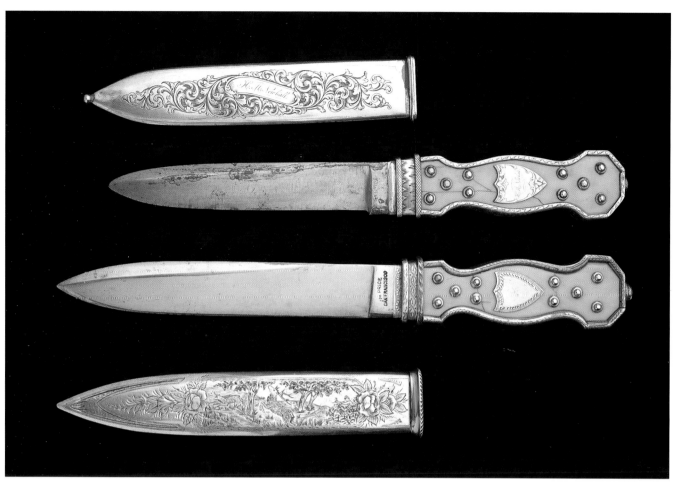

Two, two-piece ivory, gold stud, and silver band handled Bowie knives, both ricassos stamped *M. Price / San Fran*. 11 1/2 in. and 11 7/8 in. Circa 1857-1889. *Collection of Herbert G. Ratner Jr., Richard A. Stoner photograph.* each **D**

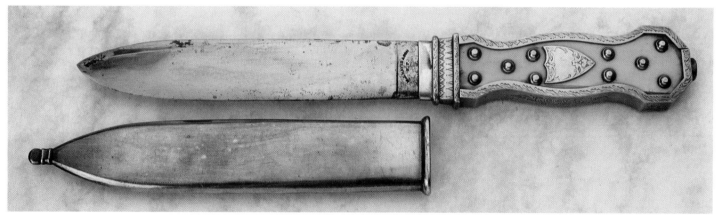

Above:
Ivory, silver stud and band handled Bowie knife with ricasso stamped *M. L. HAYES / & SON / S. F.* Circa 1891-1897. *Donald & Gloria Littman collection, photo courtesy of Al and Carol Cali.* **D**

Below:
Two-piece ivory, gold stud , and silver band handled Bowie knife with ricasso stamped *M. PRICE / SAN FRAN*. 10 1/4in. Circa 1857-1889. *Courtesy Al and Carol Cali.* **D**

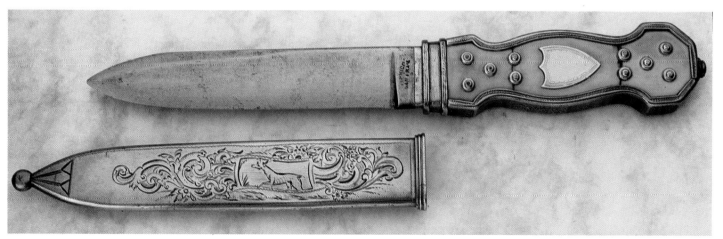

Ivory, silver banded and studded handle Bowie knife, ricasso stamped *M Price/ San Fran.* Circa 1857-1889. *Courtesy Peter McMickle.* **D**

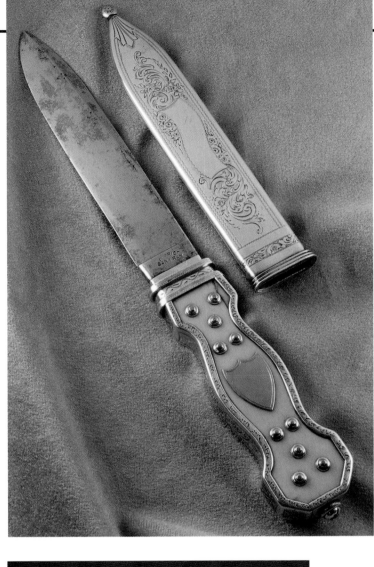

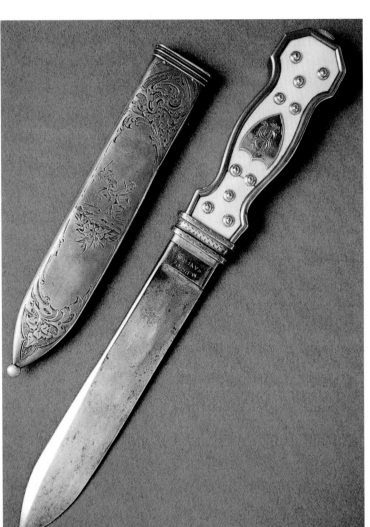

Two-piece ivory, silver band, and gold stud handled Bowie knife with ricasso stamped *M. PRICE / SAN FRAN.* 10 1/4 in. Circa 1857-1889. *Roger Baker, photo courtesy of Witherell's.* **D**

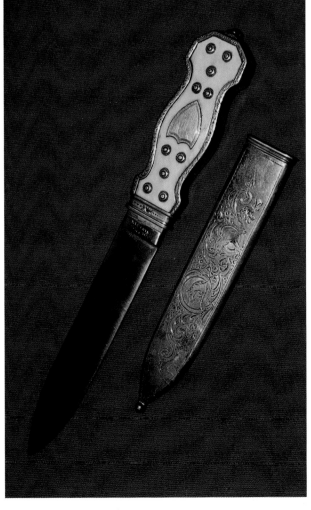

Two-piece ivory, silver band, and gold stud handled Bowie knife with ricasso stamped *M. PRICE / SAN FRAN.* 10 1/4 in. Circa 1857-1889. *Courtesy James A. Klein.* **D**

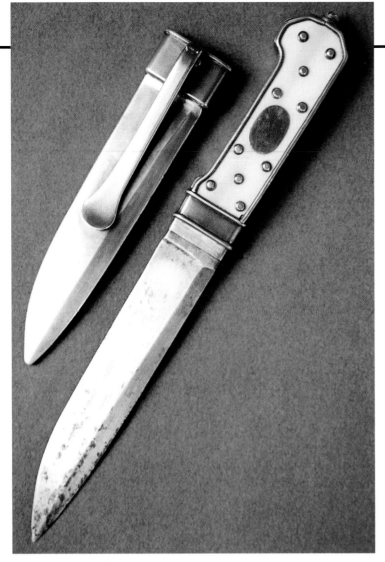

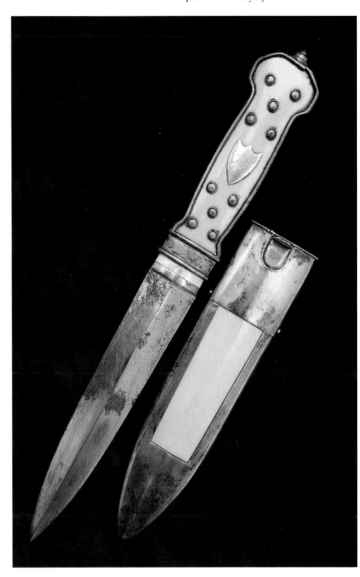

"California style," studded ivory handled Bowie knife, 10 in. approximately. Circa 1857-1890. *Oakland Museum of California History, photo courtesy of Witherell's.* **D**

"California style," two-piece studded ivory handled Bowie knife, 10 1/2 in. Circa 1857-1890. *Roger Baker, photo courtesy of Witherell's.* **D**

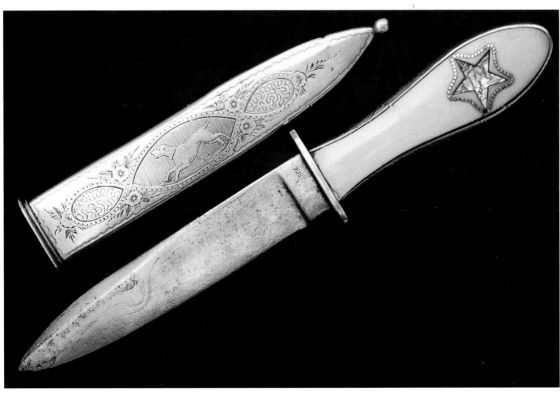

Ivory and abalone, banded handled Bowie knife with ricasso stamped *M. PRICE / SAN FRANCISC0.* 10 in. Circa 1857-1889. *Paul Schweizer, photo courtesy of Witherell's.* **D**

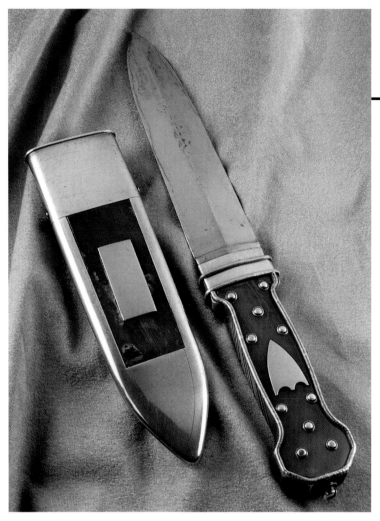

"California style," silver wrapped and stud handled Bowie knife, circa 1857-1887. *Courtesy Peter McMickle.* **D**

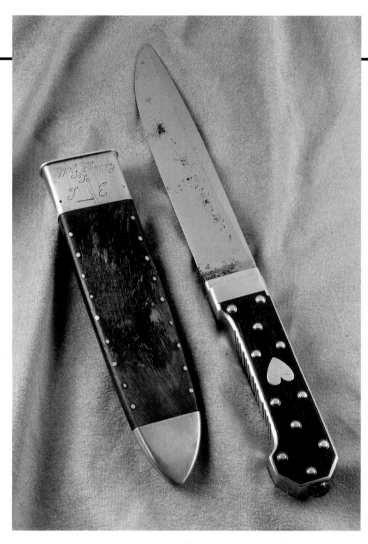

"California style," silver wrapped and studded horn handled Bowie knife, circa 1857-1887. *Courtesy Peter McMickle.* **D**

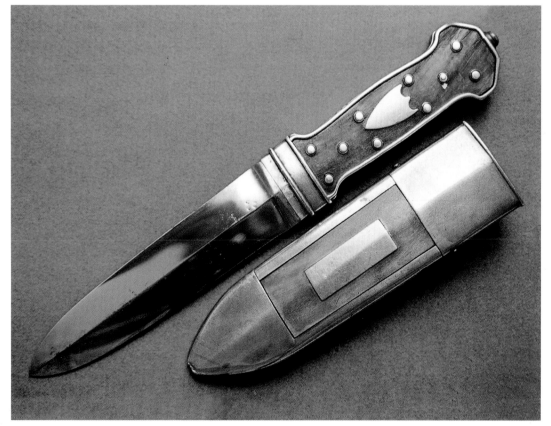

"California style," silver studded horn handled Bowie knife, 11 1/2 in. Circa 1857-1890. *Roger Baker, photo courtesy of Witherell's.* **D**

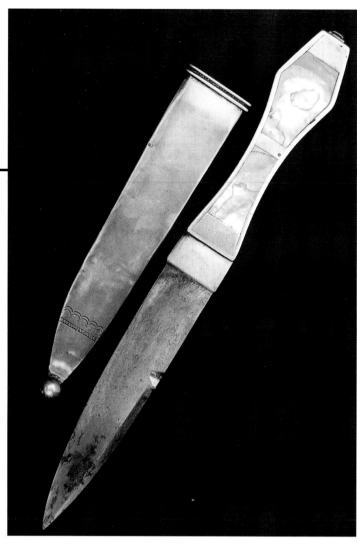

"California style," silver and abalone handled Bowie knife, 9 1/4 in.Circa 1860-1900. *Paul Schweizer, photo courtesy of Witherell's.* **C**

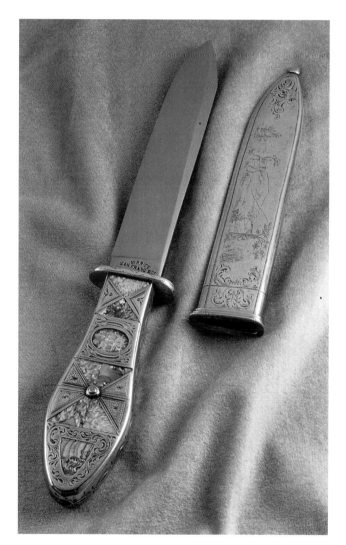

Engraved silver, gold, and abalone inlaid handled Bowie knife with ricasso stamped *M PRICE / SAN FRANCISCO.* Circa 1857-1889. *Courtesy Peter McMickle.* **D**

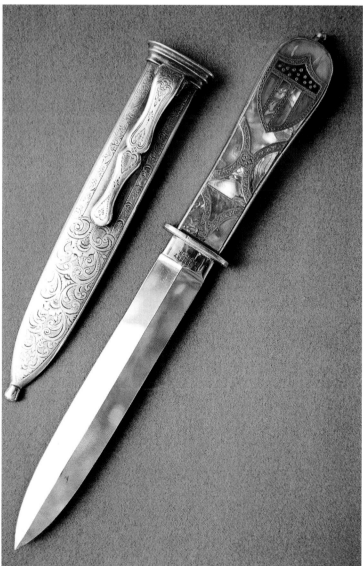

"California style," partitioned abalone handled Bowie knife with ricasso stamped *R. MURPHY / BOSTON.* 11 in. *Roger Baker, photo courtesy of Witherell's.* **D**

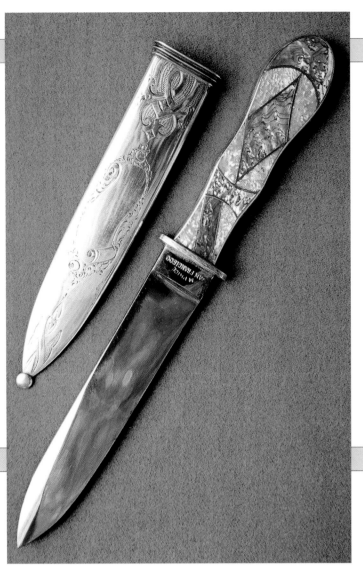

Left:
Partitioned abalone handled Bowie knife with ricasso stamped *M. PRICE / SAN FRANCISC.*, 10 1/2 in. Circa 1857-1889. *Roger Baker, photo courtesy of Witherell's.* **D**

Center:
"California style," partitioned abalone handled Bowie knife with ricasso stamped *SHONFMAN,* .8 3/4 in. Circa 1860-1900. *Courtesy Al and Carol Cali.* **D**

Below:
"California style," abalone handled Bowie knife, 9 1/4 in. Circa 1860-1900. *Courtesy Al and Carol Cali.* **D**

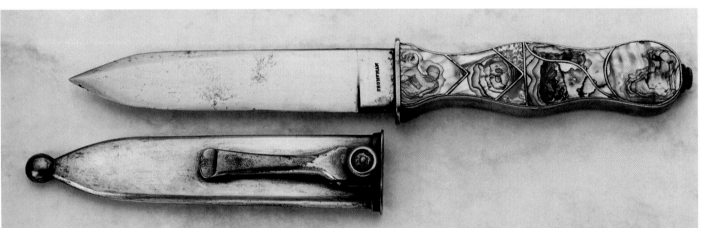

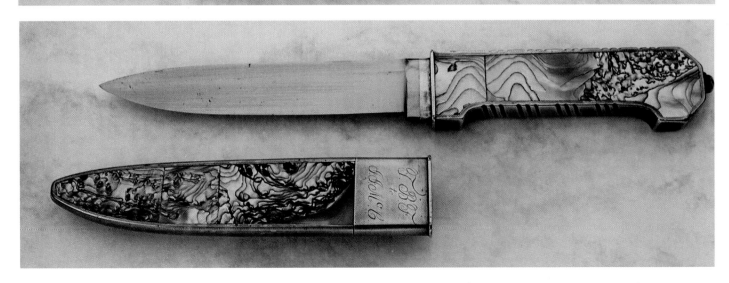

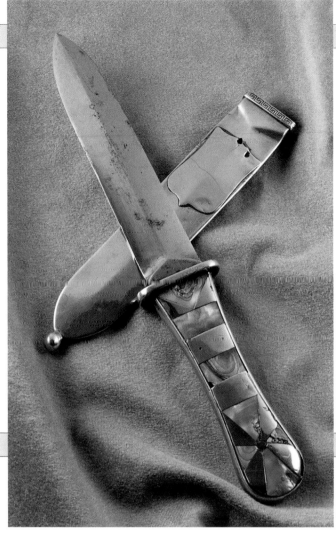

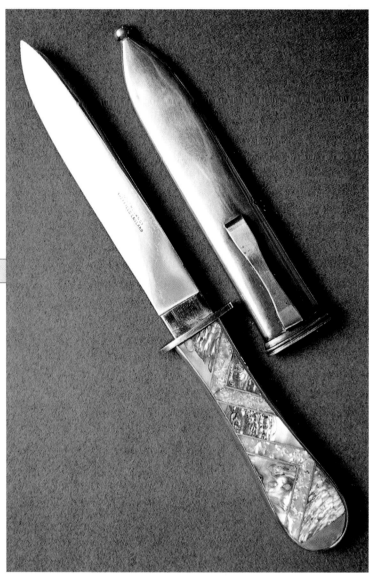

Partitioned abalone handled Bowie knife with ricasso stamped *NATHAN / JOSEPH / SAN / FRANCISC*. Blade stamped *QUEEN'S OWN CO. / SHEFFIELD ENGLAND*. 10 in. *Roger Baker, photo courtesy of Witherell's.* **D**

"California style," silver and partitioned abalone handled Bowie knife, circa 1857-1900. *Courtesy Peter McMickle.* **D**

Partitioned abalone handled Bowie knife, sheath stamped *WILL & FINCK.*, 11 1/4 in. Circa 1863-1900. *Courtesy Al and Carol Cali.* **D**

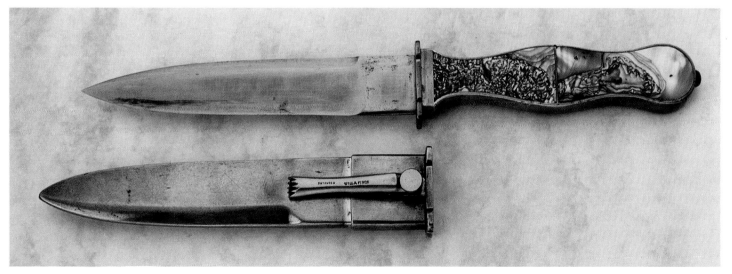

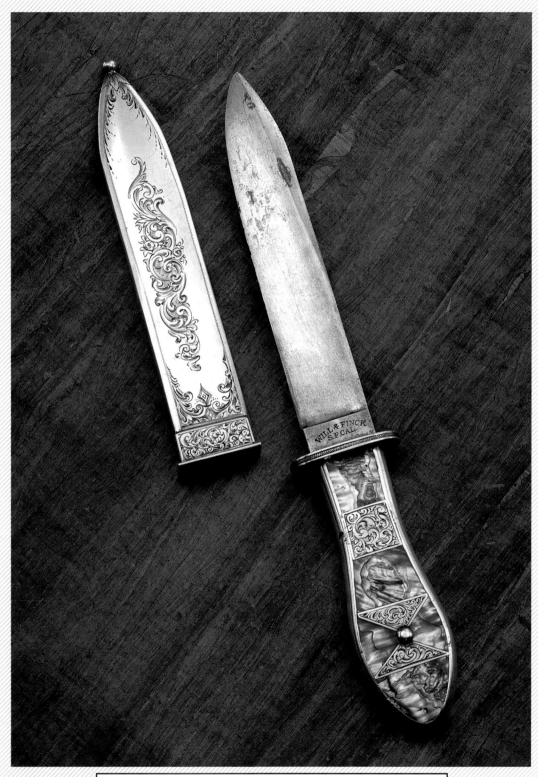

Partitioned and engraved abalone handled Bowie knife with ricasso stamped *WILL & FINCK / S. F. CAL.* 10 1/4 in. Circa 1863-1900. *Phil Lobred, photo PointSeven Studios.* **D**

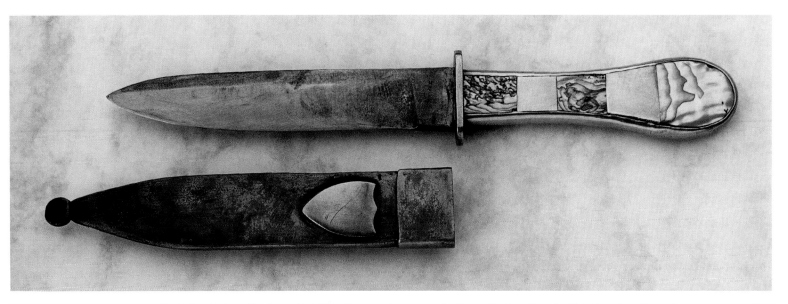

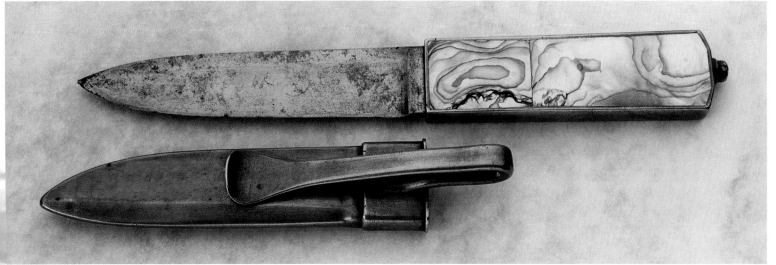

Top:
"California style," partitioned abalone handled Bowie knife, ricasso illegibly marked. Circa 1860-1900. *Jim Klein, photo courtesy Al and Carol Cali.* **D**

Center:
"California style," abalone handled Bowie knife, 8 in. Circa 1860-1900. *Courtesy Al and Carol Cali.* **D**

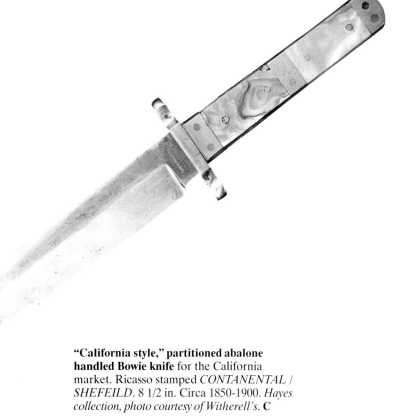

"California style," partitioned abalone handled Bowie knife for the California market. Ricasso stamped *CONTANENTAL / SHEFEILD*. 8 1/2 in. Circa 1850-1900. *Hayes collection, photo courtesy of Witherell's.* **C**

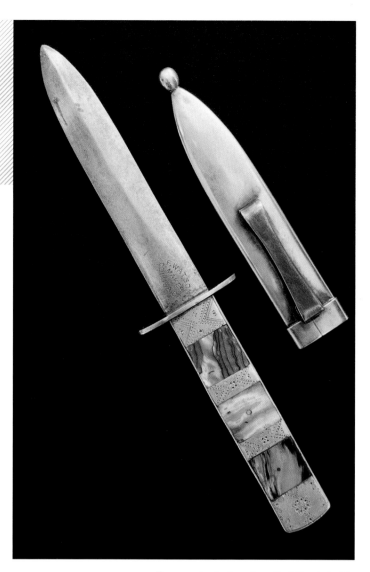

Engraved, abalone handled Bowie knife with ricasso stamped *F. WATSON / MAKER / COLUSA, CAL.* Circa 1890s. *Jim Mackie, photo courtesy of Witherell's.* **D**

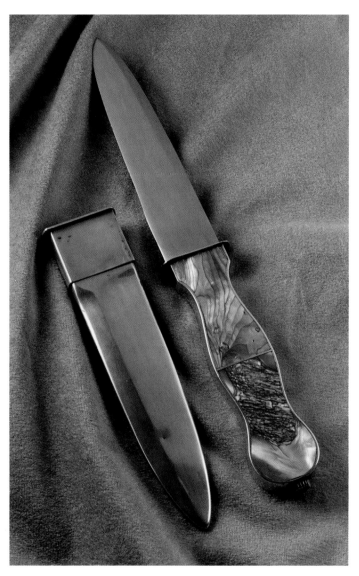

"California style," partitioned abalone handled Bowie knife, circa 1857-1900. *Courtesy Peter McMickle.* **C**

Silver mounted and abalone inlaid handled gentleman's knife with crooked blade, stamped *F. WATSON / MAKER / COLUSA / CAL.* Circa 1890s. *Hayes collection, photo courtesy of Witherell's.* **C**

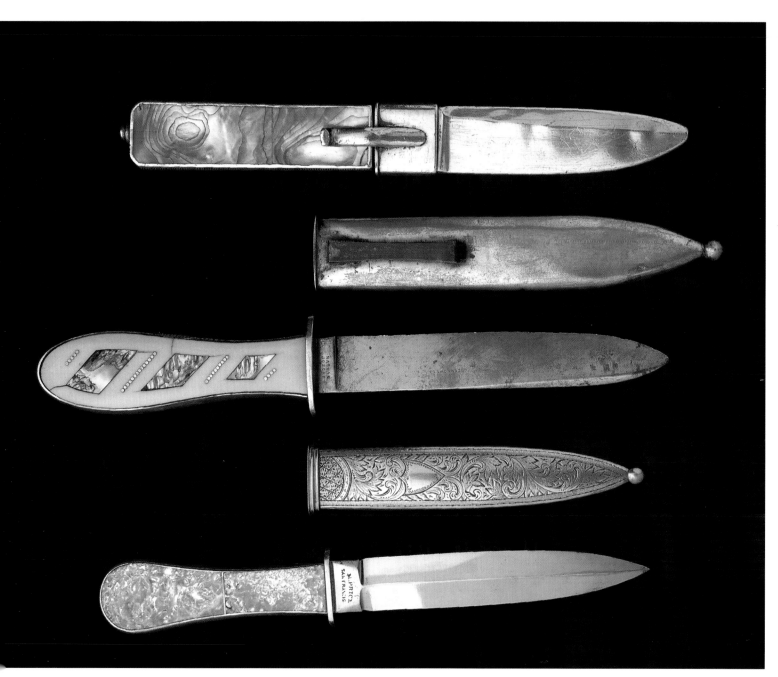

Three "California style," abalone handled Bowie knives. Top, ricasso stamped *M. Price San Francis.* 8 1/2 in. Circa 1857-1889. Middle, ricasso stamped *Nathan Joseph San,* blade, *Queens Own.* 10 1/2 in. Bottom, 5 5/8 in. *Collection of Herbert G. Ratner Jr., Richard A. Stoner photograph.* each **D**

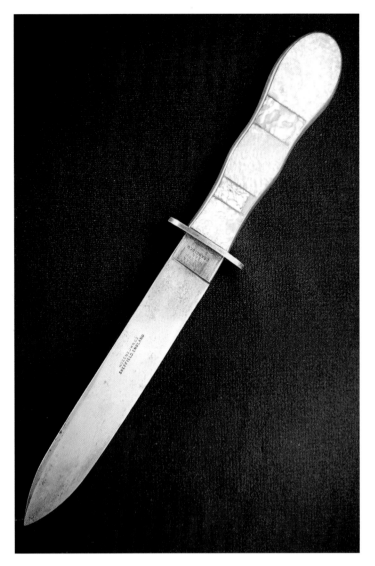

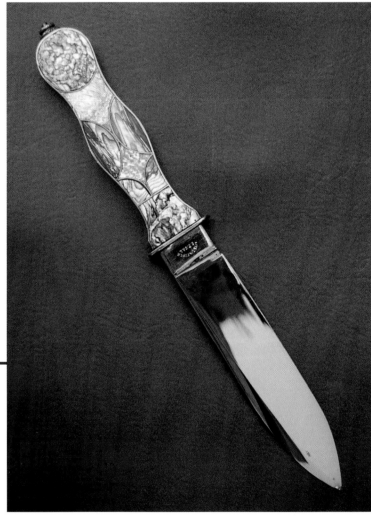

Abalone handle Bowie knife with ricasso stamped *NATHAN / JOSEPH II / SAN / FRANCISCO,* Blade stamped *QUENNS OWN / SHEFFIELD, ENGLAND.* 10 in. Circa 1893-1910. *Mike and Sally Butler, photo courtesy of Witherell's.* **C**

"California style," partitioned abalone handled knife with replaced blade. Circa 1860-1900. *Hayes collection, photo courtesy of Witherell's.* **B**

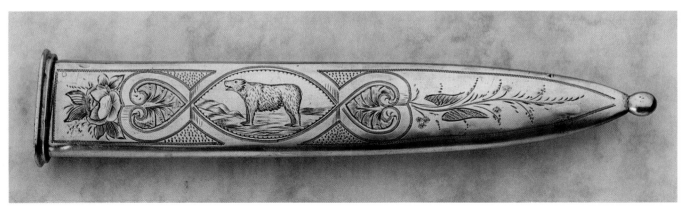

Bowie knife sheath engraved with California Bear for a Michael Price knife, 7 in. Circa 1857-1889. *Courtesy Al and Carol Cali.* **A**

Daggers

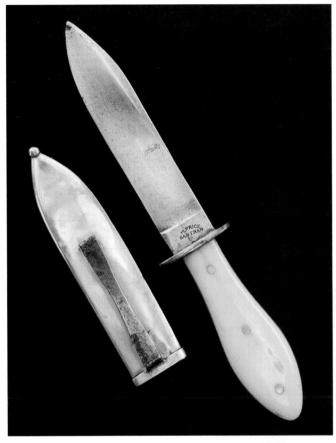

Two-piece, ivory handled dirk with ricasso stamped *M. PRICE / SAN FRAN.* 9 in. Circa 1857-1889. *P.I. F. collection, photo courtesy of Witherell's.* **D**

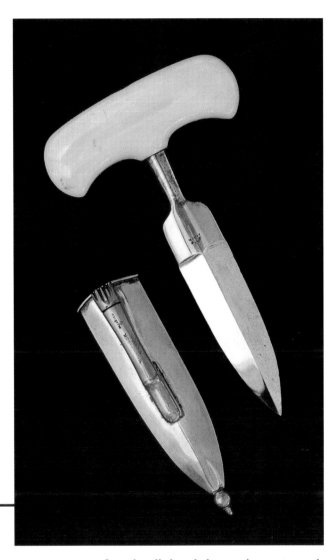

Ivory handled push dagger, ricasso stamped *WILL & FINCK,* Silver sheath stamped *WILL & FINCK PATENTED.* 6 1/4 in. Circa 1872-1900. *Hayes collection, photo courtesy of Witherell's.* **D**

Two-piece, ivory handled dirk with ricasso stamped *Will & Finck / S. F. Cal.* Circa 1863-1900. *P.I.F. collection, photo courtesy of Witherell's.* **C**

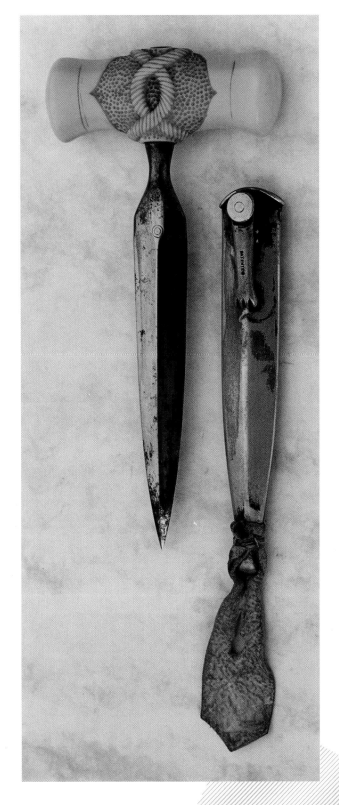

Ivory handled push dagger, ricasso stamped
WILL & / FINCK. 6 1/2 in. Circa 1863-1900.
Courtesy Al and Carol Cali. **D**

Carved ivory handled push dagger, ricasso
stamped *WILL & FINCK / S. F. CAL,* 6 1/4 in.
Circa 1863-1900. *Courtesy Al and Carol Cali.* **D**

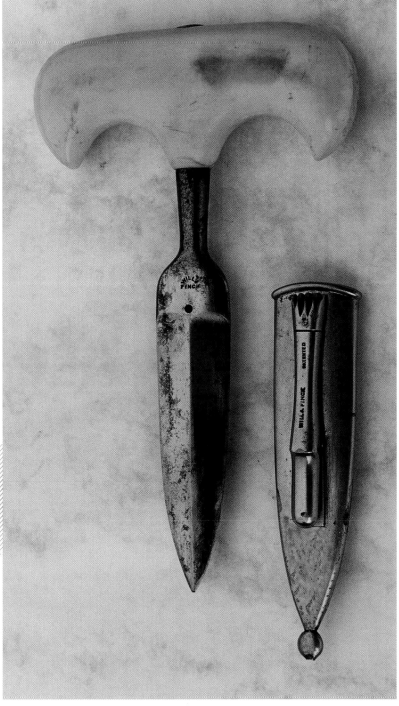

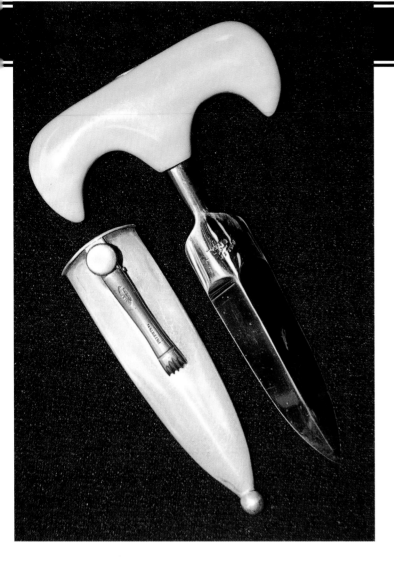

Ivory handled push dagger, ricasso stamped *WILL & FINCK / S. F. CAL.* Circa 1863-1900. *Paul Schweizer, photo courtesy of Witherell's.* **D**

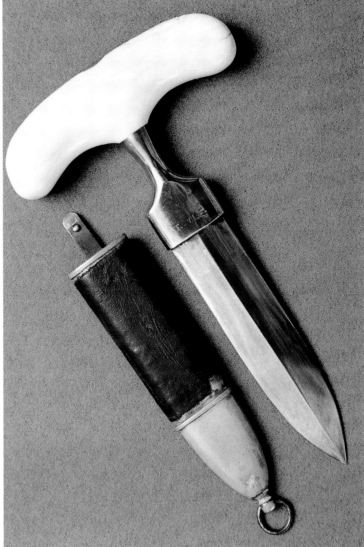

Ivory handled push dagger, ricasso stamped *F WILL.* 6 in. Circa 1860-1863. *Roger Baker, photo courtesy of Witherell's.* **D**

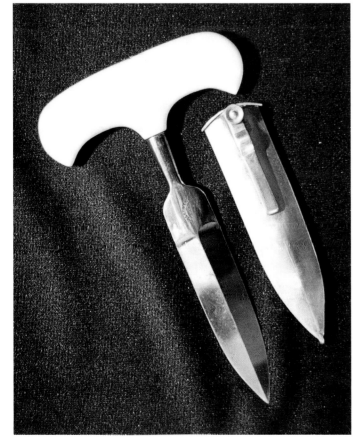

Ivory handled push dagger, ricasso stamped *Will & Finck / S. F. Cal.* 6 3/4 in. Circa 1863-1900. *P.I.F. collection, photo courtesy of Witherell's.* **D**

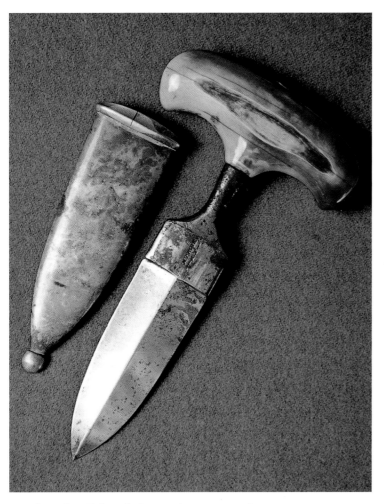

Ivory handled push dagger, ricasso stamped
M. PRICE / S. F. 5 in. Circa 1857-1889. *Roger
Baker, photo courtesy of Witherell's.* **D**

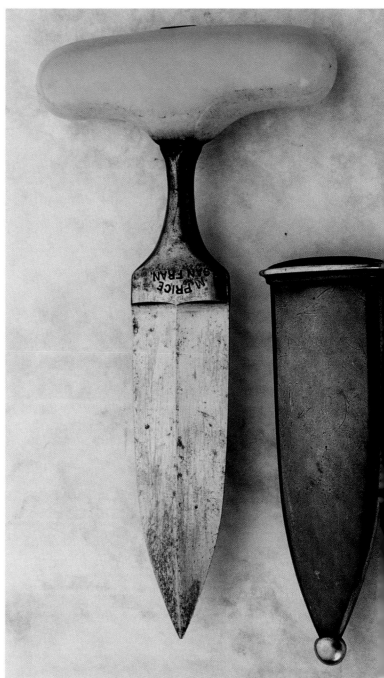

Ivory handled push dagger, ricasso stamped
M. PRICE / SAN FRAN. 4 3/4 in. Circa 1857-
1889. *Courtesy Al and Carol Cali.* **D**

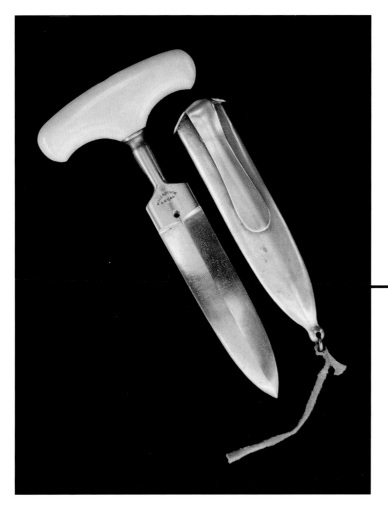

Ivory handled push dagger, ricasso stamped
Will & Finck / S. F. Cal. 7 1/4 in. Circa 1863-
1900. *P.I.F. collection, photo courtesy of
Witherell's.* **D**

Ebony handled push dagger, ricasso stamped
M. PRICE / SAN FRAN. Circa 1857-1889.
Courtesy Al and Carol Cali. **D**

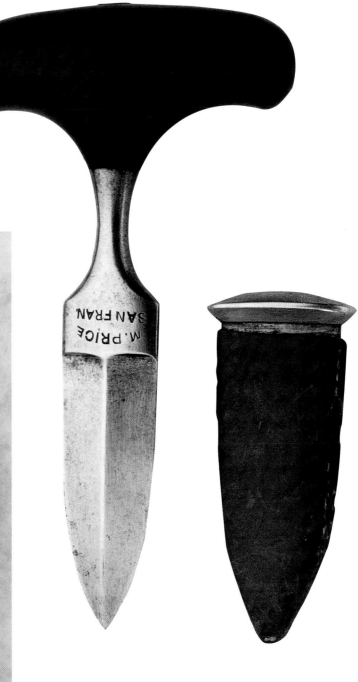

Ivory handled push dagger, ricasso stamped
WILL & / FINCK. 7 1/2 in. Circa 1863-1900.
Courtesy Al and Carol Cali. **D**

Chapter 6
Beer and Spirits Advertising

Early California advertising items include some of the finest lithography and illustrations of their time. The subject matter covered in this category includes a vast diversity of products. It was not the intent of the product manufacturers that these advertising items be preserved for decades, but as a testament to their successful designs and quality materials many were kept as decorative items long after their original use was over. Today, they remain desirable as they reflect the past. California advertising items today are available in a range of values from a few dollars to several thousands.

The most desirable California advertising subjects are those that include images which represent the romance of the Wild West. Some of the signs, calendars, and trays presented in this chapter were manufactured by the chromo-lithography process which required several printing plates, each plate using a separate color and resulting in a very high quality result that is seldom matched by the four-color printing process common today. Chromolithography could be applied to tin or paper. Another process represented among these advertisments is reverse painting on glass, which required extensive hand work and was the most expensive imagery to produce. A few examples were further enhanced with gold- or silver-leaf or mother-of-pearl.

════ Glass Reverse Painted Signs ════

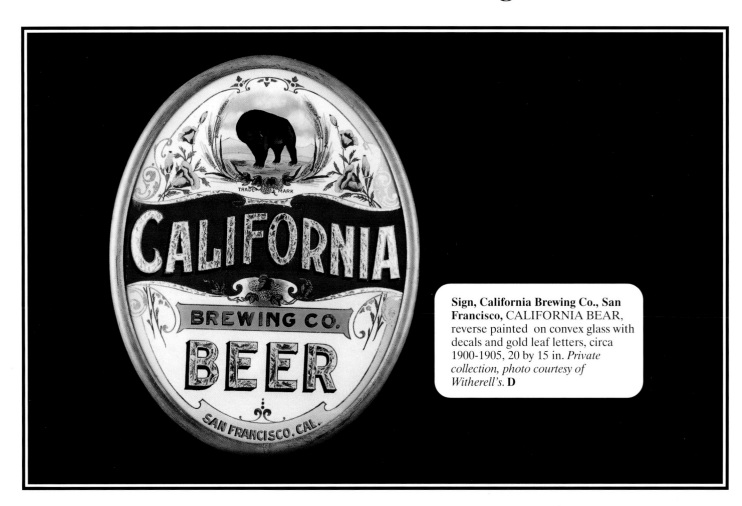

Sign, California Brewing Co., San Francisco, CALIFORNIA BEAR, reverse painted on convex glass with decals and gold leaf letters, circa 1900-1905, 20 by 15 in. *Private collection, photo courtesy of Witherell's.* **D**

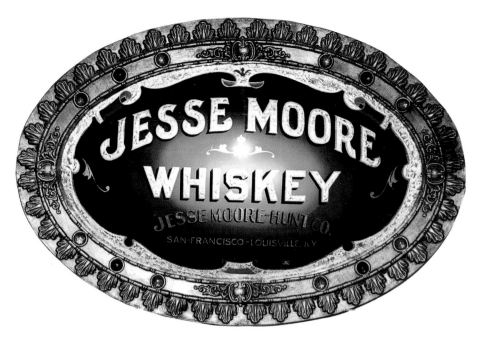

Sign, Jesse Moore Whiskey, San Francisco, GAPHICS ONLY,
reverse on convex glass with gold and silver leaf letters, circa 1900s,
15 by 22 in. *Mike and Sally Butler, photo courtesy of Witherell's.* **D**

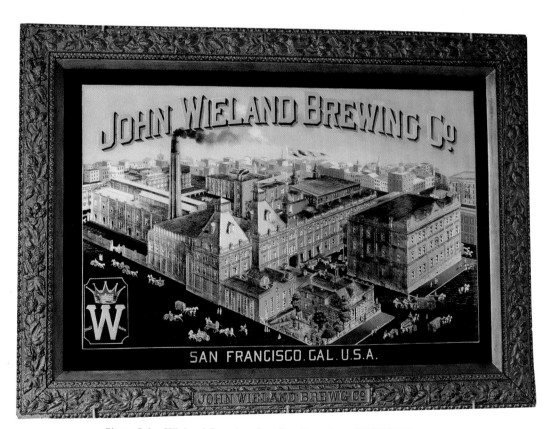

Sign, John Wieland Brewing Co., San Francisco, FACTORY
SCENE, reverse painted on glass with silver and gold leaf, circa
1887 1890, 48 by 31 in. *Courtesy Roger Graham.* **D**

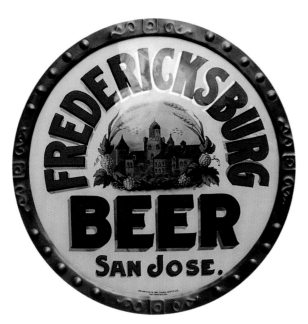

Sign, Fredericksburg Beer, San Jose, THE CASTLE, reverse painted with decal on glass, circa 1900-1918, 19 in. *Bill Rebello collection, photo courtesy of Witherell's.* **C**

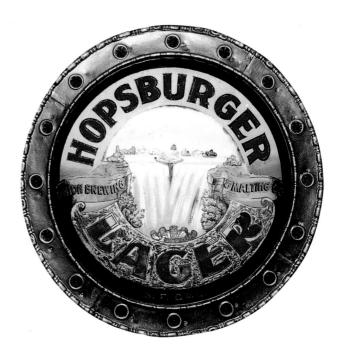

Sign, Union Brewing and Malting Co., San Francisco, HOPSBURG LAGER, reverse painted on glass with gold leaf lettering and background, circa 1900s, 22 in. *Mike and Sally Butler, photo courtesy of Witherell's.* **C**

Light-Up Corner Sign, Buffalo Brewing Co., Sacramento, FACTORY SCENE, reverse painted with silver leaf letters and decal, circa 1900s, 23 by 15 in. *Mike and Sally Butler, photo courtesy of Witherell's.* **C**

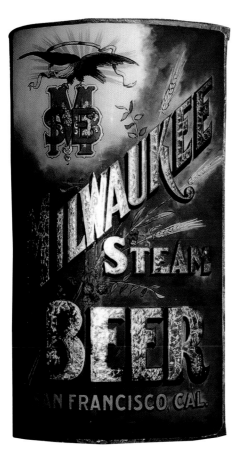

Corner sign, Milwaukee Steam Bear, San Francisco, EAGLE, reverse painted on glass with gold and silver leaf letters, circa 1902-1920, 24 by 12 in. *P.I.F. collection, photo courtesy of Witherell's.* **C**

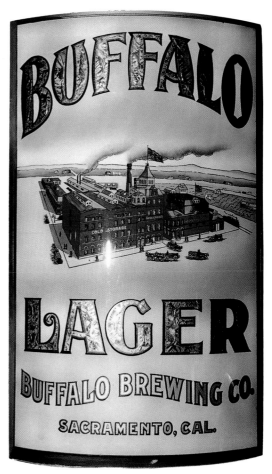

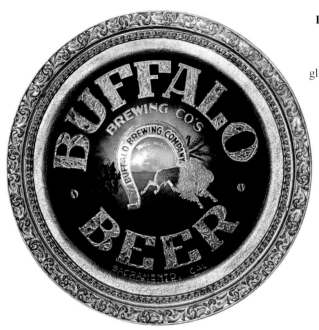

Sign, Buffalo Brewing Co., Sacramento, GOLDEN BUFFALO, reverse on convex glass with gold and silver leaf letters, circa 1900s, 22 in. *Private collection, photo courtesy of Witherell's.* **C**

Corner Sign, Buffalo Brewing, Sacramento, GRAPHICS ONLY, reverse painted, with silver leaf letters on glass, circa 1900s, 24 by 12 in. *Mike and Sally Butler, photo courtesy of Witherell's.* **B**

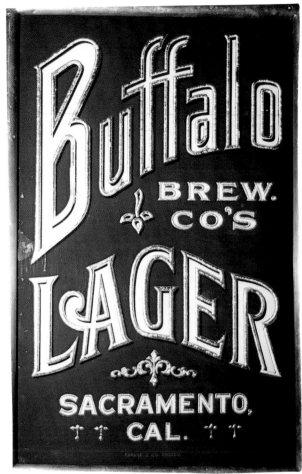

Sign, Enterprise Brewing Co., San Francisco, YOSIMTE BEER, reverse painted on convex glass with decals and gold leaf letters, circa 1905-1910, 20 by 16 in. *Mike and Sally Butler, photo courtesy of Witherell's.* **C**

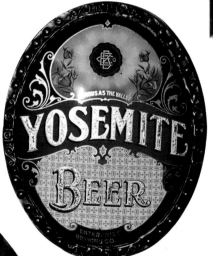

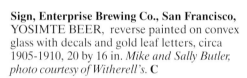

Right:
Sign, Jackson Beer, San Francisco, JACKSON, reverse painted and decal on glass, circa 1900-1918, 26 by 16 in. *Bill Rebello collection, photo courtesy of Witherell's* **C**

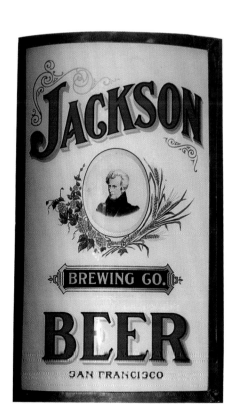

Sign, Enterprise Brewing Co., San Francisco, YOSIMITE LAGER, reverse painted on convex glass, with decals and gold leaf letters, circa 1905-1910, 20 by 16 in. *P. I. F. collection, photo courtesy of Witherell's.* **C**

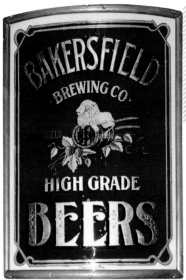

Sign, Bakersfield Brewing Co., Bakersfield, HIGH GRADE BEERS, reverse painted on convex glass with stencil, gold and silver leaf letters, circa 1900s, 22 by 15 in. *Charlie Zawila, photo courtesy of Witherell's.* **B**

Sign, Wieland's Beer, San Francisco, GOLDEN CROWN, paint on milk glass, circa 1900-1918, 22 by 16 in. *Bill Rebello collection, photo courtesy of Witherell's.* **B**

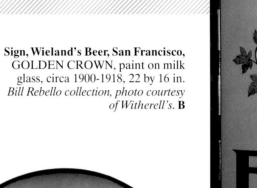

Sign, Napa City Beer, HOP & MALT, reverse painted on convex glass, circa 1900s, 20 in. *P. I. F. collection, photo courtesy of Witherell's.* **C**

Sign, Santa Cruz Brewing Co., Santa Cruz, CASINO, reverse painted on glass with decals and gold leaf letters, circa 1908-1912, 16 by 20 in. *Private collection, photo courtesy of Jim Mackie.* **D**

Sign, Old Joe's Steam Beer, San Francisco, E PLURIBUS UNUM, reverse painted on glass with decal and silver leaf, circa 1900s, 19 in. *Courtesy Roger Graham.* **D**

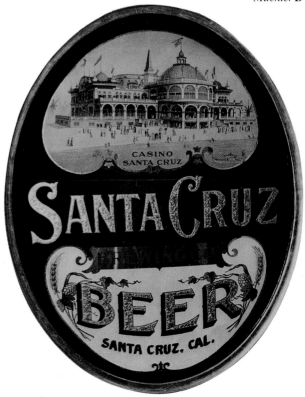

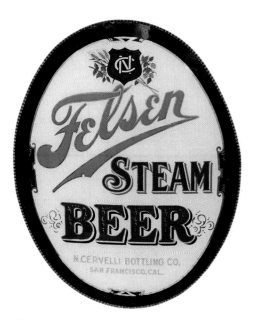

Sign, Felsen Steam Beer, San Francisco,
GRAPHICS ONLY, reverse on glass,
circa 1900s, 22 by 18 in. *Private collection,
photo courtesy of Witherell's.* **C**

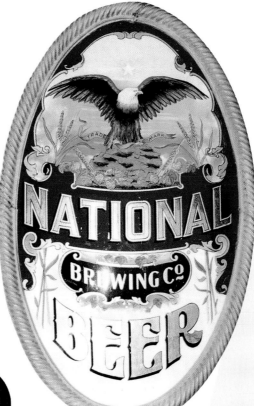

**Sign, National Brewing
Co., San Francisco,**
AMERICAN EAGLE,
reverse on glass, circa
1894-1916, 28 b7 15 in.
*Private collection, photo
courtesy of Witherell's.* **D**

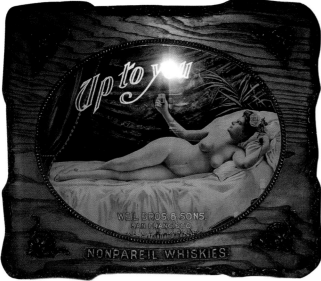

Sign, Weil Bros. & Son, San Francisco, UP
TO YOU, reverse on glass, circa 1900s, 15 by
20 in. *Private collection, photo courtesy of
Witherell's.* **D**

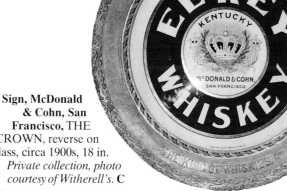

**Sign, McDonald
& Cohn, San
Francisco,** THE
CROWN, reverse on
glass, circa 1900s, 18 in.
*Private collection, photo
courtesy of Witherell's.* **C**

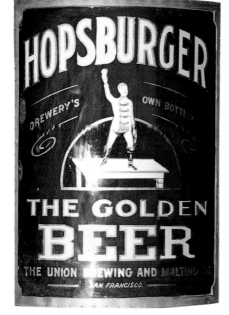

**Sign, Union Brewing
and malting Co., San
Francisco,** THE
GOLDEN BEER,
reverse on glass, circa
1902-1916, 20 by 15 in.
*Private collection, photo
courtesy of Witherell's.* **C**

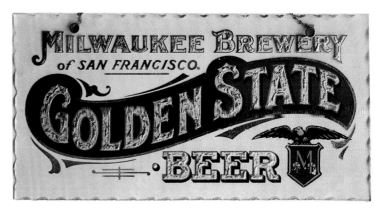

Sign, Milwaukee Brewery, San Francisco,
GOLDEN STATE BEER, reverse on glass,
circa 1902-1920, 4 by 12 in. *Private collection,
photo courtesy of Witherell's.* **A**

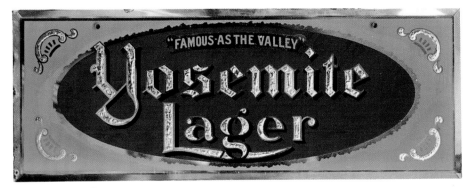

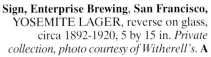

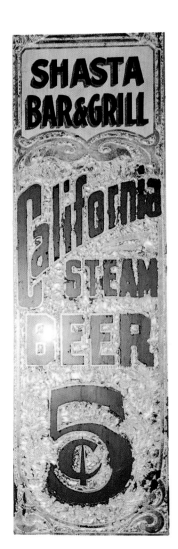

Sign, Enterprise Brewing, San Francisco, YOSEMITE LAGER, reverse on glass, circa 1892-1920, 5 by 15 in. *Private collection, photo courtesy of Witherell's.* **A**

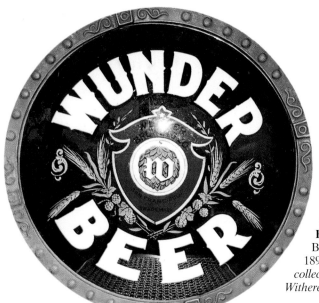

Sign, Shasta Bar & Grill, CALIFORNIA STEAM BEER, reveres on glass, circa 1900s, 48 by 12 in. *Private collection, photo courtesy of Witherell's.* **C**

Sign, Wunder Beer San Francisco, RED, WHITE, & BLUE, reverse on glass, circa 1898-1909, 18 in. *Private collection, photo courtesy of Witherell's.* **C**

Windows

Window, Gilt Edge Whiskey, San Francisco, stained glass, circa 1900s, 20 by 44 in. *Gary Dubnoff, photo courtesy of Witherell's.* **C**

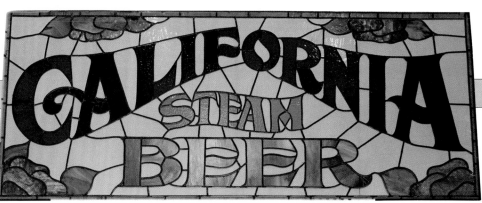

Window, California Steam Beer, stained glass, circa 1900s, 24 by 48. *Gary Dubnoff, photo courtesy of Witherell's.* **C**

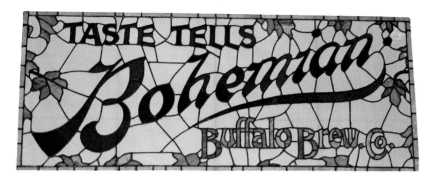

Window, Buffalo Brewing Co.,
Sacramento, stained glass, circa
1900s, 24 by 48 in. *Gary Dubnoff,
photo courtesy of Witherell's.* C

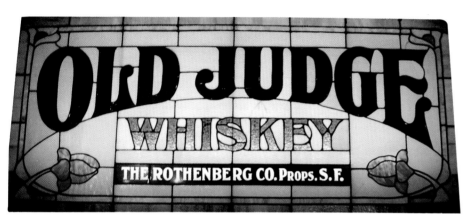

Window, The Rothenberg Co., San Francisco,
OLD JUDGE WHISKEY, stained glass, circa
1900s, 20 by 60 in. *Fat Lady, photo courtesy of
Witherell's.* C

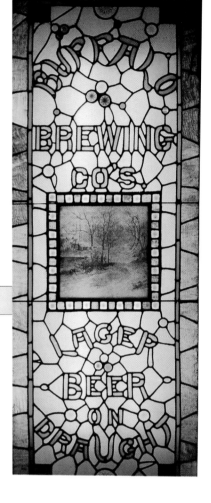

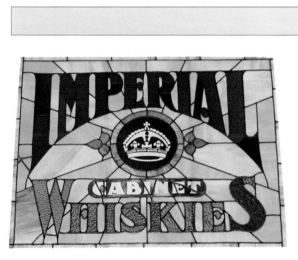

Window, Buffalo Brewing Co., Sacra-
mento, stained glass, circa 1900s, 63 by
24 in. *Charlotte and Don Smith collec-
tion, photo courtesy of Witherell's.* C

Window, Imperial Whiskeys, San
Francisco, stained glass, circa 1900s,
36 by 48 in. *Gary Dubnoff, photo
courtesy of Witherell's.* C

Window, Milwaukee Brewing Co.,
San Francisco, GOLDEN STATE
BEER, stained glass, circa 1900s, 40
in. *Fat Lady, photo courtesy of
Witherell's.* C

Paper and Tin Signs

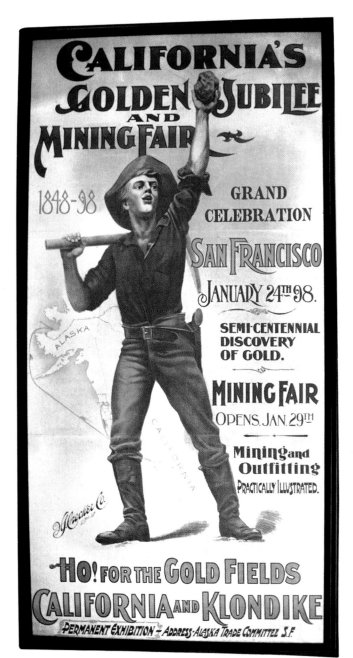

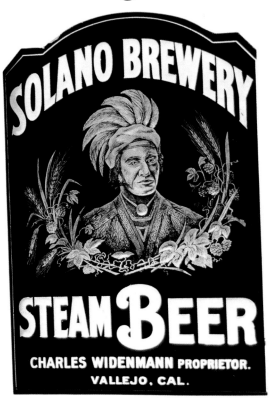

Above:
Sign, Salono Brewery, Vallejo, INDIAN CHIEF, lithograph on tin, circa 1900s, 26 by 16 in. *Private collection, photo courtesy of Witherell's.* **B**

Poster, California's Golden Jubilee and Mining Fair, HO! FOR THE GOLD FIELDS, lithograph on paper, circa 1898, 97 by 42 in. *Al and Carole Cali, photo courtesy of Witherell's.* **D**

Right:
Sign, California Brewing Co, San Francisco, GOLDEN BEAR, lithograph and gold leaf on tin, circa 1880s, 34 by 24. *Bill Rebello collection, photo courtesy of Witherell's.* **D**

Left:
Sign, Meyerfeld, Mitchell and Co., San Francisco, DAY'S OF 49, lithograph on paper, circa 1900s, 22 by 33 in. *Bill Rebello collection, photo courtesy of Witherell's.* **C**

Left:
Sign, Jesse Moore Whiskey, San Francisco, OLD FRIENDS, lithograph on self-framed tin, circa 1903, 26 by 38 in. *Private collection, photo courtesy of Witherell's.* **C**

Sign, Broadway Brewing, San Francisco, STEEM BEER, porcelain, circa 1900s, 22 by 14 in. *Paul Schweizer, photo courtesy of Witherell's.* **B**

Sign, Fredericksburg Brewery, San Jose, EXTRA PALE, lithograph on tin, circa 1890s, 22 by 17 in. *Bill Rebello collection, photo courtesy of Witherell's.* **C**

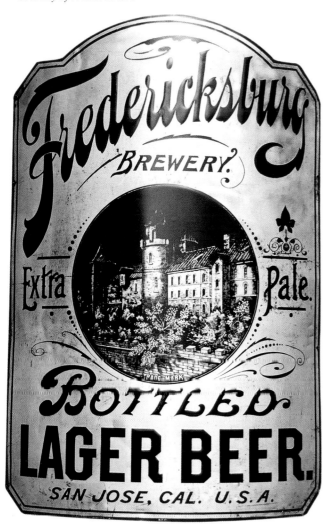

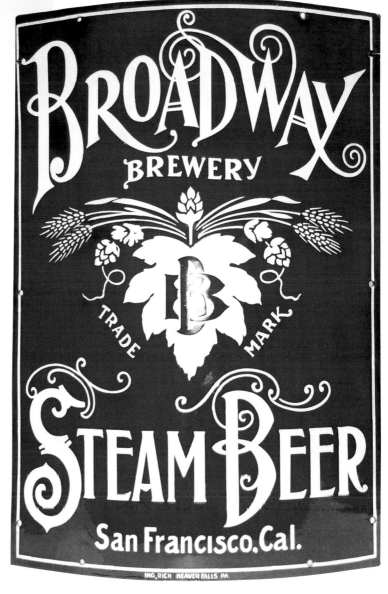

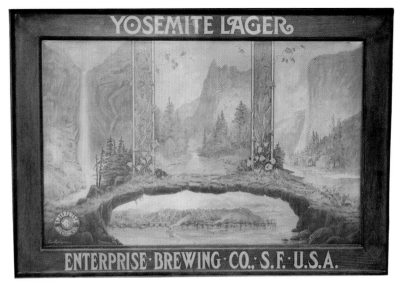

Sign, Enterprise Brewing Co., San Francisco, YOSEMITE VALLEY, lithograph on tin, circa 1892-1920, 22 by 32 in. *Private collection, photo courtesy of Witherell's.* **B**

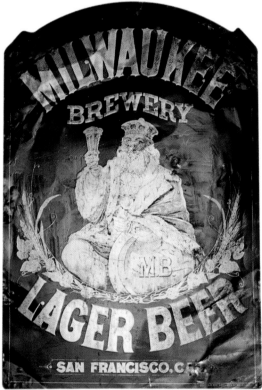

Left:
Sign, Milwaukee Brewery, San Francisco, LAGER BEER, lithograph on tin, circa 1902-1920, 24 by 16 in. *Private collection, photo courtesy of Witherell's.* **A**

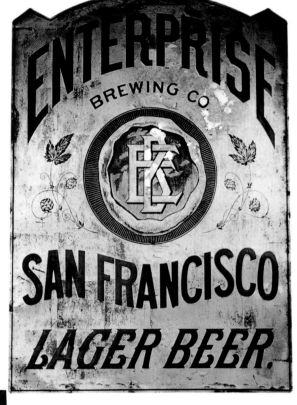

Sign, Enterprise Brewing Co., San Francisco, INTERTWINED INITIALS, lithograph on tin, circa 1892-1920, 24 by 16 in. *Private collection, photo courtesy of Witherell's.* **B**

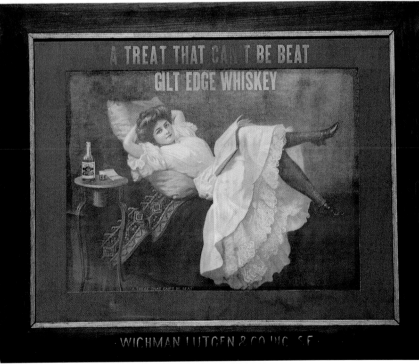

Sign, Gilt Edge Whiskey, San Francisco, TREAT THAT CAN'T BE BEAT, lithograph on paper, circa 1900s, 18 by 24 in. *Al and Carol Cali collection, photo courtesy of Witherell's.* **C**

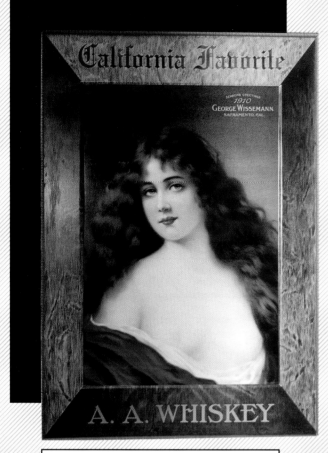

Sign, George Wissemann, Sacramento, CALIFORNIA FAVORITE, lithograph on tin, circa 1900s, 26 by 18 in. *Private collection, photo courtesy of Witherell's.* **C**

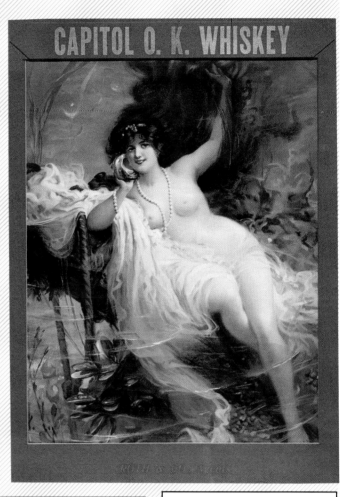

Sign, Roth & Co., San Francisco Agent, CAPITAL O. K. WHISKEY, lithograph on paper, circa 1900s, 22 by 16 in. *Mike and Sally Butler, photo courtesy of Witherell's.* **C**

Sign, Wieland's Beer, San Francisco, FACTORY SCENE, lithograph on paper, circa 1890-1905, 22 by 31 in. *Bill Rebello collection, photo courtesy of Witherell's.* **C**

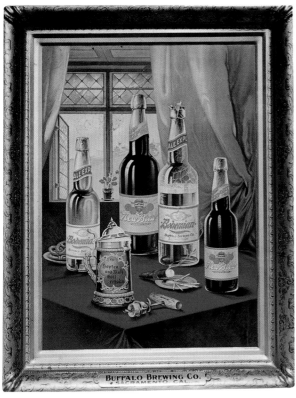

Self-framed tin sign, Treadwell Whiskey, San Francisco, CUSTERS LAST STAND, lithograph on tin, circa 1900s, 20 by 30 in. *Al and Carol Cali, photograph courtesy Witherell's.* **B**

Sign, Buffalo Brewing Co., Sacramento, BEER BOTTLE STILL LIFE, lithograph on tin, circa 1900s, 24 by 18 in. *Charlotte and Don Smith collection, photo courtesy of Witherell's.* **A**

Sign, Old Gilt Edge Bourbon, San Francisco, PUSSY SHOW, embossed, lithograph on paper, die-cut, circa 1900s, 8 by 8 in. *Photo courtesy Witherell's.* **B**

Right:
Sign, Enterprise Brewing Co., San Francisco, YOSEMITE LAGER, porcelain, circa 1900s, 22 by 13 in. *Paul Schweizer, photo courtesy of Witherell's.* **B**

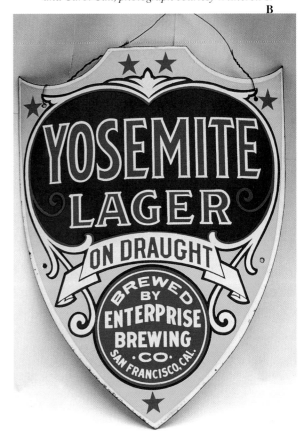

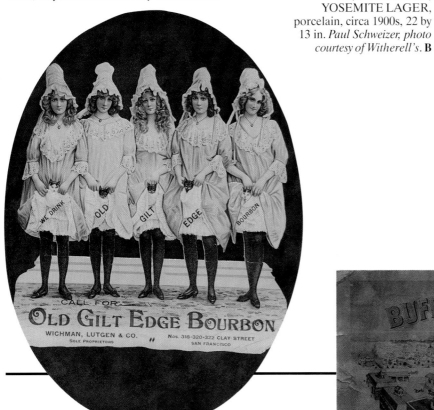

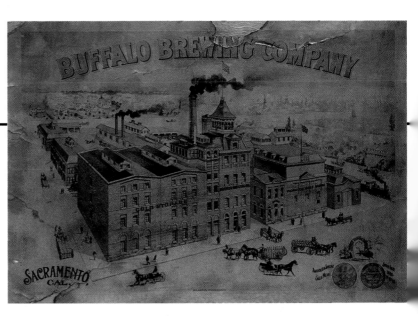

Sign, Buffalo Brewing Co., Sacramento, FACTORY SCENE, lithograph on paper, circa 1900s, 28 by 38 in. *Charlotte and Don Smith collection, photo courtesy of Witherell's.* **A**

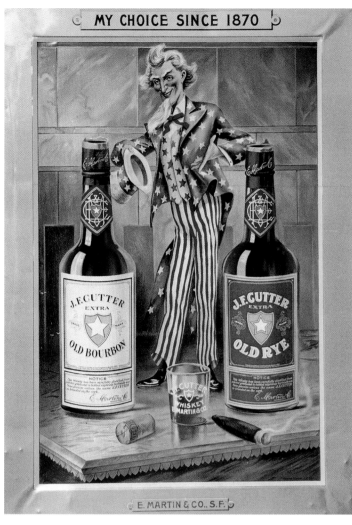

Sign, E. Martin Co., San Francisco, UNCLE SAM, lithograph on self framed tin, circa 1900s, 24 by 17 in. *Private collection, photo courtesy of Witherell's.* **C**

Sign, Buffalo Brewing Co., Sacramento, GRAPHICS ONLY, Porcelain, circa 1900s, 20 by 15 in. *Charlotte and Don Smith collection, photo courtesy of Witherell's.* **B**

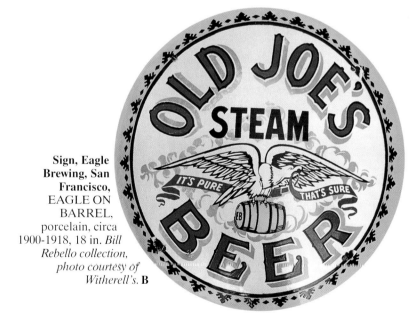

Sign, Eagle Brewing, San Francisco, EAGLE ON BARREL, porcelain, circa 1900-1918, 18 in. *Bill Rebello collection, photo courtesy of Witherell's.* **B**

Left:
Sign, Wieland's Beer, San Francisco, BOTTLE OF BEER, lithograph on tin, circa 1906-1918, 39 by 13 in. *Bill Rebello collection, photo courtesy of Witherell's.* **A**

Sign, Buffalo Brewing Co., Sacramento, SEMI-NUDE LADY, lithograph on tin, circa 1900s, 8 by 22 in. *Charlotte and Don Smith collection, photo courtesy of Witherell's.* **A**

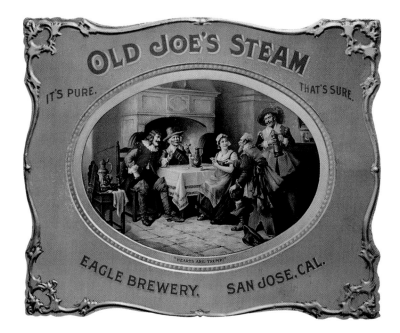

Sign, Eagle Brewing, San Francisco, OLD JOE'S STEEM, lithograph on tin, circa 1900-1918, 17 by 21 in. *Bill Rebello collection, photo courtesy of Witherell's.* **A**

Sign, California and Oregon Stage Co., VIEW OF MT. SHASTA, lithograph on paper, circa 1870s, 15 by 20 in. *Mike and Sally Butler, photo courtesy of Witherell's.* **D**

Sign, Ruhstaller's, Sacramento, COCK-FIGHT, lithograph on tin, circa 1912, 24 by 20 in. *Charlotte and Don Smith collection, photo courtesy of Witherell's.* **B**

Sign, Fredericksburg Brewery, San Jose, FACTORY SCENE, lithograph on paper, circa 1900s, 20 by 26 in. *Bill Rebello collection, photo courtesy of Witherell's.* **B**

Sign, Jesse Moore Whiskey, San Francisco, THE SPORTS, reverse painted on glass, circa 1898, 15 by 20 in. *Mike and Sally Butler, photo courtesy of Witherell's.* **D**

Sign, Wieland's Brewery, San Francisco, PA-POOSE, lithograph on tin, circa 1920s, 12 by 37 in. *Bill Rebello collection, photo courtesy of Witherell's.* **C**

Sign, Fredericksburg Brewing, San Jose, GOLD MEDAL, embossed tin, circa 1900s, 14 by 19 in. *Bill Rebello collection, photo courtesy of Witherell's.* **A**

Sign, Fredericksburg Brewing, San Jose, THE CASTLE, lithograph on tin, circa 1900-1918, 14 by 19 in. *Bill Rebello collection, photo courtesy of Witherell's.* **A**

Sign, Cyrus Noble Whiskey, San Francisco, BUCKING THE TIGER, lithograph on paper, circa 1900s, 26 by 41 in. *P. I. F. collection, photo courtesy of Witherell's.* **C**

Sign, Boca Brewing Co., San Francisco, HARBOR SCENE, lithograph on paper, circa 1900s, 20 by 30 in. *Private collection, photo courtesy of Witherell's.* **D**

Sign, Enterprise Brewing Co., San Francisco,
SEATED MAN, lithograph on self framed tin,
circa 1900s, 26 by 18 in. *Private collection,
photo courtesy of Witherell's.* **A**

Sign, Buffalo Brewing Co., Sacramento,
THE ENQUEST, lithograph on tin, circa
1902-1905, 17 in. *Private collection,
photo courtesy of Witherell's.* **B**

Sign, Enterprise Brewing Co., San Francisco,
GRAPHICS ONLY, embossed tin, circa
1890s, 24 by 18 in. *Private collection, photo
courtesy of Witherell's.* **A**

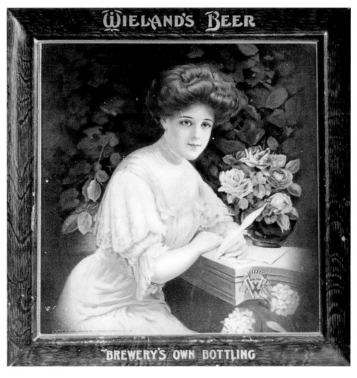

**Sign, Wieland's Beer, San Francisco, LADY
WITH LETTER, lithograph on self framed
tin, circa 1900-1918, 14 in. *Bill Rebello
collection, photo courtesy of Witherell's.* **A**

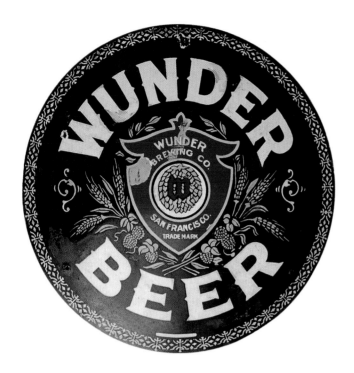

Sign, Wunder Brewing, San Francisco, RED WHITE & BLUE, porcelain, circa 1898-1909, 18 in. *Private collection, photo courtesy of Witherell's.* **A**

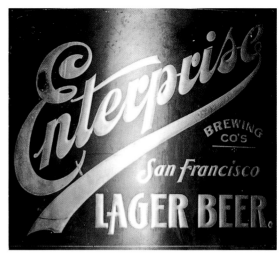

Sign, Enterprise Brewing, San Francisco, GRAPHICS ONLY, lithograph on tin, 1892-1920, 16 by 20 in. *Private collection, photo courtesy of Witherell's.* **A**

Sign, Dr. Walker's Vingar Bitters, CALIFORNIA, reverse painted on glass, circa 1900s, 17 in. *Richard Siri collection, photo courtesy of Witherell's.* **C**

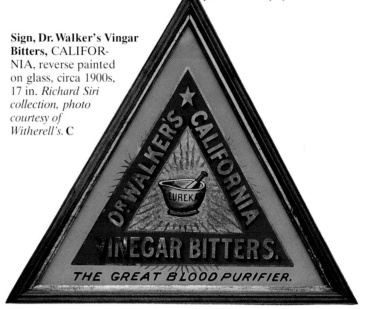

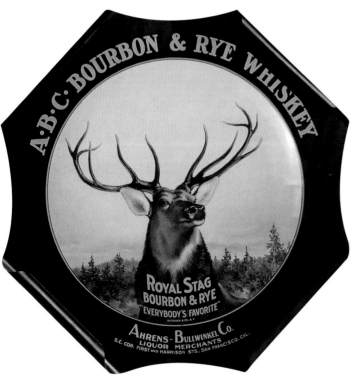

Sign, Ahrens Bullwinkel Co., San Francisco Agent, ROYAL STAG BOURBON AND RYE, lithograph on tin, circa 1900s, 14 in. *Bill Rebello, photo courtesy of Witherell's.* **A**

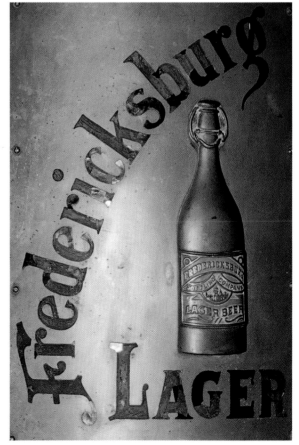

Sign, Fredericksburg Brewing, San Jose, LAGER, brass, circa 1893-1920, 24 by 16 in. *Private collection, photo courtesy of Witherell's.*
B

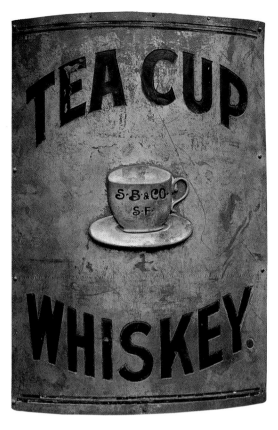

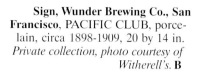

Sign, Wunder Brewing Co., San Francisco, PACIFIC CLUB, porcelain, circa 1898-1909, 20 by 14 in. *Private collection, photo courtesy of Witherell's.* B

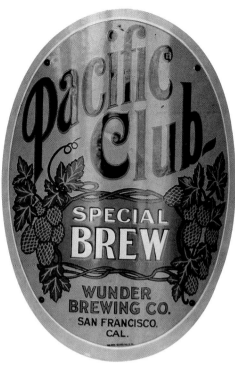

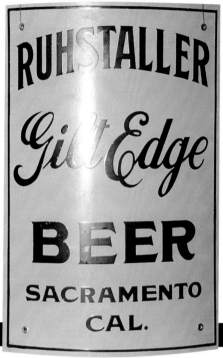

Sign, Tea Cup Whiskey, San Francisco, BRASS CORNOR SIGN, circa 1890s, 25 by 18 in. *Richard Siri collection, photo courtesy of Witherell's.* B

Sign, Ruhstaller Brewery, Sacramento, GRAPHICS ONLY, porcelain, circa 1897-1920, 24 by 15 in. *Private collection, photo courtesy of Witherell's.* A

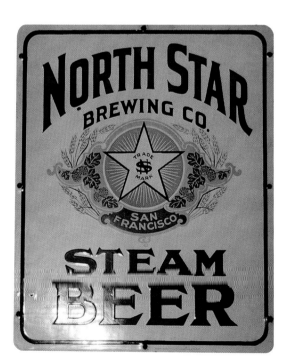

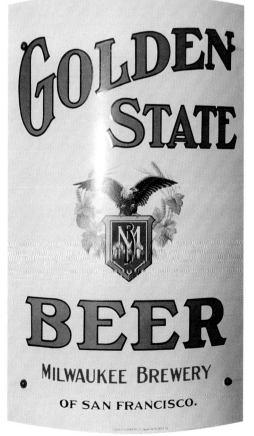

Sign, North Star Brewing Co., San Francisco, TRADE MARK, porcelain, circa 1897-1920, 20 by 15 in. *Private collection, photo courtesy of Witherell's.* A

Sign, Milwaukee Brewery, San Francisco, SPREAD WING EAGLE, porcelain, circa 1902-1920, 24 by 16 in. *Private collection, photo courtesy of Witherell's.* B

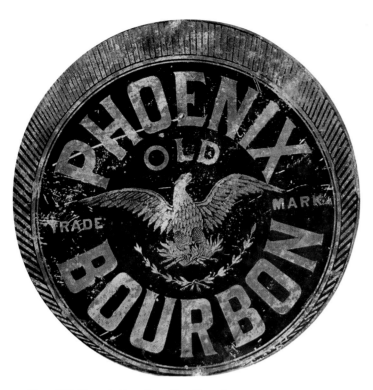

Sign, Old Phoenix Bourbon, San Francisco,
EAGLE, lithograph on tin, circa 1900s, 16 in.
Private collection, photo courtesy of Witherell's. **A**

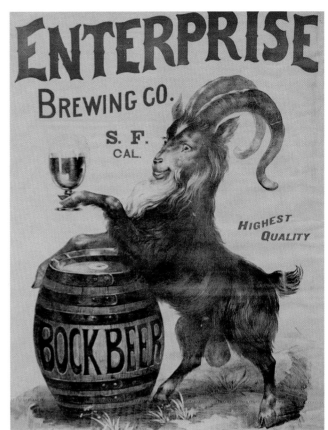

Sign, Enterprise brewing, San Francisco,
HIGHEST QUALITY, lithograph on paper,
circa 1892-1920, 34 by 24 in. *Private collec-*
tion, photo courtesy of Witherell's. **A**

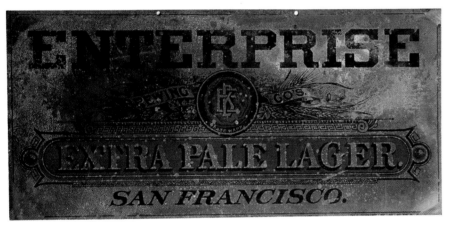

Sign, Enterprise Brewing Co.,
San Francisco, EXTRA PALE
LAGER, lithograph on tin, circa
1892-1920, 6 by 18 in. *Private*
collection , photo courtesy of
Witherell's. **A**

Sign, Wunder Brewing, San Francisco,
PACIFIC CLUB, lithograph on tin, 1898-
1909, 12 in. *Private collection, photo courtesy*
of Witherell's. **A**

Sign, Buffalo Brewing, Sacramento, FAC-
TORY SCENE, lithograph on paper, circa
1890-1920, 20 by 30 in. *Private collection,*
photo courtesy of Witherell's. **B**

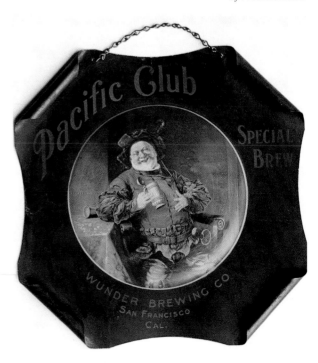

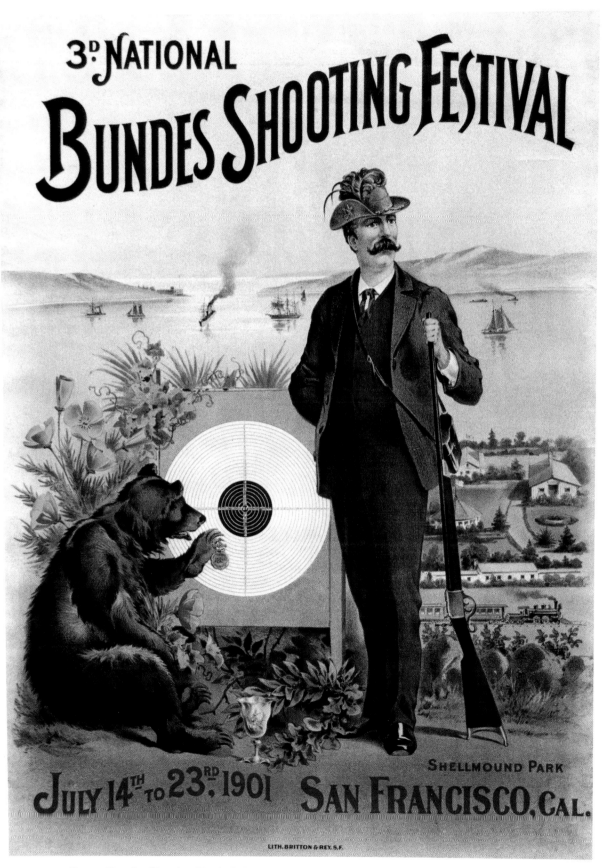

Poster, Bundes Shooting Festival, San Francisco, 3rd NATIONAL, lithograph on paper, circa 1901, 41 by 28 in. *Richard Siri collection, photo courtesy of Witherell's.* **D**

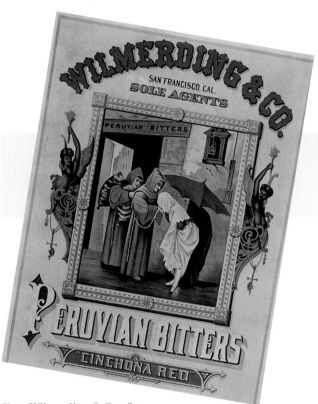

Sign, S.B. Rothenberg, Oakland, BERLINER BITTERS, lithograph on paper, circa 1890s, 20 by 14 in. *Richard Siri collection, photo courtesy of Witherell's.* **B**

Sign, Wilmerding & Co., San Francisco Agent, PERVIAN BITTERS, lithography on canvas, circa 1880s, 27 by 21 in. *Richard Siri collection, photo courtesy of Witherell's.* **C**

Sign, Spruance, Stanley & Co., San Francisco, AFRICAN STOMACH BITTERS, lithography on tin, circa 1880s, 28 by 20 in. *Richard Siri collection, photo courtesy of Witherell's.* **C**

Sign, G.W.Chesley & Co., San Francisco, PORTRAIT OF A LADY, lithograph on tin, circa 1890s, 27 by 13 in. *Richard Siri collection, photo courtesy of Witherell's.* **C**

Sign, Roth & Co., San Francisco, BOTTLED
IN BOND, lithography on tin, circa 1879-
1919, 28 by 22 in. *Richard Siri collection,
photo courtesy of Witherell's.* **A**

Sign, Spruance, Stanly & Co., San Francisco,
LADY IN RED OUTFIT, lithograph on
paper, circa 1900s, 24 by 20 in. *Richard Siri
collection, photo courtesy of Witherell's.* **B**

Sign, California Fig Syrup Co., San Francisco,
SYRUP OF FIGS, decal on wood, circa 1900s,
20 by 14 in. *Richard Siri collection, photo
courtesy of Witherell's.* **B**

Sign, Roth & Co., San Francisco, O.K.
CAPITOL WISKEY, lithography on paper,
circa 1879-1919, 23 by 18 in. *Richard Siri
collection, photo courtesy of Witherell's.* **B**

Sign, Roth & Co., San Francisco, O.K. CAPTOL, lithograph on paper, circa 1879-1919, 18 by 23 in. *Richard Siri, photo courtesy of Witherell's.* **B**

Sign, Roth & Co., San Francisco, LADIES ON BENCH, lithograph on paper, circa 1879-1919, 20 by 24 in. *Richard Siri collection, photo courtesy of Witherell's.* **B**

Sign, Roth & Co., San Francisco, LAYTON RYE, lithograph on paper, circa 1879-1919, 25 by 13 in. *Richard Siri, photo courtesy of Witherell's.* **B**

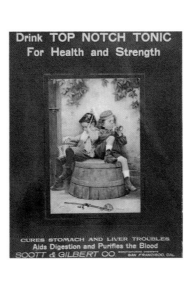

Sign, Scott & Gilbert Co., San Francisco, TOP NOTCH TONIC, lithograph on paper, circa 1900s, 14 by 11 in. *Richard Siri collection, photo courtesy of Witherell's.* **A**

Sign, Roth & Co., San Francisco, LAYTON RYE, lithograph on paper, circa 1879-1919, 28 by 19 in. *Richard Siri collection, photo courtesy of Witherell's.* **B**

Sign, F. Chevalier & Co., San Francisco Agents, CASTLE WISKEY, lithograph on paper, circa 1890s, 18 by 22 in. *Richard Siri collection, photo courtesy of Witherell's.* **B**

Sign, National Lager Bottling Works, San Francisco, VICTORY, lithograph on paper, circa 1900s, 30 by 20 in. *Private collection, photo courtesy of Witherell's.* **B**

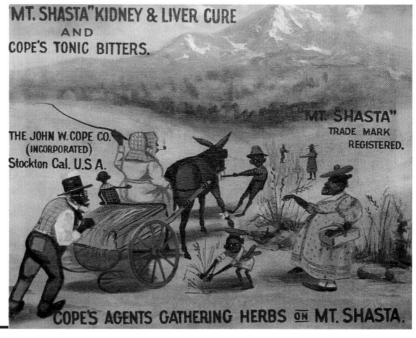

Sign, Mt. Shasta, Stockton, HARVESTING HERBS, Oil on canvas, circa 1880s, 24 by 30 in.*Richard Siri collection, photo courtesy of Witherell's.* **C**

Lithographed Chargers and Trays

Charger, Ruhstaller's, Sacramento, GERMAIN COUPLE, lithograph on tin, circa 1907, 24 in. *Charlotte and Don Smith collection, photo courtesy of Witherell's.* **B**

Charger, Wieland's Brewery, San Francisco, BONNET GIRL, lithograph on tin, circa 1907, 16 in. *Bill Rebello collection, photo courtesy of Witherell's.* **B**

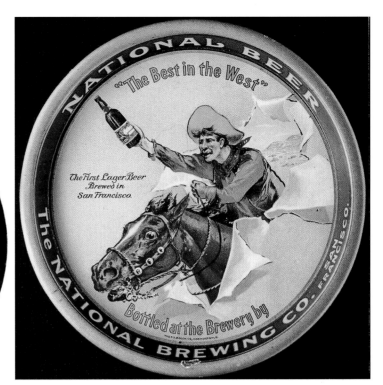

Tip tray, National Brewing Co., San Francisco, BEST IN THE WEST, lithograph on tin, circa 1903, 4 in. *Mike and Sally Butler, photo courtesy of Witherell's.* **A**

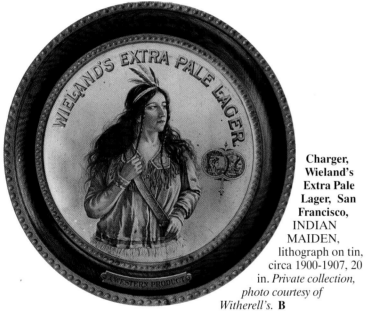

Charger, Wieland's Extra Pale Lager, San Francisco, INDIAN MAIDEN, lithograph on tin, circa 1900-1907, 20 in. *Private collection, photo courtesy of Witherell's.* **B**

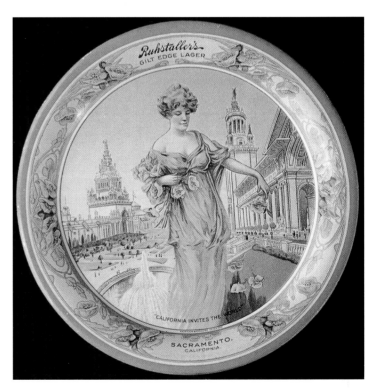

Tip tray, Ruhstaller's, Sacramento, CALIFORNIA INVITES THE WORLD, lithograph on tin, circa 1915, 4 in. *Mike and Sally Butler, photo courtesy of Witherell's.* **A**

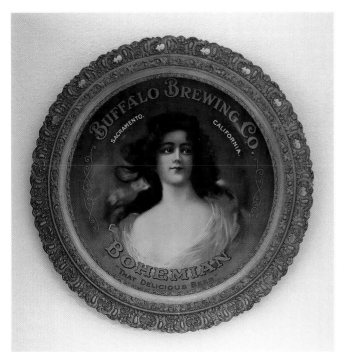

Charger, Buffalo Brewing Co., Sacramento, PRETTY LADY, lithograph on tin, circa 1907, 24 in. *Private collection, photo courtesy of Witherell's.* **C**

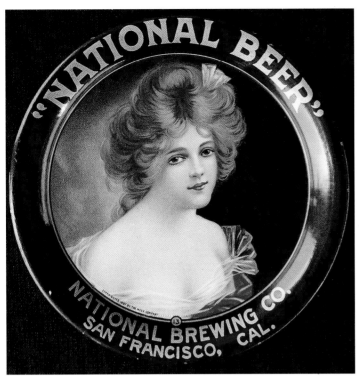

Tip tray, National Brewing Co., San Francisco,
RED HEADED BEAUTY, lithograph on tin,
circa 1907, 4 in. *Mike and Sally Butler, photo
courtesy of Witherell's.* **A**

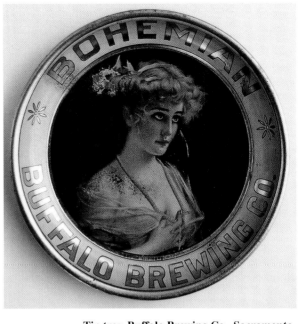

Tip tray, Buffalo Brewing Co., Sacramento,
LADY WITH PEARLS, lithograph on tin,
circa 1905, 4 in. *Charlotte and Don Smith
collection, photo courtesy of Witherell's.* **A**

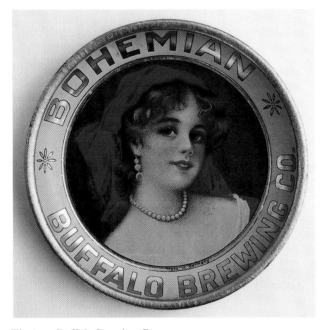

**Tip tray, Buffalo Brewing Co.,
Sacramento,** LADY WITH RED
BANDANA, lithograph on tin, circa
1905, 4 in. *Charlotte and Don Smith
collection, photo courtesy of
Witherell's.* **A**

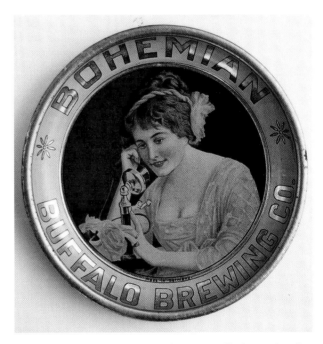

**Tip Tray, Buffalo Brewing Co.,
Sacramento,** LADY ON
PHONE, lithograph on tin, circa
1910s, 4 in. *Charlotte and Don
Smith collection, photo courtesy of
Witherell's.* **A**

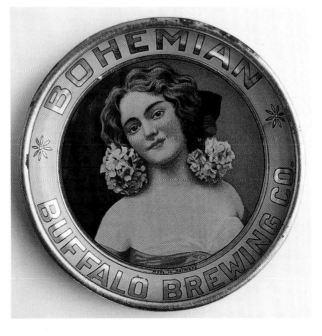

**Tip tray, Buffalo Brewing Co.,
Sacramento,** LADY WITH
HYDRANGIA, lithograph on tin,
circa 1905, 4 in. *Charlotte and Don
Smith collection, photo courtesy of
Witherell's.* **A**

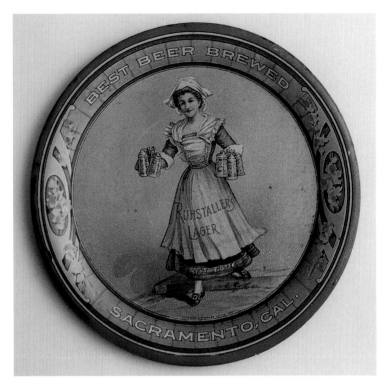

Tip Tray, Ruhstaller's, Sacramento, LADY WITH STEINS, lithograph on tin, circa 1910s, 4 in. *Charlotte and Don Smith collection, photo courtesy of Witherell's.* **A**

Tip tray, Buffalo Brewing Co., Sacramento, SAN FRANCISCO EXHIBITION, lithograph on tin, circa 1915, 4 in. *Chalotte and Don Smith collection, photo courtesy of Witherell's.* **A**

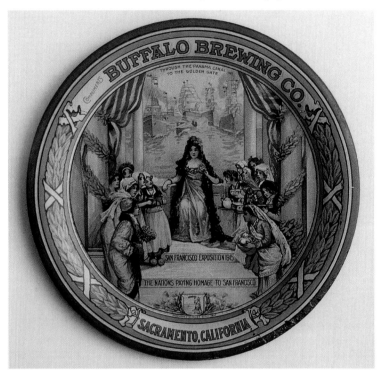

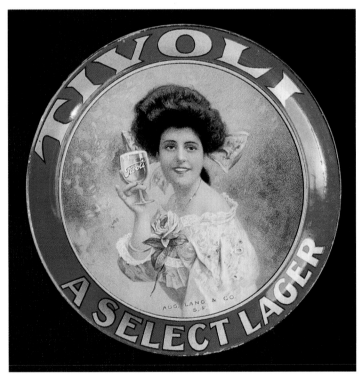

Tip tray, Aug. Lang & Co., San Francisco, TIVOLI GIRL, lithograph on tin, circa 1900s, 4 in. *Mike and Sally Butler, photo courtesy of Witherell's.* **A**

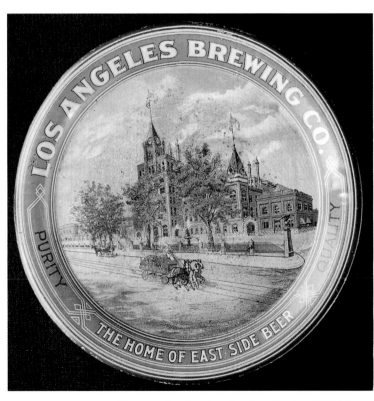

Tip tray, Los Angeles Brewing Co., FACTORY SCENE, lithograph on tin, circa 1897-1910, 5 in. *Mike and Sally Butler, photo courtesy of Witherell's.* **A**

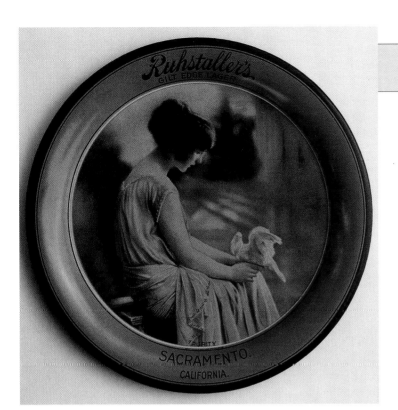

Tip tray, Ruhstaller's, Sacramento, PURITY, lithograph on tin, circa 1910s, 4 in. *Charlotte and Don Smith collection, photo courtesy of Witherell's.* **A**

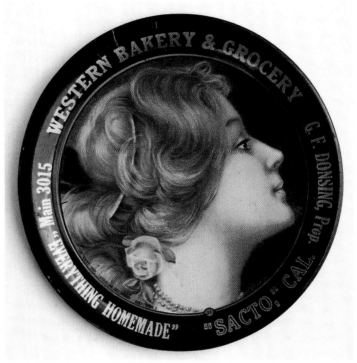

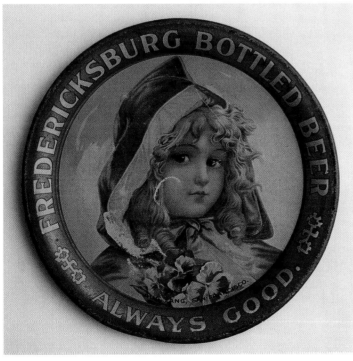

Tip tray, Fredericksurg, San Francisco Agent, GIRL WITH BONNETT, lithograph on tin, circa 1905, 4 in. *Charlotte and Don Smith collection, photo courtesy of Witherell's.* **A**

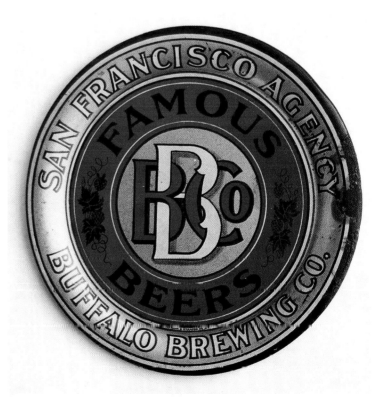

Tip tray, Buffalo Brewing Co., San Francisco Agent, FAMOUS BEERS, lithograph on tin, circa 1905, 4 in. *Charlotte and Don Smith collection, photo courtesy of Witherell's.* **A**

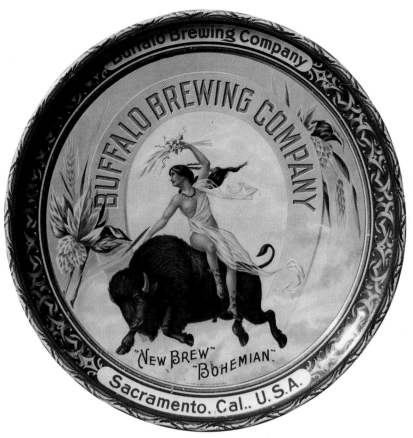

Tray, Buffalo Brewing Co., Sacramento,
INDIAN SQUAW RIDING BUFFALO,
lithograph on tin, circa 1901, 11 in. *Private
collection, photo courtesy of Witherell's.* **C**

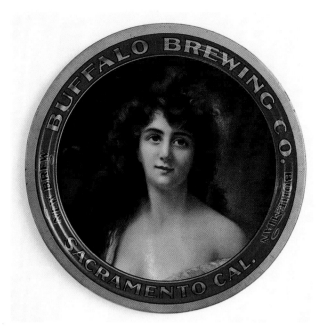

Tray, Buffalo Brewing Co., Sacramento, NEW
BREW, lithograph on tin, circa 1902, 13 in.
*Charlotte and Don Smith collection, photo
courtesy of Witherell's.* **A**

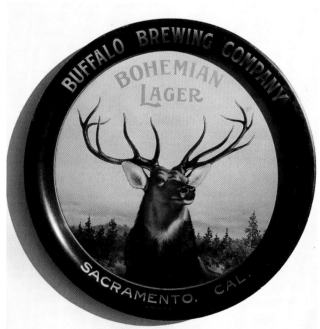

Tray, Buffalo Brewing Co., Sacramento, THE
ELK, lithograph on tin, circa 1900s, 13 in.
*Charlotte and Don Smith collection, photo
courtesy of Witherell's.* **A**

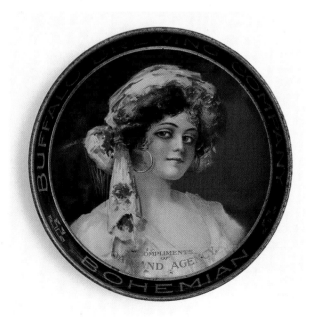

Tray, Buffalo Brewing Co., Oakland Agent,
GYPSY GIRL, lithograph on tin, circa 1900s,
13 in. *Charlotte and Don Smith collection,
photo courtesy of Witherell's.* **A**

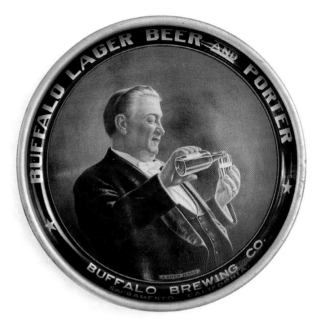

Tray, Buffalo Brewing Co., Sacramento, A GOOD JUDGE, lithograph on tin, circa 1900s, 13 in. *Charlotte and Don Smith collection, Photo courtesy of Witherell's.* **A**

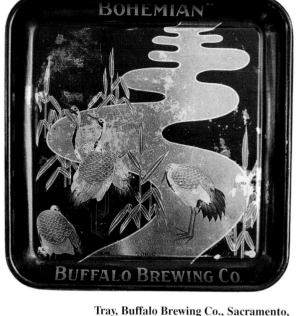

Tray, Buffalo Brewing Co., Sacramento, TOKIA, lithograph on tin, circa 1900s, 13 in. *Charlotte and Don Smith collection, photo courtesy of Witherell's.* **A**

Left:
Tray, Buffalo Brewing Co., Sacramento, SAN FRANCISCO EXPOSITION, lithograph on tin, circa 1915, 13 in. *P.I.F. collection, photo courtesy of Witherell's.* **A**

Tray, Buffalo Brewing Co., Sacramento, CARNATION GIRL, lithograph on tin, circa 1900s, 13 in. *Charlotte and Don Smith collection, photo courtesy of Witherell's.* **A**

Tray, Buffalo Brewing Co., Sacramento, MONARCH OF ALL BEERS, lithograph on tin, circa 1900s, 13 in. *Charlotte and Don Smith collection, photo courtesy of Witherell's.* **A**

Tray, Buffalo Brewing Co., Sacramento,
HAPPY DAYS, lithograph on tin, circa 1910s,
13 in. *Charlotte and Don Smith collection,*
photo courtesy of Witherell's. **A**

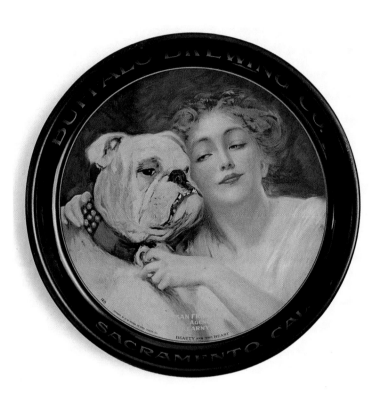

Tray, Buffalo Brewing Co., San Francisco
Agency, BEAUTY AND THE BEST, lithograph on tin, circa 1910s,13 in. *Charlotte and*
Don Smith collection, photo courtesy of
Witherell's. **B**

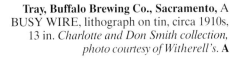

Tray, Buffalo Brewing Co., Sacramento,
INDIAN CHAISING BUFFALO'S, lithograph on tin, circa 1910, 13 in. *Private*
collection, photo courtesy of Witherell's. **A**

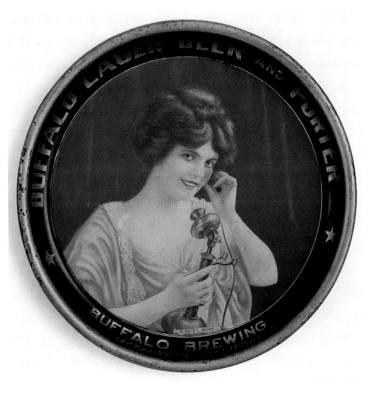

Tray, Buffalo Brewing Co., Sacramento, A
BUSY WIRE, lithograph on tin, circa 1910s,
13 in. *Charlotte and Don Smith collection,*
photo courtesy of Witherell's. **A**

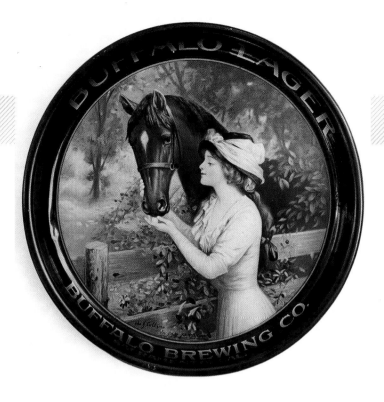

Tray, Buffalo Brewing Co., Sacramento, IN OLD KENTUCKY, lithograph on tin, circa 1900s, 13 in. *Charlotte and Don Smith collection, photo courtesy of Witherell's.* **A**

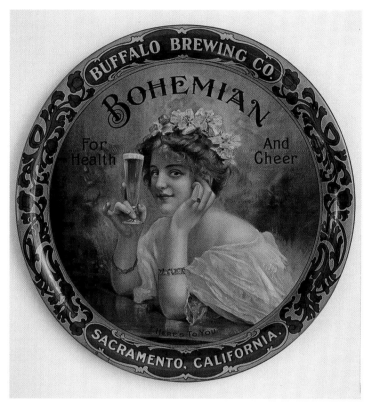

Tray, Buffalo Brewing Co., Sacramento, HERE'S TO YOU, lithograph on tin, circa 1905, 13 in. *Charlotte and Don Smith collection, photo courtesy of Witherell's.* **A**

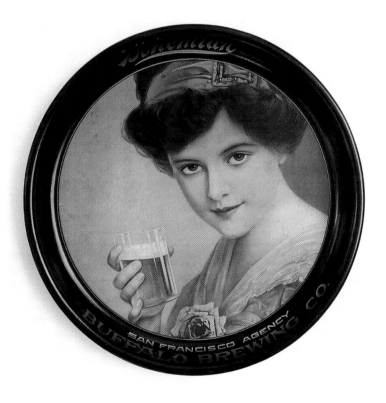

Tray, Buffalo Brewing Co., San Francisco Agency, JOIN ME, lithograph on tin, circa 1910s, 13 in. *Charlotte and Don Smith collection, photo courtesy of Witherell's.* **A**

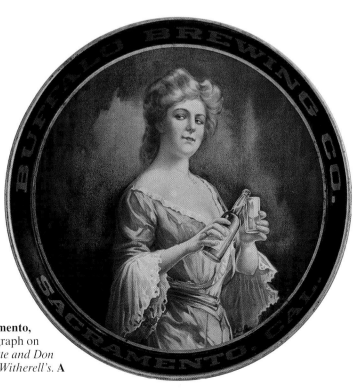

Tray, Buffalo Brewing Co., Sacramento, LADY WITH BOTTLE, lithograph on tin, circa 1910, 13 in. *Charlotte and Don Smith collection, photo courtesy of Witherell's.* **A**

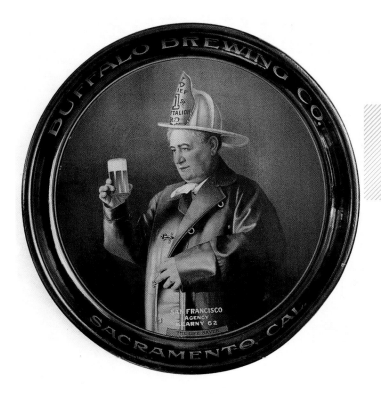

Tray, Buffalo Brewing Co., San Francisco Agent, THE LIFE SAVER, lithograph on tin, circa 1900s, 13 in. *Charlotte and Don Smith collection, photo courtesy of Witherell's.* **A**

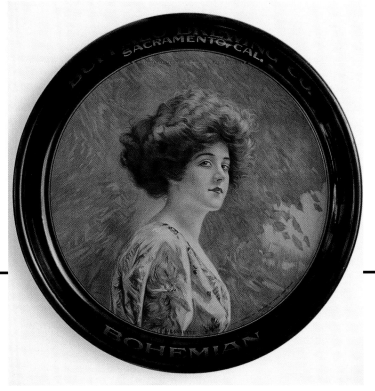

Tray, Buffalo Brewing Co., Sacramento, JEANETTE, lithograph on tin, circa 1912-1915, 13 in. *Charlotte and Don Smith collection, photo courtesy of Witherell's.* **A**

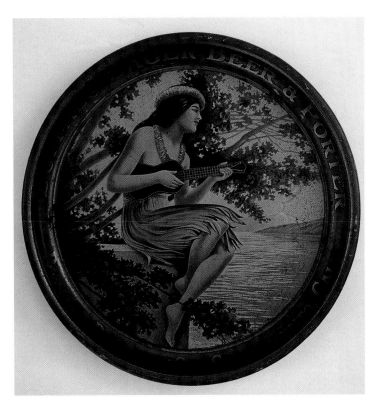

Tray, Buffalo Brewing Co., Sacramento, HAWIAN GIRL, lithograph on tin, circa 1900s, 13 in. *Charlotte and Don Smith collection, photo courtesy of Witherell's.* **A**

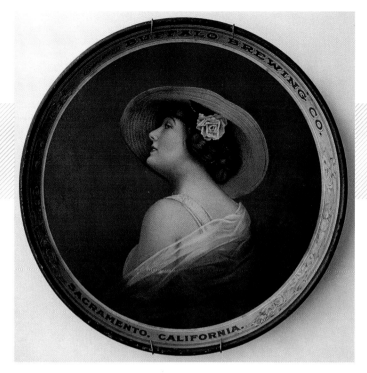

Tray, Buffalo Brewing Co., Sacramento,
LADY IN RED GROUND, lithograph on tin,
circa 1900s, 12 in. *P.I. . collection, photo*
courtesy of Witherell's. **A**

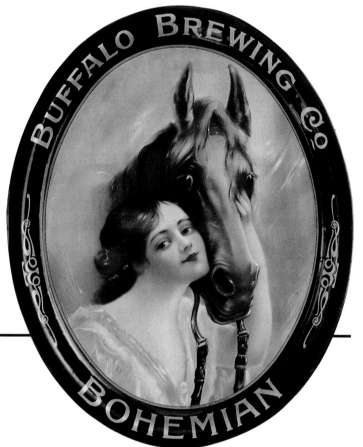

Tray, Buffalo Brewing Co., Sacramento, GIRL
WITH HORSE, lithograph on tin, circa 1900s,
16 in. *Charlotte and Don Smith collection,*
photo courtesy of Witherell's. **B**

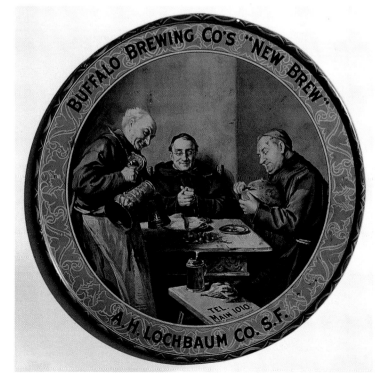

Tray, Buffalo Brewing Co., San Francisco
Agent, THREE MONKS, lithograph on tin,
circa 1900s, 13 in. *Charlotte and Don Smith*
collection, photo courtesy of Witherell's. **A**

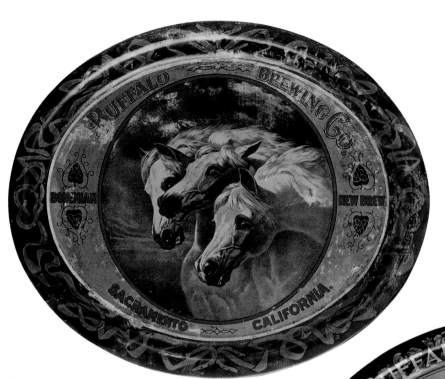

Tray, Buffalo Brewing, Sacramento, A TRIO
OF HORSES, lithograph on tin, circa 1900s,
16 in. *Charlotte and Don Smith collection,
photo courtesy of Witherell's.* **B**

Tray Buffalo Brewing Co., Sacramento,
APPLE STILL LIFE, lithograph on tin, circa
1900s, 16 in. *Charlotte and Don Smith collec-
tion, photo courtesy of Witherell's.* **A**

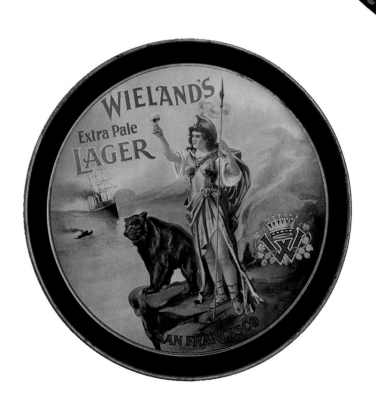

Tray, Wieland's Brewery, San Francisco,
SALUTE TO GOLDEN GATE, lithograph on
tin, circa 1910, 12 in. *Bill Rebello collection,
photo courtesy of Witherell's.* **B**

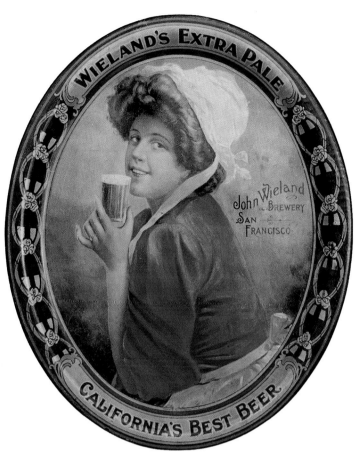

Tray, Wieland's Brewery, San Francisco,
BONNET GIRL, lithograph on tin, circa
1907, 17 By 13 in. *Bill Rebello collection, photo
courtesy of Witherell's.* **A**

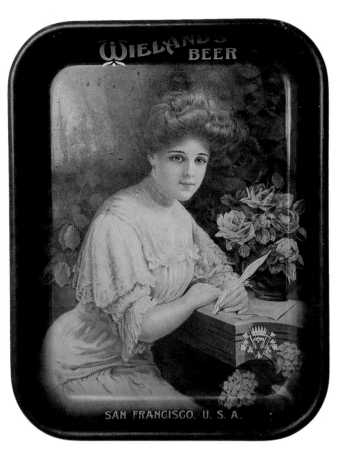

Tray, Wieland's Beer, San Francisco, LADY
WITH LETTER, lithograph on tin, circa
1900s, 14 in. *Al and Carole Cali, photo courtesy
of Witherell's.* **A**

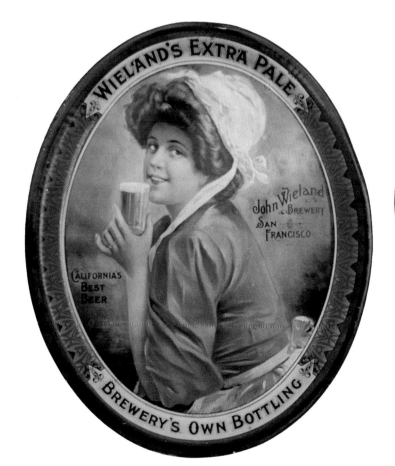

Tray, Wieland's Brewery, San Francisco,
BONNET GIRL, lithograph on tin, circa
1907, 17 by 13 in. *Bill Rebello collection, photo
courtesy of Witherell's.* **A**

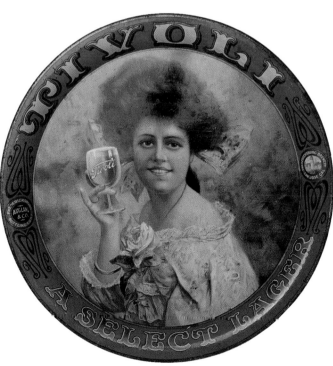

Tray, Fredericksburg Brewery, San Jose,
TIVOLI GIRL, lithograph on tin, circa 1900s,
13 in. *Al and Carol Cali, photo courtesy of
Witherell's.* **A**

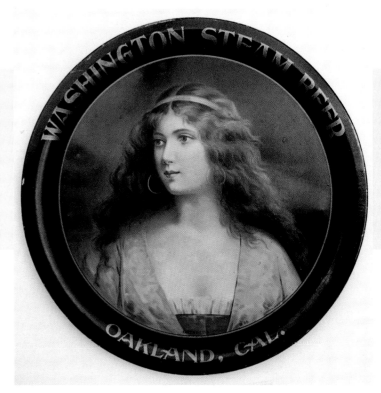

Tray, Washington Steem Beer, Oakland, CRISELDA, lithograph on tin, circa 1900-1918, 12 in. *Bill Rebello collection, photo courtesy of Witherell's.* **A**

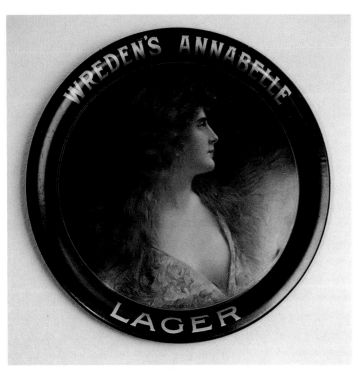

Tray, Wreden's Annabelle, San Francisco, ANNABELLE, lithograph on tin, circa 1900s, 13 in. *Gary Dubnoff, photo courtesy of Witherell's.* **A**

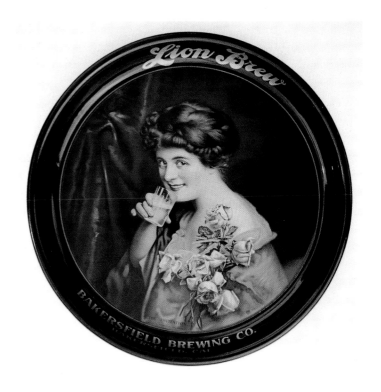

Tray, Bakersfield Brewing Co., Bakersfield, LION BREW, lithograph on tin, circa 1910s, 12 in. *Charlie Zawila, photo courtesy of Witherell's.* **A**

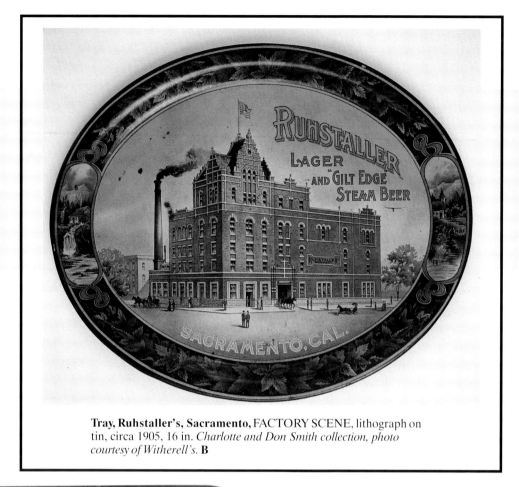

Tray, Ruhstaller's, Sacramento, FACTORY SCENE, lithograph on tin, circa 1905, 16 in. *Charlotte and Don Smith collection, photo courtesy of Witherell's.* **B**

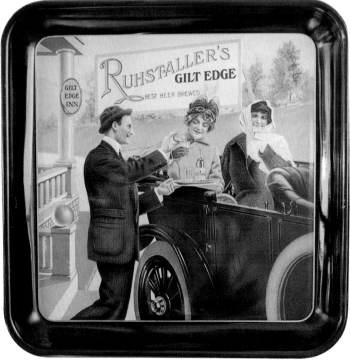

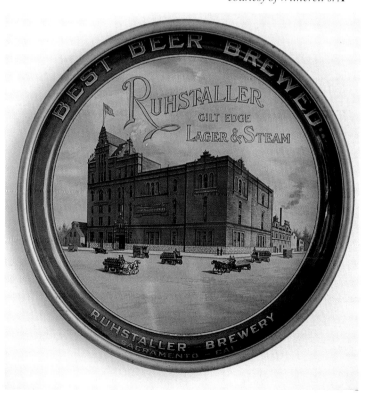

Tray, Ruhstaller's, Sacramento, FACTORY SCENE, lithograph on tin, circa 1910-1912, 13 in. *Charlotte and Don Smith collection, photo courtesy of Witherell's.* **A**

Tray, Ruhstaller's, Sacramento, GILT EDGE INN, lithograph on tin, circa 1910s, 13 in. *Charlotte and Don Smith collection, photo courtesy of Witherell's.* **A**

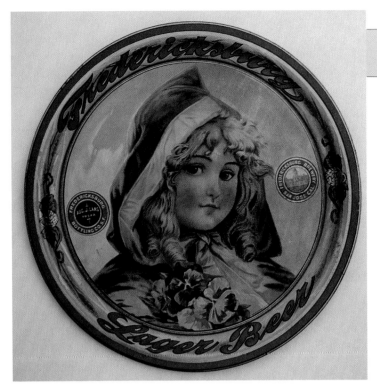

Tray, Fredericksburg Brewery, San Jose,
GIRL IN BLUE, lithograph on tin, circa 1905,
12 in. *Bill Rebello collection, photo courtesy of
Witherell's.* **A**

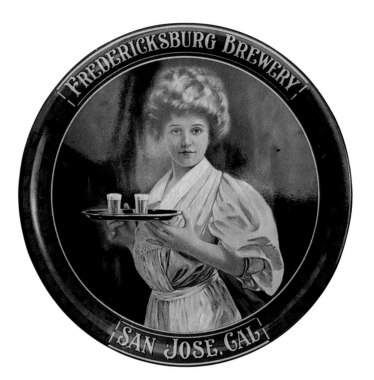

Tray, Fredericksburg Brewing, San Jose,
BEER MAIDEN, lithograph on tin,
circa 1905-1910, 13 in. *Bill Rebello
collection, photo courtesy of Witherell's.* **A**

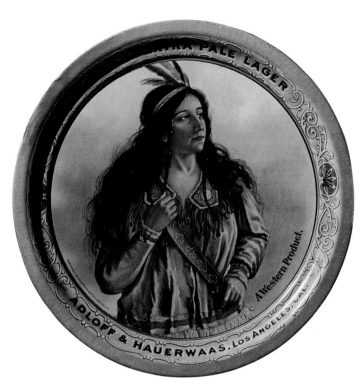

Tray, Wieland's, San Francisco, A WESTERN
PRODUCT, lithograph on tin, circa 1900-
1907, 13 in. *Private collection, photo courtesy of
Witherell's.* **A**

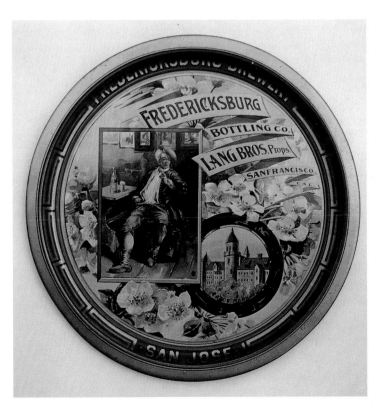

Tray, Fredericksburg Brewing, San Jose,
LANG BROS., lithograph on tin, circa 1900-
1918, 12 in. *Bill Rebello collection, photo
courtesy of Witherell's.* **A**

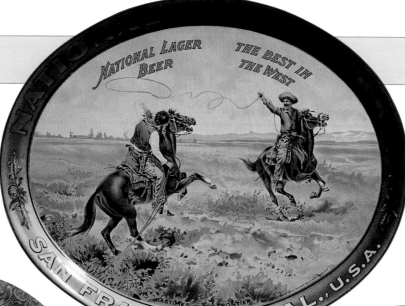

Tray, National Brewing, San Francisco, EASY TIMES ON THE FRONTIER, lithograph on tin, circa 1903, 16 in. *Private collection, photo courtesy of Witherell's.* **B**

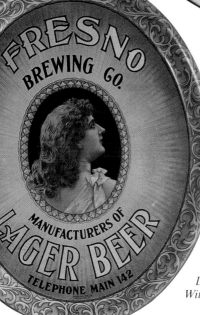

Tray, Fresno Brewing Co., Fresno, PORTRAIT OF LADY, lithograph on tin, circa 1910s, 15 in. *Gary Dubnoff, photo courtesy of Witherell's.* **A**

Tray, National Brewing Co., San Francisco, THE BEST IN THE WEST, lithograph on tin, circa 1903, 16 in. *Private collection, photo courtesy of Witherell's.* **B**

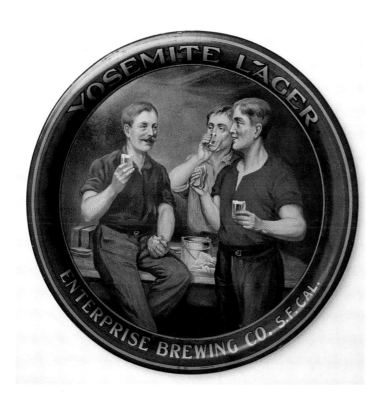

Tray, Enterprise Brewing Co., San Francisco, 12 O'CLOCK, lithograph on tin, circa 1906, 12 in. *Al and Carol Cali, photo courtesy of Witherell's.* **A**

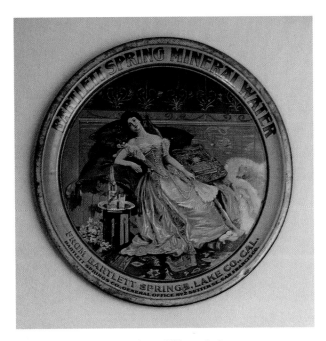

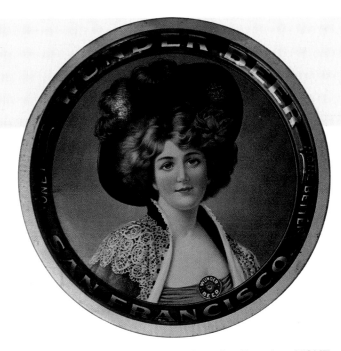

Tray, Wunder Beer, San Francisco, NONE
PURER / NONE BETTER, lithograph on tin,
1900s, 13 in. *Gary Dubnoff, photo courtesy of
Witherell's.* **A**

Tray, Bartlett Springs Mineral Water, Lake
County, RECLINING VICTORIAN LADY,
lithograph on tin, circa 1900s, 13 in. *Gary
Dubnoff, photo courtesy of Witherell's.* **A**

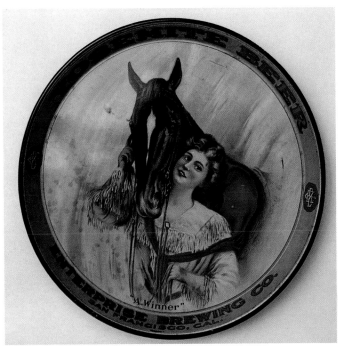

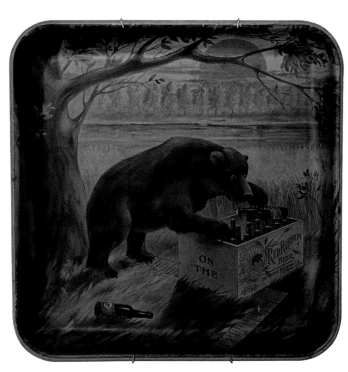

Tray, Red Ribbon Beer, Los Angeles, BEAR
WITH BEAR, lithograph on tin, circa 1910,
13 in. *Hayes collection, photo courtesy of
Witherell's.* **A**

Tray, Enterprise Brewing Co., San Francisco,
A WINNER, lithograph on tin, circa 1900s, 13
in. *Al and Carole Cali, photo courtesy of
Witherell's.* **A**

Tray, Buffalo Brewing Co., Sacramento, ROSE STILL LIFE, lithograph on tin, circa 1900s, 16 in. *Charlotte and Don Smith collection, photo courtesy of Witherell's.* **A**

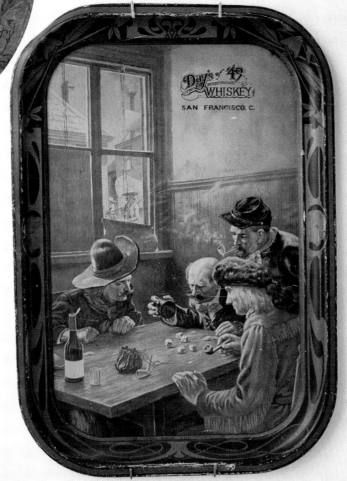

Tray, Day's of 49 Whiskey, San Francisco, THE DICE THROWERS, lithograph on tin, circa 1900s, 16 in. *P.I.F. collection, photo courtesy of Witherell's.* **A**

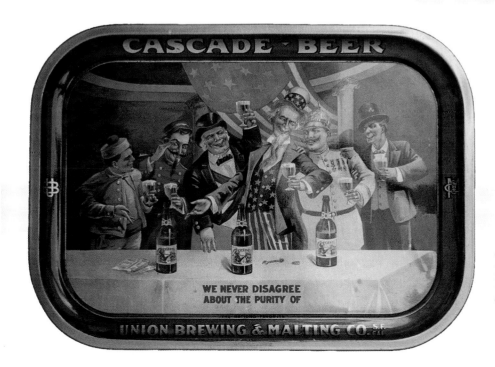

Tray, Union Brewing and Malting Co., San Francisco, THE NATIONS FAVORITE, lithograph on tin, circa 1900-1919, 16 in. *Al and Carol Cali, photo courtesy of Witherell's.* **A**

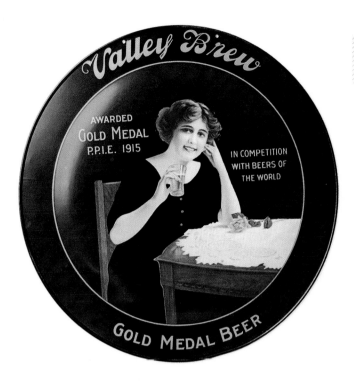

Tray, Valley Brew, Stockton, P.P.I.E., lithograph on tin, circa 1915, 13 in. *P. I. F. collection, photo courtesy of Witherell's.* **A**

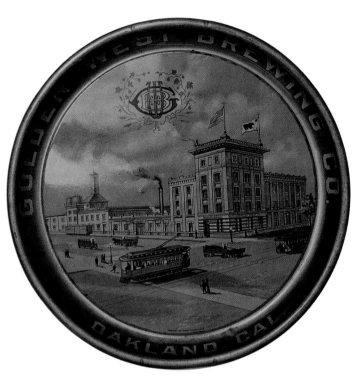

Tray, Golden West Brewing Co., Oakland, FACTORY SCENE, lithograph on tin, circa 1907-1920, 13 in. *Al and Carol Cali, photo courtesy of Witherell's.* **A**

Tray, El Dorado Brewing Co., Stockton, GYPSY LADY, lithograph on tin, circa 1910, 13 in. *Hayes collection, photo courtesy of Witherell's.* **A**

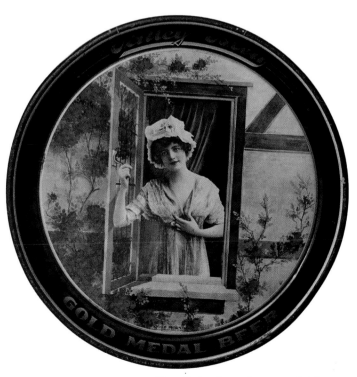

Tray, Valley Brew, Stockton, LADY IN WINDOW, lithograph on tin, circa 1910, 13 in. *Hayes collection, photo courtesy of Witherell's.* **A**

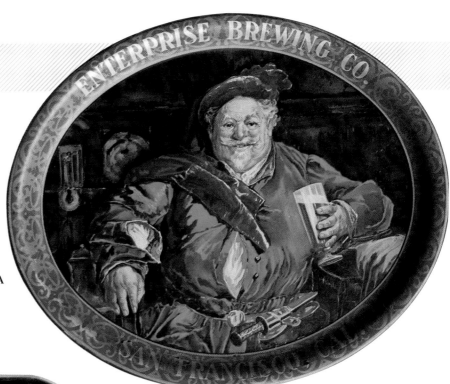

Tray, Enterprise Brewing Co., San Francisco, SEATED MAN, lithograph on tin, circa 1892-1920, 16 in. *Private collection, photo courtesy of Witherell's.* **A**

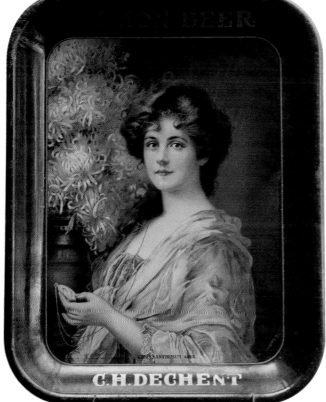

Tray, Yukon Beer, CHRYSANTHEMUM GIRL, lithograph on tin, circa 1897-1920, 13 in. *Private collection, photo courtesy of Witherell's.* **A**

Tray, Acme Brewing Co., San Francisco, SIERRA, lithograph on tin, circa 1907-1916, 16 in. *Private collection, photo courtesy of Witherell's.* **A**

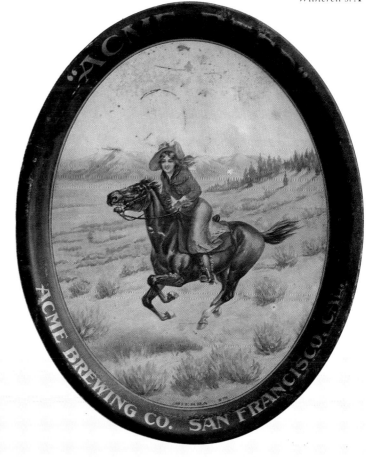

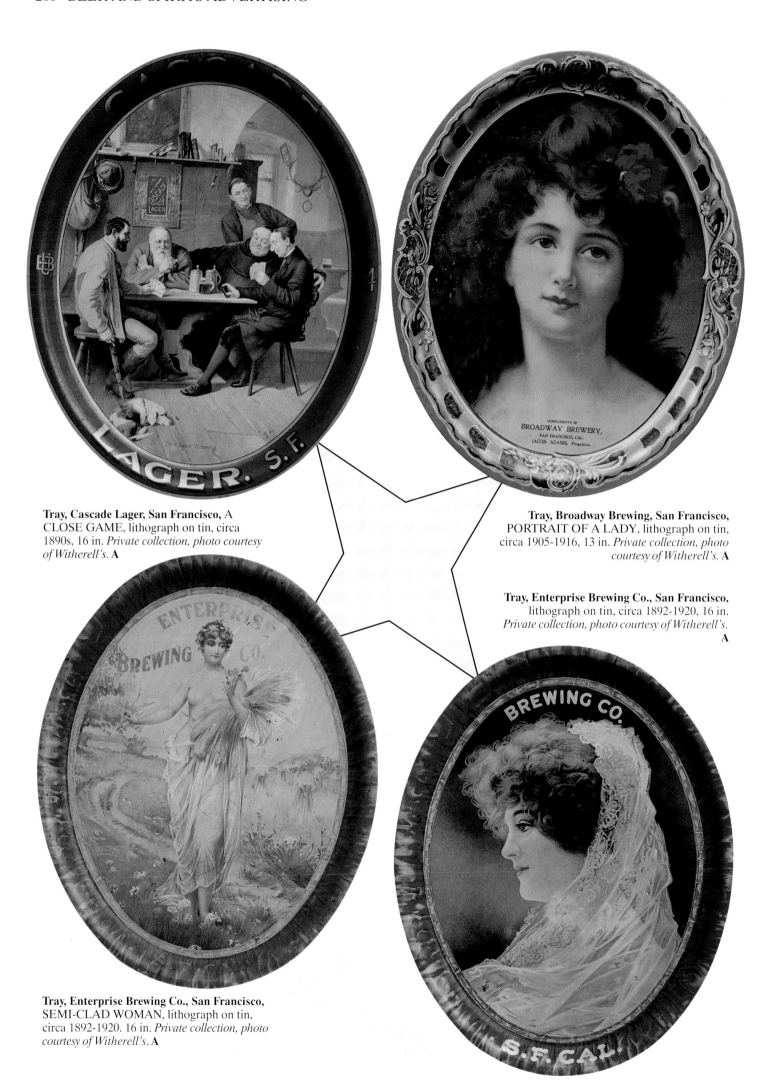

Tray, Cascade Lager, San Francisco, A
CLOSE GAME, lithograph on tin, circa
1890s, 16 in. *Private collection, photo courtesy
of Witherell's.* **A**

Tray, Broadway Brewing, San Francisco,
PORTRAIT OF A LADY, lithograph on tin,
circa 1905-1916, 13 in. *Private collection, photo
courtesy of Witherell's.* **A**

Tray, Enterprise Brewing Co., San Francisco,
lithograph on tin, circa 1892-1920, 16 in.
Private collection, photo courtesy of Witherell's.
A

Tray, Enterprise Brewing Co., San Francisco,
SEMI-CLAD WOMAN, lithograph on tin,
circa 1892-1920. 16 in. *Private collection, photo
courtesy of Witherell's.* **A**

Tray, A.H. Lochbaum, San Francisco Agent, NEW BREW, lithograph on tin, circa 1890-1920, 13 in. *Private collection, photo courtesy of Witherell's.* **A**

Tray, Chicago Brewery, San Francisco, MAN WITH GUITAR, lithograph on tin, circa 1893-1906, 13 in. *Private collection, photo courtesy of Witherell's.* **A**

Tray, Theo. Gier Co., Oakland, VINE-YARDS, lithograph on tin, circa 1900s, 13 in. *Private collection, photo courtesy of Witherell's.* **A**

Tray, Fresno Brewing Co., Fresno, SMOKING DOG, lithograph on tin, circa 1900-1920, 13 in. *Private collection, photo courtesy of Witherell's.* **A**

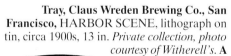

Tray, Claus Wreden Brewing Co., San Francisco, HARBOR SCENE, lithograph on tin, circa 1900s, 13 in. *Private collection, photo courtesy of Witherell's.* **A**

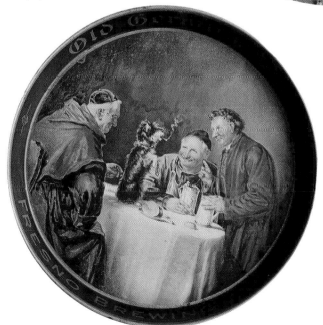

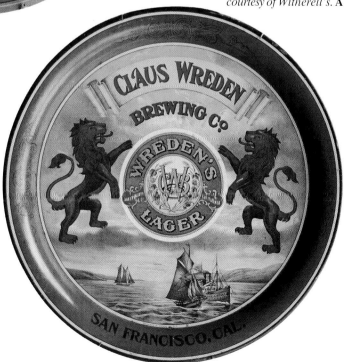

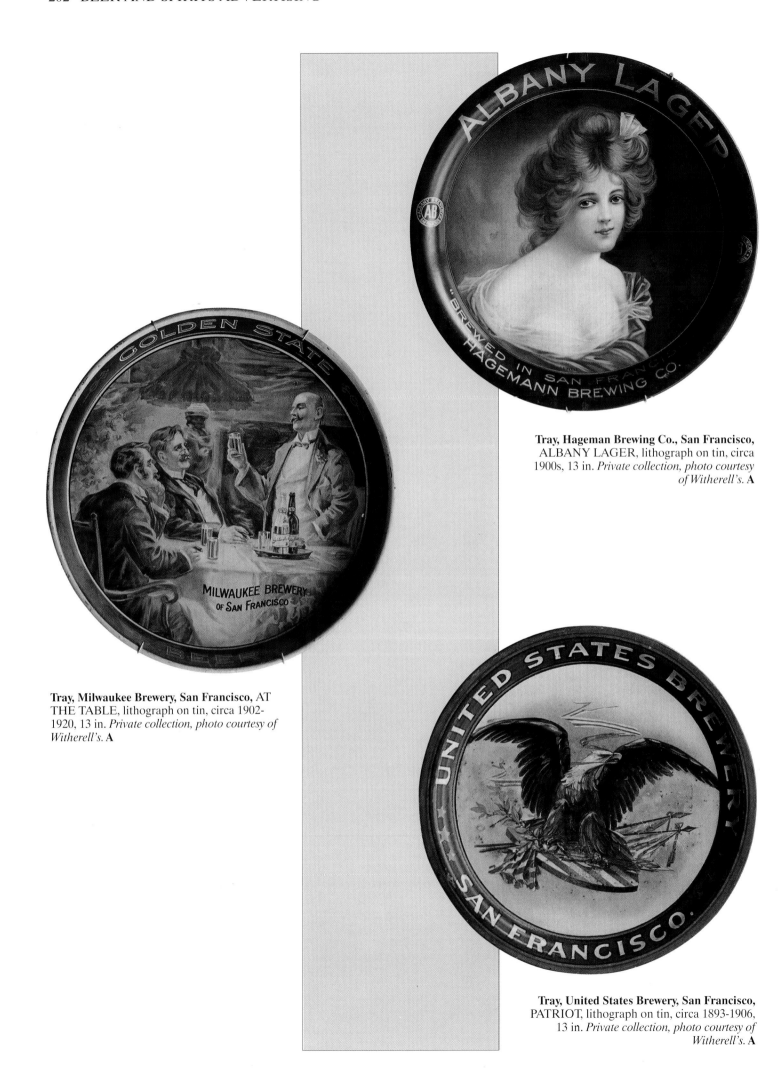

Tray, Hageman Brewing Co., San Francisco, ALBANY LAGER, lithograph on tin, circa 1900s, 13 in. *Private collection, photo courtesy of Witherell's.* **A**

Tray, Milwaukee Brewery, San Francisco, AT THE TABLE, lithograph on tin, circa 1902-1920, 13 in. *Private collection, photo courtesy of Witherell's.* **A**

Tray, United States Brewery, San Francisco, PATRIOT, lithograph on tin, circa 1893-1906, 13 in. *Private collection, photo courtesy of Witherell's.* **A**

═══ Calendars ═══

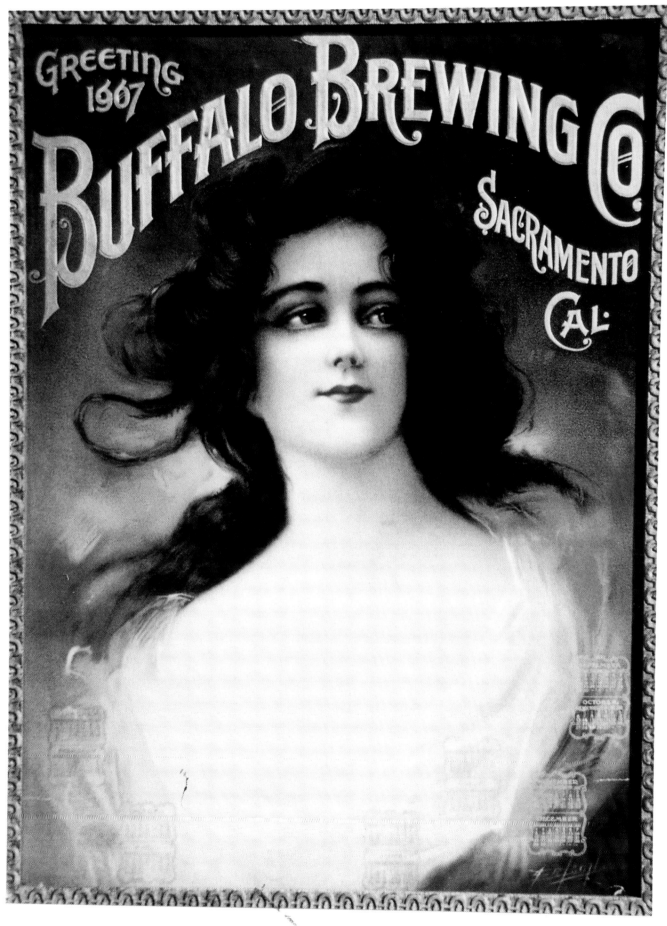

Calendar, Buffalo Brewing Co., Sacramento, PRETTY LADY, lithograph on paper, circa 1907. 20 by 15 in.
Private collection, photo courtesy of Witherell's. **C**

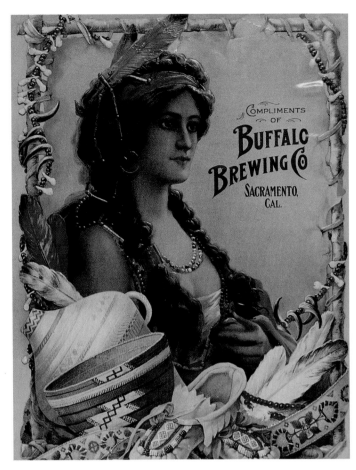

Calendar, Buffalo Brewing Co., Sacramento,
INDIAN MAIDEN, lithograph on paper, die-
cut, circa 1900s, 20 by 15 in. *Charlotte and
Don Smith collection, photo courtesy of
Witherell's.* **C**

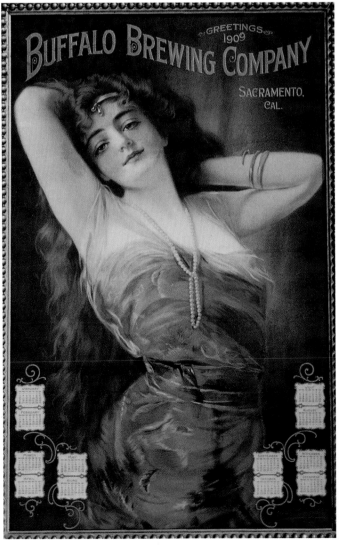

Calendar, Buffalo Brewing Co., Sacramento,
AFTER THE OPRA, lithograph on paper,
circa 1909, 26 by 16 in. *Private collection, photo
courtesy of Witherell's.* **C**

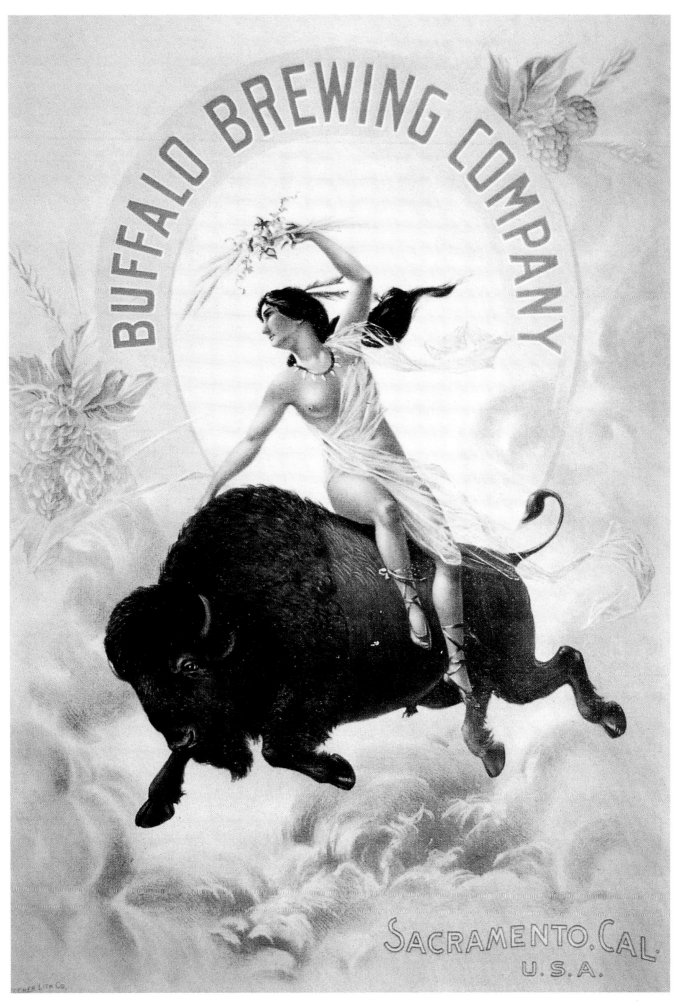

Calendar, Buffalo Brewing Co., Sacramento, INDIAN SQAW RIDING BUFALO, lithograph on paper, by Stretcher Litho., Rochester, N.Y., circa 1901. 20 by 15 in. *Private collection, photo courtesy of Witherell's.* **D**

Calendar, Buffalo Brewing Co., Sacramento,
COOKS WATER LADY, embossed litho-
graph on paper, circa 1900s, 24 by 12 in.
*Charlotte and Don Smith collection, photo
courtesy of Witherell's.* **B**

Calendar, Buffalo Brewing Co., Sacramento,
TIPPING THE WAITER, lithograph on
paper, circa 1915, 20 by 15 in. *Mike and Sally
Butler, photo courtesy of Witherell's.* **B**

Calendar, Buffalo Brewing Co., Sacramento, GYPSY GIRL,
lithograph on paper, circa 1902, 20 by 15 in. *Private collection, photo
courtesy of Witherell's.* **C**

Right:
**Calendar, Buffalo Brewing Co.,
Sacramento,** RED ROSES,
embossed lithograph on paper,
circa 1900s, 24 by 12 in. *Charlotte
and Don Smith collection, photo
courtesy of Witherell's.* **B**

Calendar, Buffalo Brewing Co., Sacramento,
YELLOW ROSES, embossed lithograph on
paper, circa 1900s, 24 by 12 in. *Charlotte and
Don Smith collection, photo courtesy of
Witherell's.* **B**

Calendar, Buffalo Brewing Co., Sacramento,
LADY WITH FLOWERS ON HAT, litho-
graph on paper, die-cut, circa 1900s, 20 by 15
in. *Mike and Sally Butler, photo courtesy of
Witherell's.* **B**

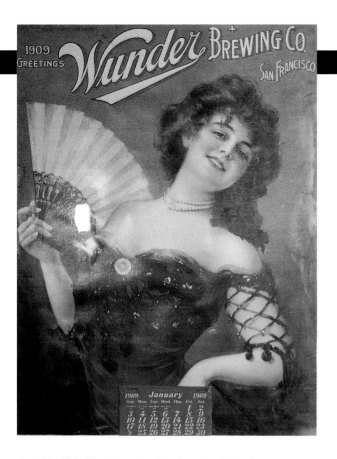

Calendar, Wunder Brewing, San Francisco, LADY WITH FAN, lithograph on paper, circa 1909, 20 by 15 in. *Gary Dubnoff, photo courtesy of Witherell's.* **C**

Sign, Wunder Brewing, San Francisco, LADY IN RED, lithograph on paper, circa 1907, 22 by 17 in. *Private collection, photo courtesy of Witherell's.* **C**

Calendar, California Powder Works, San Francisco, GIRL WITH ROSES, lithograph on paper, circa 1900s, 20 by 15 in. *P.I.F. collection, photo courtesy of Witherell's.* **B**

Calendar, California Powder Works, San Francisco, LADY IN RED, lithograph on paper, circa 1900s, 20 by 15 in. *P.I.F. collection, photograph courtesy Witherell's.* **B**

Calender, California Powder Works, San Francisco, LADY IN LACE GOWN, lithograph on paper, circa 1900s, 20 by 16 in. *Al and Carol Cali collection, photo courtesy of Witherell's.* **B**

Calendar, El Dorado Saloon, Placerville, LADY WITH MUF, lithograph on paper, die-cut, circa 1916, 20 by 15 in. *Al and Carol Cali, photo courtesy of Witherell's.* **B**

Calendar, Brassy & Co., San Jose, LADY IN
ORANGE, lithograph on paper, circa 1900s,
20 by 16 in. *Al and Carol Cali collection, photo
courtesy of Witherell's.* **B**

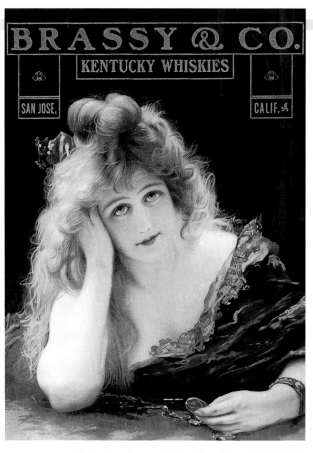

Calendar, Brassy & Co., San Jose, ALURING
LADY, lithograph on paper, circa 1900s, 20 by
15 in. *Mike and Sally Butler, photo courtesy of
Witherell's.* **B**

Calendar, Fredericksburg Brewing, San Jose,
ELF ON BARREL, lithograph on paper, circa
1899, 22 by 17 in. *Bill Rebello collection, photo
courtesy of Witherell's.* **A**

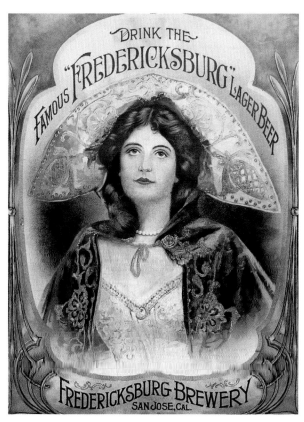

Calendar, Fredericksburg Brewing, San Jose,
SPANISH MAIDEN, lithograph on paper,
circa 1900s, 20 by 15 in. *Bill Rebello collection,
photo courtesy of Witherell's.* **B**

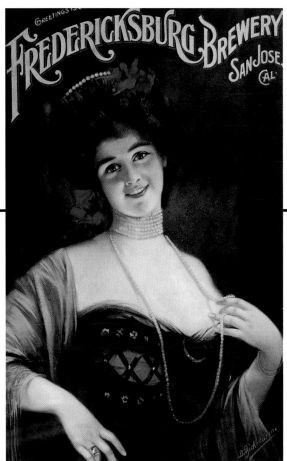

Calendar, Fredericksburg Brewing, San Jose, LADY WITH PEARLS, lithograph on paper, circa 1908, 27 by 17 in. *Bill Rebello collection, photo courtesy of Witherell's.* **B**

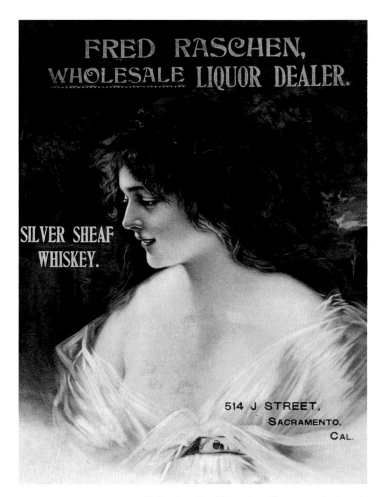

Calendar, Fred Raschen, Sacramento Agent, SILVER SHEAF WHISKEY, lithograph on paper, circa 1900s, 20 by 16 in. *John Rauzy, photo courtesy of Witherell's.* **B**

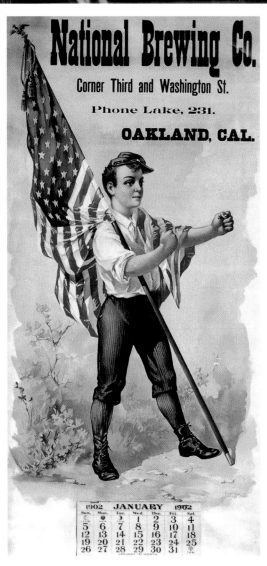

Calendar, National Brewing Co., Oakland, BOY WITH FLAG, lithograph on paper, circa 1902, 30 by 15 in. *Bill Rebello collection, photo courtesy of Witherell's.* **B**

Sign, El Rahir Cigar, San Jose, INDIAN WITH RIFLE, lithograph on paper, circa 1900. *Hayes collection, photograph courtesy Witherell's.* **B**

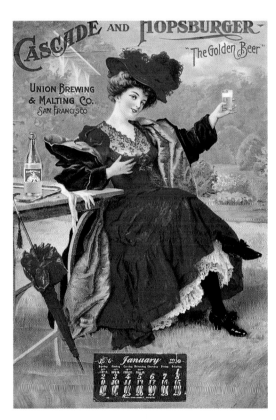

Calendar, Union Brewing and Malting Co., San Francisco, LADY IN RED WITH BEER GLASS, lithograph on paper, circa 1910, 20 by 15 in. *Mike and Sally Butler, photo courtesy of Witherell's.* **B**

Sign, El Rahir Cigar, San Jose, INDIAN WITH SPEAR, lithograph on paper, circa 1900. *Hayes collection, photo courtesy of Witherell's.* **B**

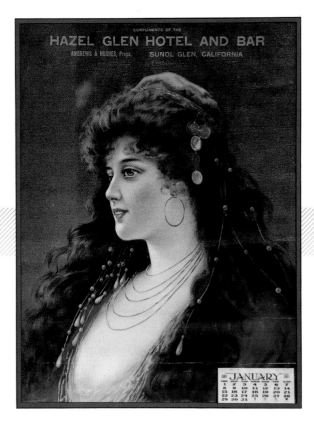

Calendar, Hazel Glen Hotel and Bar, Sunol Glen, GYPSY GIRL, Lithograph on paper, circa 1911, 20 by 15 in. *Bill Rebello collection, photo courtesy of Witherell's.* **B**

Calendar, California Wine House, AMERICAN BEAUTIES, embossed lithograph on paper, circa 1908, 24 by 12 in. *Private collection, photo courtesy of Witherell's.* **A**

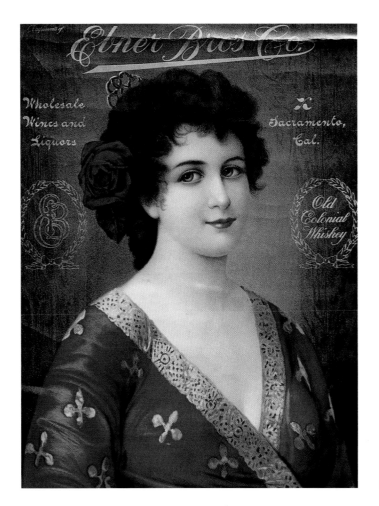

Calendar, Ebner Bros. Co., Sacramento Agent, OLD COLNIAL WHISKEY, lithograph on paper, circa 1900s, 20 by 16 in. *John Rauzy, photo courtesy of Witherell's.* **B**

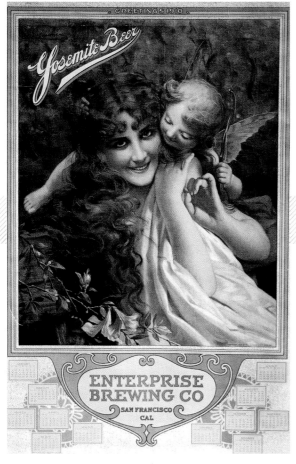

Calendar, Enterprise Brewing, San Francisco,
LADY WITH CHERUB, lithograph on
paper, circa 1910, 30 by 20 in. *Bill Rebello*
collection, photo courtesy of Witherell's. **B**

Calendar, Enterprise Brewing, San Francisco,
LADY IN PINK, lithograph on paper, circa
1909, 30 by 20 in. *Bill Rebello collection, photo*
courtesy of Witherell's. **B**

Left:
Calendar, Enterprise Brewing
Co., San Francisco,
YOSEMITE BEER, lithograph
on paper, circa 1910s, 23 by 15
in. *Charlie Zawila, photo courtesy*
of Witherell's. **B**

Calendar, Enterprise Brewing Co., San
Francisco, LADY IN BOAT, lithograph on
paper, circa 1908, 28 by 22 in. *Charlotte and*
Don Smith collection, photo courtesy of
Witherell's. **A**

Calendar, John Tons, Stockton Agent,
RAINIER BREWING, lithograph on paper,
circa 1909, 28 by 18 in. *Bill Rebello collection,*
photo courtesy of Witherell's.

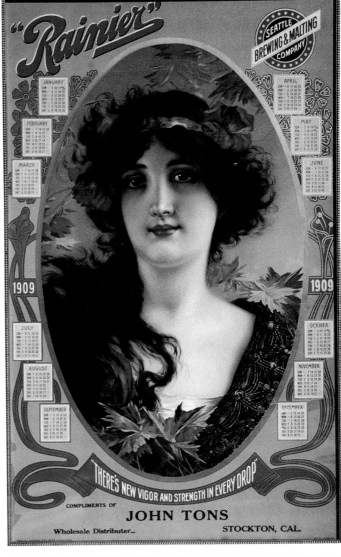

Calendar, John Tons, Stockton Agent,
RAINIER BREWING, lithograph on paper,
circa 1910, 28 by 18 in. *Bill Rebello collection,*
photo courtesy of Witherell's. **B**

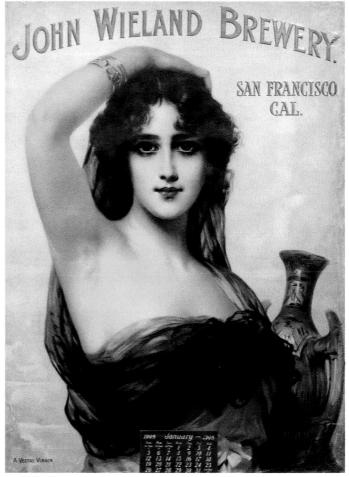

Calendar, Wieland's Brewery, San Francisco,
A VESTAL VIRGIAN, lithograph on paper,
circa 1908, 22 by 17 in. *Bill Rebello collection,*
photo courtesy of Witherell's. **B**

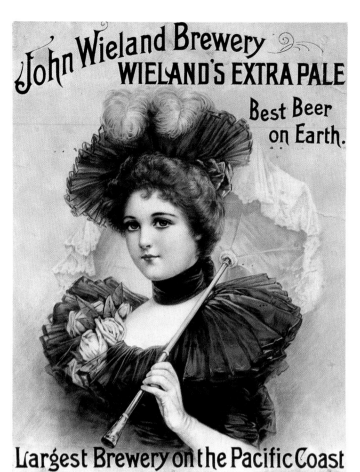

Calendar, Wieland's Brewery, San Francisco, WOMAN WITH SHAWL, lithograph on paper, circa 1900s, 22 by 17 in. *Bill Rebello collection, photo courtesy of Witherell's.* **B**

Calendar, Wieland's Brewery, San Francisco, LADY WITH PARASOL, lithograph on paper, circa 1898, 22 by 17 in. *Bill Rebello collection, photo courtesy of Witherell's.* **B**

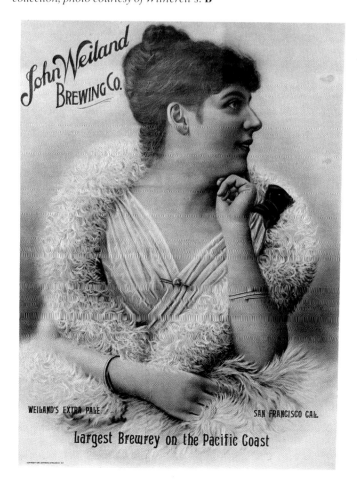

Calendar, Wieland's Brewery, San Francisco, EXTRA PALE LAGER BEAR, lithograph on paper, circa 1902, 22 by 17 in. *Bill Rebello collection, photo courtesy of Witherell's.* **B**

Calendar, Wieland's Brewery, San Francisco, LADY IN CHAIR, lithograph on paper, circa 1900s, 20 by 15 in. *Bill Rebello collection, photo courtesy of Witherell's.* **B**

Calendar, Wieland's Brewery, San Francisco, LADY WITH SOMBRARO, lithograph on paper, circa 1900s, 22 by 17 in. *Bill Rebello collection, photo courtesy of Witherell's.* **B**

Calendar, Adloff & Hauerwaas Co., Los Angeles Agents, LADY WITH CHERUBS, lithograph on paper, die cut, circa 1908, 20 by 13 in. *Bill Rebello collection, photo courtesy of Witherell's.* **A**

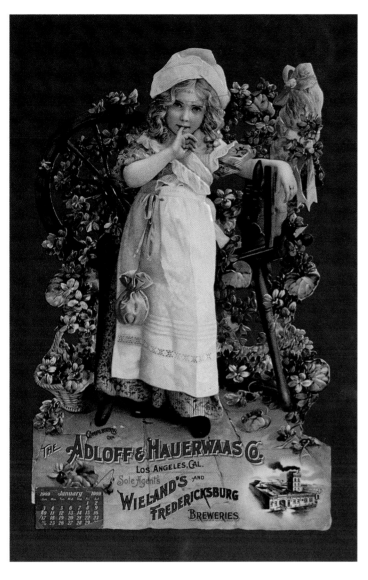

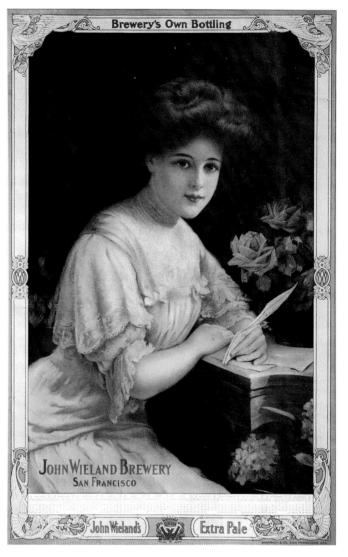

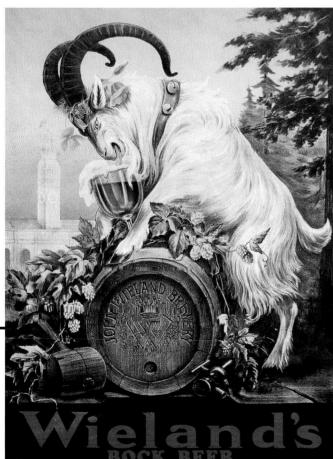

Calendar, Adloff & Hauerwaas Co., Los Angeles Agents, GIRL WITH SPINNING WHEEL, lithograph on paper, die cut, circa 1909, 20 by 13 in. *Bill Rebello collection, photo courtesy of Witherell's.* **A**

Calendar, Wieland's Brewery, San Francisco, LADY WITH LETTER, lithograph on paper, circa 1910, 30 by 20 in. *Bill Rebello collection, photo courtesy of Witherell's.* **B**

Sign, Wielands Beer, San Francisco, GOAT DRINKING BEER, lithograph on paper, circa 1910s, 22 by 18 in. *Bill Rebello collection, photo courtesy of Witherell's.* **B**

Calendar, National Brewing Co., San Francisco, ASTI GIRL, lithograph on paper, circa 1900s, 20 by 16 in. *John Rauzy, photo courtesy of Witherell's.* C

Advertisement, Pettijohns California Breakfast Food, BEAR IN MIND, lithograph on paper, circa 1900s, 52 by 30 in. *Private collection, photograph courtesy Witherell's.* B

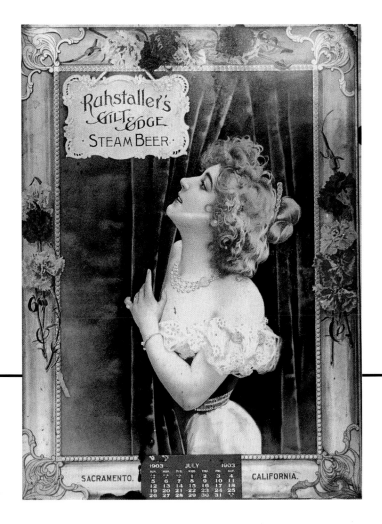

Calendar, Ruhstaller's, Sacramento, CURTAIN CALL, lithograph on paper, circa 1900s, 24 by 20 in. *Charlotte and Don Smith collection, photo courtesy of Witherell's.* A

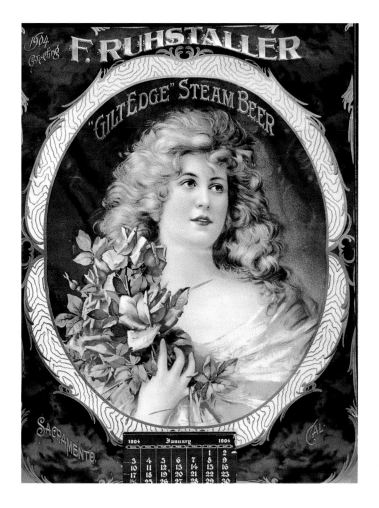

Calendar, F. Ruhstaller's Brewery, Sacramento, "Gilt Edge" steam beer, Lady with roses, 1904. C

Calendar, Ruhstaller's Brewery, Sacramento, LADY WITH PINK FLOWERS, lithograph on paper, circa 1909, 20 by 15 in. *Mike and Sally Butler, photo courtesy of Witherell's.* B

Calendar, Ruhstaller's, Sacramento, LADY WITH PINK ROSES, lithograph on paper, circa 1900s, 28 by 15 in. *Mike and Sally Butler, photo courtesy of Witherell's.* B

Calendar, The Union Metallic Cartridge Co., San Francisco Etc., THE BUFFALO, lithograph on paper, circa 1900, 30 by 14 in. *Don Reed, photo courtesy of Witherell's.* **C**

Calendar, California Powder Works, San Francisco, GOLD MINERS, lithograph on paper, circa1890s, 18 by 13 in. *Gary Dubnoff, photo courtesy of Witherell's.* **B**

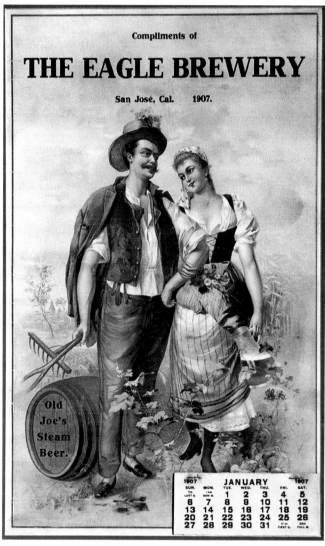

Calendar, Eagle Brewing Co., San Jose, OLD JOE'S STEAM BEER, lithograph on paper, circa 1907, 21 by 13 in. *Bill Rebello collection, photo courtesy of Witherell's.* **A**

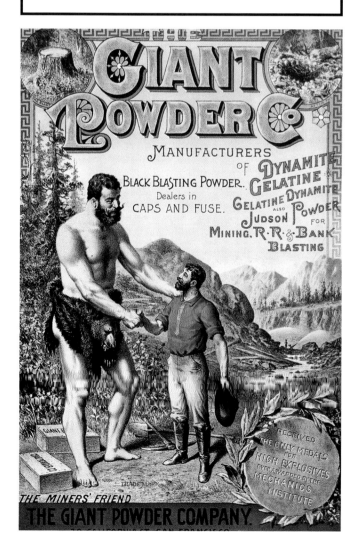

Calendar, Giant Powder Co., San Francisco, GIANT AND MINER, lithograph on paper, circa 1890s, 20 by 13 in. *Bill Rebello collection, photo courtesy of Witherell's.* **B**

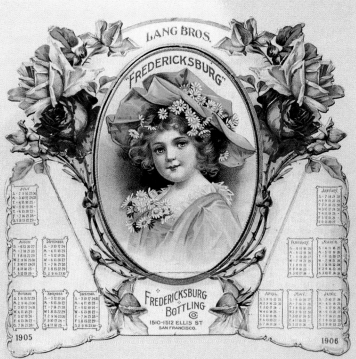

Calendar, Fredericksburg Brewing, San Jose, GIRL WITH BLUE BONNET, die cut, circa 1906, 8 by 10 in. *Bill Rebello collection, photo courtesy of Witherell's.* A

Sign, Wieland Beer, San Francisco, OFFICER AND DOGS, lithograph on paper, circa 1900s, 24 by 16 in. *Bill Rebello collection, Photo courtesy of Witherell's.* B

Sign, California Wines, Anaheim, CALIFORNIA STATE SEAL, lithograph on paper, circa 1890s, 18 by 14 in. *Private collection, photo courtesy of Witherell's.* C

Calendar, National Brewing Co., San Francisco, IN THE SONOMA MOUNTAINS, lithograph on paper, circa 1910, 20 by 15 in. *Private collection, photo courtesy of Witherell's.* B

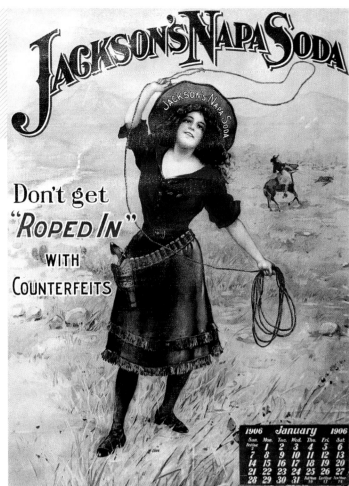

Calendar, Jackson's Napa Soda, ROPED IN, lithograph on paper, circa 1906, 20 by 15 in. *Private collection, photo courtesy of Witherell's.* **B**

Calendar, McLeod & Hatje, San Francisco, HERE'S TAE YE!, lithograph on paper, circa 1902, 23 by 18 in. *Bill Rebello collection, photo courtesy of Witherell's.* **A**

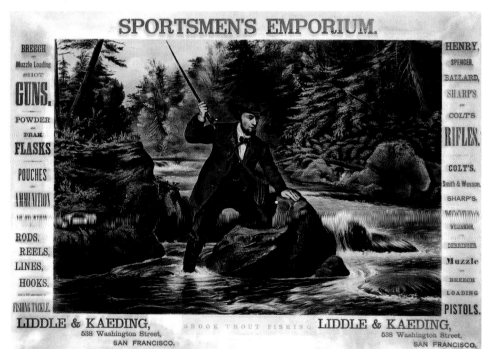

Sign, Liddle & Kaeding, San Francisco, BROOK TROUT FISHING, lithograph on paper, circa 1860-1865, 24 by 30 in. *Roger Baker, photo courtesy of Witherell's.* **D**

Calendar, Gilt Edge Whiskeys, San Francisco,
SEMI NUDE LADY ON SOFA, lithograph
on paper, circa 1900s, 20 by 15 in. *Gary
Dubnoff, photo courtesy of Witherell's.* **C**

Calendar, The California Winery, LADY
WITH GRAPES, lithograph on paper, die-cut,
circa 1900s, 18 by 14 in. *Private collection,
photo courtesy of Witherell's.* **A**

Calendar, Acme Brewing Co., San Francisco,
LADY IN PURPLE GROUND, lithograph
on paper, die cut, circa 1910, 20 by 16 in. *Al
and Carol Cali collection, photo courtesy of
Witherell's.* **A**

Calendar, Brunswick Billiard Parlor, Chico,
COWGIRL, lithograph on paper, die-cut,
circa 1908, 18 by 14 in. *Bob Butterfield, photo
courtesy of Witherell's.* **B**

Calendar, Wieland's Brewery, San Francisco,
CALIFORNIA BOTTLING CO., lithograph
on paper, circa 1900s, 20 by 15 in. *Bill Rebello
collection, photo courtesy of Witherell's.* **B**

Calendar, Wm. Lewis and Co., San Francisco,
LADY IN BLACK HAT, lithograph on paper,
circa 1900s, 20 by 16 in. *Al and Carol Cali
collection, photo courtesy of Witherell's.* **B**

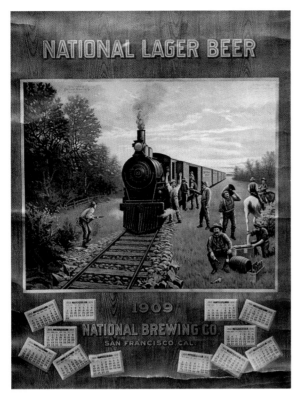

Calendar, National Brewing Co., San Francisco, TRAIN ROBERY, lithograph on paper, circa 1909, 20 by 16 in. *Private collection, photo courtesy of Witherell's.* **B**

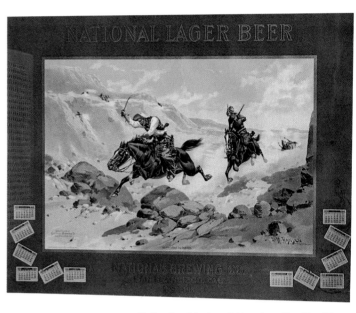

Calendar, National Brewing Co., San Francisco, THE ATTACK, lithograph on paper, circa 1908, 16 by 20 in. *Private collection, photo courtesy of Witherell's.* **B**

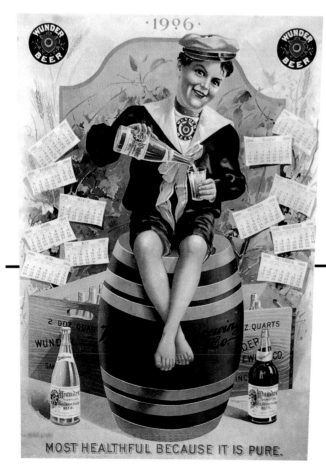

Calendar, Wunder Brewing Co., San Francisco, MOST HELPFUL BECAUSE IT IS PURE, circa 1906, 20 by 16 in. *Private collection, photo courtesy of Witherell's.* **B**

Calendar, St. Louis Brewing Co., San Francisco, OH MAMMA, lithograph on paper, circa 1907, 20 by 16 in. *Private collection, photo courtesy of Witherell's.* **B**

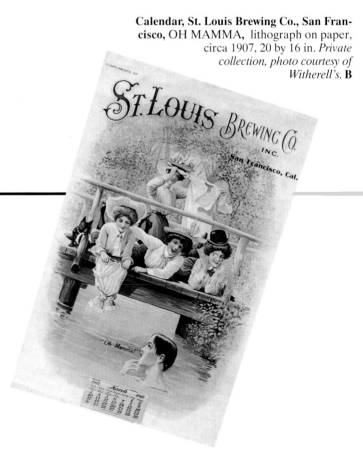

Calendar, Union Brewing & Malting Co., San Francisco, LADY IN RED, lithograph on paper, circa 1907, 20 by 16 in. *Private collection, photo courtesy of Witherell's.* **B**

Calendar, Fredericksburg Bottling Co., San Francisco, GIRL WITH PINK ROSE, lithograph on paper, circa 1903, 20 by 16 in. *Private collection, photo courtesy of Witherell's.* **B**

Calendar, Hibernia Brewery, San Francisco, GIRL WITH MIXED ROSES, lithograph on paper, circa 1905, 20 by 16 in. *Private collection, photo courtesy of Witherell's.* **B**

Calendar, Roth & Co., San Francisco, LADY IN WHITE, lithograph on paper, circa 1879-1919, 20 by 15 in. *Richard Siri collection, photo courtesy of Witherell's.* **B**

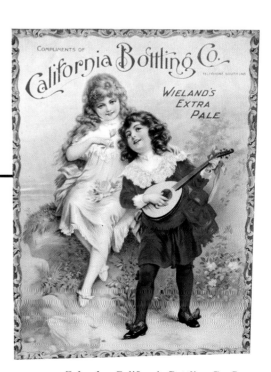

Calander, California Bottling Co, San Francisco, WIELAND'S EXTRA PALE, lithogrph on paper, circa 1900s, 20 by 16 in. *Private collection, photo courtesy of Witherell's.* **B**

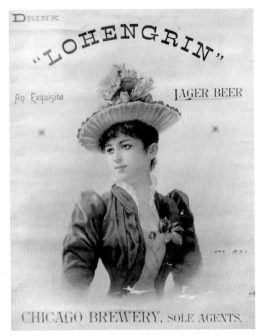

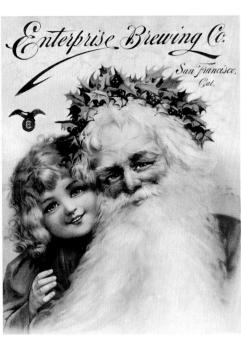

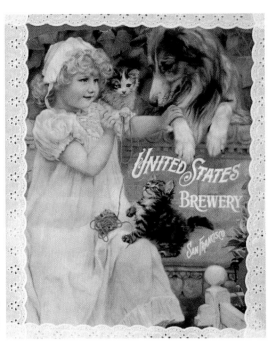

Calander, Chicago Brewery, San Francisco, LOHENGRIN, lithograph on paper, circa 1893-1906, 20 by 16 in. *Private collection, photo courtesy of Witherell's.* **A**

Calander, Enterprise Brewing Co., San Francisco, SEASONS GREATINGS, lithograph on paper, circa 1892-1920, 20 by 16 in. *Private collection, photo courtesy of Witherell's.* **B**

Calendar, United States Brewery, San Francisco, PLAYFUL MOMENT, lithograph on paper, circa 1893-1906, 20 by 16 in. *Private collection, photo courtesy of Witherell's.* **A**

══ Back Bar Bottles ══

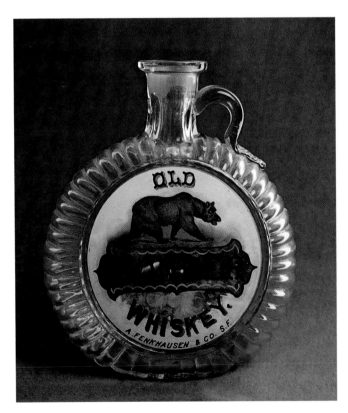

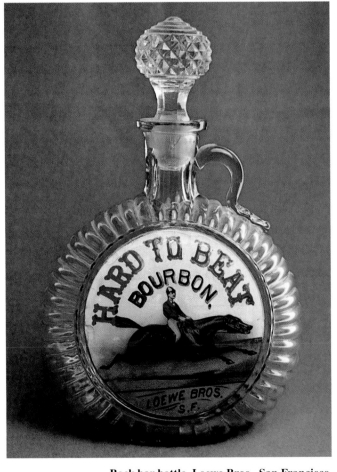

Back bar bottle, A Fenkausen & Co., San Francisco, OLD WHISKEY, label under glass, circa 1875-1893, 12 in. *Roger Baker, photo courtesy of Witherell's.* **B**

Back bar bottle, Loewe Bros., San Francisco, HARD TO BEAT, label under glass, circa 1865-1889, 13 in. *Roger Baker, photo courtesy of Witherell's.* **B**

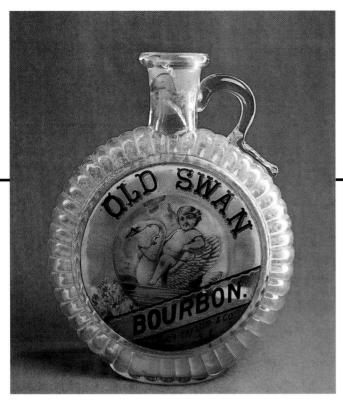

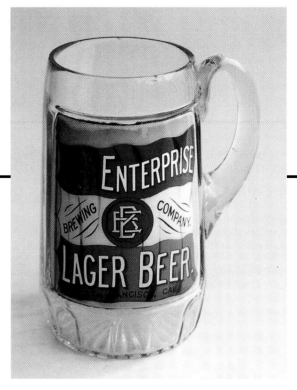

Back bar bottle, Thos Taylor & Co., San Francisco, OLD SWAN, label under glass bottle, circa 1865-1901, 12 in. *Roger Baker, photo courtesy of Witherell's.* **B**

Mug, Enterprise Brewing Co., San Francisco, RED, WHITE, & BLUE, reverse on glass, circa 1892-1920, 12 in. *Private collection, photo courtesy of Witherell's.* **C**

Right: Back bar bottle, N. Van Bergen & Co., San Francisco, GOLD DUST WHISKEY, label under glass, circa 1875-1900, 13 in. *Roger Baker, photo courtesy of Witherell's.* **D**

Back bar bottle, Thos Taylor & Co., San Francisco, OLD SWAN BOURBON, label under glass, circa 1865-1901, 13 in. *Roger Baker, photo courtesy of Witherell's.* **B**

Directory of Makers and Manufacturers

Acme Brewing Co.
Brewery in San Francisco, 1907-1916

Anaheim Brewery
Brewery in Anaheim, 1872-1904

Anchor Brewery
Brewery in Oakland , 1905-1910

1858 Listed in San Francisco city directory as an importer and wholesale dealer at 102 Merchant St.
1860 A. Andrews, watches and jewelry at 174 Washington St.
1861 Left California, spending time in South America, New Orleans, Chicago, and New York.
1870 Appears again in San Francisco, dwelling at the Nucleus House.

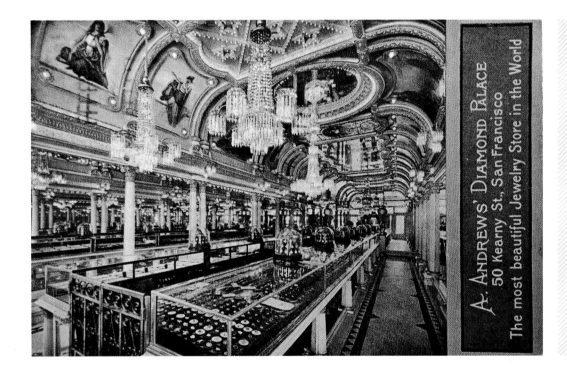

Andrews, Abrahm
Purveyor of gold quartz jewelry etc., in California between 1852-1856, 1858-1860, and 1873-1900s.
1827 circa. Born in London.
1837 circa. Family moves to New Orleans.
1842 circa. Apprenticed as Jeweler.
1846 Served as Captain, during the Mexican War, with the Second Ohio Regiment.
1847 circa. Opened a jewelry establishment in St. Louis.
1849 Arrived in Sacramento and opened a jewelry establishment with Mr. A. Hiller.
1853 The great fire and flood destroyed their stock and left them $60,000 in debt.

1873 Listed in San Francisco city directory as importer and dealer in diamonds, jewelry, etc., at 221 Montgomery St., through 1900.

Bakersfield Brewery
Brewery in Bakersfield, 1911-1920

Baehr, William
Manufacturing jewelry in California, 1867-c.1900
1868 The firm of Puhlman & Baehr is dismembered, with Puhlman joining Pierre Frontier as Frontier and Co., and Beahr remaining at the Clay street location as William Baehr & Co, manufacturing jewelry.

1869 William Baehr & Co., relocates to 649 Sacramento Street where they continued to manufacture jewelry through 1898.

Baldwin, Marcus M.

Jewelry importer, watchmaker, and lapidary in California, 1856-1874

1856 In business with Robert Josephi as Baldwin & Josephi at 171 Washington St. Advertisement states, "Manufactures of all kinds of California Jewelry and lapidaries."

1858 In business as Marcus M. Baldwin Lapidary, at 174 Clay Street. Advertisement states, "Quartz and all kinds of precious stones cut in the most approved styles at short notice."

1859 In business with Louderback as Louderback and Baldwin at 171 Washington Street. Advertisement states, "Manufacturing jewelers and lapidaries. highest price paid for gold bearing quartz."

1861 In business with Read as Baldwin & Read at 516 Clay Street as lapidaries and jewelry manufactures.

1862 M.M. Baldwin & Co., listed as a jewelry manufacture at 516 Clay St.

1864 Pohlman & Bellemer manufacturing jewelers take over at 516 Clay Street and M.M. Baldwin & Co., is listed as a jewelry importer at 311 Montgomery St.

1867 M.M. Baldwin & Co., listed as jewelry importer at 433 Montgomery St.

1868 M.M. Baldwin & Co., listed as watchmaker at 433 Montgomery St. He employees George Ecker, a former partner of George Shreve as watchmaker.

1875 The firm is dissolved and George Ecker gains employment with H. Hayes as a jeweler.

Barrett, Samuel (?-1860) and Robert Sherwood (1830-1893) as Barrett & Sherwood

Purveyors of watches, gold quartz jewelry, etc. in California (c.1851-1902)

1830 Robert Sherwood, born in Londonderry, Ireland

1849 An 1856 advertisement claims they were, "established under the present style, Dec. 1849" but there is no directory listing to substantiate this, nor is it consistent with other information.

1850 March, Robert Sherwood arrived in San Francisco and worked for a while in the mines of Calaveras County. He returned to San Francisco and opened a jewelry store on Clay Street. After a few months he formed a partnership with Samuel Barrett.

1852 Barrett and Sherwood are listed in the San Francisco directory for the first time, as Chronometer and watchmakers, manufactures of watches and jewelry, at 161 Clay St.

1853 Paul Evans, claims the firm exhibited gold quartz work at the New York Crystal Palace Exposition. See Paul Evans, "Gold Quartz: The jewelry of San Francisco," *Spinning Wheel Antiques & Early Crafts*, May, 1977: 9.

1854 At 135 Montgomery St.

1856 Advertisement states, *QUARTZ JEWELRY - This branch of California Art is OUR OWN INVENTION, and we claim to be unrivaled in its manufacture. Our designs are new and tasteful, and the Quartz rich and variegated.*

1858 Advertisement states, *we are the inventors of the art of manufacturing quartz rock jewelry.*

1860 Samuel Barrett passed away after a short illness.

1862 Possibly due to fire, the firm relocates to 517 Montgomery St.

1880 William J. Sherwood assumes control of the firm.

1887 The firm relocates to 140 Montgomery St.

1893 Robert Sherwood died suddenly of heart failure. He left his estate, valued in excess of $500,000.00, to his widow and four children.

1898 Rudolph Barth is listed as successor to the firm and they relocate to 141 Post St.

Bellemere, August (1836-1887)

Manufacturing jeweler, lapidary, and quartz cutter in California, 1859-1887

1858 Gustave Bellemere (relation unknown) jeweler with Hass & Louderback.

1859 August Bellemere a native of New York is listed simply, as a jeweler in the San Francisco directory.

1860 August Bellemere, jeweler with Baldwin & Read.

1864 Manufacturing jewelry with Henry Pohlman at 516 Clay St.

1865 Bellemer leaves the firm and in 1868 is in business with Pierre Frontier as Frontier & Co., manufacturing jewelry at 706 Market St.

1878 The *Alta California* reports, "Presentation. Aug. Bellemere, one of the earliest residents of San Francisco, leaves for the East this morning, en route to the Paris Exposition. ... Learning of his proposed departure, a number of friends... presented Mr. Bellemere with a handsome gold watch and chain, suitably inscribed."

1880 Listed as a manufacturing jeweler, lapidary, and quartz cutter at 331 Kearney St.

1888 Absent from San Francisco city directory.

Bohlin, Edward

See James H. Nottage, *Saddlemaker to the Stars:The leather and Silver Art of Edward H. Bohlin*; Autrey Museum of Western History, 1996.

Bosq, Romain

Manufacturing jeweler and lapidary in California, c.1875-1001

1875 Joins the firm of Frontier & Co.

1879 Listed as a lapidary and diamond setter at 13 Trinity.

1880 F. Conner joins him as R. Bosq & Co., lapidaries and diamond setters at 332 Bush St.

1883 The firm is dissolved.

Bradford Novelty Machine Co.

Bradford, William A., proprietor.

Dealer of coin operated gambling devices in California, 1904-1916

1904 Listed as W. A. Bradford Co, buying and selling phonographs, novelties, and nickel-in-slot machines at 1143 Market St.

1907 Listed as W. A. Bradford Novelty Co., cash slots and card machines at 2144 Market St.

1916 Absent from San Francisco city directory.

Breuner, John (1824-1890)

Importer, jobber, and Manufactor of furniture in California, 1852-current

1824 Born in Baden, Germany September 14.

1840 circa. Apprenticed as a cabinetmaker in Strasburg and Paris.

1850 Arrived in Sacramento and commenced gold mining.

1852 circa. Began building improved mining cradles and other equipment.

1856 Opened at 6th and K Streets as John Breuner Co., and began importing home furnishings.

1864 Began furnishing the California State Capital which continued through 1890 and included some 130 statements.

1869 Sold to the State of California's governors office 120 carved walnut legislative desks. This work is latter propertied to be that of J. B. Luchsinger. See Luschsinger.

1870 Exhibited at California Sate Fair and awarded first premium.

1871 Exhibited at California State Fair and awarded first premium.

1872 Exhibited at California State Fair and awarded first premium. In a letter published in the *State Agricultural Society,* he addresses the committee, first having described his 1871 display which consisted of 37 items including an inlayed rosewood chamber suite. "It is estimated that the furniture annually imported into California from the Eastern States (like that of New York or Boston) and other countries cannot be less in cash value than two million five hundred thousand dollars, while there may be five hundred thousand dollars worth manufactured here." It was further noted he produced about seven thousand dollars worth of material annually from his own shop.

1890 Passed away October 5, but the business continued under his sons, John Breuner Jr. and Louis F. Breuner.

1900 Purchased the firm and good will of California Furniture Co., San Francisco.

1924 Opened a branch in Stockton.

1927 Opened a branch in Richmond.

1930 Opened a branch in Berkeley.

1940 Opened a branch in Vallejo.

1946 Opened a branch in Oakland.

1955 Reopened the San Francisco store as the parent company.

1956 June 1956 article in *California Magazine of the Pacific* reported, "From small beginnings in rough frontier country, Breuner's has emerged as Northern California's largest home furnishings organization and the second largest home furnishings organization in the United States."

Broadway Brewing Co.
Brewery in San Francisco, 1905-1916

Buffalo Brewing Co.
Brewery in Sacramento, 1890-1920

California Brewing Co.
Brewery in San Francisco, 1892-1915

California Furniture Manufacturing Company
See Cole, Nathaniel Palmer (see right)

California Jewelry Factory
See Hadenfield, Charles

Cole, Nathaniel Palmer (1831-1903)
Importer, jobber, and Manufactor of furniture in California, 1864-1900

1831 Born Oxford, New Hampshire.

1864 Arrived in San Francisco and organized the N. P. Cole furniture Company.

1865 Reorganizes at 518 Front St. under the name N. P. Cole & Co., with O. W. Merriam a resident of Boston.

1867 Relocates to 310, 312 and 314 Pine St.

1869 Relocates to 220-226 Bush St. The following caption appears in the September 8, 1869, *San Francisco Alta,* "A CHAIR TO BE PRESENTED TO THE PRESIDENT BY CALIFORNIA CITIZENS. Some six months since a number of gentleman from various parts of the State, in no way affiliated with each other in political matters, determined to make a present, however insignificant in value, to President Grant, in recognition of their estimation of his course as an honest and upright man. For the accomplishment of this result various Committees were appointed in the different counties. It was finally decided that the present should take the shape of a chair of the state worthy of any Sovereign in the world. Acting upon this idea, the committee on design and purchase, after several consultations, left the matter entirely in the hands of Mr. N.P. Cole, of the firm of N.P. Cole & Co. The result has been the that probably the finest chair ever built in the civilized world has just been completed. The framed of the chair, which is more than seven feet in height, is constructed entirely of California laurel, and is most exquisitely carved. The legs rest upon claws of California lion carved in excellent taste. The fronts of the arms are supported by carved heads of grizzlies. The back, which is altogether to straight for the reputed habits of the president, is supported

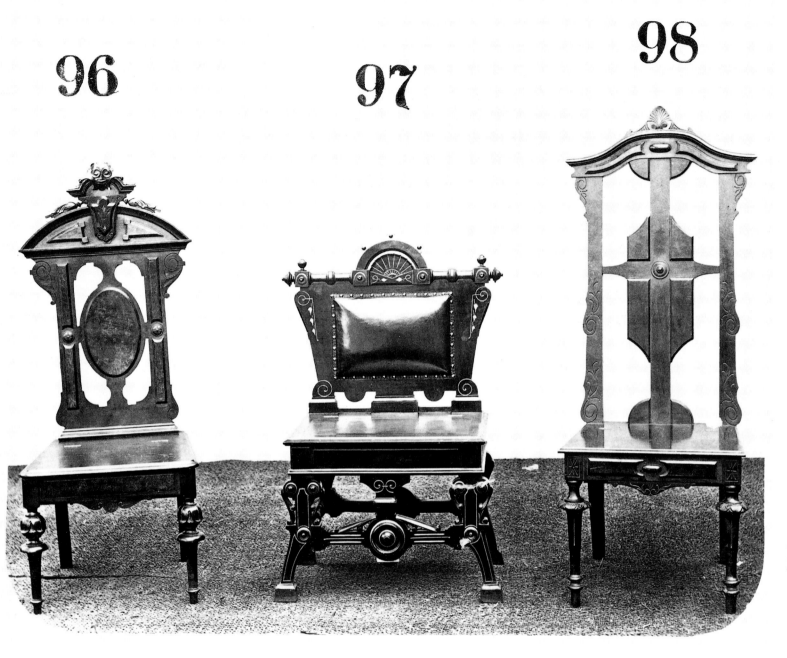

Figures 96-98 from California Furniture Manufacturing Company
catalog, circa 1872-1888. *Courtesy Winterthur Library.*

by Corinthian columns, on the top of which is a globe supported by and eagle. In the center and as a forepiece, are the Nation's shield, surrounded by a wreath and the National flags, all carved from the same wood. The back and seat are trimmed with blue bread cloth of the finest quality. There was nothing but the needles used in the various parts of the work that was not strictly California manufacture. The matter of sending on to Washington this most extraordinary work of California has been delayed this far by the committee of arrangements simply from a wish to keep it back until all the new..." The remainder of the article is lost.

1872 Reorganized under the name California Furniture Manufacturing Company and Ottis W. Merriam becomes treasury and secretary.

1873 Directory lists address of 220-226 Bush and 315-321 Pine.

1874 Directory lists address of 220-226 Bush.

1875 An account describes the firm as, "one of the largest manufactory establishments in the city, and turns out goods worth hundreds of thousands of dollars yearly."

1876 Expanded to 649 and 651 Market Street. The August 10, edition of the *San Francisco Journal of Commerce and Price Current* explains that after their fire the previous year they "*...purchase largely in the East.*"

1877-79 Directory lists address of 220-226 Bush and 649-651 Market.

1887 His residence on the N. W. corner of Franklin and Sacramento Streets, was featured in *Artistic Homes*

of California. It was designed by Wright and Sanders the architect of the Latham's, Thurlow Lodge.

1888 Moved to Starr King building at 117-121 Geary between Grant and Stockton.

1900 The firm and good will was sold to the John Breuner Company. See John Breuner.

1903 Passed away.

Collins, C. E.
Importer and manufactore of California and Washoe Silver jewelry, c.1862-1868

1861 C. E. Collins, watchmaker & jeweler at 602 Montgomery Street.

1864 Advertisement states, "C. E. Collins manufacturer of California gold Jewelry and Washoe silver jewelry."

1865 Jewelry importer at 602 Montgomery.

1869 Absent from San Francisco City Directory.

Chicago Brewery
Brewery in San Francisco, 1893-1906

Clune, William H. (?-c1927)
Dealer of music boxes and coin operated gambling devices in California, 1902-1912

1893 Appears in Los Angeles City Directory as a conductor with Southern Pacific Company, residing at 150 N. Water.

1895 Absent from Los Angeles.

1896 Resides in Los Angeles at 1411 Buena Vista.

1898 Employed as sewer flusher.

1900 Listed as manufacture, residing at 1131 Wall.

1902 Selling music boxes at 707 S. Main St.

1909 Listed as Wm. H. Clune, picture machines at 727 S. Main Street, residing at 456 Locus Avenue.

1910 Listed as Wm. H. Clune, electric signs at 727 S. Main Street, residing in South Pasadena.

1912 Listed as W. H. Clune, proprietor of Clune Amusement Circuit, 727 South Main Street and president of Clune Theaters Co., 215 W. 7th room 404.

1913 Listed as president of Clune Theater Company, office at 210 West 7th room 289. Theaters at 110, 453 S. Main and 528 S. Broadway.

1920 Listed as President of Clune Theater Company and Clune Film Producing Company.

1922 Listed as President of Clune Theater Company, Clune Commercial Film Company and Clune Studios, motion picture producers at 5356 Melrose.

1927 circa. Passed away with Jas. W. Clune now as president of Clune Theaters Co., and Doyle-Clune Oil Company.

Curry, Charles, Nathaniel, and John.
Gun dealers in San Francisco (1854-1887)

1854 Charles appears in the San Francisco Directory as a dealer in fancy goods at 83 Battery St.

1856 Charles Curry gun-warehouse at 87 1/2 Battery St.

1858 Charles Curry gun-warehouse 87 Battery St.

1859 Nathaniel Curry joins his brother as a salesman in Charles Curry guns & sporting material.

1860 Charles Curry, gunsmith at 87 Battery St.

1861 Charles Curry, gunsmith at 317 Battery St. Nathaniel Curry is absent from directory.

1863 Charles Curry dies and the only entry is N. Curry (presumably Nathaniel) at 317 Battery St.

1864 John Curry a resident of Monroe County Ohio is listed as owner of N. Curry & Bro., guns, pistols, & sporting material, 317 Battery St.

1867 John Curry moves to San Francisco, dwelling at ?28 Bryant St.

1869 The firm relocates, under John's continued ownership, to 113 Sansome. John dwells at 450 Bryant St.

1883 The firm appears as N. Curry & Brother.

1887 The firm is absent from San Francisco city directory.

Deviercy, Eugene
Manufacturing gold quartz jewelry etc. in California, 1856-1865

1856 In business with Pierre Frontier as Frontier, Deviercy & Co., jewelry manufactures at 81 Bush St.

1858 In addition to Frontier & Deviercy he becomes part owner in A. Dubois & Co.

1865 Absent from the San Francisco directory.

Doerger, Charles
Turner of ivory, hardwoods, and cane manufacture in California, 1860-1879

1860 Appears in the San Francisco directory as an ivory turner at 730 Washington St.

1868 In business with Albert Jellinek, as Jellinek and Doerger with a factory at 24 California Street in San Francisco.

1869 Partnership is disolved but both continue independently. An ad for Charles Doerger gives an address of 520 Merchant Street and states, "He constantly has on hand and manufactures to order ...walking canes."

1872 Listed under the heading "Cane Manufacturers," 620 Merchant St.

1879 Absent from San Francisco city directory.

Dubois, Alexander (1827-1864)
Manufacturing jewelry in California, c. 1849-1863

1849 circa. His obituary printed in the September 8, 1864 edition of the *Alta California* states, "Mr. Dubois was one of the pioneer businessmen of San Francisco, coming here in 1849, and immediately engaged in the watchmaking and jewelry business, in the front of the Miners' Restaurant."

1854 Appears in San Francisco directory for the first time as A. Duboce dwelling on Green.

1856 Listed as Dubois & Co., with Pierre Frontier and Eugene Deviercy manufacturing watches and jewelry at 142 Kearney St.

1858 Advertisement states, "A. Dubois & Co. / Watch-makers / and / Jewelers. / 129 Montgomery Street, / San Francisco. / FINE QUARTZ JEWELERY ON HAND AND CUT TO ORDER."

1860 The firm relocates to 433 Montgomery St.

1862 circa. Sold out to Otto Wiedero & Co., and retired from business.

1864 Alexander Dubois lost his life in the *Washoe* disaster. As reported in the September 7, 1864 *Alta California,* "Explosion of the Washoe-Terrible loss of life and limb. Sacramento, September 6th. - At half past 4 o'clock, this morning the fire bells of the city were rung, and our citizens were aroused to learn that a dreadful catastrophe had occurred during the night, attended by terrible destruction of life and limb... One of the boilers of the steamer Washoe had exploded ... on the trip up from San Francisco... The scene on board was such as has rarely been witnessed on the Pacific Coast. The floor of the cabin and a portion of the deck were covered with the dead and wounded. The mattresses and bedding of the boat had been brought into requisition and some forty sufferers were stretched out; some of them enduring great agony and others to badly injured to be conscious of their condition."

Ecker, George O. (1826-1884)
Watchmaker, jeweler, and salesman in California, c.1849-1884

1852 George Ecker, a native of New York, is listed in the San Francisco directory as a watchmaker at 144 Montgomery St.

1856 Absent from San Francisco directory.

1858 Watchmaker with J. W. Tucker & Co.

1865 Joins G. C. Shreve & Co. as part owner.

1867 Leaves Shreve and joins M. M. Baldwin as a watchmaker.

1873 Joins Henry Mayers as a salesman.

1875 With Mayers as a jeweler.

1884 November 19, 1884 edition of the *San Francisco Call* reports, "George O. Ecker, a salesman in the jewelry establishment of Colonel Andrews, and manager during the proprietor's absence at the World's Fair in New Orleans as commissioner from California, was taken suddenly ill in the store yesterday morning, fell to the floor and died in a few minutes... The deceased, who came to this city from New York in 1849, was always in the jewlering business during his residence here..."

Eagle Brewing
Brewery in San Jose, 1897-1920

El Dorado Brewing Co.
Brewery in Stockton, 1893-1920

Emanuel, Lewis (1829-1897) and **Emanuel, Emanuel (1834-1899)**

Manufacturing Furniture in California, 1860- c.1899

1829 L. Emanuel, born in London.

1834 E. Emanuel, born in London.

1852 The brothers left England for Australia in pursuit of gold.

1854 Sailed to the Amazon River area of South America in pursuit of gold with no success, they left for California, arriving in 1854.

1859 L. Emanuel started a small shop in San Francisco making "pony" bedsteads on ground which later occupied the Grand Hotel.

1860 Moved into Hobbs, Gilmore & Co.'s mill, on the corner of Market and Beale streets, under the name L. Emanuel & Co., and at the same time adding to his line of manufacture several other styles of bedsteads, cots, cribs, and extension tables.

1864 circa. Moved into Miller and Hawley's mill on Trement street.

1865 E. Emmanuel first appears in the San Franciso directory as a salesman with W. J. Stringer.

1868 E. Emmanuel joins the firm and they reorganizes under the heading L. & E. Emanuel Furniture Factory. The company relocates into larger premises on Berry street. Here they built a mill, factory, engine room, and lumber yard.

1869 The entire plant was destroyed by fire at a reported loss of between $40,000 and $50,000. They rebuilt at the same location this time adding a varnish shop and extending their line of house hold goods and chamber sets.

1876 Advertised a manufacture of chamber, library, parlor, and dining suites of East India Teak, Island Tamanos, Island Walnut, Mexican Prima Vera, and California Oak.

1877 The September 27, 1877, *San Francisco Journal of Commerce and Price Current* described their exhibit at the Mechanics institute. It partially consisted of two bed-room sets in black walnut priced at $750.00 each. It further stated, "their designs are all new and original being made by their own artists."

1881 circa. Opened a retail location at the former Goodwin & Co. location of 319 Pine. Here it was reported they carried a large stock, including upholstered goods, and did a prosperous business.

1883 Moved factory to Fourth and Bryant street, and relocated their retail operation from Pine Street to the Bancroft building located at 725 Market, the former location of W. J. Heney & Co.

1886 The Market street location was destroyed by fire at a loss of about $80,000.

1887 circa. Relocate to 432-434 Fourth St., and produce high grade furniture with a specialty of wood mantels, and store and bank fixtures. The firm employees 150 men, and pay out in wages $80,000 to $90,000 annually.

1895 Reorganize as the West Coast Furniture Company.

1897 circa. L. Emanuel passed away

1899 E. Emanuel passed away.

Enterprise Brewing Co.
Brewery in San Francisco, 1892-1920

Esponosia, Alberto
See Ned and Jody Martin, et al, *Bit and Spur Makers in the Vaquero Tradition: A Historical Perspective,* Hawk Hill Press: California, 1997, p.96-97.

Fey, August Charles (1862-1924)
Manufacture and dealer of coin operated gambling devices in California, 1899-1936

1862	Born in Vohringer, France.
1885	Arrived in California.
1891	Listed in the San Francisco directory as an electrician.
1895	In business with Holtz selling electrical supplies at 406 mission St.
1897	Listed as a mechanical engineer and model maker at 406 Market St.
1899	In business with Gustave Schultze as Charles Fey & Co., manufactures of automatic machines at 406 Market St. It has been published that Fey revamped the CARD BELL and renamed it the LIBERTY BELL in 1899. This date is dismissed by Peter Tamony. See *Western Folklore*; University of California press, Volume XXVII, 1968, who cites evidence to place it at 1905. Marshal Fey disputes this theory and dates it at 1895. See Marshall A. Fey, *California Historical Quarterly*, Volume LIV, Spring 1975.
1902	W. J. Mc Farland joins Shultze and Fey as Charles Fey & Co., manufactures of automatic machines at 406 Market St.
1903	Gustave Shultze leaves the firm.
1906	The factory at 406 Market was destroyed in the earthquake and fire. Charles Fey opens as independent owner of Charles Fey & Co., automatic machines at 395 Jesse St.
1909	Listed as slot machines at the same address.
1911	Charles Fey & Co., slot machines at 1071 Mission St. Charles Fey is also listed as a model maker at his residence 1049 Broderick.
1913	Edmund Fey joins his father as Charles Fey & Co., and they relocate to 585 Mission St.
1919	After Edmond Feys discharge from the Army he rejoins his father as Charles Fey & Son.
1923	circa. The firm develops the SILVER DOLLAR, the first silver dollar three-reel machine.
1942	circa. The firm continued to invent, manufacture, and modify machines up until this point.

Fredericksburg Brewery
Division of San Francisco Breweries, LTD in San Jose, 1893-1920

Fresno Brewing Co.
Brewery in Fresno, 1900-1920

Friedell, Clemens
See Leslie Greene Bowman, et al, *Silver in the Golden Sate,* The History Department, Oakland Museum, Oakland, 1986, p.41-55.

Frontire, Pierre
Manufacturing jewelry and lapidary in California, 1856-1880

1856	Partner with E. Deviercy in the jewelry firm, Frontier & Deviercy rear of 81 Bush St.
1858	P. Frontier and E. Deviercy form an additional partnership with Alexander Dubois as A. Dubois & Company at 119 Montgomery. Advertisement states, "Fine quartz jewelry on hand and cut to order. Every kind of jewelry manufactured set and repaired.
1861	The firm relocates to 433 Montgomery.
1862	A. Dubois & Co., is succeeded by Otto Wiedero & Co., comprising the interests of P. Frontier, E. Deviercy and Otto Wiedero a former watchmaker with George C. Shreve & Co. (1860-1862) The 433 Montgomery Street address appears to be a retail location run by Wiedero, perhaps to compete with his former employer located at 525 Montgomery Street. Frontier & Deviercy maintain an independent operation manufacturing jewelry at 437 Pine Street. The 1863 Advertisement states, "Otto Wiedero & Co. (Successors to A. Dubois & Co.) watchmakers and jewelers. Fine quartz jewelry on hand & cut to order."
1865	Frontier & Deviercy The firm relocates to 740 Commercial Street.
1867	Deviercy leaves the firm and Frontier continues the business at 740 Commercial St., as Pierre Frontier.
1868	The firm reorganizes as Frontier & Co., with Henry Pohlman and August Bellemere, at 706 Market Street.
1869	Advertisement states, "Lapidaries and Manufacturing jeweler. Grand assortment of moss agate. Quartz specimens bought and sold."
1871	Puhlman leaves the firm and they reorganized as Frontier and Bellemer. Lapidaries and manufacturing Jewelers with grand assortment of moss agate. Quartz specimens bought and sold. Also listed as quartz cutters.
1875	Romain Bosq joins the firm and they relocate to 206 Sutter Street, as Frontier Bellemere & Co.
1879	Frontier is listed independently as a lapidary.
1881	Absent from San Francisco city directory.

Garcia Saddlery Co.
See Ned and Jody Martin et al, *Bit and Spur Makers in the Vaquero Tradition: a Historical Perspective,* Hawk Hill Press: California, 1997, p. 226-227.

Galleazzi, Giuseppe
Accordion maker in California, 1895-c.1905
1895 Accordion maker at 1339 DuPont.

Giannini, Peter A.
Manufacturing California watch-cases etc. in California, 1858-c.1898
1856 Watchcase maker at 174 Clay St.
1861 Watchcase maker at 622 Clay St.
1870 Advertisement states, "Wholesale dealer in watches and jewelry and manufacture of California watch cases."
1873 Relocates to 5 1/2 Kearny Street.
1881 Relocates to 109 Montgomery Street. The *Alta California* reports, "Presentation. Mr. P. A. Giannini, a pioneer merchant of this city, and one of the oldest and best rifle shots on this coast, will leave for Switzerland, his native home, to visit his relatives there and take part in the great Swiss Mutual Benevolent society, of which Mr. Gianini is Treasurer, He was presented by the President, Mr. Borel, the well known banker, with a gold and gold quartz match box, the finest we have ever seen here. It has the Swiss cross inlaid in quartz, on the side, mineral specimens on top, and is altogether of beautiful workmanship..."
1898 Peter A. Giannini, importer of Swiss watches at 208 Sutter St.

Golden West Brewing Co.
Brewery in Oakland, 1911-1920

Goodwin, James Porter (1815-1900)
Furniture Dealer and Manufactor in California, 1851-1886
1815 Born March 10 in Londonderry, Ireland. His father was an officer in the English army, and stationed in Ireland. The family emigrated to America when James was quite young and Settled in Providence, Rhode Island. It was here he was educated and learned the cabinet-making business.
1849 Set sail for California via the isthmus of Panama, November 1849.
1850 Arrived in California early January.
1851 Possibly worked in the furniture business as Geo. O. Whitney & Co., at 159 Sacramento St.
1858 Organized under the name James P. Goodwin, importer and manufacture of furniture at 130 and 132 California St.
1864 Reorganizes in partnership with Philip Holmes, a resident of New York, under the name Goodwin & Co., at 510-528 Washington and 413 Jackson.
1866 The company maintains the Washington address, closes the Jackson St. address and opens an additional outlet at 636 Market. Philip Holmes relocates to Boston.
1867 The January 30 issue of the *San Francisco Alta* reports, "Among the passengers the Eastern States,

by the steamer Constitution, is J. P. Goodwin the pioneer furniture dealer of San Francisco, whose establishment is the most extensive on the Pacific Coast, and one of the Largest in the United States. He leaves us but for a brief time, and which a view to still further increase his business facilities."
Additionally, their ad in the November 11, issue of the *Alta* claimed they where awarded every first premium in their category at the State Fair, Sacramento. Eleven in total for best designs, quality, neatness, finish, and durability for parlor and chamber furniture. They further claimed to be the oldest established house on this coast.
1868 The company relocates to 322-324 Pine St. and James P. Goodwin Jr. Joins the firm.
1871 January, Nevada Secretary of State C.N. Noteware purchased from J.P. Goodwin Legislative desks and chairs. He was allocated $10,000 by the legislature for the complete furnishings of the capital. The Legislative desks and chairs took $4,236.00 of that sum. They were used for 49 years.
1873 The company reorganizes under the name Goodwin & Co., in the partnership of James P. Goodwin, George P. May, and George O. Britton and relocates to 312 Pine St.
1879 The 1892 *Bay of San Francisco* reports, "Near the close of 1879 Goodwin & Co., who had been the principal customers to handle Emanuel Brothers productions in San Francisco failed."
1883 Listed with L & E Emanuel.
1887 Retired.
1900 Passed away at his Taylor St. residence February 23.

Hadenfeldt, Charles (1843-1903)
Purveyor and manufacture of gold quartz jewelry etc., in California, c.1869-1903
1843 Born in Schoenfeld, Germany.
1869 circa. Arrived in California and gained employment with Hubash & Kutz.
1875 June 9, 1903, *San Francisco Call* states; "... he bought the good will and interest of this firm (Hubash and Kutz) and a copartnership was formed under the name of Wenzel, Rothchild, & Hadenfeldt." Prior to this Baruch Rothchild had been employed as a secretary with the Occidental Insurance Company since 1867 and Herman Wenzel, in various partnerships as a watchmaker and jewelry manufacture, since 1863.
1883 The firm moves from its Post Street location to 9 Hardie Place.
1885 Wenzel leaves the firm and they reorganize as California Jewelry Factory.
1900 circa. The firm is disolved.

Hayes, Michael Jr. (1836-1901) with **William Hayes**
Manufacturing cutlery in California, c.1874-1901

1836 Born Limerick, Ireland
1874 Micheal Hayes, cutler with Micheal Price.
1885 Micheal Hayes leaves Micheal Price.
1887 Micheal J. Hayes, cutler at 1432 Market St.
1891 William Hayes joins the firm as M. J. Hayes and son and they relocate to 1424 Market St.
1895 The firm relocates to 1518 Market St.
1897 Isidore Spitz joins the firm as Hayes & Spitz and they relocate to 1386 Market St.
1901 Micheal J. Hayes dies and the firm is closed.

WM. J. Heney & Co. trade card, circa 1868-1873. *California Historical Society, FN-31062*

Heney, Richard Sr. (1825-1893)

Mattress maker and furniture importer in California, 1867-1891 (see above)
1825 circa. Richard Heney Sr. born in Belfast Ireland.
1845 Richard Heney Jr. born in Lima, New York where his father worked as a merchant.
1863 Richard Heney Sr. along with his family arrived in San Francisco.
1864 Listed in San Francisco directory as a mattress maker with Jacob Schreiber.
1868 The bedding and furniture business of William J. Heney & Co., is begun at 751 Market St., with his sons Richard Heney Jr. and William J. Heney.
1873 The firm relocates to 725 Market St.
1875 circa. Period article describes the firm as "being one of the largest furniture establishments in the city."
1881 Richard Jr., leaves the firm and pursues a career in viticulture. The firm relocates to 14-16 Ellis St.
1887 Richard Sr. retires from the firm.
1891 The business is dissolved.
1893 Richard Heney Sr. passed away leaving a widow and seven children.

Hubash, Joseph

Manufacturing jewelry in California, 1859- 1886
1859 Jeweler at 140 Sacramento St., in San Francisco.

1860 Manufacturing jeweler at 193 Clay St.
1861 Manufacturing jeweler at 610 Montgomery St.
1863 Manufacturing jeweler at 409 Sansome St.
1867 Hubash enters into a partnership with Charles Gullman and William H. Gleeson as Hubash, Gulman, & Gleeson, manufacucting jewelry at 519 Montgomery St.
1869 The partnership is disolved and a new one is formed with Gabriel W. Kutz as Hubash & Kutz at the same location manufacturing jewelry. Kutz is sporadically listed in the San Francisco city directories prior to this, first in 1856 as a cigar manufacture and later in 1859 in partnership as Esberg & Kutz.
1875 Henry A. Elleau, formerly a manufacturing jeweler at 121 Montgomery St., joins the firm as Hubash, Kutz & Co., and they relocate to 328 Bush St. The obituary of Charles Hadenfeldt, printed in the June 9, 1903 *San Francisco Call*, states, "Mr. Hadenfeldt came to this city in 1868 and at once connected himself with the firm Hubash & Kutz. Three years later he bought the good will and interest of this firm and a copartnership was formed under the name of Wenzel, Rothschild & Hadenfeldt." They are listed at 121 Montgomery St. The firm, Hubash, Kutz & Co., however continues to manufacture jewelry with H. Elleau at 328 Bush St.
1879 Hirschman joins Hubash as Hubash & Hirschman at the same address.
1881 Hubash is listed as an independent jeweler through 1886.

Jackson Brewing Co.

Brewery in San Francisco, 1897-1920

Jellinek, Albert

Turner of ivory, hardwood and cane manufacture in California, 1858-1878
1856 Albert is first listed in the San Francisco city directory as a porter at 70 Sacramento St.
1858 Listed as a turner.
1859 Absent.
1861 Listed as a turner with Brown & Wells at 535 Market Street.
1868 In partnership with Charles Doerger as Jellinek & Doerger, turners in ivory and hardwood at 24 California Street in San Francisco. An advertisement states, "Billiard material of every description furnished at the most reasonable rates. Also on hand, lemon squeezers, que presses and croquets. A great variety of rosewood, ebony, manzanita, and mountain mahogany canes."
1869 The partnership is disolved but both continue in business independently as a wood and ivory turner.
1874 Doing business as McDonald Company as a wood and ivory turner.
1877 Listed simply as a woodturner through 1879.

Johnson, Christian with **John Best**
Manufactoring furniture in California, 1860-c.1898
1850 John Best listed as polisher with John Wigmore.
1865 Christian Johnson is cabinetmaking at 213 Kearney and John Best is cabinetmaker with John Wigmore.
1868 Begin Manufactoring furniture as Johnson & Best with a showroom on Market.
1877 John Best is absent from the San Francisco city directory and the firm is disolved. Christian continues to be listed as a cabinetmaker through 1898.

Kesmodel, Frederick
Cutler and Surgical Instrument maker in California, 1856-c.1871
1856 Cutler residing on Washington St.
1858 Cutler and surgical instrument maker at 209 Kearney St.
1859 Cutler and surgical instrument maker at 185 Kearney St.
1861 Cutler and surgical instrument maker at 817 Kearney St. Employees Frederick Will.
1863 Frederick Will leaves and the firm of Will & Finck is begun.
1867 Cutler and surgical instrument maker at 538 Mission St.
1868 Absent from San Francisco city directory.
1870 Cutler with Will and Finck.

Klepzig, John Christian Erhart (1817-1878)
Gunsmith in California, 1856-1878
1817 Born in Norway.
1845 circa. Worked in New York.
1856 Listed in the San Francisco city directory as gunsmith at 212 Washington St.
1858 Manufacturing guns at 212 Washington St.
1859 Gunsmith with Severine Gullickson at 212 Washington St.
1861 Gunsmith with Severine Gullickson at 733 Washington St.
1878 Committed suicide.

Koehler, Gottard (1823-1895)
Manufacture of silverware and gold quartz jewelry in California, 1858-1890
1823 Born in Saxony.
1854 G. Koehler is listed in the San Francisco Directory as a jeweler at 130 1/2 Montgomery St.
1858 William Koehler (relation unknown) with Reichel & Koehler.
1860 circa. Lived in Oregon.
1861 John J. Kohler (relation unknown) listed as Jeweler with F.R. Reichel.
1864 Gottard Koeler listed as jeweler with F. R. Reichel.
1868 circa. Gottard Koehler and Charles Ritter (bookkeeper with F.R. Reichel 1865-1867) formed the partnership of Koehler & Ritter. Successors to Frederick R. Reichel and advertised as, "Manu-

facturers of jewelry and silver ware, also diamond, enameled and Quartz Jewelry made to order. No. 620 Merchant St."
1874 One of three firms to advertise as quartz cutters
1875 Reported in *San Francisco Journal of Commerce,* awarded at the Mechanics' Institute award for "best designing, modeling, and best workmanship in silver." Additionally, they advertised as manufacturing quartz jewelry and listed themselves under quartz cutters and lapidaries.
1877 Relocate to 26 Post St.
1881 The firm relocates and lists a factory at 13 Trinity with office at 120 Sutter St.
1884 The firm of Koehler & Ritter is disolved.
1887 Gottard Koehler employed as a jeweler with August Koehler & John Philips at the firms old location, 13 Trinity.
1890 Gottard employed as a jeweler at 3 Hardie Place.

Laine, Julius
Lapidary and quartz cutter in California, 1856-1895
1856 Listed in San Francisco city directory as lapidary.
1858 Absent.
1859 Quartz cutter with E. Rondel at Sutter St.
1861 Lapidary.
1877 Listed as J. Laine & Son (Manuel) as lapidaries at 618 Merchant St.
1881 Jules listed indapendently at 339 Bush St.
1883 Moves to 9 Hardy Place
1887 Jules is listed as a lapidary, precious stones cut and polished, quartz specimens bought and sold.
1895 Absent from San Francisco city directory.

Liddle, Robert with **Charles Keading.**
Dealer and manufacture of firearms in San Francisco, c.1854-1898
1824 Robert Liddle Born in England.
1836 Apprenticed as a gunsmith in Baltimore.
1853 Arrived in San Francisco via the Isthmus of Panama in February and mined for a few months on the south fork of the Salmon River. A short while latter he returned to San Francisco and resumed work as a gunsmith on Davis Street.
1854 circa. Returned to Baltimore and brought his family back to San Francisco.
1858 Listed as a gunsmith dwelling on Union Street.
1860 circa. Formed a partnership with Charles Keading as Robert Liddle & Co., at 418 Washington Street.
1866 circa. The two formed the partnership Liddle & Keading and relocated to 538 Washington St., selling guns and sporting material.
1891 Keading is absent from the firm and Robert operates as R. Liddle & Co., gunsmiths.
1895 The firm relocates to 110 Montgomery St.
1896 Robert is listed as manager of the Emporium Sporting Goods Store.

Laird, David White (1836-1887)
Manufacturing jewelry, badges, and medals in California, 1865-1887
1836 Born in Edinburgh, Scotland
1865 Listed in San Francisco city directory as manufacturing jeweler at 620 Merchant St.
1867 Relocates to 614 Merchant St.
1869 Relocates to 610 Merchant St.
1873 Advertised additionally as a lapidary.
1877 Listed as proprietor of San Francisco Jewelry Manufactory at 613 Montgomery St.
1878 Advertisement states, "San Francisco Jewelry Manufactory / D. W. Laird / 613 Montgomery Street / WATCHES AND JEWELERY / Badges and Medals, of all kinds for sale, / Made to order and repaired."
1879 Relocates to 21 post St.
1881 Relocates to 27 Post St.
1887 Passed away at his home.

Los Angeles Brewing Co.
Brewery in Los Angeles, 1897-1920

Louderback, William (1827-1859)
Manufacturing jewelry in California, 1854 -1859
1854 Listed in the San Francisco directory as jeweler with A. Holmes at 161 Clay St.
1856 In business with Hass as Hass & Louderback jewelers at 171 Washington St.
1859 In business manufacturing jewelry with Marcus Baldwin as Louderback & Baldwin at 171 Washington Street. August 21, 1859 *Alta California* reports, "Fatal and melancholy accident - At the alarm of fire last evening about 8 o'clock, which proved to be unfounded, a terrible and fatal accident occurred to Mr. Wm. Louderback, of the firm Louderback & Baldwin, jewelers of Washington Street. Mr. L. was a member of Tiger Engine company No. 14 - a Company which he joined only some three weeks since. It appears that while running to the fire with the engine, his foot tripped, and he fell, the engine passing over his stomach. As it is estimated at 3,400 pounds, some idea may be formed of the cruel nature of the accident... Mr. Louderback was a native of Ireland, 32 years of age, and leaves a wife and three young children."

Luchsinger, John B. (1826-1889) and Son
Manufacturing furniture in California (1864 1887) (see right)
1826 Born in Switzerland
1843 Married Marry Elizabeth Luchsinger in Switzerland then migrated to Syracuse New York.
1844 circa. Moved to Galena, Illinois and bore their first child Jacob.
1847 circa. Moved to Minnesota.
1864 First appears in San Francisco Directory and listed as John B. Luchsinger Furniture Manufactory at 116 Bush St.

1865 Henry Luchsinger listed as cabinetmaker with Goodwin & Co.
1867 Relocates to 718-720 Minna St.
1868 Henry listed as manager of Boston Furniture Co., 619 Market St.
1869 Possibly manufactured 120 carved walnut Legislative desks for the California State Capital. An assumption based on a July 14, 1962 letter from architectural historian A. Lawrence Kocher to the California State Assembly which states, in part, "May I call attention to an error made as to the origin of the desks? They emphatically did not come to the capital "from around the horn" as was facetiously implied; nor were they made in Sacramento by a local factory. It may be of a suprise to your body to learn that the design of the desks was by the San Francisco factory of John B. Luchsinger & Son, located at 710-718 Minna Street, between 8th and 9th. The son, Jacob Luchsinger, was a state senator of California, around 1870 when the Assembly was built. It is a recorded observation to a daughter, Mrs. Howard Hunt of ..., that as the factory was at work on the desks the young Jacob Luchsinger had not a most distant thought of his future destiny of occupying one of them."
1873 His sons join the firm. George as a clerk, Jacob as partner and Henry as a cabinetmaker. Henry continues to manage the Boston Furniture store at 735 Market St.
1874 One of three firms to bid the manufacture of furniture for the San Francisco Mint. On April 11, 1874 the architect, Alfred B. Mullett awarded the contract to John B. Luchsinger and Son for submitting the lowest bid to make the furniture in San Domingo mahogany, writing that he was, "satisfied that mahogany furniture will be found most durable and consequently the cheapest."
1875 His son John H. joins the firm.
1877 Exhibited at the San Francisco Mechanics' Institute and awarded first premium for the best office furniture, desks, etc., and best sideboards of California manufacture. Their booth was described in the September 27, 1877 edition of the *San Francisco Journal of Commerce and Price Index* which states in part, "It is all home and custom made, none being manufactured for the market- all on orders. The firm employ superior draghtsman, who are constantly engaged in preparing beautiful and classical designs, so that a customer can make a selection before ordering. Some of the most recherché pieces turned out from Messrs. Luchsinger's workshop are to be seen at the fair. Among them is a magnificent side-board, which attracts particular attention. It can only have been made for a millionaire; it is worth $1,200 and was fashioned from a solid block of walnut. He also has a beautiful chamber set of birds-eye maple and mahogany...The firm has a factory with 15,000 square feet of flooring and with a capacity of 100

J. B. Luchsinger & Son trade card, open.
Courtesy Luchsinger family collection.

J. B. Luchsinger & Son trade card, circa 1876. *Courtesy Luchsinger family collection.*

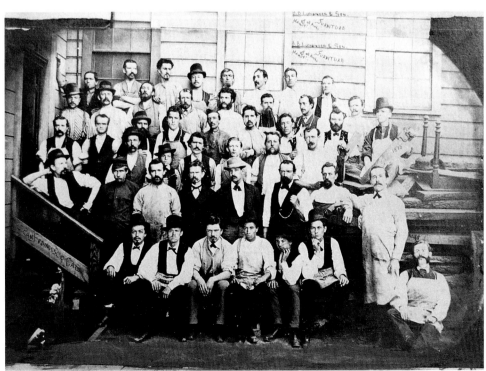

Photograph of J. B. Luchsinger & Son employees and shop, circa 1875. *Courtesy Luchsinger family collection.*

workman. It is three stories in height and is well supplied with steem power. From it has come forth some of the most sumptuous bank and office fittings imaginable, including the furniture for the Nevada State Bank, the London Bank, The Anglo California Bank, First National Gold Bank, and the Board room for the new stock exchange." Henry is listed as cabinetmaker with his father and proprietor of Henry Luchsinger & Co., a furniture establishment at the old Boston Furniture Store location at 735 Market St. with George Luchsinger as a clerk there.

1881 George H., clerk with F. S. Chadbourn (another furniture store in the city), Henry as machinehand with John B. Luchsinger & Son, Jacob and John B. proprietors of John B. Luchsinger & Son, and Sebastian Luchsinger as varnisher with Indianapolis Chair Manufacturing Co.

1885 Henry in partnership with Conrad Bill as Luchsinger and Bill dealers furniture, bedding etc. at 31 Eddy St.

1887 The firm of John B. Luchsinger & Son is dissolved.

Maier Brewing Co.
Brewery in Los Angeles, 1907-1920

Mathie Brewing Co.
Brewery in Los Angeles, 1907-1920

McConnell, Hugh (1819-1863)
Manufacturing cutlery in California, c.1854-1863
1854 Listed in San Francisco city directory as manufactor of cutlery at 116 Pacific.
1856 Relocates to 223 Jackson St.
1859 Relocates to 191 Jackson St.
1883 Passed away.

Mills Novelty (1890-c.1946)
Mills, Mortimer Birdsul, founder
Manufactoring, selling, and renting coin operated gambling devices in California, 1899-1910 and 1926-1942
1845 Mortimer Mills born in Ontario, Canada.
1878 Moved to Chicago and opened the Mills Pneumatic Brake Company. He received 20 patents on railroad improvements over the next 5 years.
1891 Received his first patent on a coin operated machine and incorporated his second business, the M. B. M. Cigar Vending Machine Co.
1896 circa. Created two coin operated gambling devices, the LITTLE PAU-PAU and the Klondike.
1897 The controlling share of the company were transferred to his son Herbert and the name was changed to Mills Novelty.
1899 Opened a branch store in San Francisco at 221 California Street. The Chicago factory employed 500 men and had a daily production capability of 100 machines. The January 30, 1898 *San Francisco Call* described the OWL one of their most popu-

lar machines, "It was one of those big, ornamental affairs which have become so common of late in San Francisco Saloons..."

1901 The San Francisco branch relocates to 31-39 Montgomery Street and advertise themselves as the largest manufacture of slot machines in the world.
1903 Relocate to 933 Market St.
1904 Hire M. A. Larkin as manager.
1907 After the earthquake and fire relocate to 907 Market St.
1909 Relocate to 22 5th St.
1911 Closed their San Francisco branch office due to local legislation which prohibited the operation of slot machines.
1926 Reestablish a branch office in Oakland.
1942 Material shortages, due to World War II, stopped the production of slots.

Milwaukee Brewery
Brewery in San Francisco, 1902-1920

Mission Brewing Co.
Brewery in San Diego, 1912-1916

Morris, Benjamin
Manufacturing California Jewelry in California, 1856-1897
1856 In business as Mathewson & Morris 159 Sacramento St.
1859 In business with John Littlefield as Morris & Littlefield, manufacturing jewelry at 155 Sacramento St.
1861 John Littlefield is still a partner in the firm of Morris & Co., manufacturing jewelry at 643 Sacramento St.
1865 Advertisement states; *B. Morris & Co., manufacturing jewelers, 643 Sacramento Street, San Francisco. A large assortment of California jewelry constantly on hand.*
1881 Relocates to 110 Sutter St.
1897 Absent from San Francisco city directory.

Napa City Brewery
in Napa, 1900-1910

National Brewing Co.
Brewery in San Francisco, 1894-1916

North Star Brewing Co.
Brewery in San Francisco, 1897-1920

Oakland Brewing & Malting
Brewery in Oakland, 1907-1920

Oakland Novelty
1902 Listed in the Oakland city directory as simply, slot machines at 470 10th Street.

Otar, John (1891- ?)
Door, lamp, and furniture maker in California, 1919-?

1891 May 26 born in Transcaucasian Russia.
1910 Arrived in the United States.
1913 Engaged in manufacturing patinated articles.
1917 circa. Began making lamps in Boston.
1919 Arrived in California and settled in Santa Cruz. he began manufacturing lamps from a little shop on the Sims Ranch.
1920 circa. Relocated to 86 Locust St.
1921 circa. Relocated to 143 1/2 Pacific Ave.
1930 circa. *The Santa Cruz Evening News* discussed the high grade work of Mr. Otar. "The wares of Otar the lampmaker are seen in other places than in Santa Cruz. At Carmel-by-the-Sea ..., rich rare designs of grilles and hinges, andirons and firetongs—a varied assortment of the wares of Otar the Lampmaker. "

Pacific Jewelry Company

Manufacturing gold quartz jewelry etc., in California, 1877-1896. (see below and following page)

1877 Listed in San Francisco city directory as Pacific Jewelry Company, Nathan and Samuel proprietors, salesroom at 6 Battery St.
1887 The firm relocates to 17-19 Battery St.
1893 The firm relocates to 533 Market St.
1895 Schwolbe and Hackle assume control of the firm and it relocates to 406-408 Market St.
1897 Absent from San Francisco city directory.

Pacific Jewelry Company Trade
Catalog, circa 1877-1896.

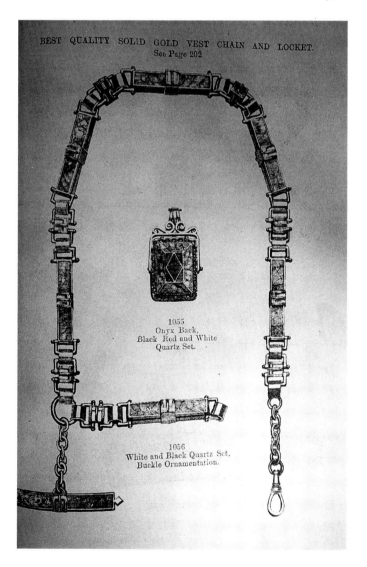

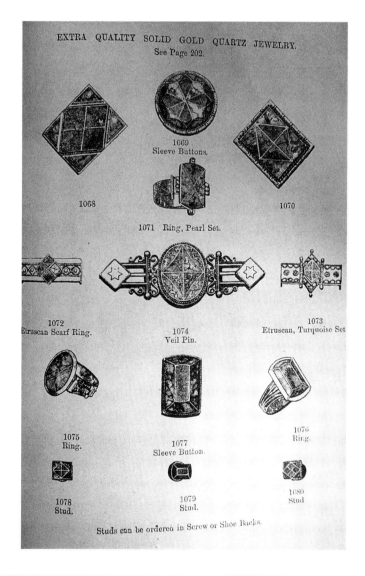

Pacific Jewelry Company Trade Catalog, circa 1877-1896.

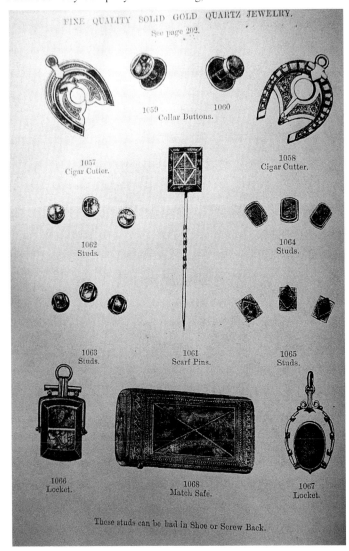

Palace Brewery
Brewery in Alameda, 1891-1907

Palmer, William J.
Furniture Manufactor in California, 1863-1879
1859 William J. Palmer appears in the San Francisco city directory as a driver with Wells Fargo & Co., dwelling at What Cheer House but is absent the following year and does not reappear until 1863.
1863 William J., listed as a carpenter.
1868 Joins the existing firm of John Wigmore as Wigmore and Palmer in the manufacture of office and school furniture at 120 Spear St. and 423 California St. Awarded gold medal for the "Best Cabinet & School Furniture" at the Mechanics' Institute Fair and Diploma at the State Fair, Sacramento.
1869 The partnership is disolved and Palmer continues on as W.J.T. Palmer & Co., in the manufacture of school and office furniture at 105-107 Mission with showrooms on Market and Sutter. Wigmore maintains the original location and commences in the lumber business.
1871 Noted by the *Sacramento Bee* for a display at the California State Fair "J. T. Palmer, San Francisco makes a nice exhibit of office and school furniture which he makes a specialty."
1873 Opened a salesroom at 323 California St.
1877 Relocate the factory to Brannon St.
1879 William J.T. Palmer is listed as agent for Fireman fund Insurance.
1892 *Tales, Sketches, Poetry, and Music* gives the following account of the firm. "W. J. T. Palmer & Co., office 323 California street; Factory 105 Mission street. The manufactory of school and office furniture has become quite a business on the coast, and this popular firm occupy the front rank in their line, having made the furniture of some of our finest and most elaborately furnished offices on the Pacific Coast. The Lick House bar, which in all its appointments, is not excelled for its beauty and ornamentation in the United States, is of the work of Messrs. Palmer and Co. This firm have recently rebuilt and enlarged their factory owing the increased demands for their goods. Messrs. Palmer & Co., are giving especial attention to the manufacture of goods from California woods..."

Plate, Adolphus Joseph
Gunsmith, importer, and dealer of firearms in California, 1856-1882
1818 Born in Prussia.
1856 Listed in the San Francisco city directory as gunsmith residing at 107 Post St.
1858 Gunsmith at 103 Commercial St.
1861 Gunsmith at 507 Commercial St.
1863 Importer at 411 Sansome St.
1867 Importer at 510 Sacramento St.
1869 Henry A. Plate is listed as a bookkeeper and A. A. Plate as a clerk with A. J. Plate.
1870 Importer and dealer of guns, pistols, trimmings, and sporting material at 510 Sacramento St.
1881 The firm relocates to 418-420 Market St., and in addition to guns advertises the manufacture of military, Masonic, and society goods.
1883 Absent from San Francisco city directory.

Plum, Charles M. & Co. (1827-1897)
Carpet, upholstery, jobber and furniture importer in California, 1854-c.1898
1827 circa. Born in New York.
1854 Listed as an upholster at 149 Montgomery St. in San Francisco directory.
1856 Listed as an upholster for Frank Baker.
1858 Listed as foreman of upholstery department for Frank Baker.
1859 Opens as Charles M. Plum Carpets & Upholstery at 12 Montgomery St.
1861 Relocates to 22 Montgomery St. and advertises the furnishing and decorating of churches and society halls.
1867 Returns East for a brief visit to his early home and is presented, from his employees a cane described in the *San Francisco Alta*, as being "of California wood, capped with a gold head all of which is the workmanship of California. The article further describes him as past president of the Mechanics Instate and a school director.
1871 Reorganizes with John Bell under the name Plum, Bell & Co., at 26 Post St.
1875 Bell leaves the firm and its reorganized as Charles M. Plum & Co. and for the first time begin advertising a line of furniture.
1877 The firm relocates to 641 & 643 Market St.
1885 Open a branch store and factory at 2004 Market St.
1887 The firm relocates to 1301-1307 Market St. where they remain through 1898.
1892 An account of the firm is published in *Master Hands in the Affairs of the Pacific Coast*. It states in part, the firm "has a widespread and high reputation for the manufacture of fine decorative wood work for interiors, artistic furniture and household decorations. Many of the finest residences on the coast were furnished complete or in part by this establishment...The house claims to have a stock of upholstery unsurpassed for variety and quality in any city in the country, and as a proof of their ability to compete with other cities, they have been awarded the gold medal for the best upholstered furniture in the world, at the Centennial Exhibition held at Melbourne, Australia, in the year of 1888." Their showroom address is given as 1301-1307 Market and factory as 215 Fell street equipped with the latest and best machinery.
1897 Passed away leaving a wife and five children.

Pohlman, Henry
Manufacturing jewelry in California, 1856-c1868

1856 In business with Doubeski as Pohlman & Doubeski, manufacturing jewelry at 102 Merchant St.

1858 Jeweler with Hass & Louderback.

1859 Foreman with Louderback & Baldwin.

1861 Jeweler.

1864 Henry Pohlman and August Bellemere take over the jewelry manufacturing end of M.M.Baldwin & Co., at 516 Clay St.

1865 August Bellemere leaves the firm and the firm is renamed Pohlman and Co.

1867 William Baehr joins the firm and its renamed Pohlman & Baehr.

1868 William Baehr takes over the operation on Clay Street and Pohlman joins Pierre Frontier as Frontier & Co., Quartz cutters, lapidaries, and jewelry manufactures.

Price, Michael Sr. (1799-1885) with Michael Price Jr. (1833-1889)

Manufacturing cutlery in California, c.1859-1889

1799 Michael Price Sr., born in Limerick, Ireland.

1810 Apprenticed as a cutler.

1833 Michael Price Jr., born in Limerick, Ireland.

1845 circa. Michael Price Jr. apprenticed with his father, a master cutler.

1857 circa. Michael Price Jr., arrived in California.

1859 Michael Price Jr., cutler at 59 Montgomery.

1861 Michael Price Jr., cutler at 221 Montgomery.

1863 Michael Price Jr., cutler at 110 Montgomery. The firm employees James H. McConnell, son of Hugh McConnell, cutler and surgical instrument maker in San Francisco. (1854-1863) Micheal Price Jr. and his wife of one year have their first and only child, Henry.

1864 Michael Price Jr. manufacturing cutlery at 110 Montgomery.

1865 Michael Price Sr. joins the firm and James H. McConnell leaves the firm to work for Will & Finck.

1867 Michael Price Sr. with Michael Price Jr. James H. McConnell rejoins the firm.

1868 Michael Price Sr. with Michael Price, manufacture and retail cutlery 110 Montgomery St. J. Herman Schintz pioneer cutler and former employee of Hugh McConnell and Will & Finck joins the firm.

1869 Michael Price Sr. with Michael Price, manufacture and retail cutlery 415 Kearney St.

1873 No Michael Price Sr. listed. Michael Price manufacture of cutlery 10 Stevens, retail 415 Kearney St. James H. McConnell is no longer listed with the firm.

1874 Michael Price Sr., manufacture cutlery 10 Stevens, salesroom 415 Kearney St. Michael Price Jr., cutler 415 Kearney St.

1881 circa. Michael Price Sr., retired.

1888 Michael Price Jr. is listed for the last time he passes away the following year.

Reichel, Frederick R. (c. 1824-1867)

Manufacturing jewelry and silverware in California, 1856-1867

1824 circa. Born in Germany.

1856 F. R. Reichel, jeweler at 159 Washington St.

1858 Frederick Reichel with William Koehler as Reichel & Koehler, manufacturing jewelry at 102 Merchant St.

1860 The firm appears to be dissolved and Frederick Reichel is listed as manufacturing jewelry at 102 Merchant St.

1861 Frederick R. Reichel manufacturing jewelry and silverware 620 Merchant St.

1864 Frederick R. Reichel manufacturing jewelry and silversmith 620 and 622 Merchant St.

1867 Passed away at the age of 43.

Reliance Novelty Company

Manufacturing coin operated gambling devices in California, 1897-1909

1897 Listed in the San Francisco city directory as Reliance Novelty Co., B. J. Werthmier manager, slot machines at 751 Market St.

1899 The company incorporates as B. J. Wertheimer manager and Charles Leonhardt president manufacturing novelties and slot machines and relocates to 21 Stockton. Charles Leonhardt has been operating cigar and tobacco establishments throughout the city since 1887.

1903 Relocated to 668 Mission St and continue the manufacture of card machines.

1904 Leonhardt leaves the company and Wetheimer becomes treasure and manager.

1907 After the earthquake and fire the company relocates to 128 Twelfth St.

1910 Due to 1910 legislation which prohibited the operation of slot machines, the firm was closed.

Royal Card Machine Company (1897-1898)

Manufacturing coin operated gambling devices in California (1897-1898)

1897 Gus Dworzek, former electrician an machinist and George Stevenson, former electrician form the Royal Card Machine Company, manufacturing card machines, novelties, etc., at 154 1st St.

1898 The firm relocates to 23 Stevens St.

1899 The firm is dissolved with both Gus and George are employed as electricians.

Royal Novelty Company

Manufacturing coin operated gambling devices in California, 1897-1900

1897 Sol Kahn, former cigar maker manages the Royal Novelty Co., at 37 Merchants Exchange Building.

1901 Absent from San Francisco directories and Sol Kahn is again manufacturing cigars.

Ruhstaller Brewery

Brewery in Stockton and Sacramento, 1897-1920

Salinas Brewing Co.
Brewer in Salinas, 1904-1920

Santa Cruz Brewing Co.
Brewery in Santa Cruz, 1906-1920

Schintz, Jacob Herman (1827-1908)
Manufacturing cutlery, corkscrews, and lemon squezzers in California, 1856-1906
1827 Born in Switzerland.
1856 circa. Arrived in San Francisco and listed in the directory for the first time as a cutler living at Tennessee House.
1858 Herman Schintz, cutler at 223 Jackson St.
1859 Jacob H. Schintz, cutler at 191 Jackson St.
1860 J. Herman Schintz cutler with Hugh McConnell.
1861 No listing for a J.H. Schintz but it is believed he and relative, Alfred Schintz were partners in a cutlery shop at 417 Kearney St. (see Bernard R. Levine, *Knifemakers of Old San Francisco,* (Badger Books; California, 1978) p.116.
1862 J.H. Schintz, cutler at 622 Sansome St.
1867 circa. J.H. Schintz, cutler with Will & Finck.
1868 circa. J. Herman Schintz, cutler with Michael Price.
1871 Two listings for Schintz appear; Jacob H., cutler dwelling at 1813 Stockton and J. Herman corkscrew manufactory at 10 Stevens St, dwelling at 47 Jesse St.
1873 J. Herman Schintz, corkscrew manufactory at 10 Stevens, dwelling at 50 Jesse.
1875 J. Herman Schintz, cutler and corkscrew manufactory at 10 Stevens St. His son Henry joins the firm.
1884 Louis Bauer took over the shop at 10 Stevenson St.
1890 J. Herman Schintz resumes the cutlery business at 2513 1/2 Mission St.
1892 circa. J. Herman cutler with Reinhold Hoppe.
1896 J. Herman cutler at 411 Shotwell St.
1906 Retired.
1908 Died as a result of an estimated 25 foot fall.

Schlotterbeck, Charles, Frederick and **Joseph**
Gunsmiths working in California, 1859-1867
1859 Charles Schlotterbeck, already formally trained as a gunsmith with Henry Derringer of Philadelphia, joins the firm of A.J. Plate as a gunsmith.
1860 Joseph Schlotterbeck makes a single appearance in the San Francisco Directory as a gunsmith.
1868 Charles Schlotterbeck, who has remained as a gunsmith with A.J. Plate is absent.
1870 Frederick Schlotterbeck, gunsmith with A. J. Plate.
1872 Frederick Schloterbeck is absent.

Schreiber, Christian
Furniture dealer and manufacture in California, 1849-c.1885
1828 Born November 14, near Carlsruhe, in Baden Germany.

1835 Immigrated with his parents, Philip and Elizabeth Schreiber, to New York.
1849 After learning the trade of cabinet-maker he moved to Akron, Ohio, where he worked in a furniture store until he was struck with gold fever April 15, 1850. He, along with a band of forty wagons, set out over land which gradually dissipated and at Green River he and another companion completed the journey on foot. They arrived July 27, whereupon Mr. Schreiber mined for two months before moving to Sacramento and was commissioned to build a billiard table which he sold for $450.
1850 Re-established in San Francisco and opened a furniture and carpet business making ship mattresses which were in great demand.
1852 Returned to the East and married in Rochester, NY. Then returned to San Francisco via the Isthmus of Panama and advertised under the name C. Schreiber, manufacture and importer at 179 Jackson St.
1856 Listed as the proprietor of the Rochester Bedding and Furniture Store.
1858 With Jacob Schreiber at 179 Jackson.
1860 Relocates to 110 Sansome St.
1861 A bill of sale notes his address as No. 406 Sansome St., 3d door North of Sacramento.
1864 Listed as J. & C. Schreiber, wholesale and retail furniture and bedding 406 Sansome St.
1867 No listing in the San Francisco directory and it's stated in *The Bay of San Francisco: A History,* The Lewis Publishing Co., Chicago, 1892, p.66, "In 1867, with his daughter, Mr. Schreiber made a trip to Europe being absent about six months. On his return he married in Rochester, New York to Martha Gerald."
1868 Listed on Sansome St. as Christian Scriber bedding, furniture and manufacture of Fullers Patented spring bed.
1872 Reorganized as Schreiber, Rohr & Co., under the partnership of Christian Schreiber, John Rohr, and John W. Meyer selling furniture and bedding at 539 Market, manufactory NE corner Main and Mission.
1873 Reorganized as Christian Schreiber & Co., with John W. Meyer and opened a Branch Store in Oakland under his brother Philips management.
1875 Sold out the business in San Francisco and relocates to a 20,000 square foot facility, on Broadway in Oakland.

Schulz, William with **Fischer, Emile A.,** and **Mohrig, Christopher Ferdinand.**
Manufacturing silver, gold quartz jewelry etc. in California, 1863-1890
1856 C. Ferdinand Mohrig listed as jeweler and watchmaker in San Francisco.
1859 C. Ferdinand Mohrig, jeweler at 220 Dupont St.
1862 C. Ferdinand Mohrig, manufacturing jewelry at

649 Washington St.

1863 William Schulz, with F. R. Reichel.

1864 William Schulz, silversmith with F. R. Reichel.

1868 circa. William Schulz and Emile Fischer begin the partnership of Schulz and Fischer, manufacturing silverware at 10 Stevenson St.

1869 circa. Christopher Mohrig joins the firm and it becomes Shulz, Fischer, and Mohrig. They furnish the golden spike, on a sub-contract, which Leland Stanford attempted to drive with a silver-headed maul, into a hole drilled in a laurel tie, the last laid in the transcontinental railroad on May 10, 1869.

1871 Manufacturing silverware and jewelry at 10 Stevens St.

1873 Schulz and Fischer buy out Mohrigs interest for $5,400.

1875 Schulz and Fischer open at 513 Market St. while Mohrig remains at 10 Stevens St., as a lapidary and manufacture of jewelry including gold and silver chains.

1879 Mohrig relocates to Berry Street where he remains until 1884.

1883 Schulz and Fischer take in as partner, Samuel McCartney and begin advertising importers as well as manufactures.

1889 Fischer leaves the firm and advertises himself as manufacturing silverware and importing platedware and cutlery at 4 Sutter Street. The old firm is renamed Schulz & McCartney and continues operating out of the 513 Market Street location.

Shreve, George C.
See Edgar W. Morse, et al, *Silver in the Golden State,* the History Department Oakland Museum, Oakland, 1986, p. 16-23.

Stone, Lucius D.
See Ned and Jody Martin, *Bit and Spur Makers in the Vaquero Tradition: A Historical Perspective,* Hawk Hill, California, 1997, p. 168-169.

Solano Brewing Co.
Brewery in Vallejo, 1904-1920

Todd, John
See Bernard R. Levine, *Knifemakers of Old San Francisco,* Badger Books, California, 1978, p. 140-143.

Tucker, John W.
Importer and manufacture of gold quartz etc., in California, 1852-1886

1852 J. W. Tucker, jeweler at 125 Montgomery Street in San Francisco.

1856 Advertisement states, "Quartz Jewelry! In this department of manufacture, I am without a competitor. In the artistic elegance in which I get up my work, I have been able to supersede all others: particular those who pretend to get up similar work in this city. If any person wants a beautiful cane head, ring setting, breastpin, etc., etc., etc., let them call on me, and I will sell them any of the above articles, or another that can be manufactured from quartz, cheaper- (but mind I guarantee them to be genuine) than they can possibly be purchased elsewhere."

1858 The August 5, 1860, *Alta California* states, "A PRESENT FROM THE RUSSIAN EMPEROR. - Mr. J. W. Tucker, of this city, having, in December 1858, sent to the emperor of Russia some beautiful specimens of gold- bearing quartz, for his mineralogical cabinet, the Emperor has been pleased to send in return, as a token of his thanks, a splendid and massive gold ring, in which is set a superb amethyst, surrounded by ten diamonds weighing a caret each. The gold of the ring is from the Ural mountains. It was on exhibit yesterday, in the window of Mr. Tucker's jewelry store, and attracted much attention. The ring is worth about $2,000."

1861 The *Alta California* states, "A HANDSOME PRESENT. - There was on exhibition at Tucker's jewelry establishment yesterday a magnificently mounted cane intended as a gift from his clerks - to Arthur M. Ebbetts, the efficient and popular officer who has just retired from the superintendence of the County Recorders office. The cane, which is of iron-wood, is mounted by a massive head of gold quartz on the side of which is inscribed... The cost of the cane is $65.00."

1862 circa. Reorganizes as J. W. Tucker & Co., at 505 Montgomery St.

1864 Advertisement states, "*J. H. Baird successor to J. W. Tucker.*"

1865 circa. John H. Baird and George O. Ecker join the firm as partners. Ecker later enters partnerships with George C. Shreve & Co., and M.M. Baldwin.

1866 The July 19, 1866 *Alta California* states, "THE ONLY FULL GOLDEN TABLE SERVICE - a new York journalist is going through the returns of the United States Internal Revenue Department in that city, noticed the fact that while there are many partial sets of gold plate for table use in New York, the only complete one belongs to G. K. Garrison, former mayor of San Francisco and was presented to him on his retirement from that office by his friends in this city in 1854. the writer says: "It consists of a large 22 inch salver, most elaborately embossed and engraved, with devices appertaining to his life in California: coffee pot etc... This set is undoubtedly the finest in America, and it is a noticeable fact that every dollar of the cost was subscribed by citizens of San Francisco... The set was manufactured by J. W. Tucker who is still in business in this city and although San Francisco was in its infancy at the time, it is a noteworthy fact that no workman at the East or in this State

have yet been able to surpass it in design and finish. Many partial sets of gold plate, and full ones of silver, have been turned out on this coast, and the elegance and richness of work of San Francico workers in the precious metals now stands unrivaled on the continent. Among the specimens of our ability in this line is the sword presented to General Hooker, while he was in command of the Army of the Potomac... This sword also manufactured by Tucker is admitted to be the richest and most elegant affair of this kind ever produced in America.(for illustration see R.L. Wilson, *Steel Canvas,* Random House; New York, 1995, 214-215) The Colfax party, while here, expressed their unbounded surprise at the excellence of the work turned out by our San Francisco jewelers, and purchased largely of it. Few visitors who are able to invest, leave our shores without taking away some specimens of the skill of our workers in precious metals and some style of goods such as the "California gold belt buckles" which originated here, have become admitted indispensable articles of fashionable wear the world over."

1867 Baird and Ecker are no longer with the firm and in October the firm relocates to 101 and 103 Montgomery St.

1869 September 29, 1869, *Alta California* states, "SOUVENIRS OF CALIFORNIA FOR HON. W. H. SEWARD. This evening being the last which will be spent in the city by Hon. W. H. Seward prior to his departure for Mexico, seems to have been dedicated to the presentation to him of souvenirs of his visit to this coast and the high esteem in which he is held by our citizens. The distinguished visitor will meet the pioneers at their hall at 7 1/2 o'clock, when he will be presented with a certification of honorary membership, designed especially for the occasion and very neatly gotten up: and also with a magnificent gold-headed cane... Mr. Seward will also be presented at the parlors of the Occidental, on the same evening with an elegant gold cigar case and a gold snuff-box, manufactured by Messrs. J. W. Tucker & Co., by order of some of our citizens. The cigar case is six inches in length, three and a half wide and one and a quarter thick, and is made of twenty carat gold. On the front is an aral, on which is neatly engraved a fine view of Sitka, having upon the upper margin the name "Seward." On the different corners are engraved a walrus, a polar bear, a fox and an otter; while on the scroll engraving on the lower border are the words "Alaska" and "California." On the reverse of the case is another aral, on which is finely engraved a water view, representing natives in their canoes hauling deer. Upon one edge is set a large diamond, valued at $600. On the two sides are the monograms, "W.H.S." and "1860" The cost of the case was about $1,500. The snuff box which is also of fine gold, is three inches in length, two inches wide and one inch thick. In the lid are specimens of gold bearing quartz from the different mines. The name "Seward" is on the front and a monogram on the reverse. All the presents referred to, as specimens of California productions, reflect the highest credit upon both the designer and the manufacturer."

1875 Relocate to 131 Kearney St., as J. W. Tucker & Co., and Tucker Jewelry Manufacturing Co.

1879 F. Dirking assumes control of the firm and they advertise as silversmiths as well.

1885 F. T. Keeler assumes control of the firm and they relocate to 7 Kearney St.

1887 Absent from San Francisco city directory.

Union Brewing Co.
Brewery in Alameda,1905-1910

Union Brewing & Malting
Brewery in San Francisco, 1902-1916

United States Brewery
Brewery in San Francisco, 1893-1906

Vanderslice, William Keyser (1823 -1899)
Manufacturing silverware, gold quartz jewelry etc. in California, 1859-1899

1823 Born in Philadelphia.

1847 Married Miss. Sherman of Boston.

1857 circa. Arrived in California.

1859 Silversmith at 134 Washington St.

1860 From the *San Francisco Department*, "SILVERWARE MANUFACTORY- We call your attention to the advertisement elsewhere of Mr. W. K. Vanderslice. This gentleman has recently established himself on Washington Street, where he has exhibited to us, and manufactured by him of pure coin, some of the finest and most precious of mechanical art we have ever beheld; pitchers, waiters cups, spoons, knives and forks and an endless number of other articles..."

1861 Opened as Vanderslice & Co., manufacturing silversmiths 728 Montgomery.

1863 Relocated to the old Hook and Ladder Company's building at 810 Montgomery.

1864 His brother in law Charles H. Sherman becomes a partner, and W. K. Vanderslice & Co., continue the manufacture of silverware etc., with James Vanderslice as a silversmith.

1866 The November 26, *California Alta* reports, "CALIFORNIA INVENTION - Mr. W. K. Vanderslice, Jr., of 810 Montgomery Street, has invented a cigar holder for smoking purposes, which is a decided improvement on the present mouth-piece... A patent has been applied for this neat little instrument.

1868 The old partnership appears dissolved and Lucius Thompson becomes a partner with James Vanderslice as silverfinisher and W. K. Vanderslice

Jr. as a bookkeeper. The December 11, 1868 edition of the *Alta California* reports, "New Enterprises Started - The manufacture of Silverware etc. It has been frequently remarked that the State of California would shortly be able to produce and manufacture all the articles necessary for use, and become perfectly independent, so far as supplies go, of the eastern States. Within the past few years Messrs. Vanderslice & Co, have commenced the manufacture of silverware...Until quite recently, the greater portion of the silverware sold in this State was imported from the East, and principally manufactured in the States of Rhode Island and Connecticut. Messrs. Vanderslice & Co. have now in their employment some twenty men, in the different branches of the business and are fully prepared to fill any demands made upon them... The quality of the work turned out by this firm will compare most favorably with anything done in the Eastern States.. They only manufacture articles made from pure silver, and use about $2,000 worth each month..."

1873 circa. Lucius Thompson a former partner of George C. Shreve, joins Vanderslice as a partner and they relocate to 136 Sutter.
1875 Advertise the manufacture of silver, watches and jewelry.
1881 Thompson is no longer with the firm.
1883 Keneth Melrose Joins the firm.
1899 W. K. Vanderslice passed away but the firm continued operating in a lesser capacity until 1906.
1908 The firm is absorbed by Shreve & Co.

Washington Brewery & Malting
Brewery in Oakland, 1901-1910

Washington Brewery
Brewery in San Francisco, 1870-1899, and Oakland, 1891-1901

Weiland, John Brewery
Brewery in San Francisco, 1893-1920

Will, Frederick Adolph (1837-1912) with Julius Finck (1831-1914)
Importers, dealers and manufactures of cutlery and Ferro material in California, 1860-1932
1837 Born in Albany New York.
1859 Arrived in San Francisco via around the horn.
1860 Frederick, cutler with Hugh McConnell.
1861 Frederick, cutler with Frederick Kesmodel.
1862 Frederick, cutler with Frederick Kesmodel.
1863 Frederick Will, cutler in business for himself at 605 Jackson St. The former location of Hugh McConnell.

1864 Frederick Will and Julius Finck, a pioneering locksmith and bell hanger in the city begin the firm of Will & Finck at 605 Jackson St.
1865 The firm relocates to 613 Jackson St. and James McConnell is employed at the firm. The September 23, 1864 *San Francisco Alta* reported, "MORE PRIZES- The list of articles donated by our citizens as prizes to be shot for by the Police Guard at their projected target excursion is on the increase. Among the articles sent in yesterday were a magnificent bowie-knife, mounted and cased in solid silver, manufactured at a cost of $40, and presented by Messrs. Will & Fink, cutlers on Jackson St... They exhibit and are awarded premiums at the California State Fair and San Joaquin Agricultural Fair."
1867 Acquire the Kearney St. property of Frederick Kesmodel and he goes to work for the firm.
1868 Will & Finck at 611-613 Jackson St., retail store at 821 Kearney St.
1869 Will & Finck at 821 Kearney St.
1871 Will & Finck at 140 Montgomery and 821 Kearney. In addition to cutlery they advertise the sale of faro material.
1872 Applied for a patent clasp and began implementing it on the sheaths of fancy dirks and bowie knives.
1875 *San Francisco Journal of Commerce* reports they were awarded first premium for best and largest display of cutlery at the Mechanics' Institute.
1876 Relocate to 769 Market St and exhibited at the Philadelphia Centennial Exhibition in Philadelphia.
1877 *San Francisco Journal of Commerce* reports they were awarded best general display of cutlery and best set of California manufactured carvers at the Mechanics' Institute.
1883 Fred Will retired and sold his share of the business.
1885 circa. The firm relocates to 818 Market as a "bazaar" and opens a new factory at 30 First St.
1932 The firm was dissolved.

Wimmer, Wesley William
See Ned and Jody Martin, *Bit and Spur Makers in the Vaquero Tradition: a Historical Perspective,* Hawk Hill Press; California, 1997, p.146-147.

Wunder Brewing Co.
Brewery in San Francisco, 1898-1909